BUILDING
CHICAGO

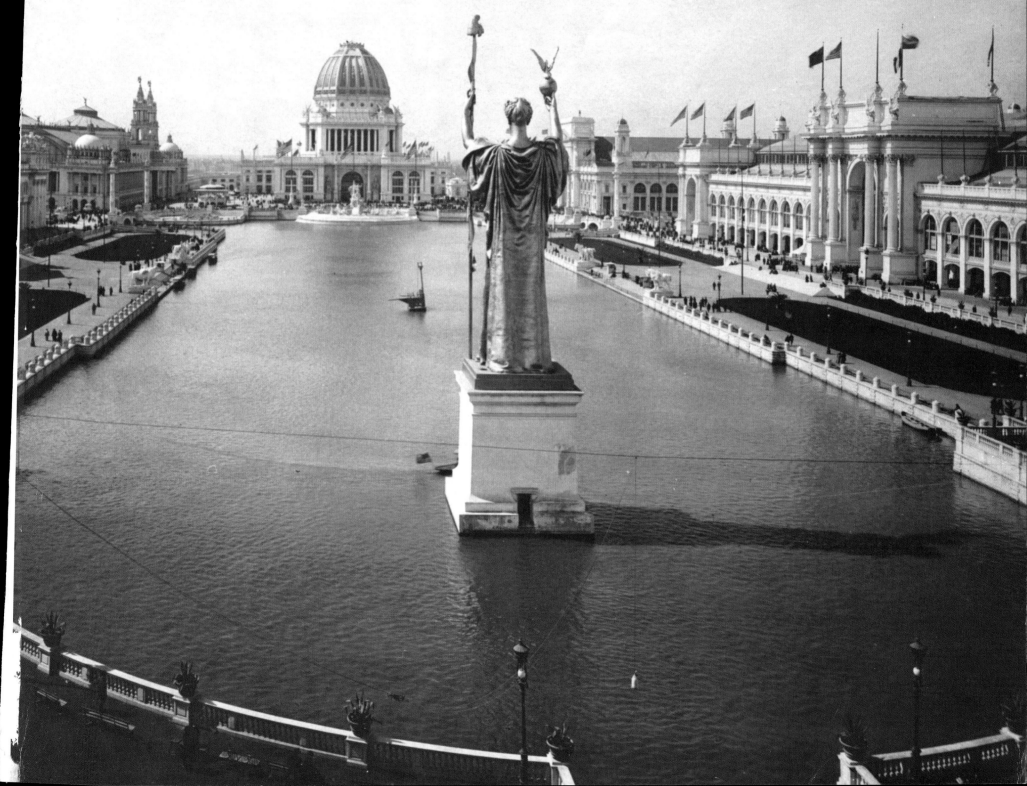

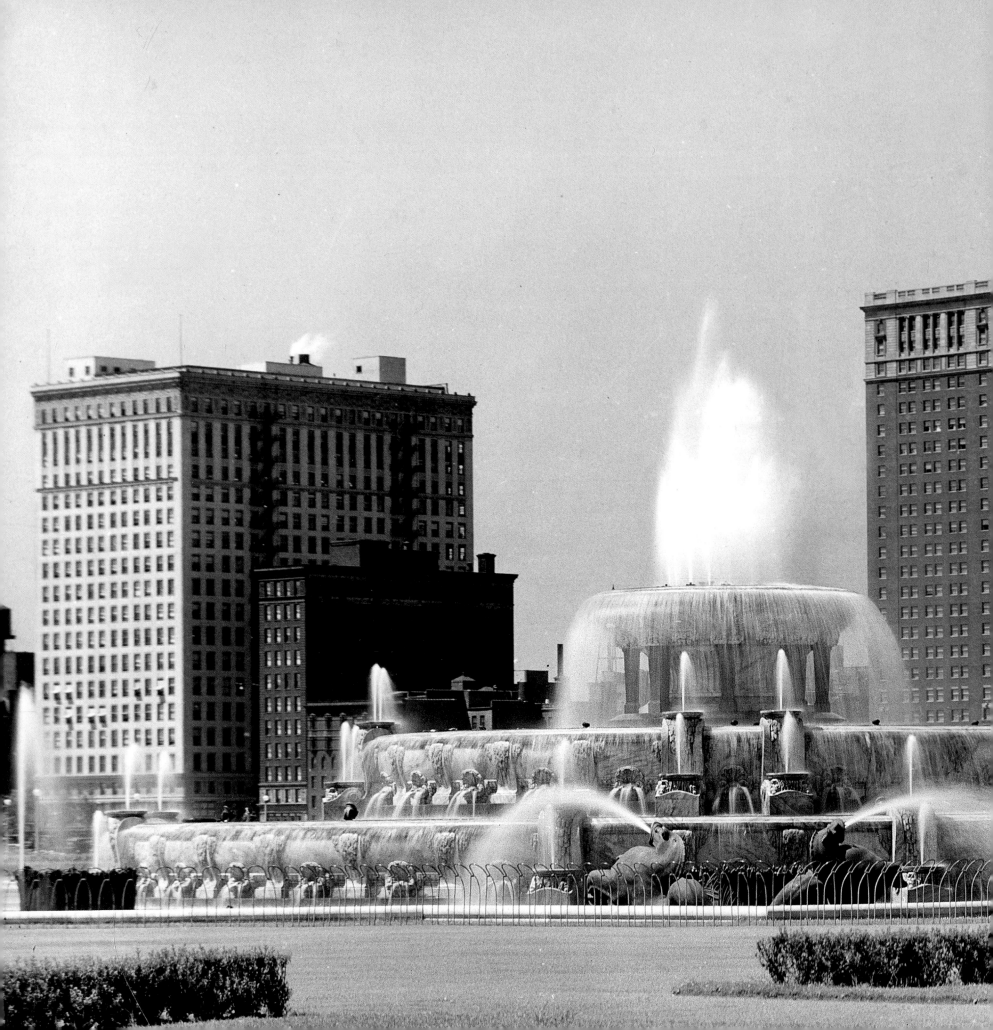

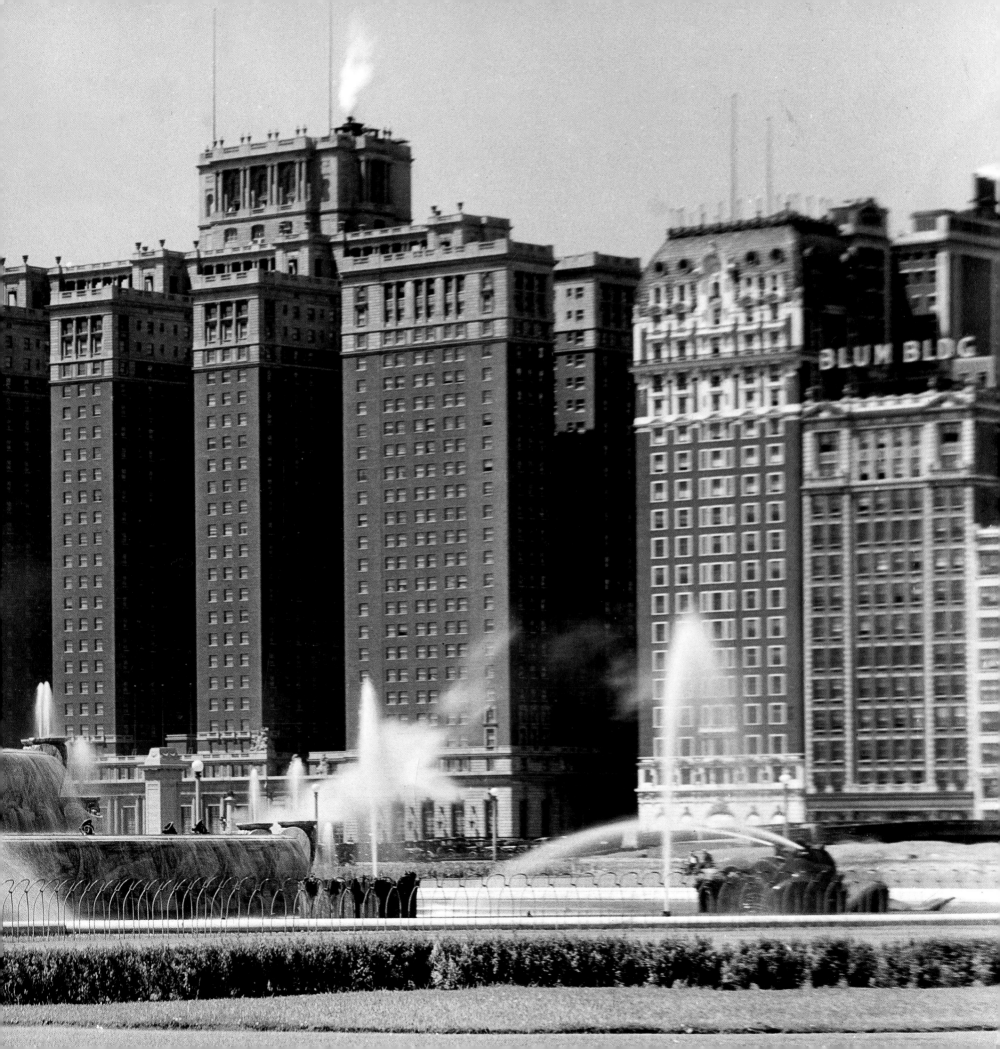

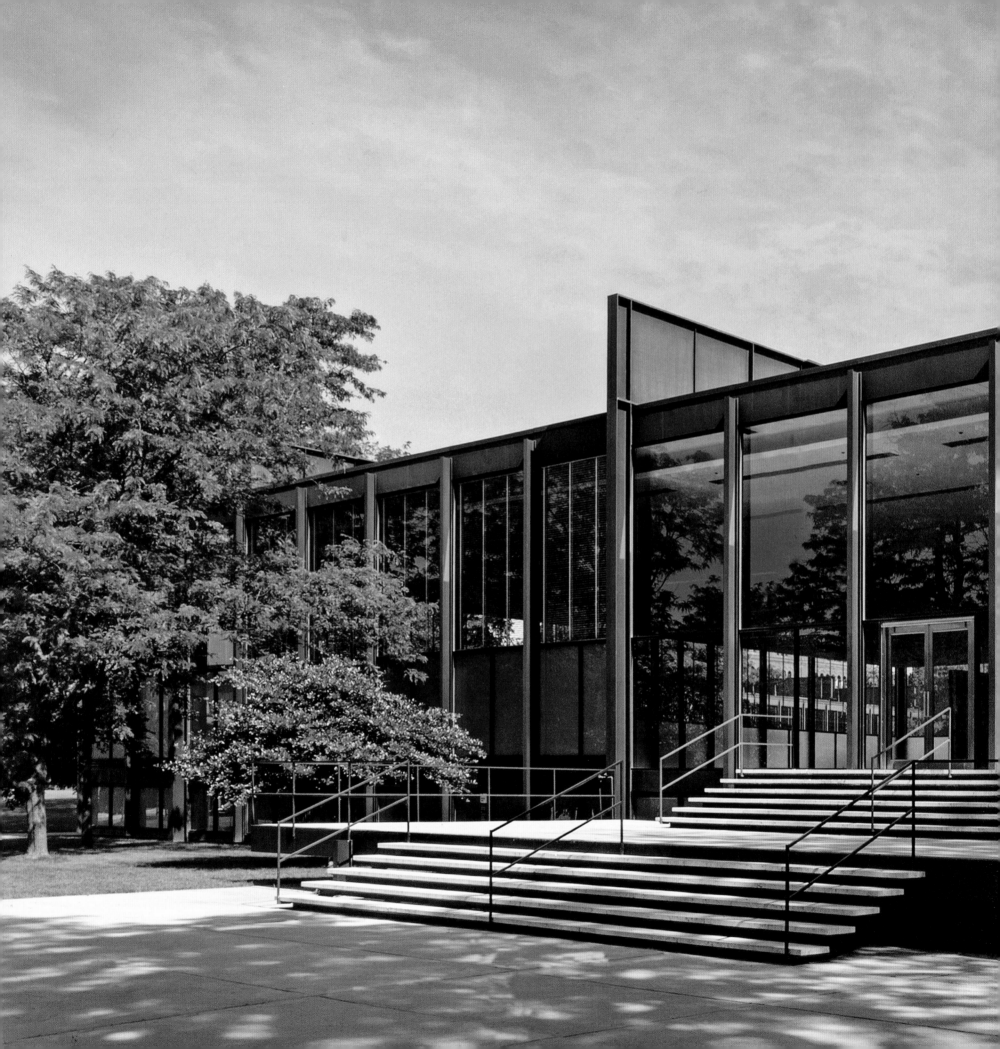

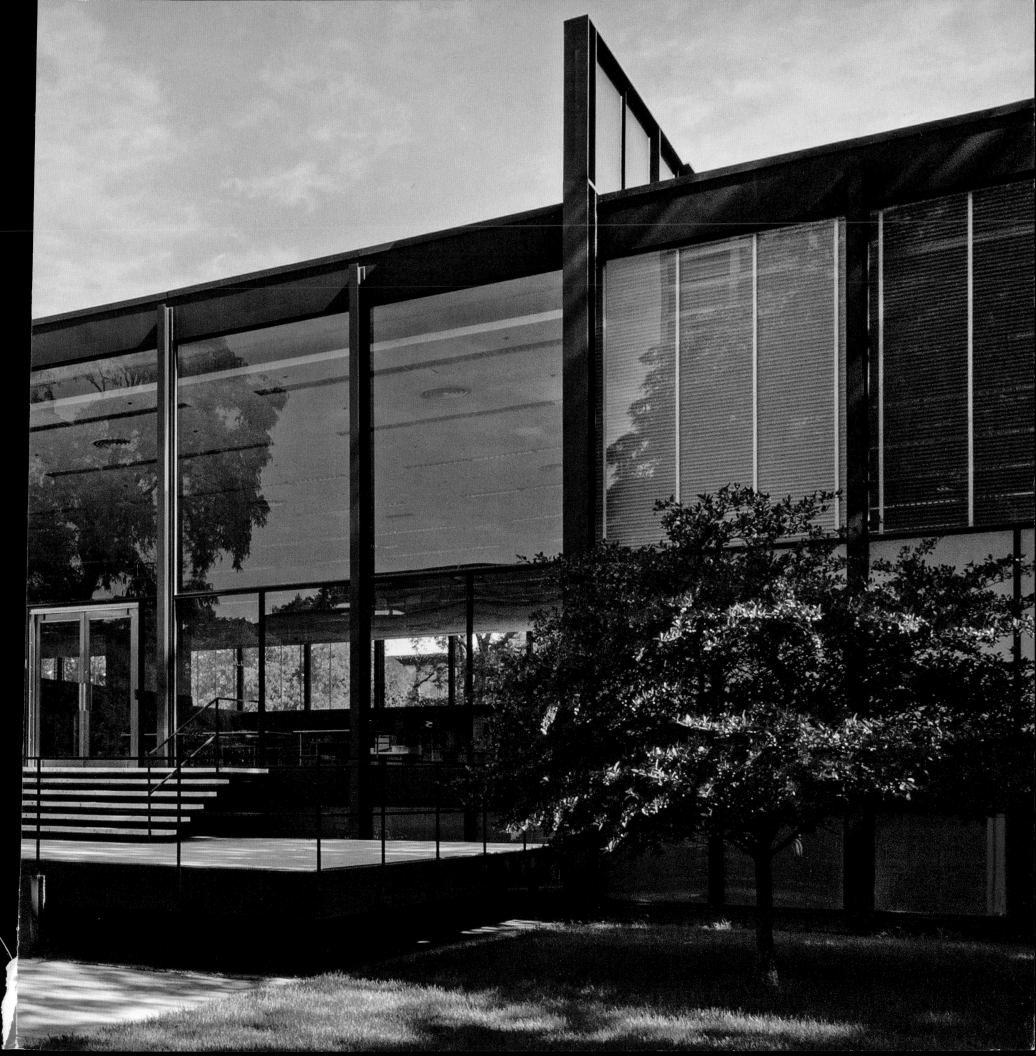

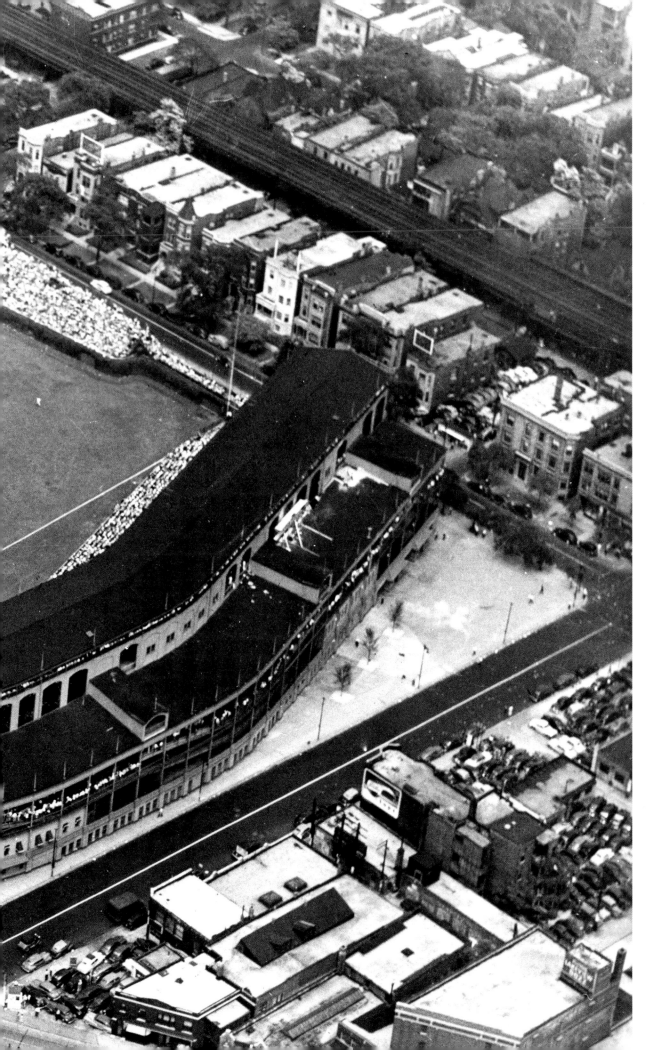

Page 1:
Daniel H. Burnham with various architects, World's Columbian Exposition, Jackson Park, 1893 (demolished). A view of Daniel Chester French's original *Statue of the Republic* overlooking the lagoon. French later created a one-third-scale replica in 1918 in Jackson Park. Photo: C. D. Arnold, Chicago History Museum, ICHi-02524.

Pages 2–3:
Alfred Alschuler, London Guarantee Building, 360 North Michigan Avenue, 1923; being renovated into hotel space, 2015, Goettsch Partners. The image taken c. 1925 shows the Wrigley Building tower in the foreground right and London Guarantee Building in the center. Photo: Kaufmann & Fabry Co., Chicago History Museum, ICHi-38229.

Pages 4–5:
Bennett, Parsons, Thomas and Frost with sculptor Marcel Loyau, Buckingham Fountain, Grant Park, 1927. This ca. late-1928 view shows the 3,000-room Stevens Hotel, now Hilton Chicago, at 720 South Michigan Avenue, the largest in the world when built in 1927. It was designed by Holabird & Roche. The building dwarfs the Marshall and Fox Blackstone Hotel of 1910 to its immediate right. During World War II, the Stevens housed some 10,000 Army Air Force cadets. It has been a Hilton hotel since 1945 and was restored in 1984–85 and again in 2012, to its current splendor. Photo: Charles R. Childs, Chicago History Museum, ICHi-68366.

Pages 6–7:
Ludwig Mies van der Rohe, Crown Hall (1956) at the Illinois Institute of Technology. The building was restored by Krueck and Sexton after nearly 50 years of continuous use. The overall goal was to respect the past while positioning the building for maximum future performance. Photo © William Zbaren, courtesy Krueck + Sexton, 2005.

Pages 8–9:
Zachary Taylor Davis, Wrigley Field, 1060 West Addison Street, 1914, aerial view 1950. Wrigley Field is the legendary home of the Chicago Cubs. After Boston's Fenway Park, it is the oldest extant stadium used for Major League Baseball. It is currently being renovated to incorporate, among other items, oversize electronic scoreboards and media screens, all of which have become points of debate in terms of its landmark status. Photo: Chicago History Museum, ICHi-17617.

Pages 10–11:
Downtown Chicago and Grant Park. Photo: June 3, 2009 © Tigerhill Studio Corp., John T. Hill, 5134-00059.

Page 12:
Adler and Sullivan, Auditorium Theatre and Hotel, 430 South Michigan Avenue, 1889, with various later restorations through 2003. This massive limestone and granite landmark is now home to Roosevelt University. It was an early example of a multiuse building with a 4,300-seat theater, offices, and a 400-room hotel. Booth Hansen and MGLM continued restoration through the building's 125th anniversary in 2015. Photo: Ganz Hall restored interior, courtesy Booth Hansen.

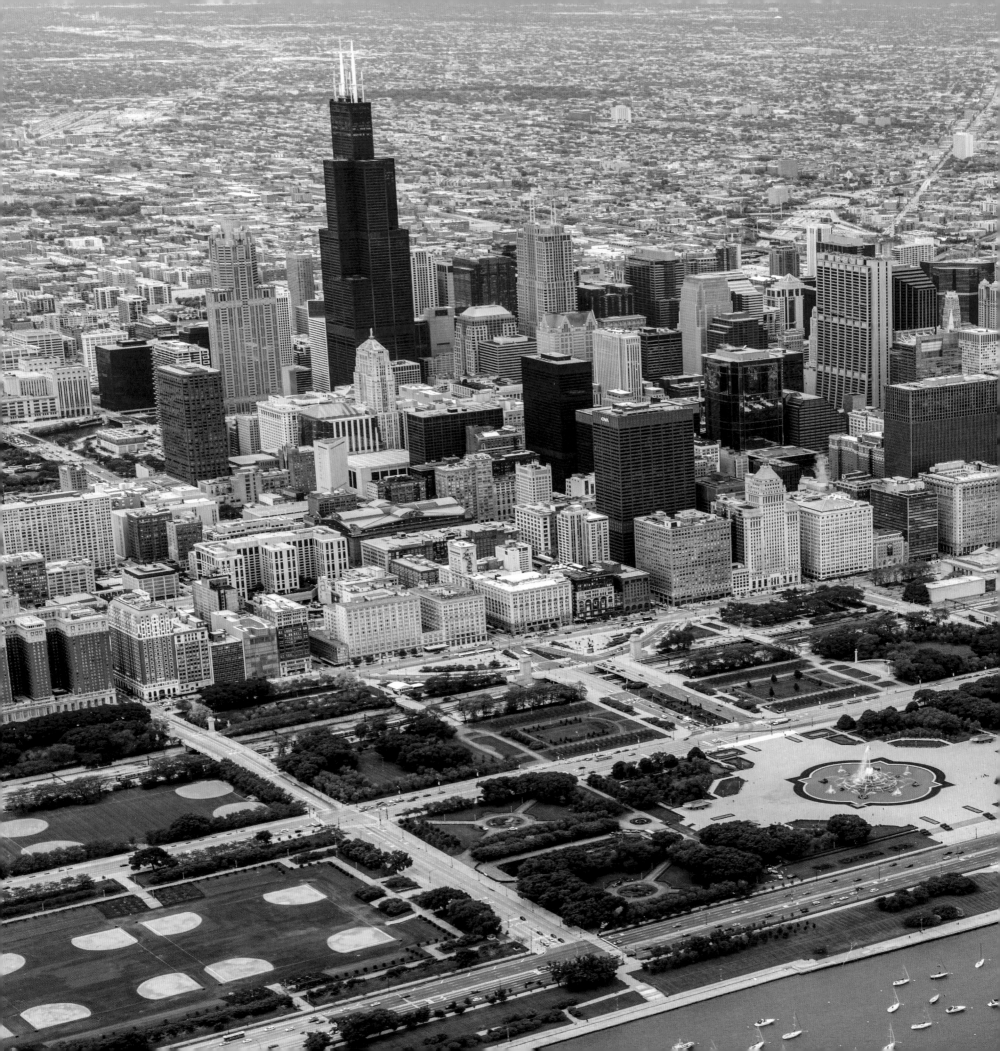

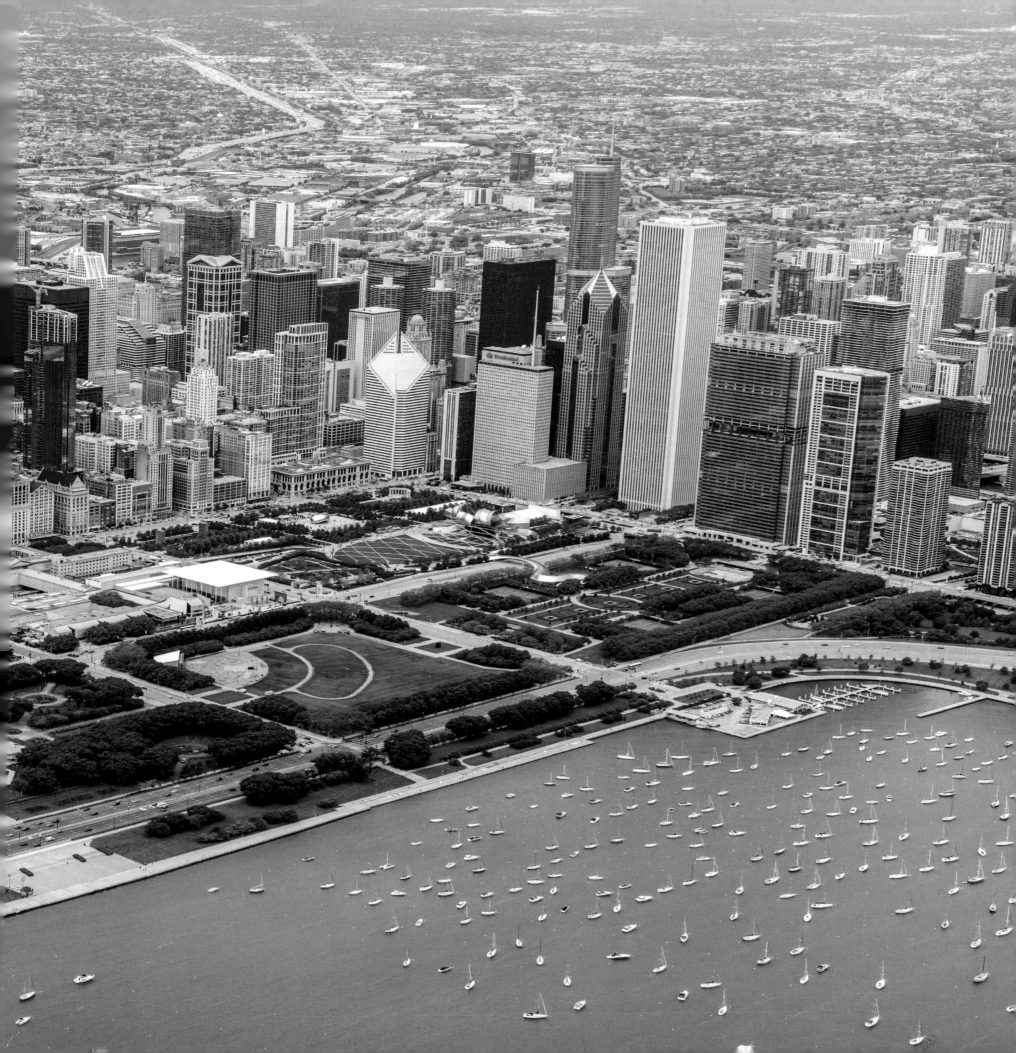

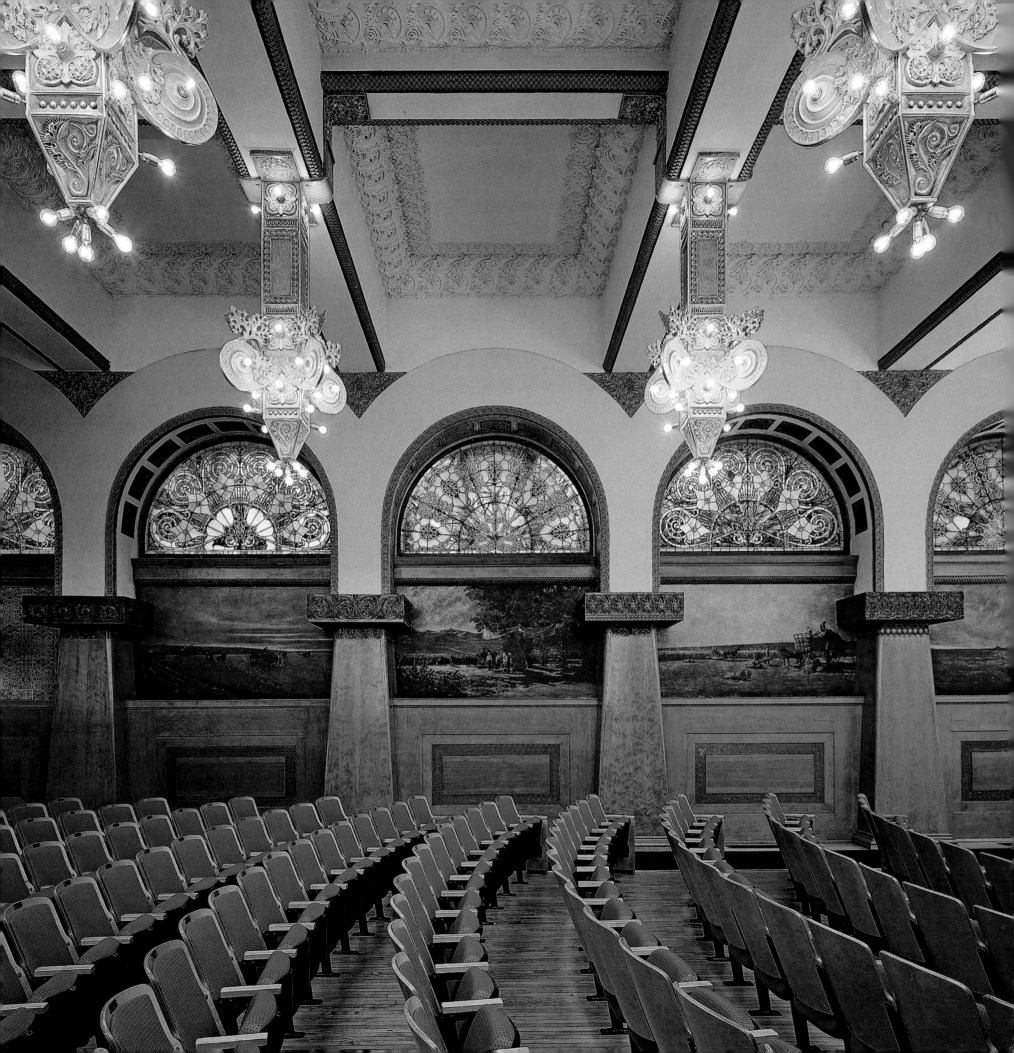

BUILDING
CHICAGO

The Architectural Masterworks

John Zukowsky

foreword by Gary T. Johnson

In association with the Chicago History Museum

RIZZOLI
NEW YORK

New York · Paris · London · Milan

First published in the United States of America in 2016 by
RIZZOLI INTERNATIONAL PUBLICATIONS, INC.
300 Park Avenue South, New York, NY 10010
www.rizzoliusa.com

In association with the Chicago History Museum
1601 North Clark Street, Chicago, IL 60614

ISBN-13: 978-0-8478-4870-6
Library of Congress Control Number: 2016936608

The publisher wishes to acknowledge Arcaid Images and express its gratitude to Lynne Bryant,
who offered up the seed from which this book was born.

ARCAIDIMAGES
Architecture Homes Heritage Destinations

Distributed to the U.S. Trade by Random House, New York

Page 16: William and Hal Pereira, Esquire Theater, 58 East Oak Street, 1938 (now greatly altered). Photo: March 5, 1938,
Hedrich Blessing Collection, Chicago History Museum, HB-04606-C.
Page 17: The sleekly curved staircase of the Attic Club (once housed within The Field Building at 135 South LaSalle Street,
see page 176), interiors designed by David Adler, 1935. Photo: Hedrich Blessing © Chicago Historical Society, Arcaid Images
70000-200-1.

Designed by Aldo Sampieri

'

Printed and bound in Italy
2016 2017 2018 2019 2020 / 10 9 8 7 6 5 4 3 2 1

TABLE OF CONTENTS

15

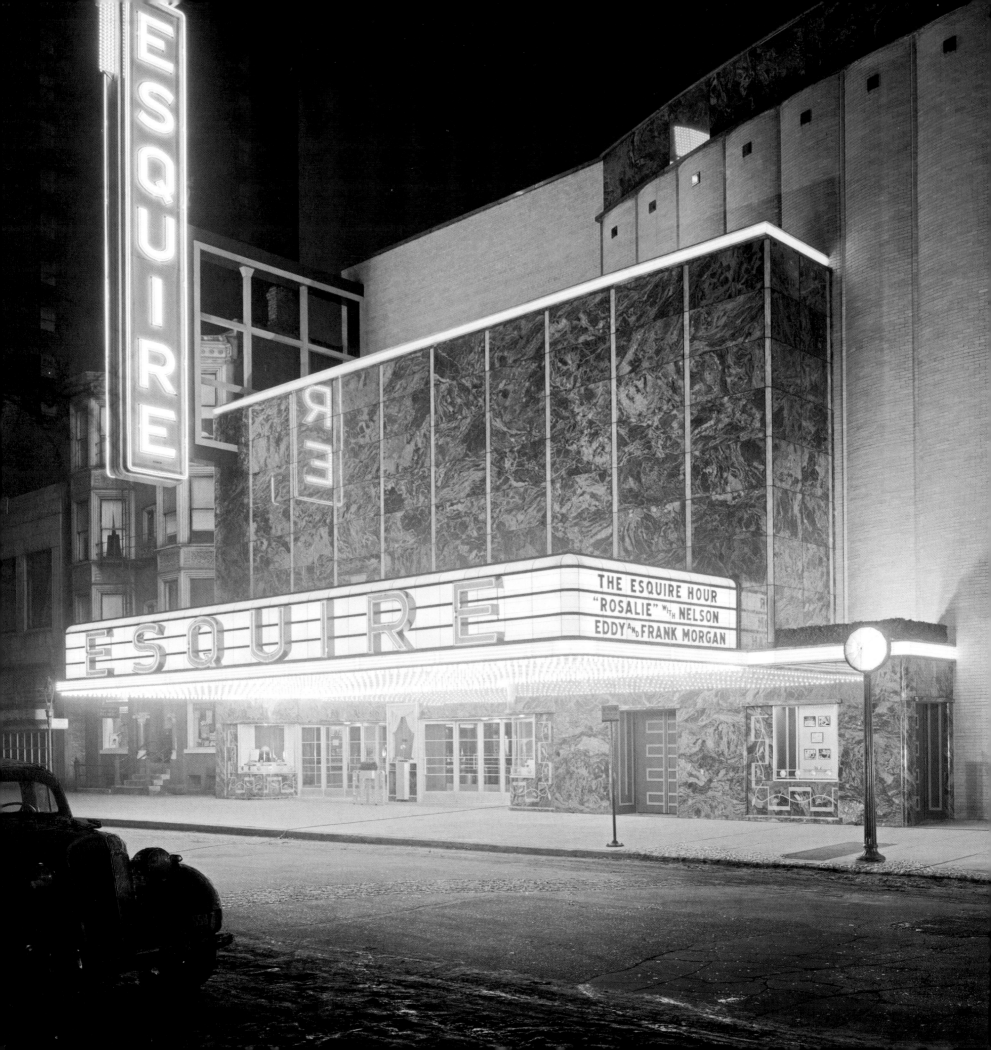

W hen I first became president of the Chicago Historical Society (I am the eighth person to hold this position), reporters would often ask me the absurd question, "If disaster struck your museum, and you could only save one thing, what would it be?" My answer always puzzled them: "The Hedrich Blessing architectural photography collection." "But," they would say, "you have the Lincoln deathbed. You have Chicago's first locomotive. You have so many historical objects. Why would you save a photo collection?" At least to me, the logic of my answer was unimpeachable: Apart from the lake itself, the most notable feature of Chicago is its architecture. There is more to learn from these architectural photos than from any other single archive that we have, especially because many of the buildings included are gone. Beyond that, these photos are genuine objects of beauty, masterworks in their own right. Even a casual reader of John Zukowsky's *Building Chicago: The Architectural Masterworks* will agree with me.

Let me tell you more about the Hedrich Blessing Archive. Ken Hedrich and Henry Blessing founded the photography firm in 1929. The firm's longtime leader, Jack Hedrich, told me that Chicago architects believed that there were no photographers at the time who could do justice to portraying their new buildings. John Root, of the architectural firm Holabird & Root, approached Ken Hedrich and said that he would work with him to develop techniques to document the architects' creations. The dialogue continued until the architects believed that the right techniques had been developed.

If you wonder what the problems were, try taking your own picture of any tall building. Because of the laws of perspective, chances are your photo will depict a building with the same sloping profile as Chicago's John Hancock Center, even though the building actually rises at a 90-degree angle from the ground. This is the most notable, but not the only, challenge facing photographers who tried to please the proud and exacting architects of the Chicago School.

The Hedrich Blessing Archive at the Chicago History Museum includes original prints and negatives from more than 40,000 assignments from the period 1929 to 1979. The firm today continues the traditions passed on from its founders and has developed new techniques for our own era of digital photography. The museum also cares for the work of many other architectural photographers, and some of their work has been chosen by the author for this book.

FOREWORD

What sets this book apart is not only Zukowsky's interpretation of the two-century sweep of Chicago architecture, but also the way that he sheds light on the past few decades. He sees historicism as the key to understanding the Postmodern Chicago of the 1980s and 1990s and a revival and refinement of modernism as the key to the Neomodernism of our own era.

Reading between the lines of Zukowsky's captions, however, is another very positive story—the way that contemporary architects such as Laurence O. Booth have been called upon to renovate and refresh Chicago's buildings from earlier times. Among these is Old St. Patrick's Church, originally built in 1856 by Carter & Bauer, restored in 2000 by Booth Hansen, and documented that same year by Hedrich Blessing.

That's right. Just as in the past, in today's Chicago a rite of passage for a new or renovated building that is pristine and ready for occupancy is a round of photography by Hedrich Blessing. For proof, look no further than two Neomodernist gems selected by Zukowsky for this book: Jeanne Gang's Aqua (2009–11) and John Ronan's Poetry Foundation building (2011).

Thanks to generous grants from the Gaylord and Dorothy Donnelley Foundation, major portions of the Hedrich Blessing Collection have been digitized as part of the Chicago History Museum's plan for making this important resource more accessible to scholars and the public.

Does the existence of digital backups change my answer to the absurd question of what I would save in a disaster? No. The architectural photo archive is my answer, and I am sticking with it. John Zukowsky's very welcome book is further proof that the unfolding story of Chicago architecture offers new lessons to learn and beauty to savor.

Gary T. Johnson
President
Chicago History Museum

Chicago, The Metropolis of the North West. Lithograph, Louis Kurz,
1864. Photo: Chicago History Museum, ICHi–05769.

INTRODUCTION

John Zukowsky

When people think of my career in museums, many recall my work at the Art Institute of Chicago from 1978 to 2004, curating architectural exhibitions with dynamic installations and organizing related publications. These were on a variety of topics, but most focused on Chicago architecture as our curatorial team pushed the newly founded (1982) department to the foreground as an equal to the long-established Department of Architecture and Design at the Museum of Modern Art in New York, created a half century before. Our success may have even catalyzed others to begin similar curatorial departments in American museums during the 1980s and 1990s. In a way, this book is a return to my work on Chicago's built environment, something that I had not done since coauthoring *Masterpieces of Chicago Architecture* for Rizzoli and the Art Institute in 2003. This current volume, *Building Chicago*, is my curated chronicle of Chicago's great buildings over two centuries. It contains my own observations as well as synthesizes more common historical opinions. Before we learn more about the book's contents, it might be helpful to have a brief overview of Chicago as it grew from prairie village to Midwestern megalopolis over the past two hundred years.

From Cow Town to Metropolis

Chicago! The word evokes so many connotations, official and unofficial. These range from the city's motto "Urbs in Horto," or "City in a Garden," to nicknames such as the Windy City, Second City, the City That Works, and the City of the Big Shoulders. Those taglines suggest a variety of connotations—a Midwestern work ethic, an inferiority complex regarding New York, the so-called greatest city in the world, as well as the region's extremes of winter weather, though the Windy City appellation may originally have derived from early observations on its politicians and the city's legendary boosterism.

But when people actually think of the urban fabric over the past century and more, many regard Chicago as the capital of American architecture, arguably more so than any other American city. The Chicago School of commercial building and the Prairie Style of residential design, both regional creations of the late nineteenth and early twentieth centuries, as well as the minimalist International Style as practiced after the end of World War II in 1945 through the early 1970s—the so-called Second Chicago School—all reinforced Chicago's title of capital city for architectural design. The worldwide prominence of the city's architects from the nineteenth and twentieth centuries, architects such as Daniel H. Burnham (1846–1912), Louis H. Sullivan (1856–1924), Frank Lloyd Wright (1867–1959), and Ludwig Mies van der Rohe (1886–1969), was followed by the international attention given to Chicago "starchitects" of the 1970s and 1980s. These included Bruce J. Graham (1925–2010), Helmut Jahn (b. 1940) and Stanley Tigerman (b. 1930), up through media attention given today to Jeanne Gang (b. 1964). All this reinforces Chicago's claim to being that architectural capital.

This heritage is both a blessing and a curse. It presents an ongoing challenge to building within the city, especially to younger designers who are making their mark on the urban environment. And that heritage also includes taglines or maxims associated with Chicago's great architects that act as both commandments and reminders of that history: "Form (ever) follows function" by Sullivan, "Make no little plans" by Burnham, and "Less is more" by Mies.

However, Chicago probably started life with a Native American appellation for its swampy site, where wild onions grew adjacent to the river and lake, so transmitted by French explorer Robert de La Salle (1643–1687) as "Checagou." Architecturally, it began as a humble, timber-framed fur-trading post likely built before 1790 by Jean Baptiste Point du Sable (b. before 1750–1818), a trader of African and European descent. This was even before the federal government constructed Fort Dearborn in 1803, named after Henry Dearborn, the U.S. Secretary of War. The fort, destroyed during the War of 1812 and rebuilt in 1816, was created originally to defend the Northwest Territory of our newly formed nation. It was a tangible result of the Northwest Ordinance of 1787, reaffirmed 1789. The ordinance created a real-estate developer's dream—a gridded landmass northwest of the Ohio River for the new nation's speculative future. This laid the seeds for Chicago's own grid plan of the 1830s. The city's destiny was established as a national transit hub via canal systems then, and later with railroads and airlines. Even today, Chicago O'Hare International Airport is one the world's busiest, having 76,949,504 passengers on more than 875,000 flights in 2015. In some ways, Chicago today is the ultimate outcome of the nineteenth-century expansionist doctrine of Manifest Destiny, with the city linking the east and west coasts of a unified nation.

In 1833 Chicago was incorporated as a town of some 200 residents, and in 1837 it officially became a city. Chicago soon burgeoned to several thousand residents, its growth made possible by quickly nailed milled-timber structures called balloon frames. They were so named because the rapidly constructed buildings were likened to blowing up balloons. These types of structures housed more than 20,000 residents when in 1848 the Illinois and Michigan Canal opened, connecting the Great Lakes to the Mississippi River, which flows into the Gulf of Mexico. In 1856 the city witnessed its first comprehensive sewage plan, which involved raising the street grade within the central business district. With commercial and public buildings also built of brick, stone, and cast iron, the city skyrocketed to more than 298,000 people by the end of the decade that saw the conclusion of the Civil War in 1865 and the opening of the transcontinental railroad in 1869. Railroads now connected the nation's eastern and western regions and had Chicago as their hub.

However, this bustling city was still very much a "cow town." Balloon-framed structures and pens made a city within a city at the Union Stock Yards of 1864 and later. The stockyards created a consolidated meatpacking district of some 375 acres that served the entire nation through the invention of refrigerated railroad cars after 1869. This was something developed even further in 1878 by meatpacker Gustavus Swift. In 1871 the stockyards processed more than 500,000 cattle and 2.4 million hogs. Within three decades that number rose to 3 million cattle and 6 million hogs. This lent credence to poet Carl Sandburg's 1914 observation that Chicago was "Hog Butcher for the world" and laid the basis for Upton Sinclair's 1906 exposé *The Jungle*. But soon after the founding of those very stockyards that contributed to Chicago's success, disaster struck with the Great Chicago of October 8–10, 1871. This firestorm decimated more than three square miles of what was mostly the commercial district. The calamity itself was immortalized in prints, and the apocalyptic ruins captured in numerous images reminiscent of more recent photographs of architectural carcasses within war-torn cities.

Destruction of Chicago by Fire, Oct. 1871. Lithograph, Thomas Kelly, 1871. Photo: Chicago History Museum, ICHi–02956.

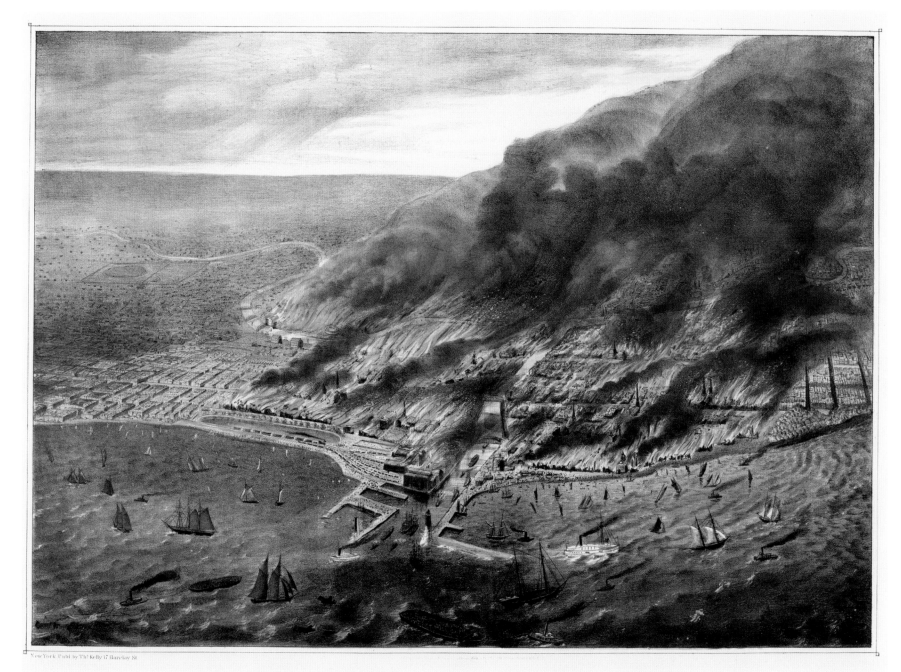

DESTRUCTION OF CHICAGO BY FIRE, OCT. 1871.

This great Fire is the largest that has ever occured in ancient or modern times, beginning Oct. 8. and lasting until the 11th. Destroying all the Business portion of the City, including Telegraph Offices, Rail Road Depots, Custom House, Banks, Insurance & Newspaper Offices, Opera House, Post Office, Board of Trade Buildings, and all the large and costly Churches, over 100,000 People were driven from there Homes and had to take refuge on the Lake, Parks & c. outside of the City. Loss is variously estimated from $ 200,000,000, to $ 300,000,000, in Property and also a great Number of Lives.

New York. Publ by Thos Kelly 17 Barclay St.

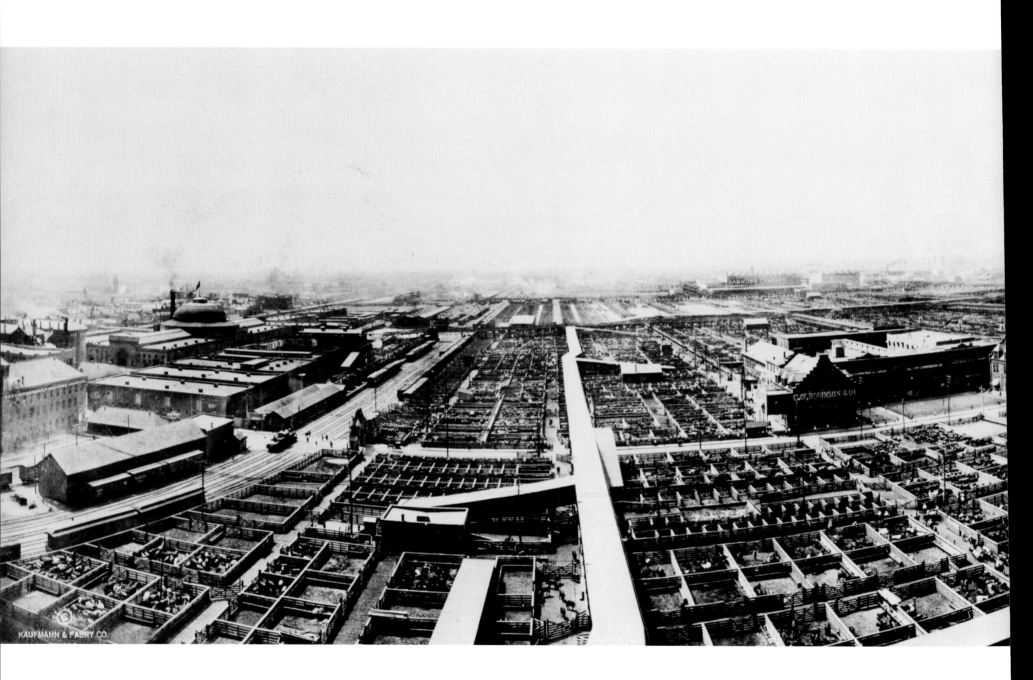

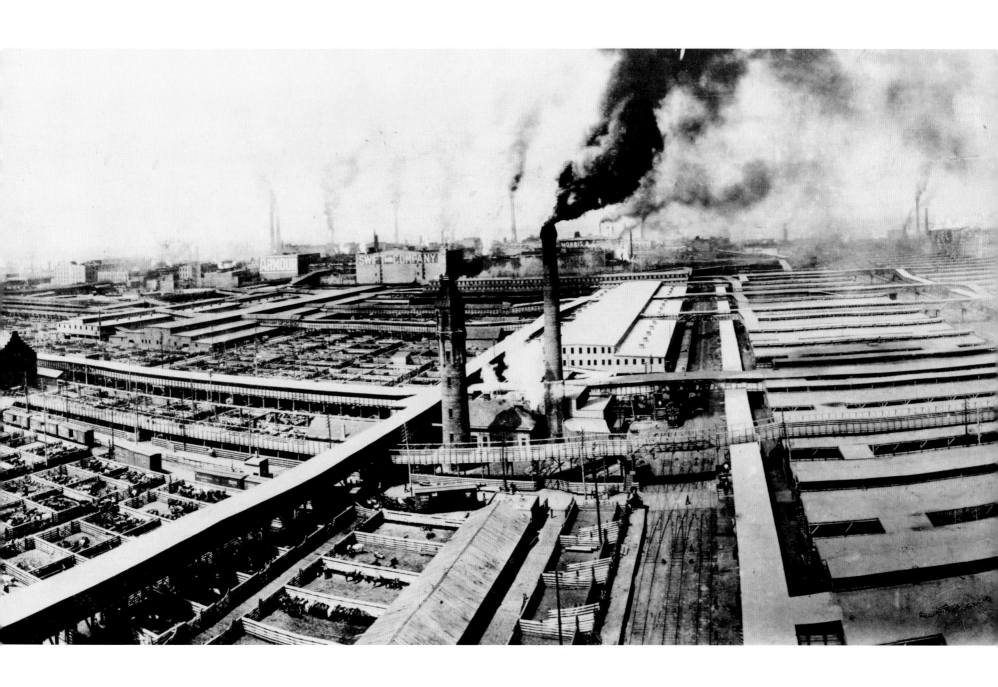

Union Stock Yards panorama, June 1901. Photo: Kaufmann & Fabry Co., Chicago History Museum, ICHi-67292.

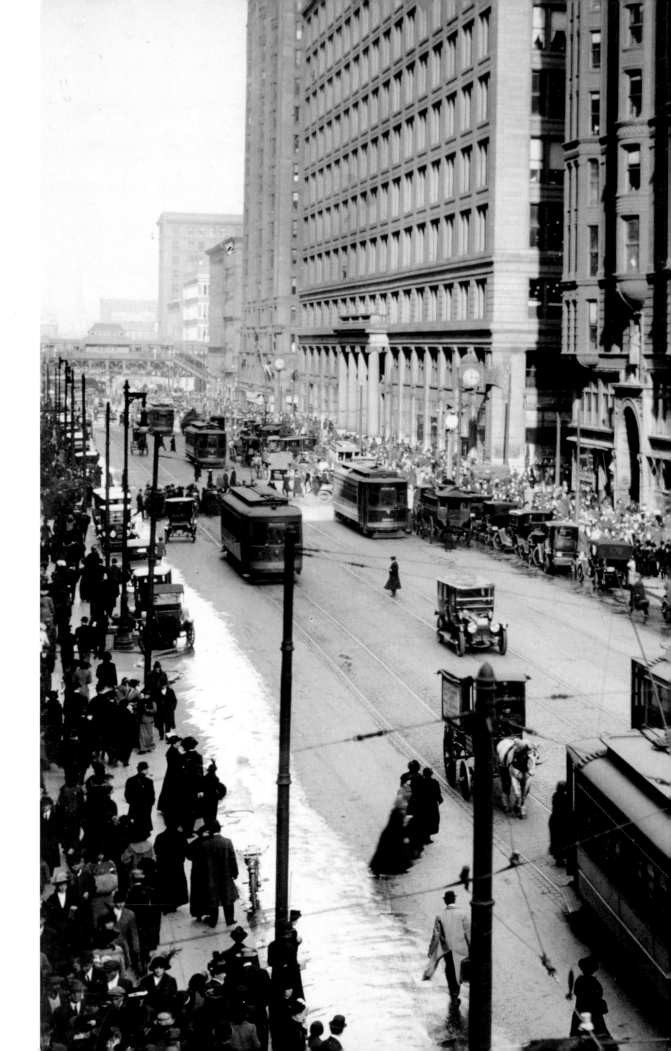

Chicago, bird's-eye view of State Street in 1913, looking north between Madison and Washington Streets. Photo: Kaufmann, Weimer & Fabry Co., Chicago History Museum, ICHi-64628.

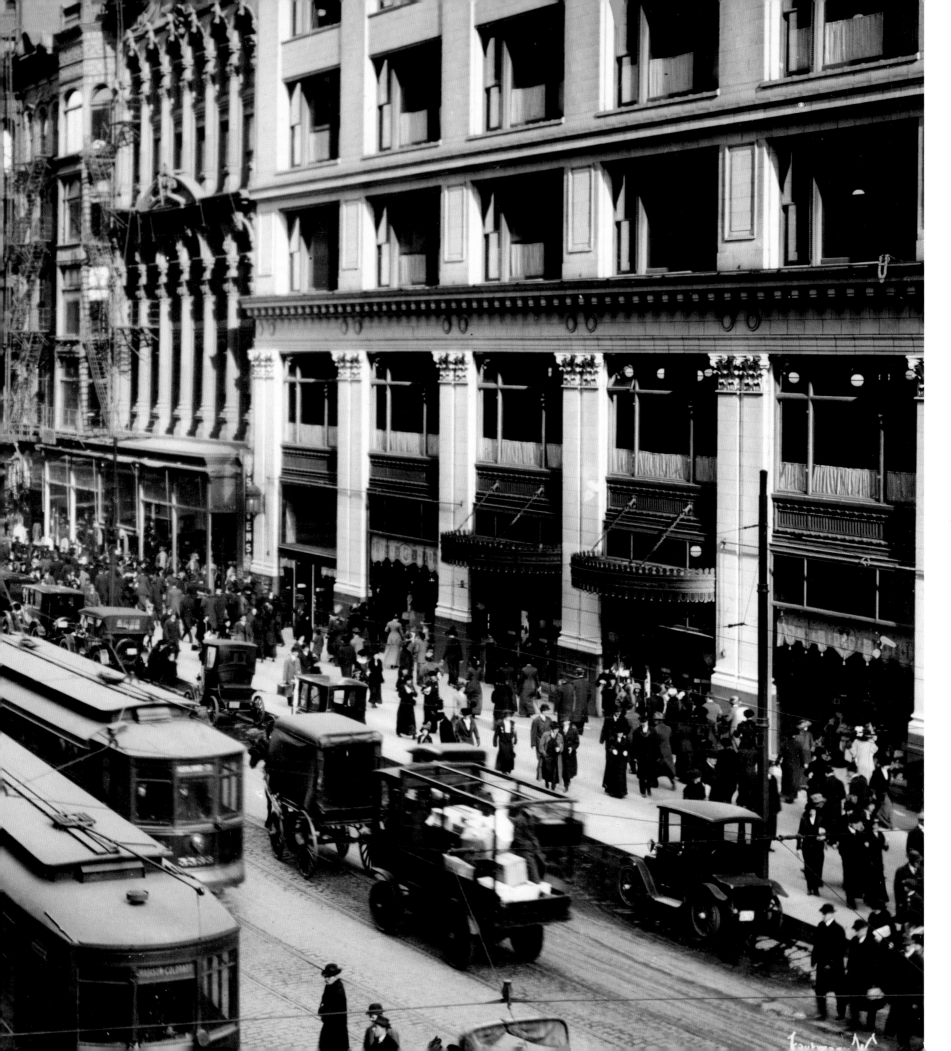

The disaster, however, turned into a blessing in disguise. It created an opportunity for architects such as Louis H. Sullivan and John Wellborn Root (1850–1891) to move from eastern cities to rebuild Chicago during a time of national recession. Their work helped spawn fireproofing and structural solutions that catalyzed the creation of the first skyscrapers in the 1880s. These were often stripped-down, simple high rises of ten to fifteen stories, in a style known later as the Chicago School. They were the products of speculative development that helped to fill out the city grid, with buildings constructed to the lot line in order to maximize rentable space. Paralleling this unique architectural expression was the homegrown Prairie Style of residential construction spearheaded by Frank Lloyd Wright and like minds. Its sweeping horizontal lines and rambling open spaces were intended to respond to the gently rolling hills in the region and the openness of America's landscape of prairies and farmlands. By the time of the vaunted Chicago World's Fair—the World's Columbian Exposition of 1893, which really put Chicago on the international map—the city's population had grown to more than a million people! Then, the city's engineering achievements included castle-like cribs still seen offshore in Lake Michigan, which marked the intakes of underwater tunnels that brought drinking water to the city, as well as locks at the mouth of the Chicago River, which prevented contamination of that freshwater.

The impact of the classical lath-and-plaster "White City" of that world's fair can be traced throughout Chicago and, indeed, the United States in terms of subsequently styled white terra-cotta and stone buildings, constructed in the first decades of the twentieth century, commercial and institutional alike. Chicago just before and after World War I (1914–18) was a dynamic city of well over 2 million people. Its city center on State and Madison Streets was labeled the busiest street corner in the world. Blocks of commercial buildings—offices and retail—were lined up for almost a mile on State Street alone. State Street itself was immortalized in the song "Chicago (That Toddlin' Town)," from 1922, being best known to us in Frank Sinatra's 1957 rendition, the crooner singing "State Street, that great street." In this era, classical influences can be seen throughout Chicago not only in specific buildings but also within the overall city planning impacted by the 1893 world's fair. This is particularly true in the 1909 *Plan of Chicago* by Daniel H. Burnham and Edward H. Bennett (1874–1954). Elements from that plan were made tangible in Chicago's lakefront parks, particularly Grant Park with Buckingham Fountain, as well as the grand boulevard of Michigan Avenue—elements that Burnham and Bennett intended to help reshape Chicago into a "Paris by the lake" or Paris on the prairie.

The building boom of the 1920s after World War I showed dramatic changes to Chicago's skyline as with other American cities, from New York to even Tulsa and Houston. Spiky masonry skyscrapers hundreds of feet high now peppered the American cityscape. This boom during the interwar years witnessed a dramatic growth in Chicago's population, which in 1920 numbered 2.7 million people and in the 1930s soared to 3.3 million! Impressions about this era in Chicago have been shaped for many by film and television projections about Chicago gangsters, in particular Al Capone, the St. Valentine's Day Massacre (1929), and Prohibition (1919–33), for example, as portrayed in a variety of media such as *The Untouchables* (book, 1957; television series, 1959–63; feature film, 1987) and *Boardwalk Empire* (television series, 2010–14). Architecturally, however, Chicago was again put on the international map with the Chicago Tribune Tower competition of 1922. This competition to "design the most beautiful office building in the world" drew entries from across the globe. European

minimalist submissions, such as those by Max Taut (1884–1967) and Walter Gropius (1883–1969) with Adolf Meyer (1881–1929), paid homage to the simple functionalism of the first Chicago School of architecture. The second-place award to Finland's Eliel Saarinen (1873–1950) began that architect's career in the United States and influenced any number of setback, masonry modernist buildings in the next decade or two as zoning laws appeared in Chicago and elsewhere.

With the stock-market crash of 1929 that heralded the ten-year Great Depression, as well as the subsequently lean World War II (1939–45) years, Chicago's urban developments were smaller in scale than those of the first decades of the twentieth century. Yet their impact on the city of the future was immeasurable. Architectural ideas were again given an international boost with the Century of Progress International Exposition of 1933–34, a world's fair that showcased modern architectural design to an American audience. Through the organizational abilities of General Manager Lenox Lohr (1891–1968), the fair actually made a profit—no mean accomplishment during the Great Depression. Even more important, as when German immigrant architects had come to the United States after the unsuccessful revolutions of 1848, and East Coast architects had arrived to rebuild Chicago after the Great Fire of 1871, architects from central Europe, and particularly Germany, fled the political turmoil of their homelands and arrived here in the 1930s to start new lives. They and their like-minded design colleagues founded the New Bauhaus (1937), reshaped Armour Institute of Technology into Illinois Institute of Technology (1940), and created the Second Chicago School of minimally modern architectural design after World War II, spearheaded by Mies van der Rohe.

The elegant steel-and-glass buildings of Mies and his followers were only one expression of what was modern architecture in Chicago, the range including organically curved and rigidly rectilinear examples in a variety of materials by a variety of firms. Commercial buildings often increased in scale, booming their way up to record-breaking heights, such as the 1,128-foot-high John Hancock Center (1970) and 1,451-foot-high Sears (1974), now Willis, Tower. These two were both the designs of architect Bruce J. Graham and structural engineer Fazlur Khan (1929–1982) of Skidmore, Owings & Merrill. During Mayor Richard J. Daley's (1902–1976) twenty-one years in office the city also witnessed the construction of major facilities. Built mostly during the 1960s, these included downtown's Chicago Civic Center (now Richard J. Daley Center), Chicago O'Hare International Airport, the McCormick Place convention center (completed in 1960, destroyed by fire in 1967, rebuilt to a new design 1969–71), and the University of Illinois at Chicago, and, on a less than positive note, a ring of public housing projects that isolated poor people within high-rise ghettos. Some of these, such as the infamous Cabrini-Green housing complex, saw demolition and redevelopment for mixed-income housing during the 1980s and 1990s.

Though Chicago's population grew somewhat in the 1960s and 1970s from its pre–World War II 3 million and more, urban flight to the suburbs, typical in many American cities, impacted suburban and exurban growth and lowered the city's population to 2.7 million by 1990. It flattened the growth curve in urban development. Nevertheless, subsequent suburban growth contributed to making Chicago a regional giant as the city's radio and television marketing reach and transportation lines expanded to exurban areas. This now shows the metropolitan regional population as between 9.5 and 9.9 million.

Perhaps even more than the works of Mies, individualistic expressions of others practicing here in the various building booms of the 1950s and 1960s, such as Bertrand Goldberg (1913–1997) and Harry Weese (1915–1998), paved the way for the Postmodernism of the later 1970s and the 1980s, with its design pluralism and reinterpretation of historic forms. The development of individualistic yet historically contextual design expressions of the 1980s and 1990s was catalyzed by several factors that include the American Revolution Bicentennial of 1976; the so-called Chicago Seven architects of the late 1970s (whose very name mimicked that given to political activists who had been tried for their anti–Vietnam War protests at the 1968 Democratic National Convention); and the reestablishment of the Chicago Architectural Club, originally a late-nineteenth-century club of draftsmen and architects that had encouraged civic and architectural dialogue.

Neomodernists of the new millennium in the twenty-first century moved the dialogue back to the future, ignoring Postmodernism's fascination with historicism and the nineteenth century. Neomodernist minimal design vocabulary of concrete, steel, and glass went well beyond classic Modernism of the 1950s and 1960s through dynamic shapes made possible by computer-assisted design programs. The city that we see today, and the buildings planned for the near future, combine bold design forms with building types for social concerns, an increased appreciation of green space, energy efficiency, use of recycled and recyclable materials, and an overall return to city living and an appreciation of urban lifestyles. Chicago's architectural past and present, and even hints at its future, are thus visually portrayed within the current volume.

Building Chicago: A Curator's Choice

This book intends to give the reader an overview of Chicago's architectural development with a somewhat curated selection of buildings, based on my experiences with research, exhibition, and publication on Chicago's built environment. It is not intended to be a comprehensive history of Chicago's architecture nor the equivalent of a fully illustrated guide to every great or even good building nor a visual guide to the officially landmarked buildings in the city and near suburbs. Instead, I hope to give you an overview that includes expected and, at times, unexpected treasures—a selection that represents universally acclaimed buildings as well as some quirky favorites. These selections are organized within chronological groupings, with each of these groupings preceded by a mini-chapter that summarizes salient historical points and that often references buildings illustrated in the plate section that follows. Some of those sites depicted within the plates have extended captions as well.

This survey provides an illustrated overview from pioneer days up through some of the city's latest sleek buildings of the early twenty-first century. The focus is mostly on built structures, whether extant or demolished. It does not include many unbuilt projects across the decades that could well have been included, from Adler and Sullivan's Fraternity Temple of 1891 to Santiago Calatrava's Spire, designed 2005 and begun 2007, though soon stopped because of the Great Recession of 2008–9 and other financial issues.

Beyond being a pictorial survey of built Chicago over 200 years, this volume documents the wealth of visual materials that exist within the Chicago History Museum. Even when I was a curator at the Art Institute of Chicago, we admired the collection of fantastic views within the Research Center at what was then the Chicago Historical Society. As you would assume, these resources include vintage lithographs and photographs from the nineteenth and twentieth centuries, to a total of more than 1.5 million images. Since 1991the museum also has acquired some 350,000 striking architectural photographs of Hedrich Blessing Photographers that chronicle their first half century, from 1929 to 1979, some of which can also be found through the online stock-photography firm Arcaid Images. These treasures within the Chicago History Museum represent the core of the book's visuals, or more than two-thirds of the illustrations here. They are supplemented by recent photographs from that great firm, along with images provided by others. Although the Chicago History Museum has an important collection of architectural drawings and related archives, the visual preference within this book is for actual photographs. This is in keeping with the focus on built rather than unbuilt structures, though a small selection of lithographs and prints have been included. All these images, especially the vintage visuals from the Chicago History Museum, give you a fascinating historical context for a number of the buildings depicted within.

Building Chicago: More Than a Sequel

In all, then, this book is intended to be more than a sequel to the 2003 volume *Masterpieces of Chicago Architecture*. As that volume highlighted the Art Institute's collection, so this current one, *Building Chicago*, focuses on the photographic treasures of the Chicago History Museum—images that survey Chicago's built environment over two centuries and more and that often capture the spirit of what people and the city's streets looked like decades ago. This built environment rivals that of any other American city, let alone any other world-class metropolis. After reading this book, it is my hope that you will have learned something about Chicago architecture that you had not known before and that you will marvel at the spectacular imagery that illustrates great buildings within a great American metropolis.

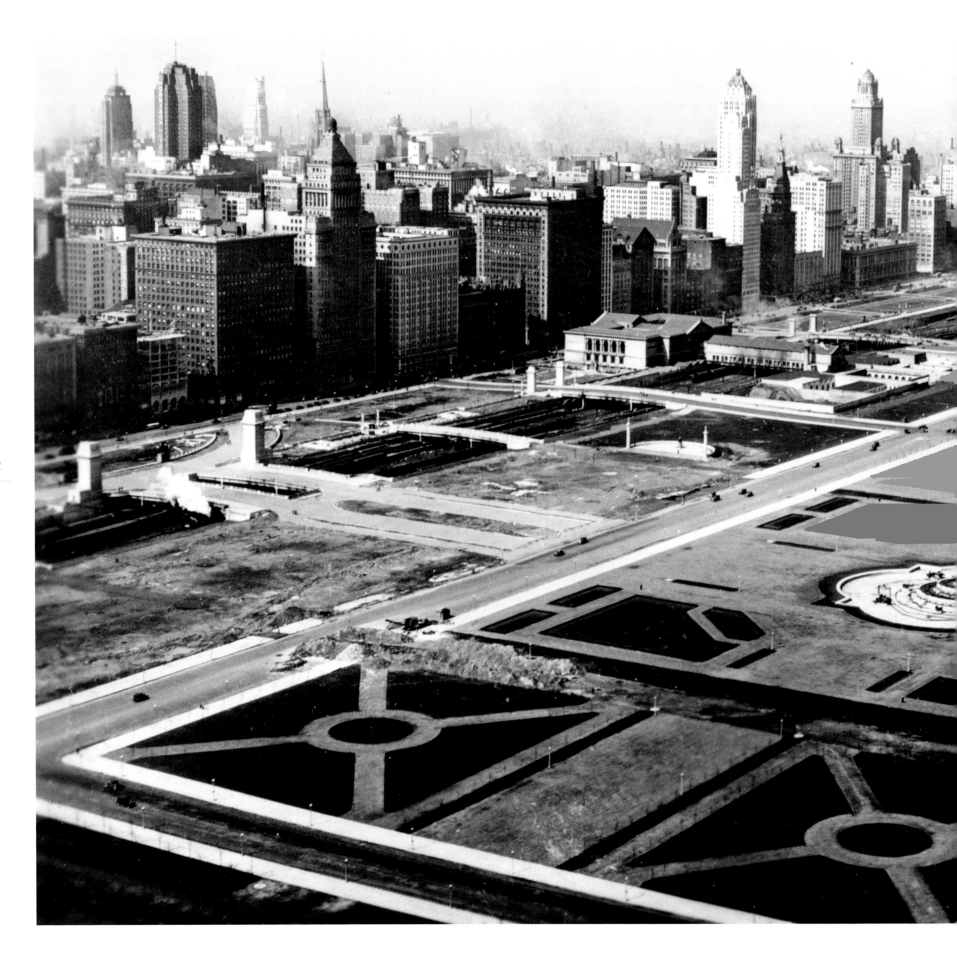

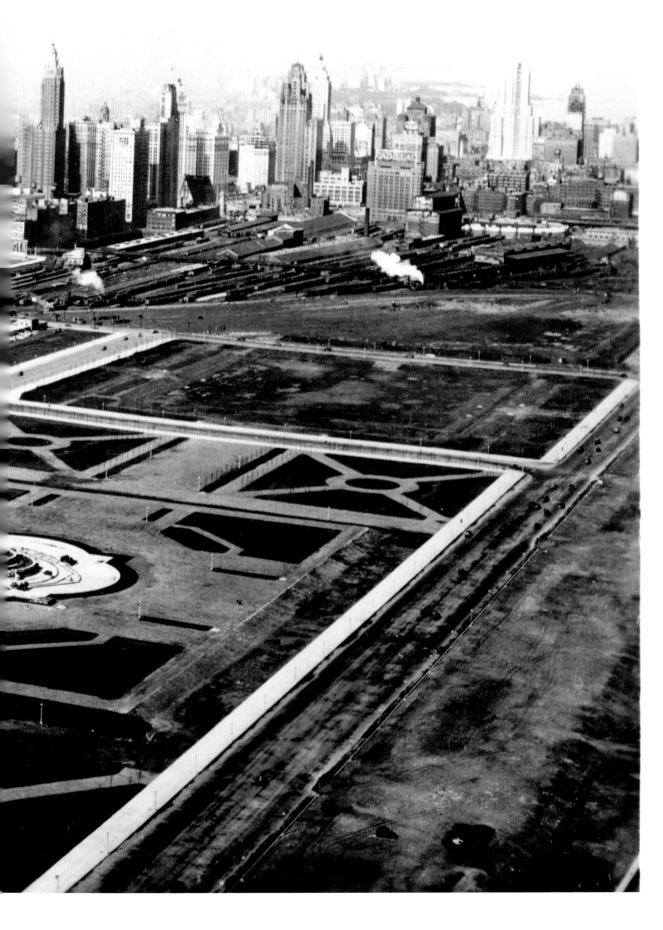

Aerial view of Grant Park and Buckingham Fountain, still under construction in the 1920s. Photo: Chicago Aerial Survey Co., Chicago History Museum, ICHi-59448.

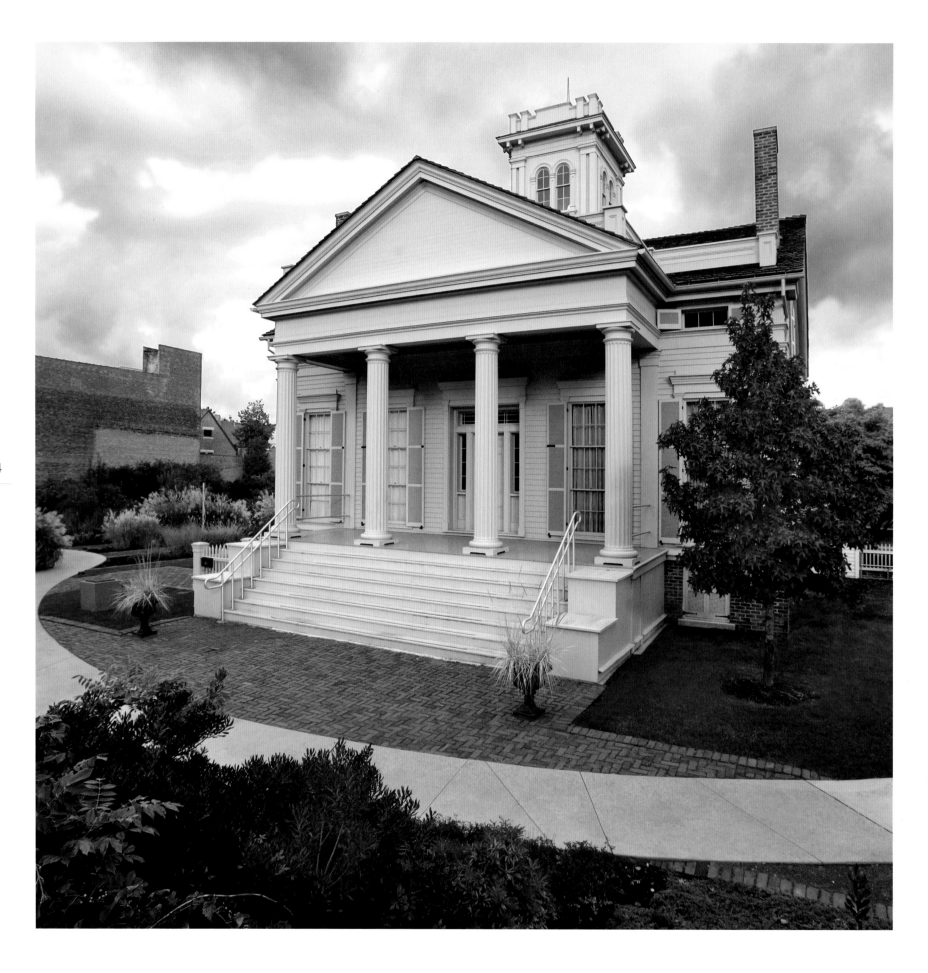

VICTORIAN CHICAGO: FROM THE FOUNDING TO THE GREAT FIRE

The United Kingdom's Queen Victoria ascended to the throne in 1837, the same year that Chicago was incorporated as a city. That British monarch's reign lasted until her death in 1901, though colloquially Victorian architecture usually refers to mid- to late-nineteenth-century buildings, particularly those in multicolored Gothic Revival style. Barely a handful of Chicago buildings equaled anything built in Victorian London from the 1830s through the 1860s. Much of Chicago's building stock, in more than three square miles of the city center along Lake Michigan and the Chicago River, was destroyed by the Great Fire of October 8–10, 1871. What was rebuilt immediately after essentially mimicked what was there before, with commercial buildings being generally four to five stories high in a variety of Italianate, French, or Gothic Revival styles. Queen Victoria herself, along with noted English personalities and authors such as Benjamin Disraeli, Alfred, Lord Tennyson, Robert Browning, and John Ruskin, donated 8,000 books to Chicago for the creation of a new, free library after the disastrous fire. That calamity during a national economic depression encouraged the migration of some East Coast architects to help rebuild the city, though even before the fire several professional architects had already established themselves there.

Perhaps the first professional builder to construct a large structure in Chicago was John Whistler (c. 1756–1829), a career British and then American army officer. He supervised the wood stockade construction of Fort Dearborn (1803) and was its first commandant. Destroyed in the War of 1812 and rebuilt 1816, the fort was eventually partially demolished, with remnants destroyed by fires in 1857 and 1871. A re-creation of the fort was built in Chicago's Lincoln Park during the early twentieth century, and then a second re-creation was constructed within the grounds of the Century of Progress world's fair of 1933–34. Neither exists today. Except for comparable log walls installed within the galleries of the Chicago History Museum that suggest the construction of the fort, we have only early, sketchy prints that show it, as well as photographs of the twentieth-century reconstructions. They give us an idea of its scale and site on the south bank of the Chicago River at what is now Michigan Avenue. The London Guarantee Building at 360 North Michigan Avenue has a bronze relief sculpture of the fort above its columned entry, and markings on the pavement on both sides of the avenue outline the ramparts.

Maryland-born John Mills Van Osdel (1811–1891) is usually considered the most prominent and first "architect" who practiced in Chicago. Trained as a carpenter, he had design and engineering stints in Baltimore, New York, and Chicago that preceded his longer-term, half century of Chicago work from approximately 1841 until his death. He is perhaps best known for works such as the combined Courthouse and City Hall (1853–58), the third Tremont House (1850), and second Palmer House (1871), the latter two being hotels destroyed in the 1871 conflagration. He also practiced after the Great Fire, rebuilding those as well as other buildings within the city. Only a very few survive today, such as the five-story Atwater Building (1877) at 28 South Wabash Avenue and the Page Brothers Building (1871–72), later part of the Chicago Theatre Center on State and Lake Streets. The latter's deteriorating cast-iron face has been replaced by a cast-concrete replica. Better examples of his extant work exist outside Chicago, in the governor's mansion in Springfield (1856) and the McHenry County Courthouse (1857) in Woodstock, both in Illinois.

Perhaps equally important for the pre–Great Fire era is Massachusetts-born William W. Boyington (1818–1898). His most famous buildings are the Chicago Board of Trade (1885; demolished) and the

Henry Clarke House, 1836; moved and restored at current location (1827 South Indiana Avenue), 1981, Wilbert R. Hasbrouck and Joseph W. Casserly of the City of Chicago; further restoration, 2004, McClier Corporation. Photo: Michael Beasley for the Clarke House Museum, courtesy Glessner House Museum.

extant and frequently photographed Water Tower (1869) and nearby Pumping Station that survived the fire, and still stand, on Michigan and Chicago Avenues. Built of local Joliet limestone, the 154-foot-high tower is a landmark of Chicago's rebirth, even though characterized by author Oscar Wilde as a "castellated monstrosity."

Boyington was both an architect and politician in New York who moved to Chicago in 1853 and who also later served as the mayor of suburban Highland Park. A more modest fire survivor of his is the wood-frame Richard Bellinger Cottage (1869) at 2121 North Hudson Street, and he also designed a later wood-frame home known as the Charles Bonner House (1889) at 5752 South Harper Avenue. Larger institutional examples of his work include Rosehill Cemetery's Gatehouse (1864), stylistically similar in style to his crenellated Water Tower, and the rusticated Romanesque Kenwood United Church of Christ (1888) at 4600 South Greenwood Avenue.

Beyond those two oft-cited early architects, others contributed to the pre– and post–Great Fire cityscape, most notably German immigrant architects who came to Chicago after the unsuccessful revolutions of 1848 in central Europe. These include Dankmar Adler (1844–1900), Augustus Bauer (1827–1894), Frederick Baumann (1826–1921), Frederick "Fritz" Foltz (1843–1916), Henry W. Hill (1852–1924), and Otto H. Matz (1830–1919), joined by later German-American architect Richard E. Schmidt (1865–1958) and by Arthur F. Woltersdorf (1870–1948). Of those, Bauer is also considered one of the city's founding-father architects akin to Van Osdel and Boyington.

36

Unlike Van Osdel, who learned by doing, Bauer was professionally trained, being a graduate of Darmstadt's Polytechnic. He immigrated to New York in 1851 and moved to Chicago within two years at the suggestion of Frederick Baumann. Bauer is known to have partnered from about 1853 to 1863 with Asher Carter and from 1866 to 1874 with Robert Loebnitz. He practiced mostly on his own thereafter, designing a number of schools. Old St. Patrick's Church (1856)—a survivor of Chicago's Great Fire and luckily restored in recent years—is considered to be one of his masterworks. Precious few of his other buildings survive. One example was the simple brick German school called the Gethsemane Building (1869) at 1352 South Union Street, demolished in 2015 for new development.

Van Osdel, Boyington, and Bauer—three early pioneers of Chicago architecture—set the stage for the rebuilding of the city after the Great Fire of 1871. They laid the groundwork for exciting developments to follow during the 1880s and 1890s. Regrettably, few pre–Great Fire buildings by their design colleagues remain. A rarity is the Greek Revival Henry B. Clarke House (1836), built originally at 1836 South Michigan Avenue and eventually moved to its current location nearby in 1977. At least restorations of that home as a house museum (the Clarke House Museum), Chicago's Water Tower, and Old St. Patrick's all give one something of an idea of what buildings were like in Chicago before the fire.

Fort Dearborn (1803); reconstruction at Century of Progress International Exposition, 1933 (demolished). The view shows the stone armory next to a wood blockhouse. Photo: Kaufmann & Fabry Co., Chicago History Museum, ICHi-37957.

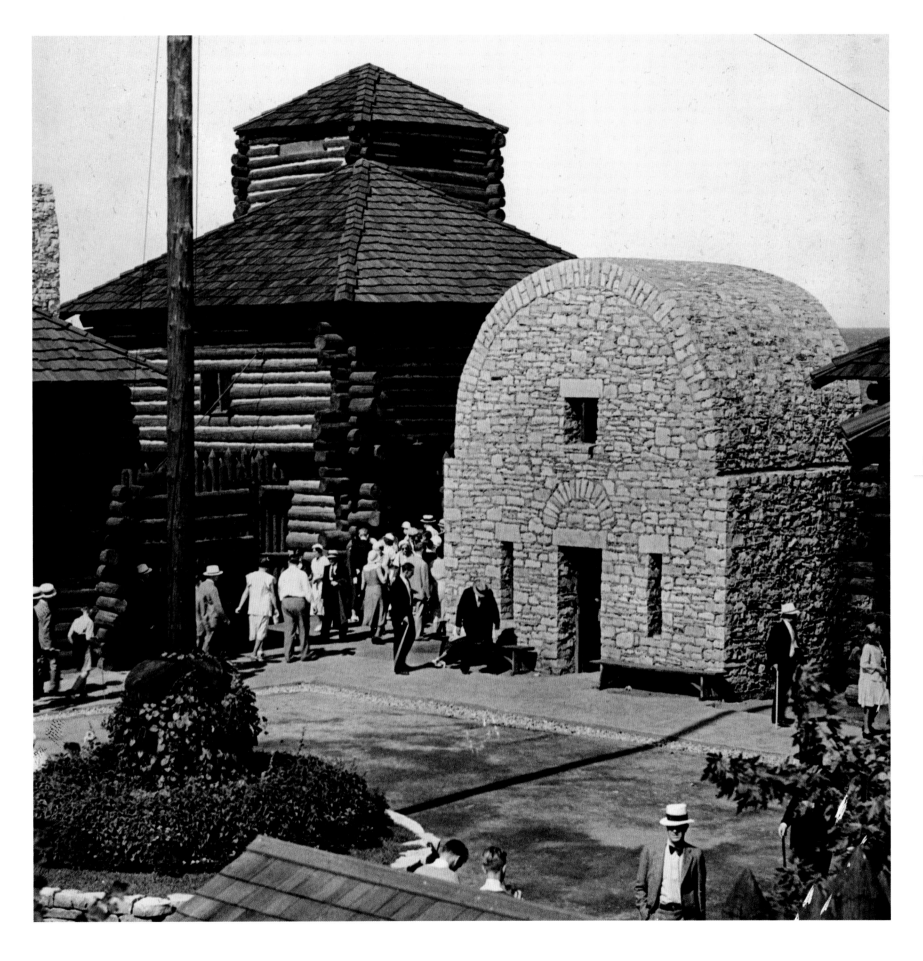

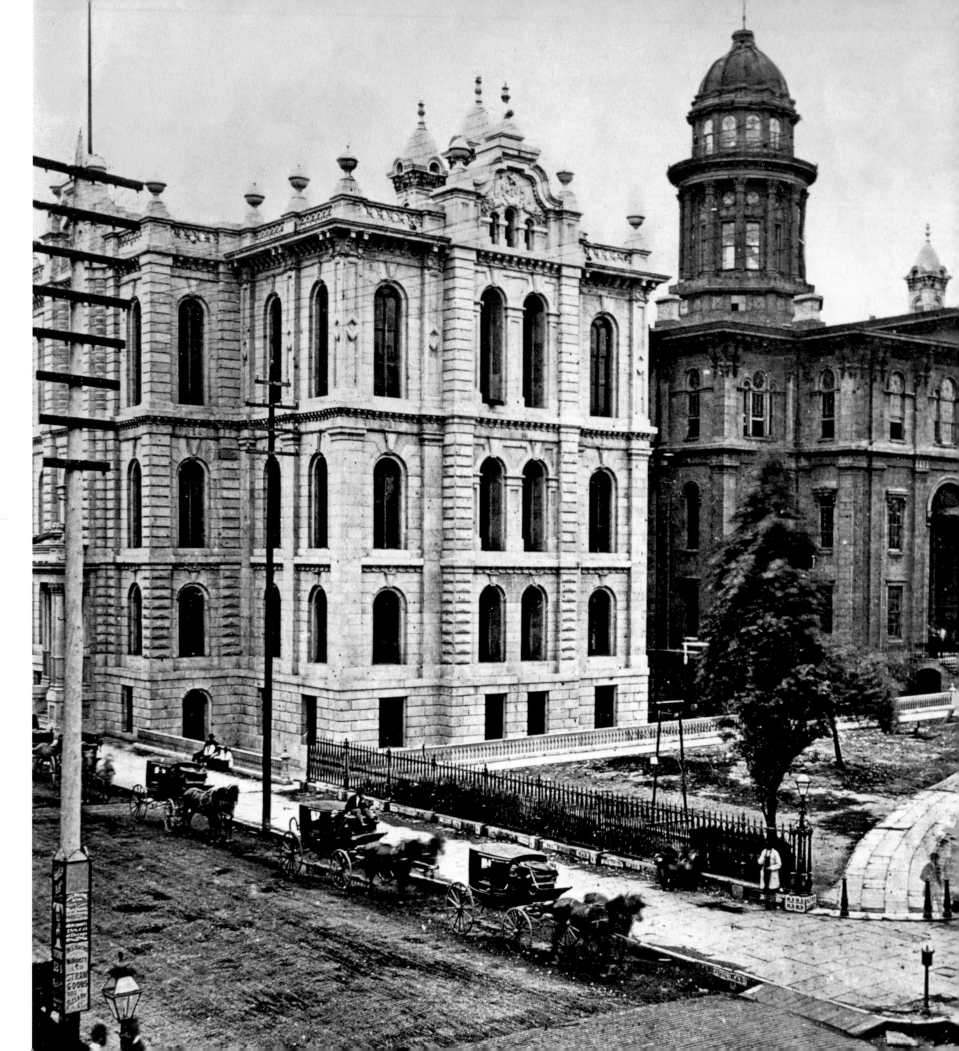

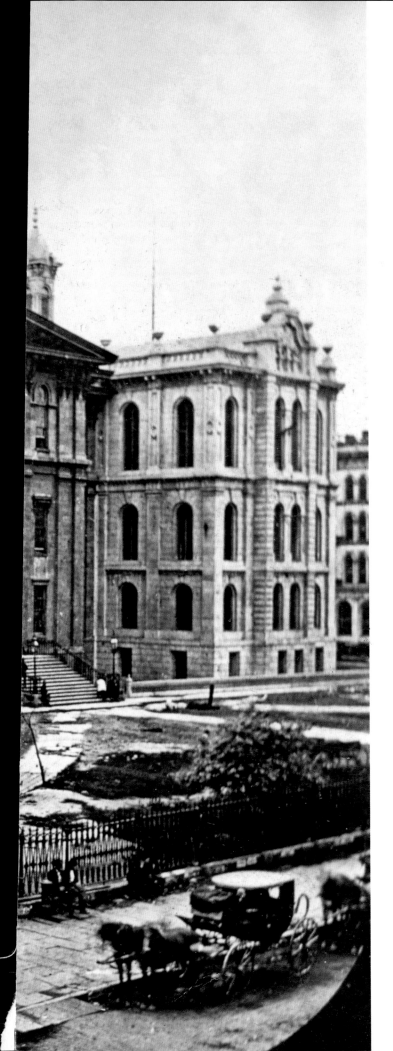

Left:
John Mills Van Osdel, City Hall and County Courthouse, southwest corner of Clark and Randolph Streets, 1858–71 (destroyed by the Great Fire of 1871). Photograph 1870. Photo: Chicago History Museum, ICHi–22314.

Overleaf:
Carter & Bauer, Old St. Patrick's Church, 140 South Des Plaines Street, 1856; restored by Booth Hansen, 2000. Photos: Nick Merrick, © Hedrich Blessing, courtesy Booth Hansen.

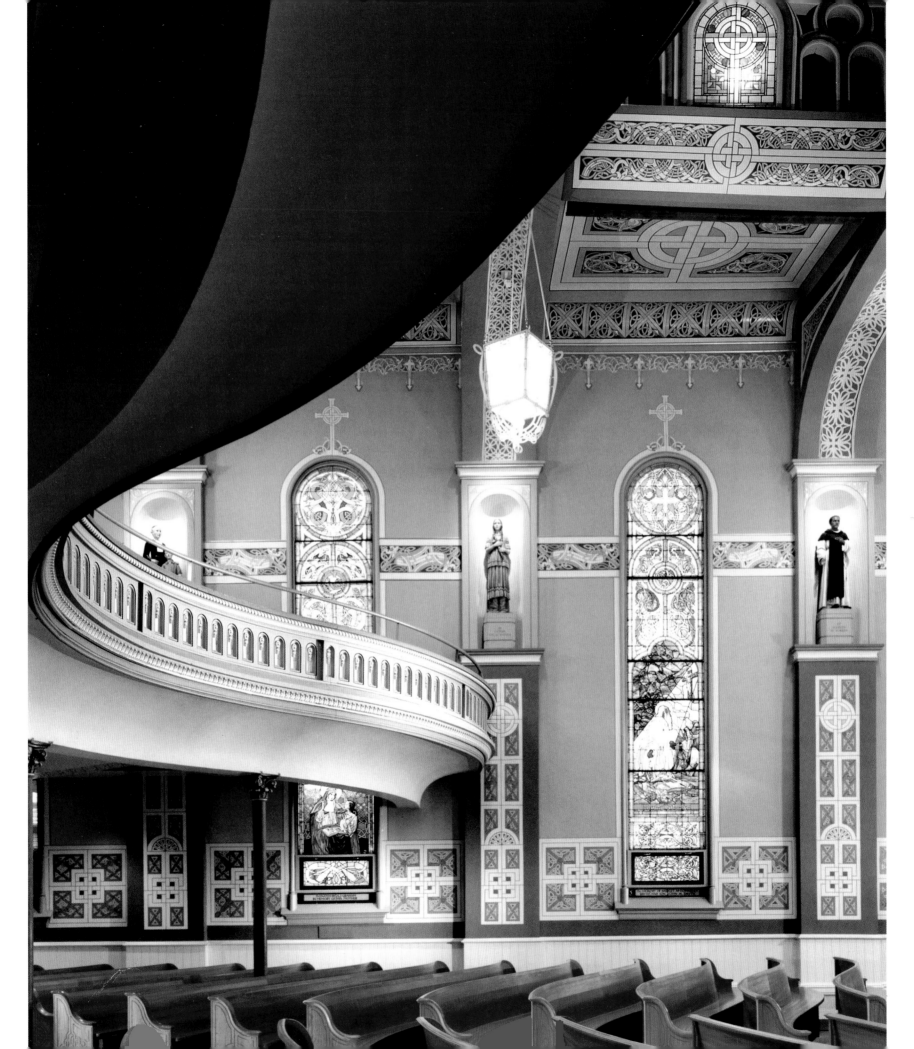

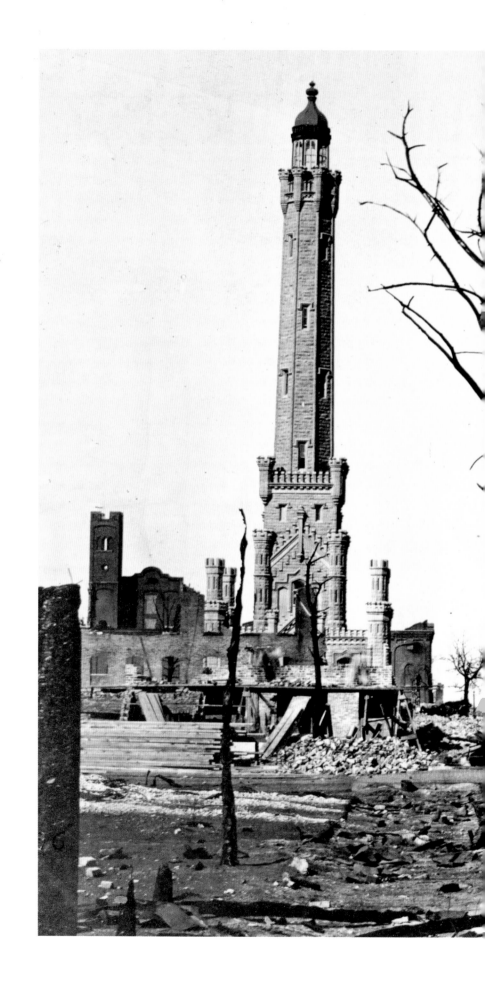

William W. Boyington, Pumping Station (right), 1866, and Water Tower (left), 1869, 806–811 North Michigan Avenue, shown after the Great Fire of 1871; Pumping Station renovated, 2003, Morris Architects. Photo: Charles R. Clark, Chicago History Museum, ICHi-02792.

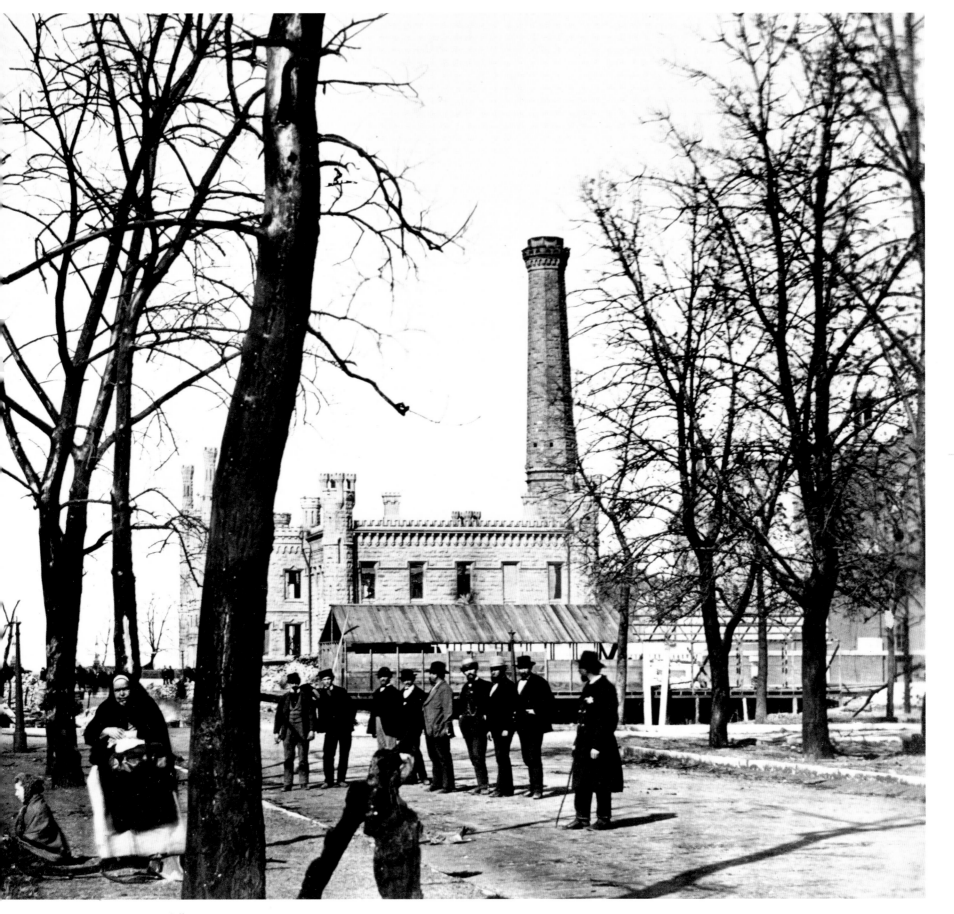

CHICAGO'S REBIRTH: THE CHICAGO SCHOOL AND PRAIRIE STYLE

It was business as usual after the Great Fire of 1871, with masonry and cast-iron commercial buildings four and five stories tall. These were built in a variety of mostly classical styles, just as before the fire. Only a few survive today, some because additional stories placed atop extended their usefulness. One such is the Delaware Building (1874) by Wheelock and Thomas with a two-story addition by Julius H. Huber (1888). It took a while—until the 1880s—for a series of architectural developments to coalesce, catalyzing the creation of the functionalist Chicago School of commercial building.

Early experiments in fireproofing iron structures with oak and then terra-cotta were pioneered and patented in 1874 by architect Peter B. Wight (1838–1925). His office was the training ground in 1872–73 for architects such as Daniel H. Burnham and John Wellborn Root. An enormous boost was given to commercial buildings with the development of safe passenger elevators. The first of these Elisha Otis inventions was used in the E. V. Haughwout Building (1857) in New York, it being a steam-powered unit. Hydraulic and then electric elevators followed in the later 1870s and very early 1880s.

Those innovations, combined with the development of wind-braced iron and then steel construction, gave architects the technical tools they needed to build bigger and better. The egalitarian grid system of many American cities, including Chicago, made developing large commercial blocks financially attractive to investors of the 1880s. Buildings filled out the grid with maximum rentable space. Gas and then more efficient and cost-effective electric lighting of the 1880s and 1890s helped give the new commercial buildings a boost in after-hours occupancy. The invention of the wide Chicago window in the Studebaker Building (1885) by Solon Spencer Beman (1853–1914), with its large fixed central pane and movable narrow sidelights, also helped give maximum daylight for tenants. This was especially true when architects used double-loaded plans with offices off a central corridor, naturally lit from both sides of a building.

The frugality of New York and particularly Boston developers also helped shape the Chicago School. Their not wanting to pay unnecessarily for extravagant ornament, and the 1890s development of cost-effective terracotta to clad steel structures as opposed to more expensive limestone, lent a skeletal, functionalist, and, thus, austere appearance to a number of Chicago high rises of the 1880s and 1890s. This was true even if they had some minor classical detailing at the cornice and base or around the large Chicago windows that visually minimized the building's mass.

The massive Burnham and Root–designed Monadnock Building (1891) is an example of Chicago School design severity. The original drawings indicated Egyptian and classical detailing that never made it to the actual structure. The adjacent south extension by Holabird & Roche two years later vindicated ornament by including it. By comparison, several good examples of minimalist functional architecture of the Chicago School are the Tacoma Building (1889; demolished), the Pontiac Building (1891), and the Chicago Building (1904–1905), all designed by Holabird & Roche; William Le Baron Jenney's (1832–1907) massive Second Leiter Building (1891); D. H. Burnham and Co.'s Reliance Building (1895); and even Louis H. Sullivan's Schlesinger and Mayer Department Store (1899 and later). Others fit into the Chicago School category despite their mass and detailing, from the first acknowledged skyscraper, the Renaissance-style Home Insurance Building (1885) by Jenney, to the robust Romanesque-style

Wheelock and Thomas, Delaware Building (Bryant Building), 36 West Randolph Street, 1874; with two-story addition, 1888, Julius H. Huber; restored, 1982, Wilbert R. Hasbrouck. Photo: © John Gronkowski.

Rookery (1887–88) by Burnham and Root and the comparably detailed Cook County Criminal Courts Building (1892) by Otto H. Matz. All those architects are to be aptly credited with the development of the Chicago School, but we should observe that civil engineer Edward Clapp Shankland (1854–1924), who worked in the office of Burnham and Root in 1888 and then started his own firm, likely contributed to the development of the Chicago School structural systems.

Sullivan refined and articulated the Chicago School characteristics further in his essay "The Tall Office Building Artistically Considered" (1896). He propounded the idea that skyscrapers are analogous to columns. As such, their designs should feature a distinct base and cornice akin to a column's base and capital, and the shaft should be appropriately vertical in overall appearance. A tangible expression of his philosophy is found in the Schiller Theatre (1892; demolished), along with the Chicago Stock Exchange (1894; demolished). During the 1960s and 1970s, both buildings would bring to the forefront in Chicago preservation problems and attitude changes. Sullivan also expressed his philosophy of decorative design in *A System of Architectural Ornament* (1924). There, he observed that all things natural have an underlying geometry. This theory directly informed his elaborate, lettuce leaf–like, cast-iron ornamentation at the ground floor of the Schlesinger and Mayer Department Store from the late 1890s and even his last work—the elaborate facade for a small building on Chicago's north side from 1922 shortly before his death.

Architect Thomas Tallmadge (1876–1940) was probably the first one to coin the term *Chicago School* to denote these types of buildings, with historian Carl Condit further categorizing them in his writings of the 1970s. The Chicago School can be many things to many people, even to the point of including a profusion of classicist ornament, as we shall see in the next chapter. Many of the Chicago School buildings go beyond the slim, minimally decorated, skeletal constructions that European Modernists praised in the 1920s. Likewise, the early 1900s work of Frank Lloyd Wright, one of the pioneers of the Prairie Style of open-space residential design, also drew praise from European modernists of the next generation. In some ways, the Prairie School of residential design paralleled the development of the Chicago School in that both sought to create distinctively new design forms appropriate to the United States. They were two similar though contrary efforts in the nineteenth century when others postulated that Colonial Revival or even the rationality of Gothic Revival architecture was appropriate to the United States in its search for a national style after the nation's centennial of 1876.

Historian H. Allen Brooks characterized Wright's work as part of the Prairie School comparable to what Condit posited for Chicago's early skyscrapers. Wright and similarly disposed architects shared offices at Steinway Hall, now demolished, at 64 East Van Buren Street in Chicago. Those colleagues included Walter Burley Griffin (1876–1937) and his architect-wife Marion Mahony (1871–1961) as well as Dwight H. Perkins (1867–1941) and the Pond brothers, Irving K. (1857–1939) and Allen B. (1858–1929). They all met together there with others such as Richard E. Schmidt, his business partner Hugh Garden (1873–1961), and Howard Van Doren Shaw (1869–1926).

The Griffins specialized in residential buildings, and after winning the competition to design the Australian capital of Canberra (1912), they practiced their Asian version of the Prairie Style there and in India through the 1930s. Perkins became a specialist in school design; son Lawrence B. Perkins

46

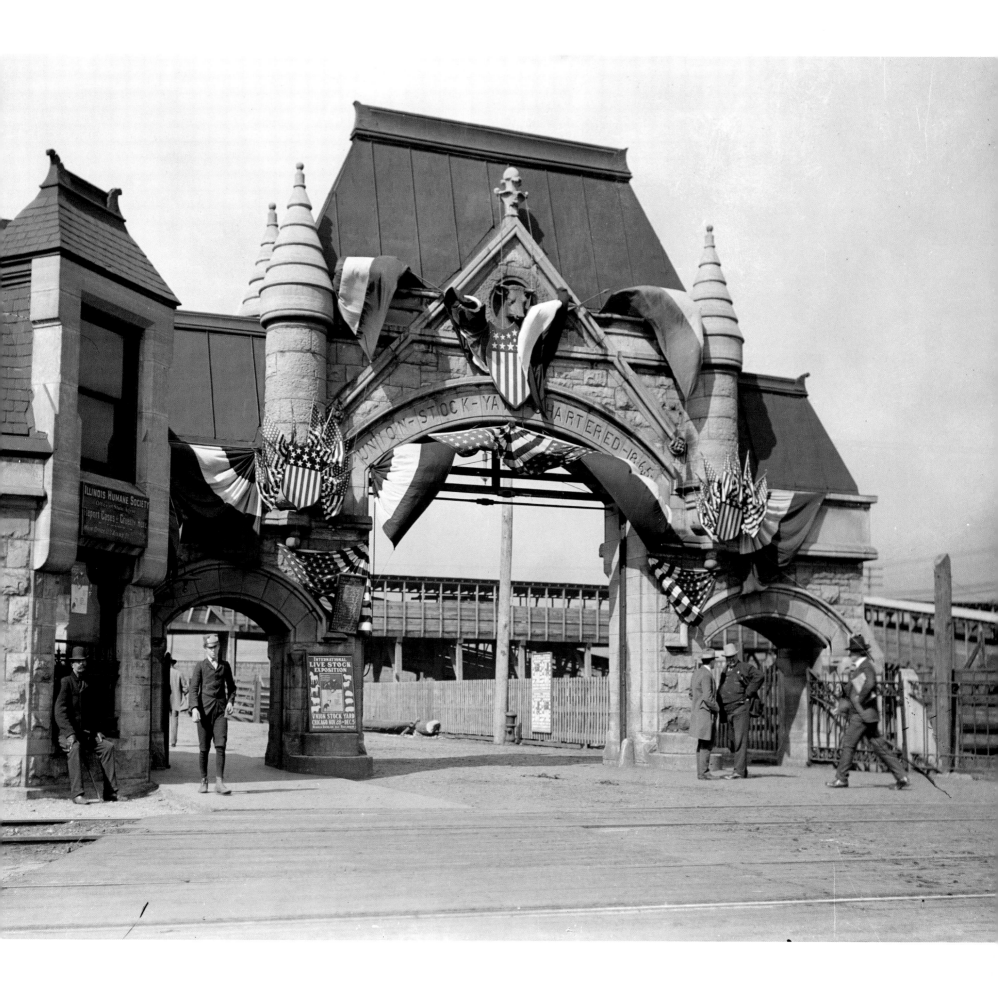

(1907–1997) inherited that specialty and founded Perkins & Will. The Steinway Hall group and like-minded colleagues designed relatively undecorated structures whose horizontal spaces, low hipped roofs, and simple rectilinear architectural forms related to the wide-open spaces of the United States, and in Wright's case, the rambling, rolling hills of Wisconsin.

Their ideas about craftsmanship paralleled the contemporary Arts and Crafts movement in England, expressions of which can be found in the United States in the works of Henry Hobson Richardson (1838–1886). Wright's own house and studio and several other homes in the Chicago suburb of Oak Park have become architectural pilgrimage sites. Prairie Style houses, just as Chicago's early skyscrapers of roughly the same era, are shrines to ingenuity in building design. And, as with the impact those skyscrapers had on European modernists of the next generations, so Wright's work published in 1910 in Berlin as *Ausgeführte Bauten und Entwürfe* (Executed Buildings and Studies, nicknamed the Wasmuth Edition after its publisher) brought Prairie Style to the next generations of those modernists.

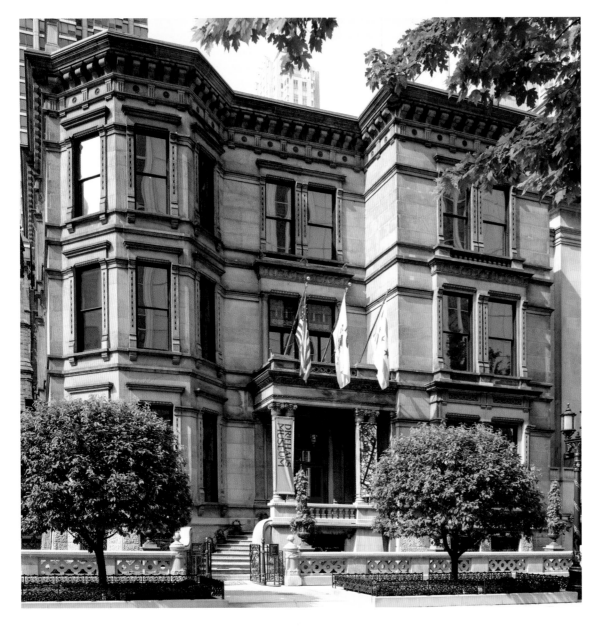

Burling and Whitehouse, Samuel M. Nickerson House
(now Richard H. Driehaus Museum), 40 East Erie Street, 1883.
Entry facade and main hall. Photos: © Alexander Vertikoff,
courtesy the Richard H. Driehaus Museum.

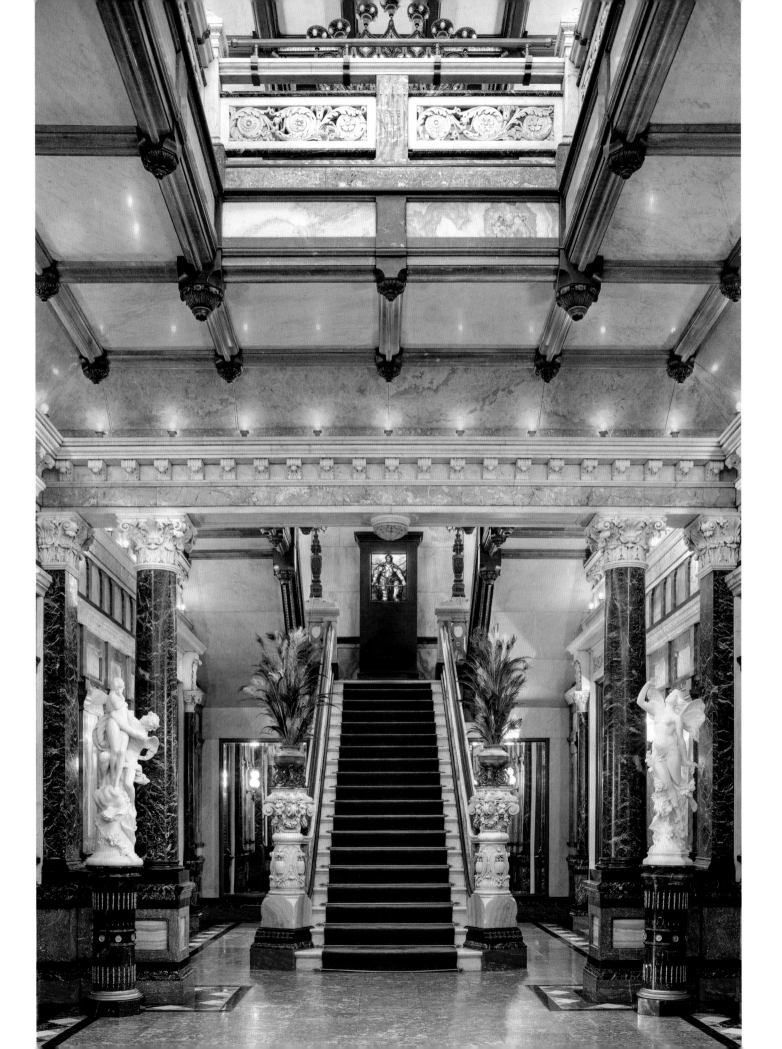

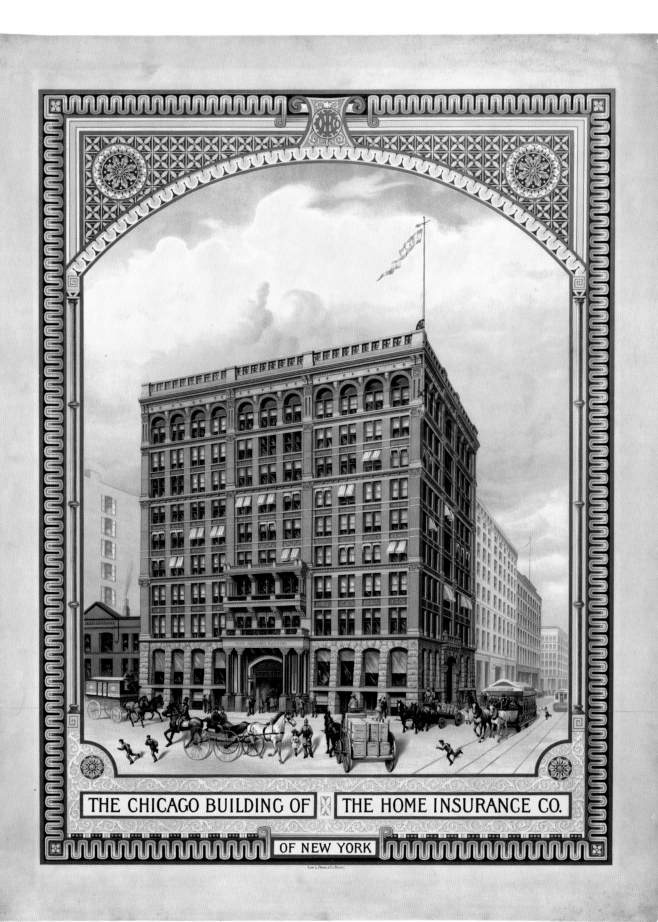

THE CHICAGO BUILDING OF ⋈ THE HOME INSURANCE CO.

OF NEW YORK

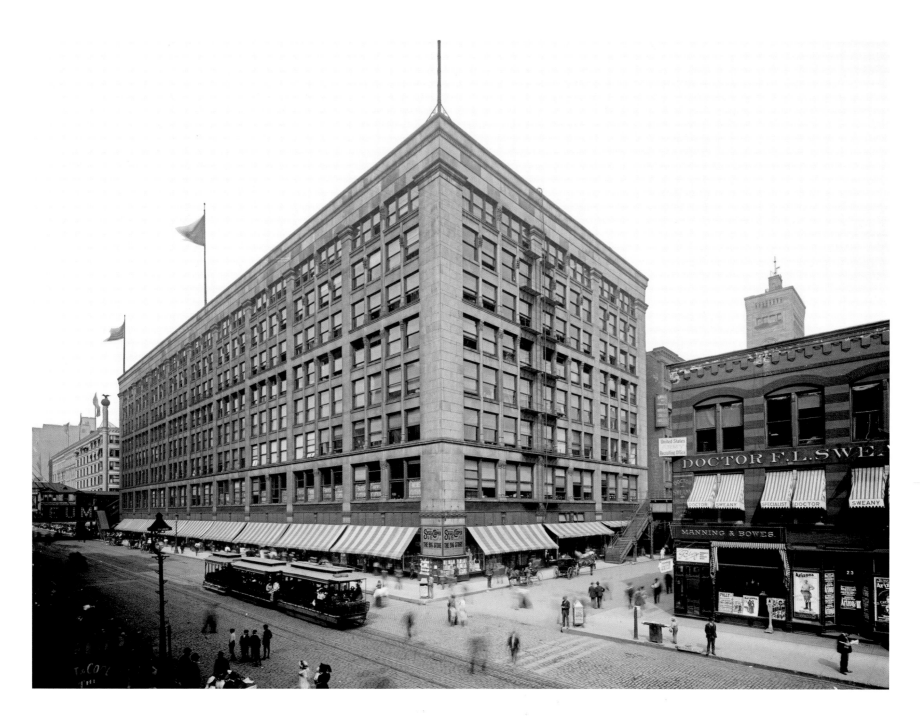

Left:
William Le Baron Jenney, Home Insurance Building, northeast corner
of LaSalle and Adams Streets, 1885, with 1891 addition (demolished).
Lithograph by L. Prang and Co., Boston, c. 1892. Photo: Chicago
History Museum, ICHi-00991.

Above:
William Le Baron Jenney, Second Leiter Building (now Robert Morris
University Center), 403 South State Street, 1891, shown in a c. 1905
photograph when it was the Siegel, Cooper & Co. store. Photo:
Barnes-Crosby Company, Chicago History Museum, ICHi-19297.

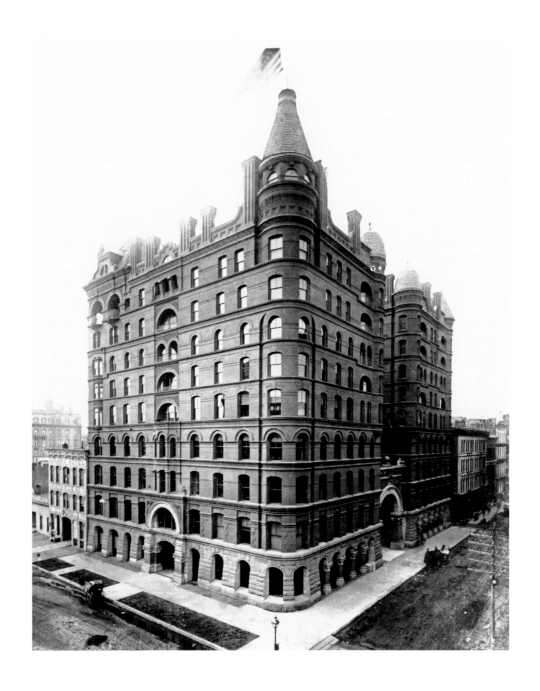

Solon Spencer Beman, Pullman Building (above), Michigan Avenue and
Adams Street, 1884(demolished), photographed c. 1885; the Pullman
Railroad Car Works, Administration Building (right), Pullman, Illinois,
south side of Chicago at 111th Street near Cottage Grove Avenue,
photographed 1908 as part of a Chicago Railways Company trolley
trip. Photos: Chicago History Museum, ICHi-19460, and *Chicago Daily
News* negative collection, DN-0006819.

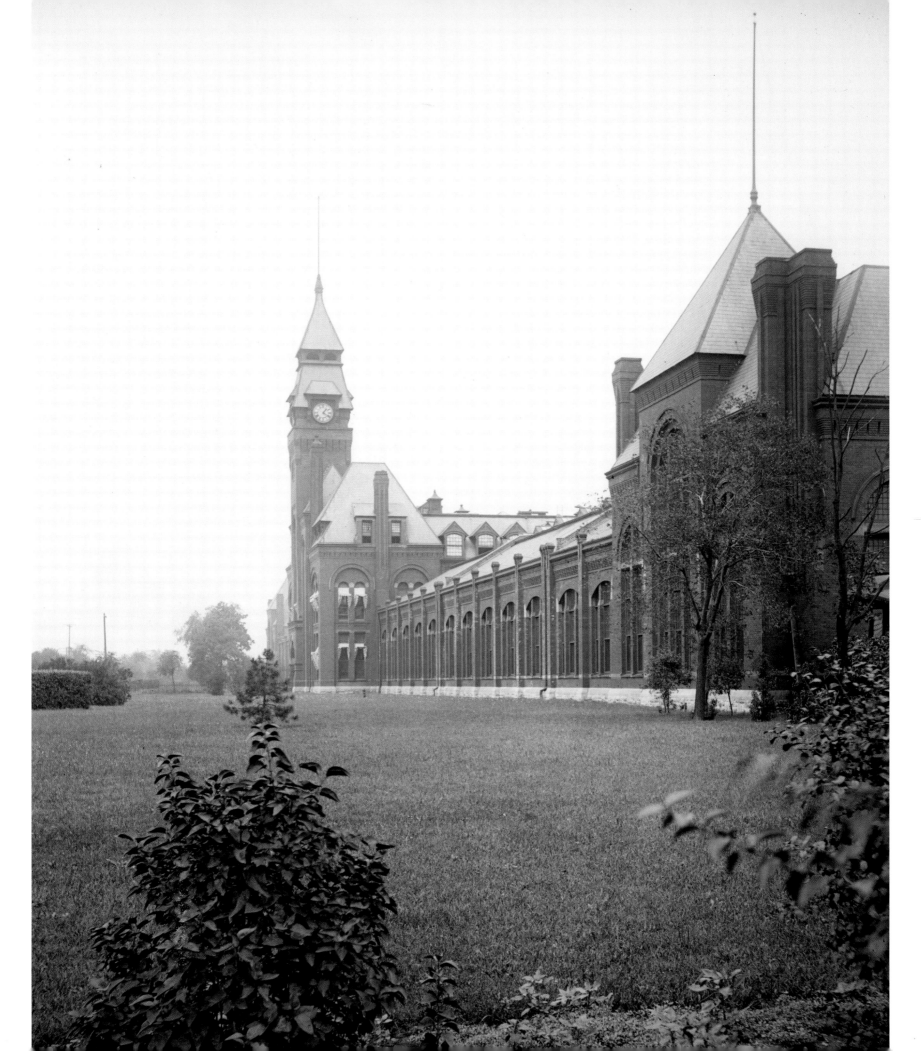

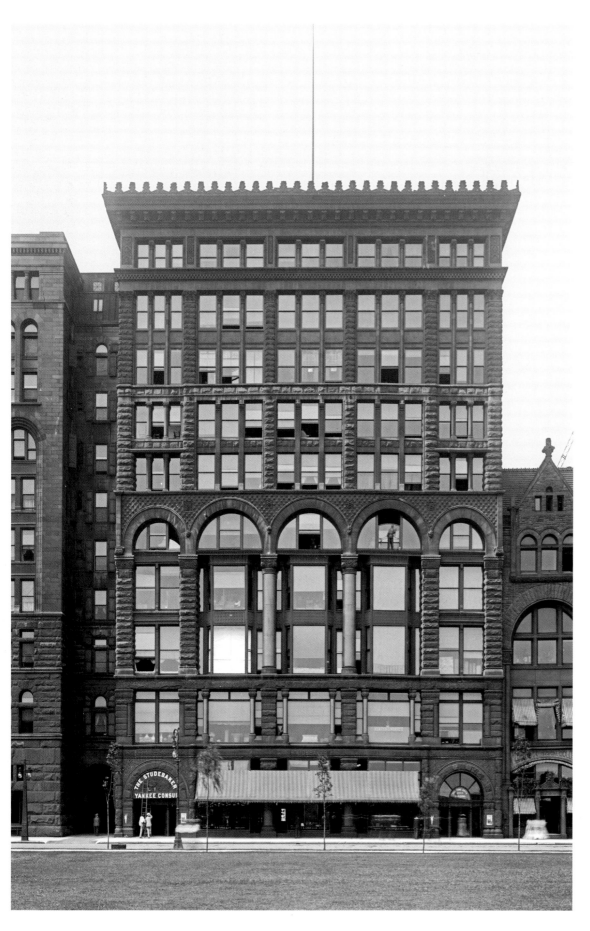

54

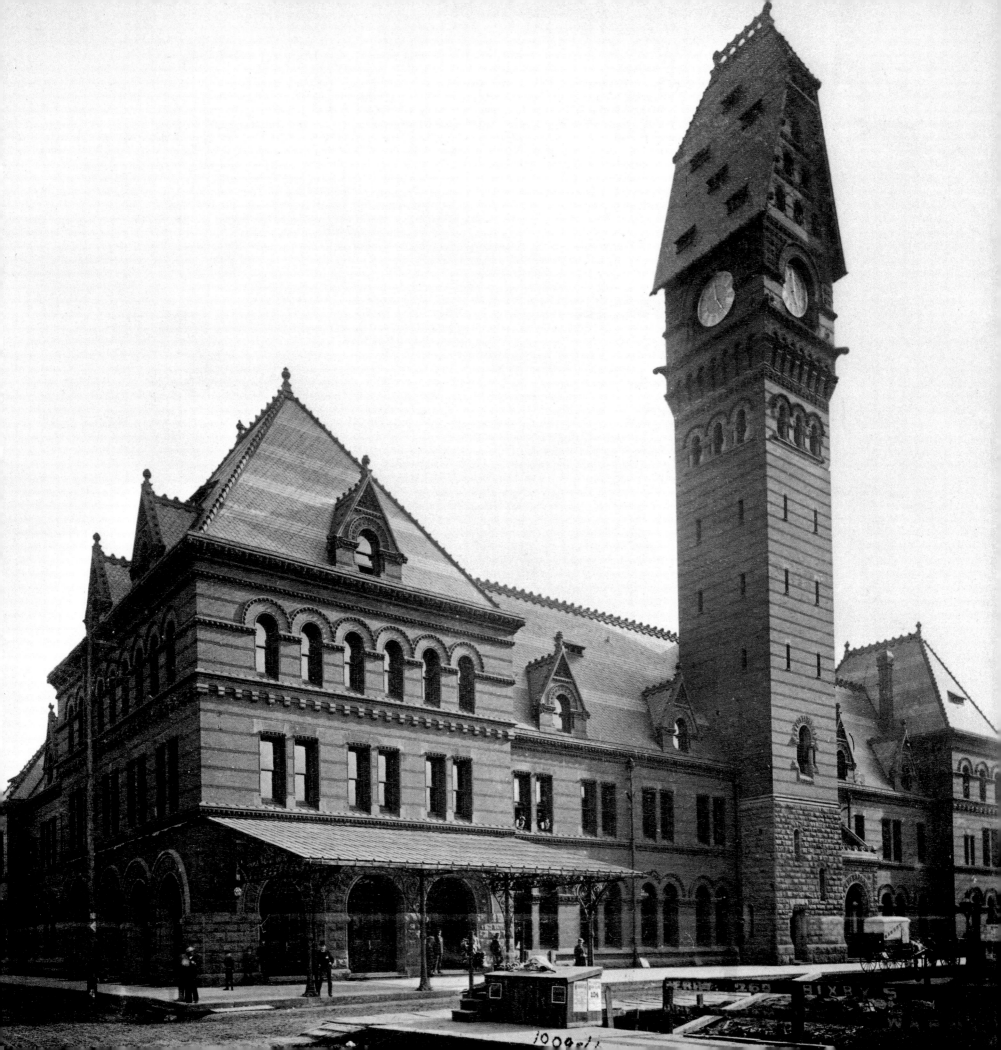

56

Cobb and Frost, Potter Palmer Castle, 1350 North Lake Shore Drive, 1885 (demolished). Potter Palmer (1826–1902) was a retail merchant who developed much of State Street and was responsible for the early Palmer House Hotels, the forerunners of the current one on State and Monroe Streets. Photo: John W. Taylor, Chicago History Museum, ICHi–39490.

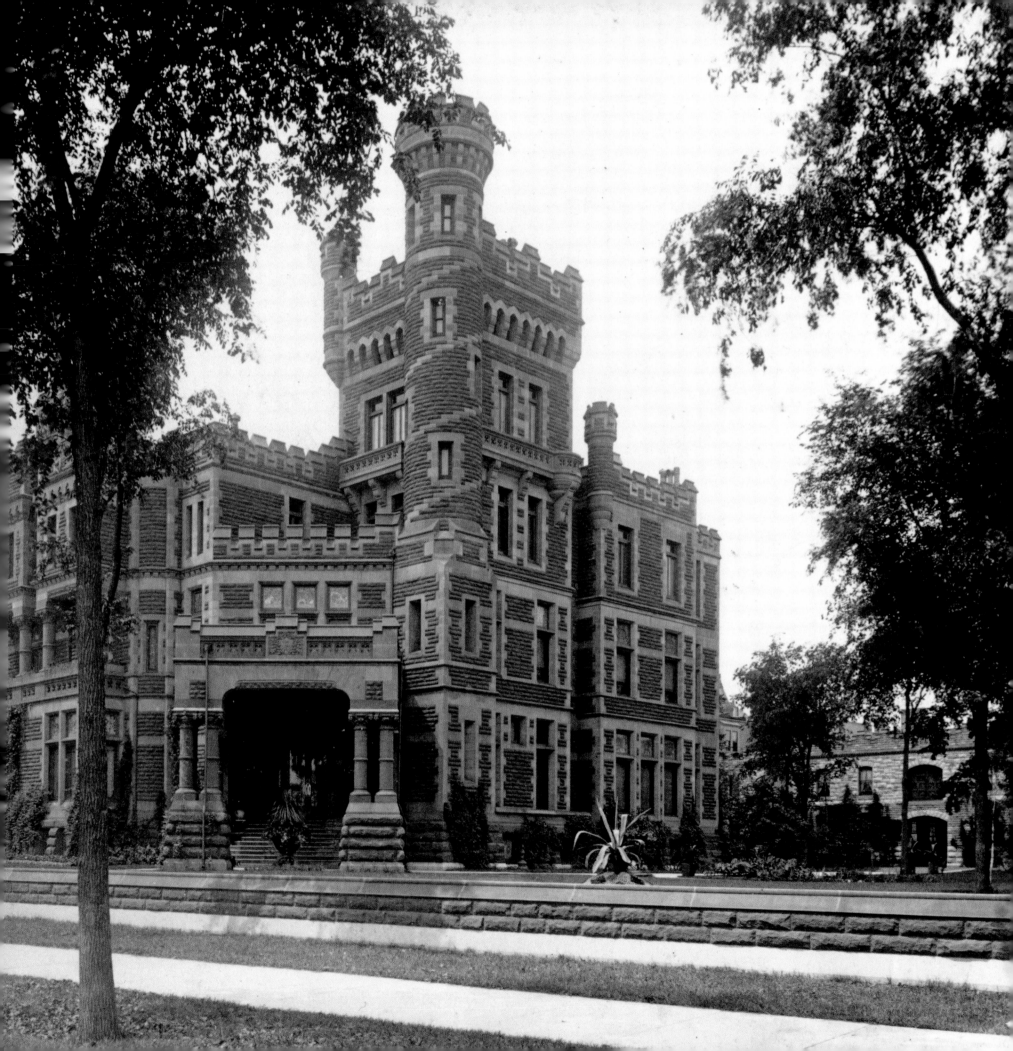

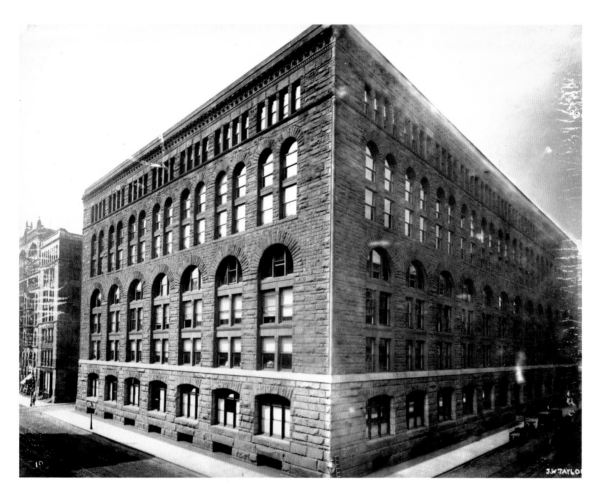

58

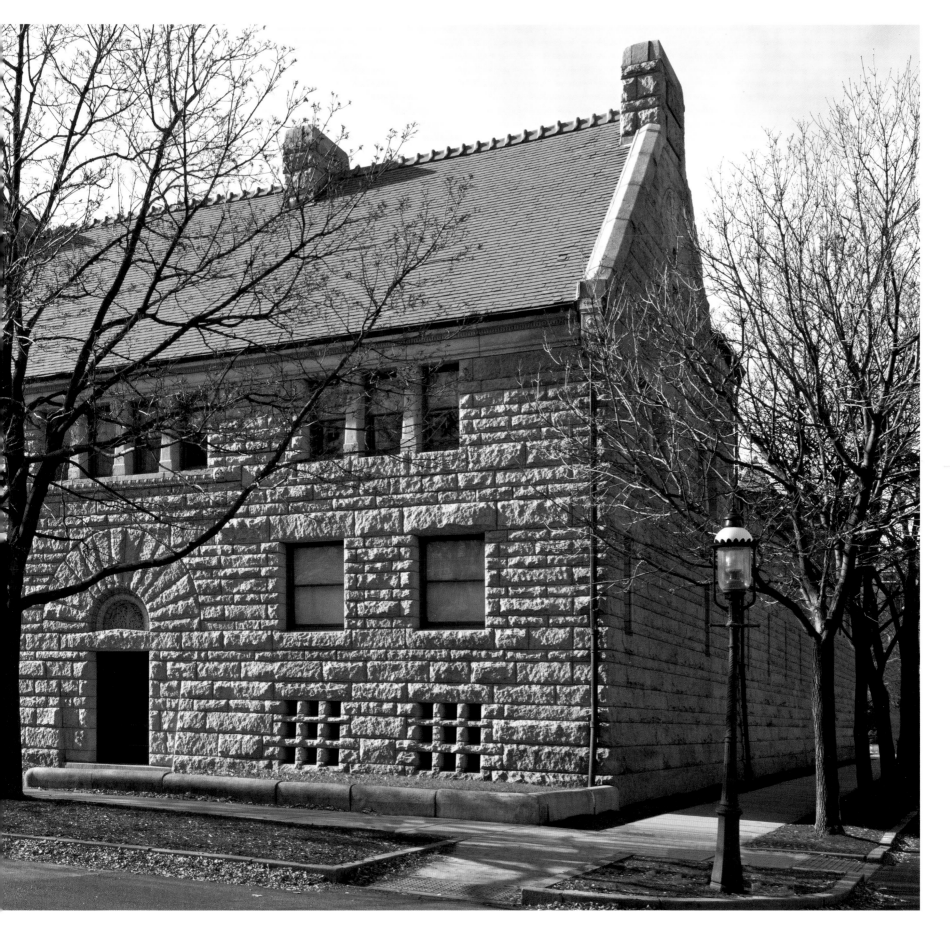

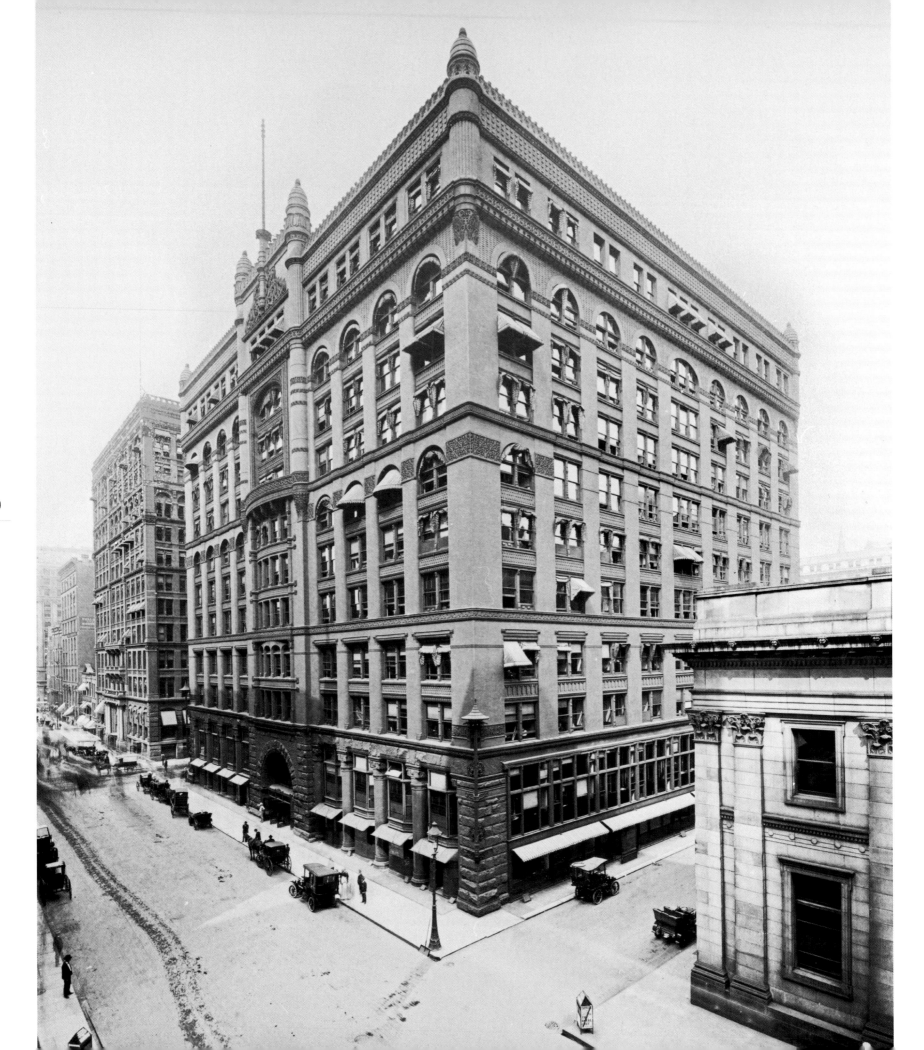

Left and overleaf:
Burnham and Root, Rookery, 209 South La Salle Street, 1887–88; alterations, Frank Lloyd Wright, 1905; and others later. The open atria of Parisian department stores likely informed John Wellborn Root's design of this spacious, lacy lobby. Wright lightened the color palette to gilt white masonry in his remodeling. Photos: Left to right, exterior in ca. 1905 by the Barnes-Crosby Company, Chicago History Museum, ICHi-19186; (overleaf, left to right) original interior by John W. Taylor, ICHi-59530; lobby today, Nick Merrick © Hedrich Blessing.

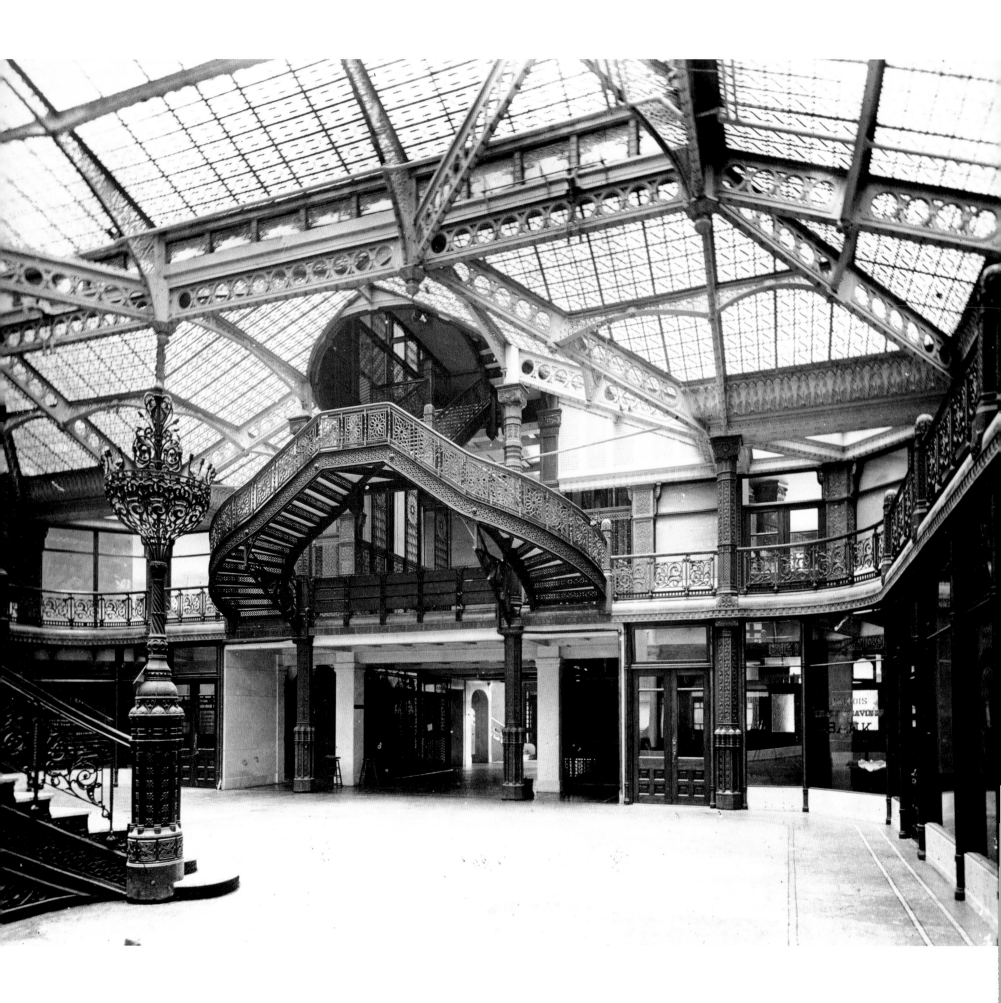

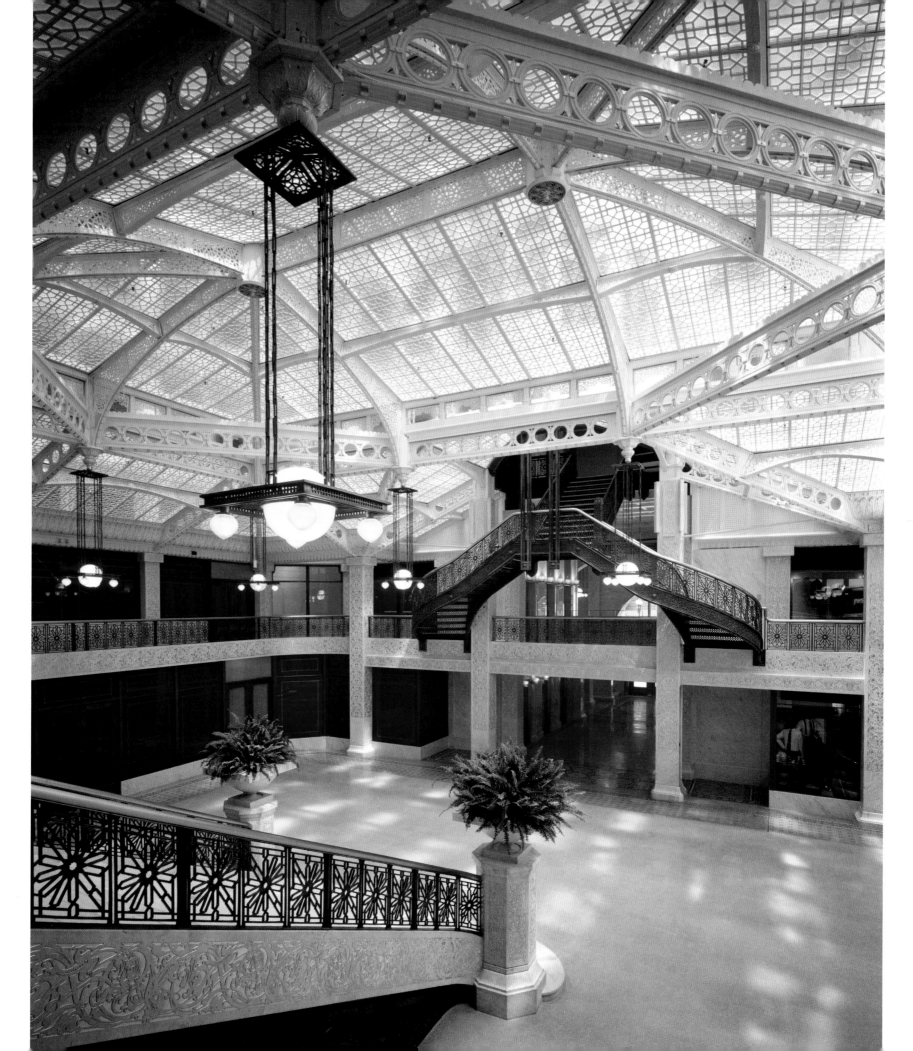

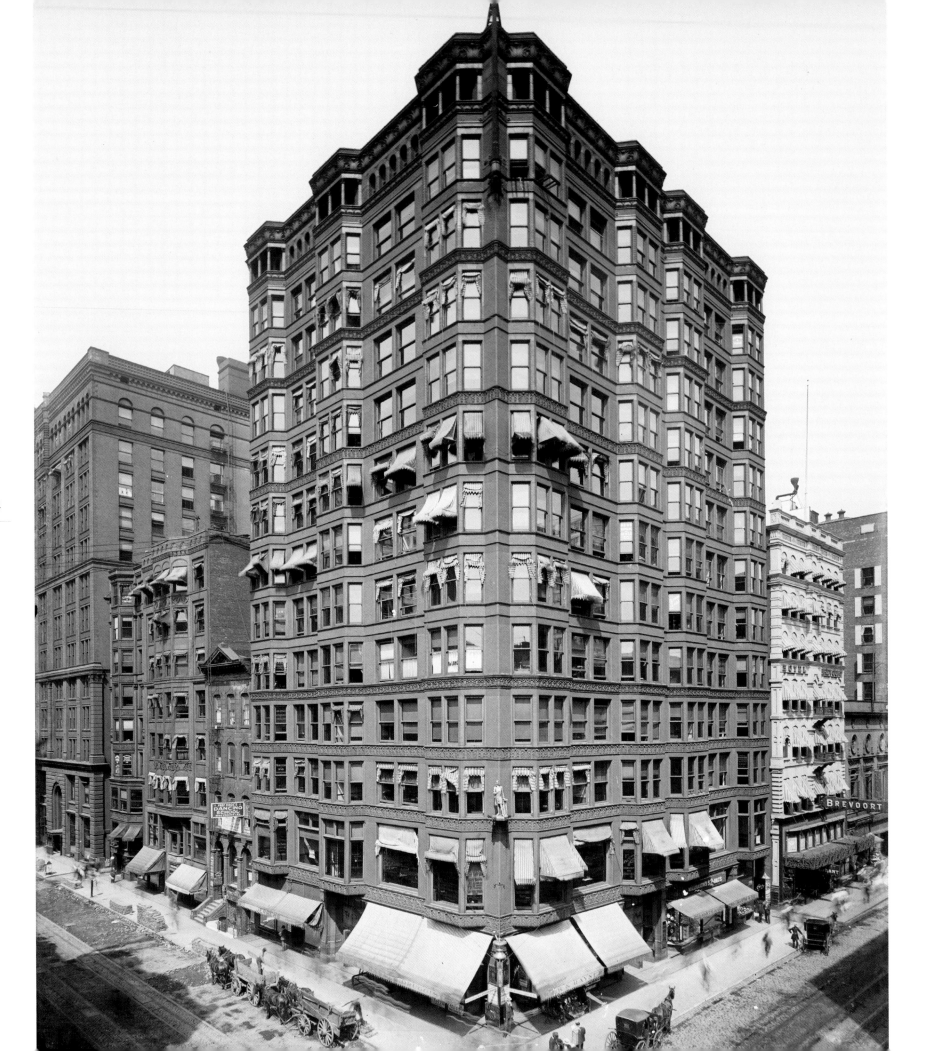

Holabird & Roche, Tacoma Building, northeast corner of La Salle and Madison Streets, 1889 (demolished), shown in a c. 1905 view. Photo: Barnes-Crosby Company, Chicago History Museum, ICHi-19223.

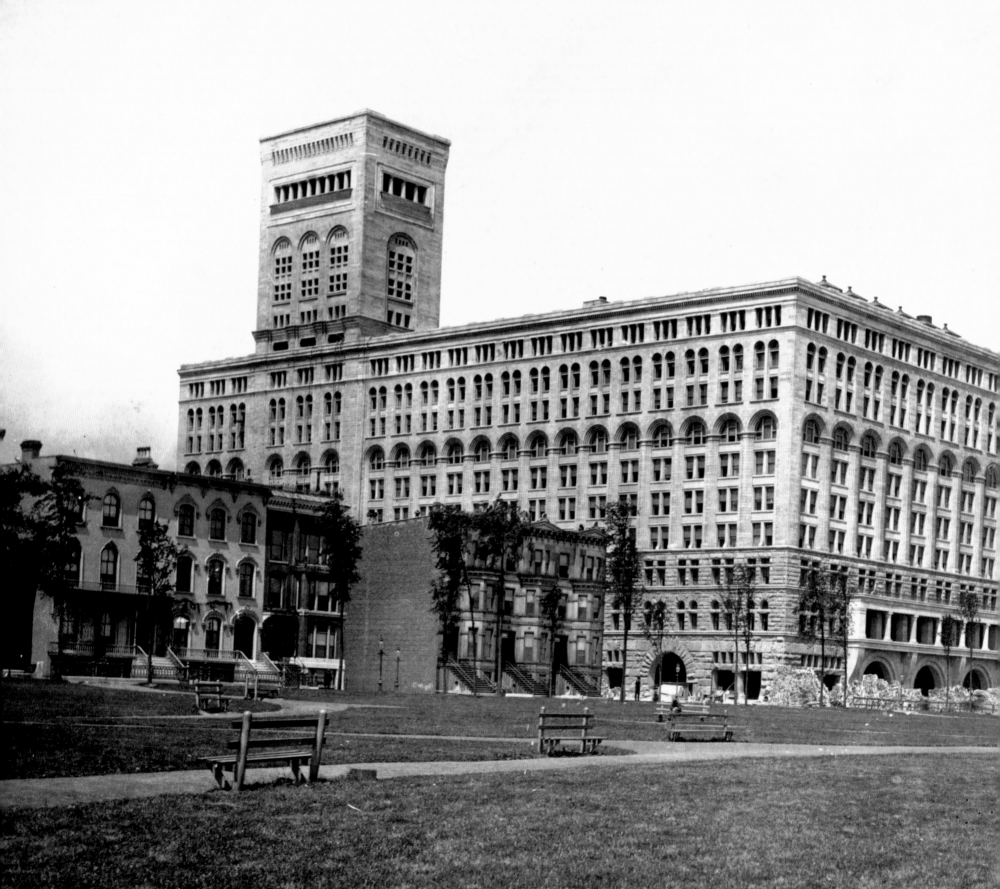

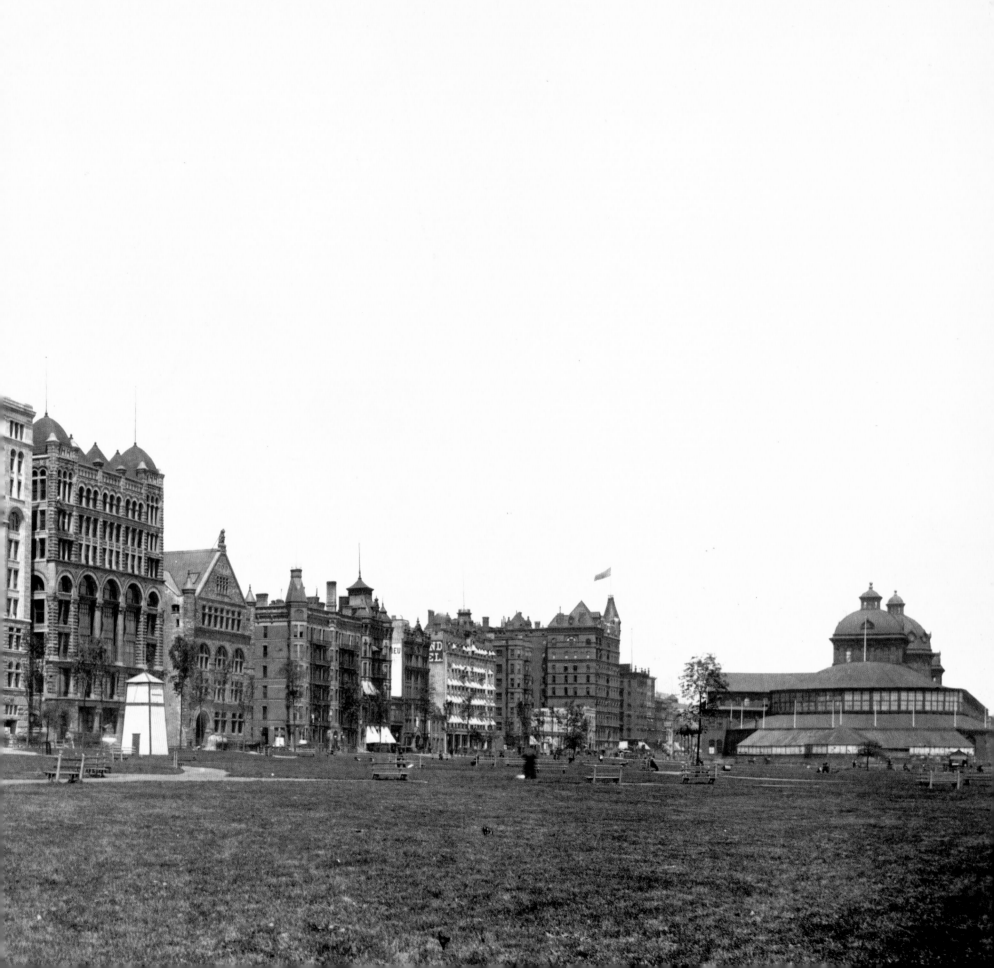

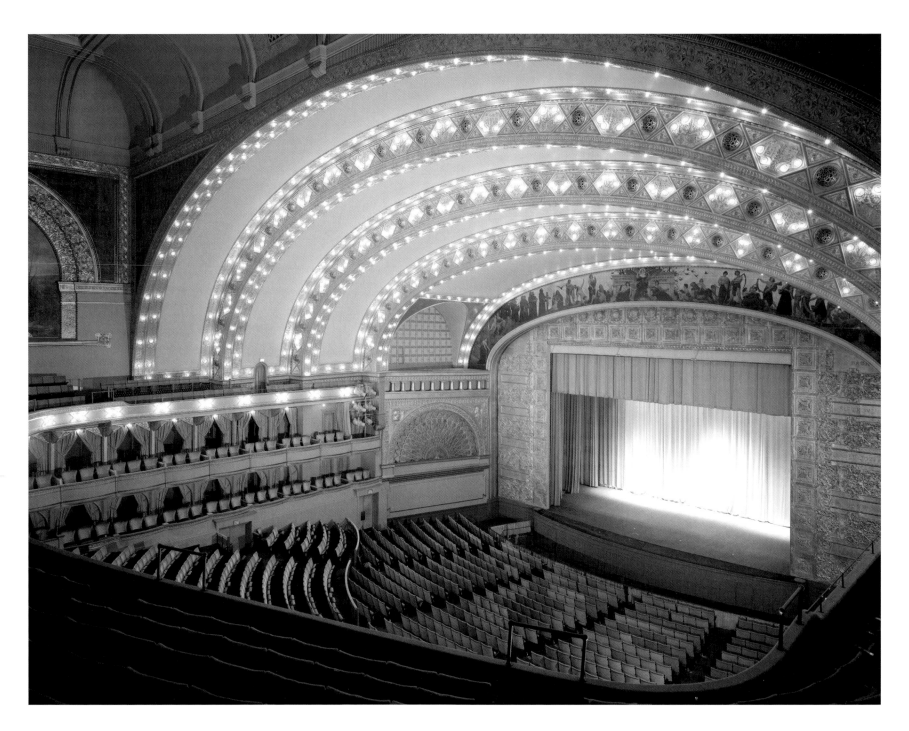

Overleaf and this spread:
Adler and Sullivan, Auditorium Theatre and Hotel, 430 South Michigan Avenue, 1889, with various later restorations through 2003. This massive limestone and granite landmark is now home to Roosevelt University. It was an early example of a multiuse building with a 4,300-seat theater, offices, and a 400-room hotel. The exterior photograph (overleaf) shows, at the right, the Interstate Exposition Hall (1873; demolished) by William W. Boyington, on the site of the current Art Institute of Chicago. The Auditorium itself has been restored by several firms, including Harry Weese in 1967 and Daniel P. Coffey in 2003, while Booth Hansen restored Ganz Hall in 2003. Restoration work by Booth Hansen and MGLM continued through the building's 125th anniversary in 2015. Photos: Exterior (overleaf) c. 1889–90, John W. Taylor, Chicago History Museum, ICHi-00568; interior of theater (above), Hedrich Blessing © Chicago Historical Society HB-31105-F, ArcaidImages.com 70894-150-1; Ganz Hall restored interior (right), courtesy Booth Hansen.

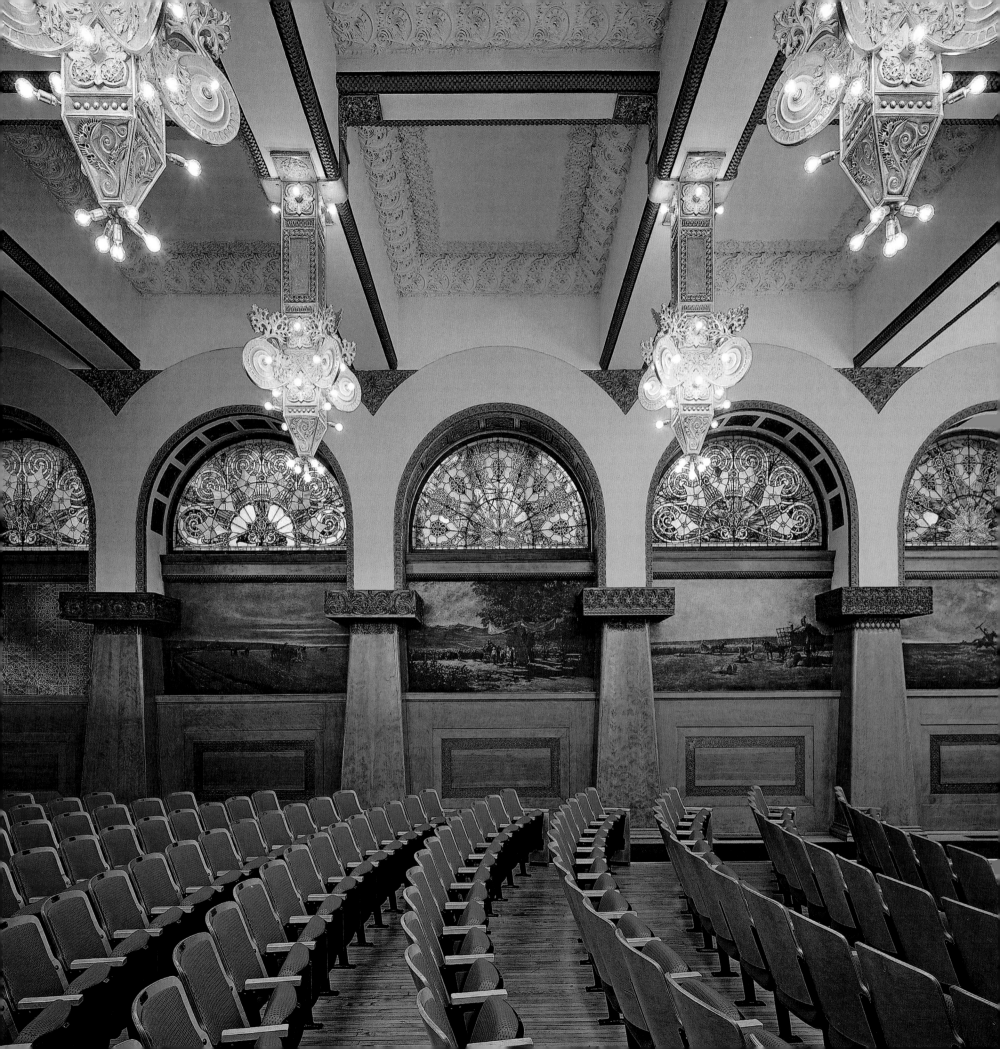

Frank Lloyd Wright for Adler and Sullivan, Charnley-Persky House, 1365 North Astor Street, 1892; restored, 1988, Skidmore, Owings & Merrill, now the headquarters of the Society of Architectural Historians. Photo: © 1990, Hedrich Blessing Photographers, courtesy Skidmore, Owings & Merrill, LLP, and the Charnley-Persky House Museum Foundation.

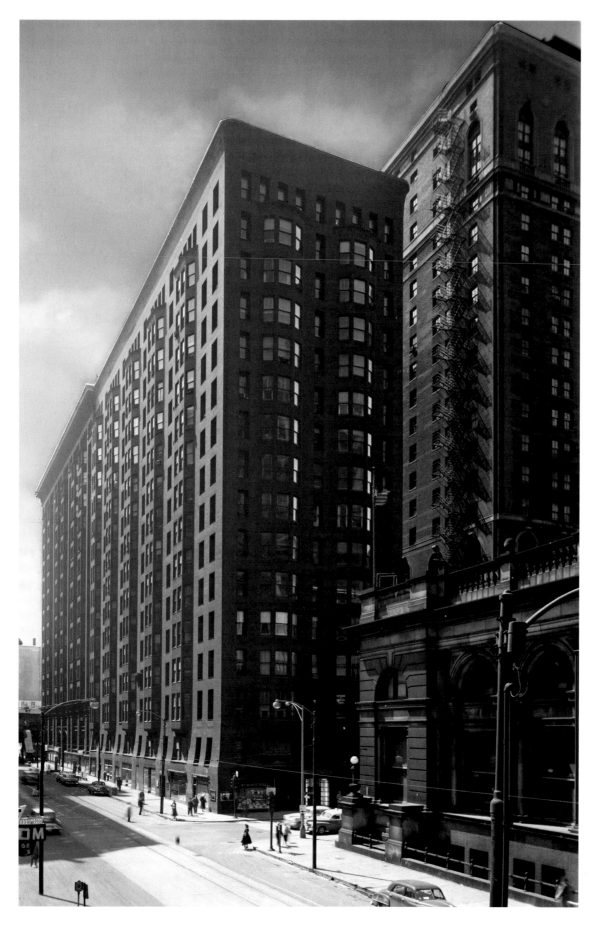

Burnham and Root, Monadnock Building, 53 West Jackson Boulevard, 1891, with Holabird & Roche addition to the south, 1893. The exterior photograph shows, at lower right, the edge of the Federal Building of 1905 (demolished) by Henry Ives Cobb, while the background, right, shows the 1928 Union League Club by Mundie and Jensen. Photos: Hedrich Blessing © Chicago Historical Society, HB-19320-B, ArcaidImages.com 70894-60-1; and interior stair detail of the Monadnock by Betty Hulett in 1968, Chicago History Museum, ICHi-51603.

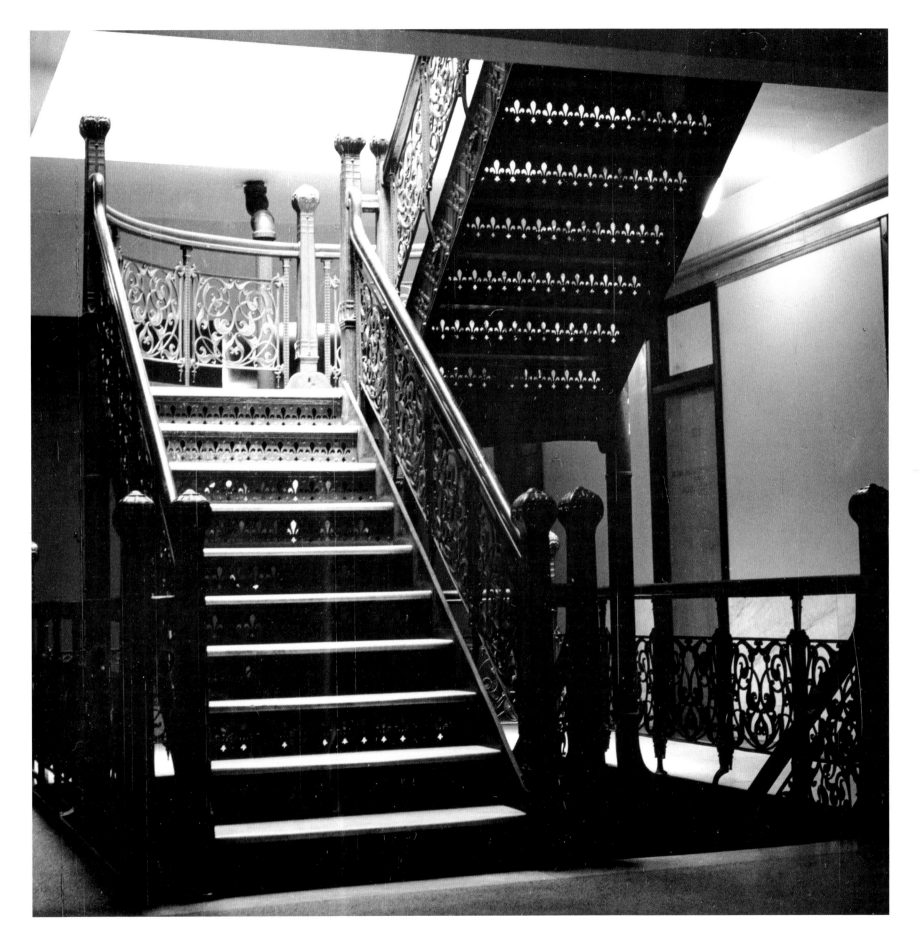

Burnham and Root, Masonic Temple, northeast corner State and Randolph streets, 1892 (demolished). Photo: John W. Taylor, Chicago History Museum, ICHi-01022.

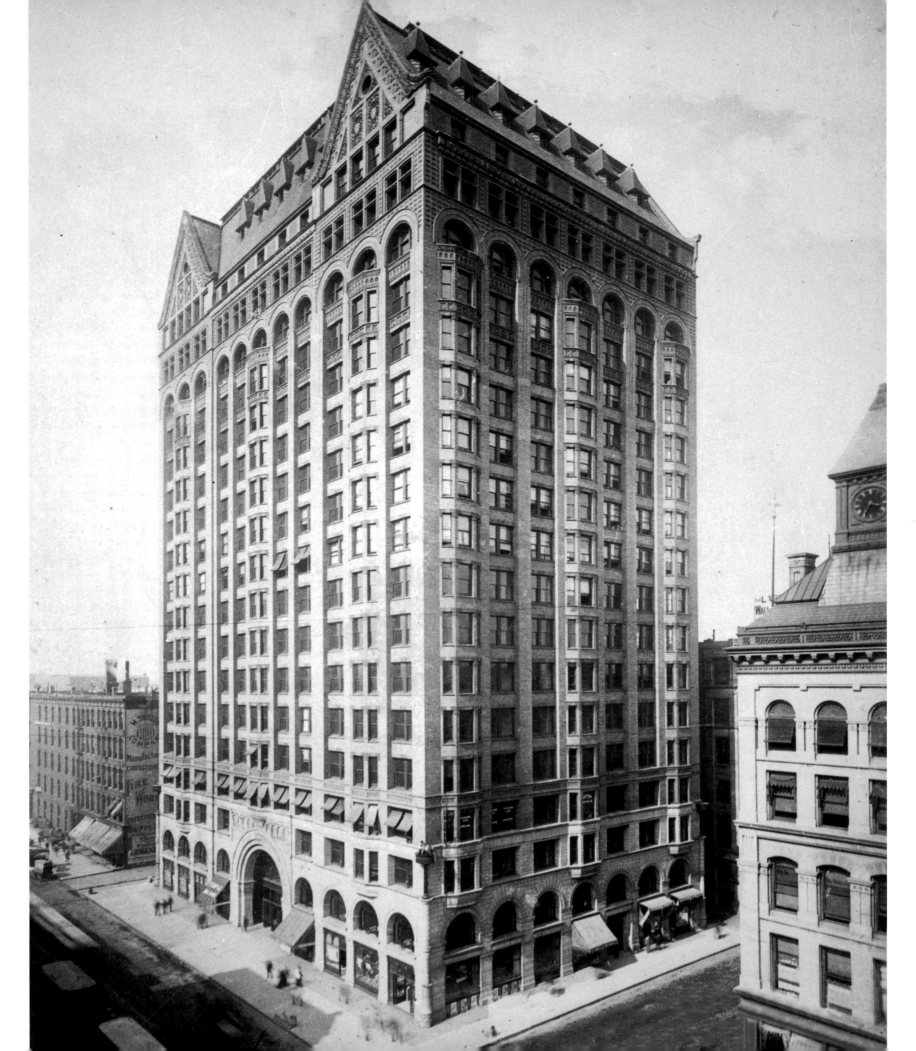

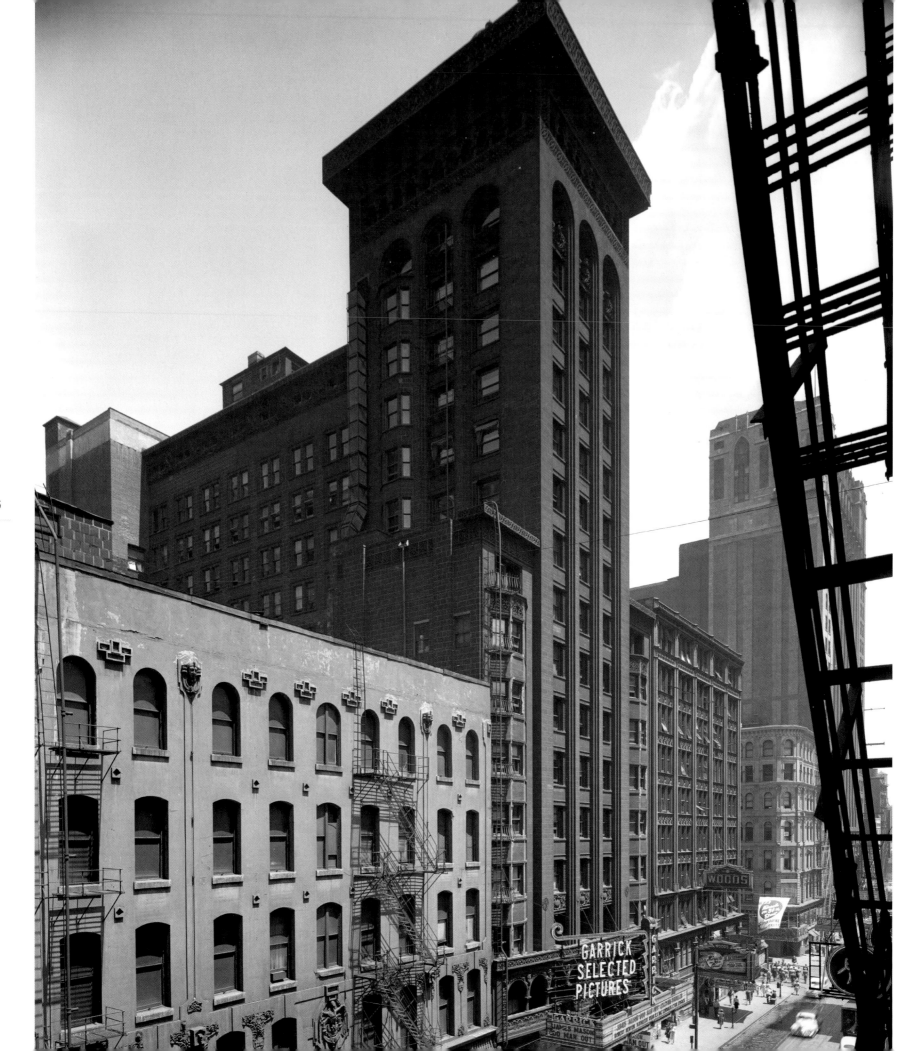

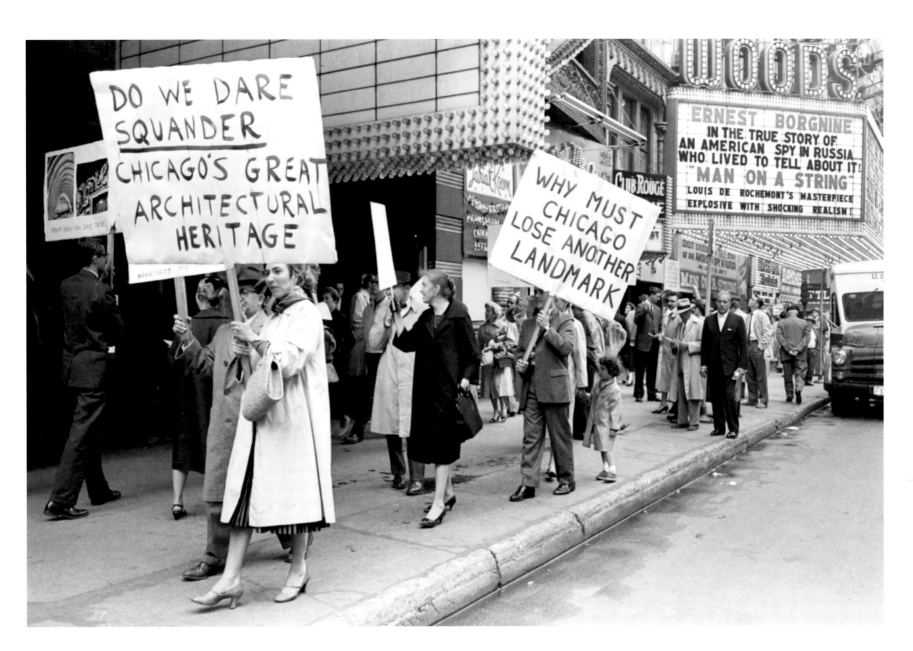

Adler and Sullivan, Schiller Theatre (later Garrick Theater), 64 West
Randolph Street, 1892 (demolished). Greater preservation awareness
of the importance of Chicago School and Prairie Style buildings grew
in the 1960s and 1970s with the publications of Carl Condit, as well
as with the journal *Prairie School Review* (1964–81) and the Prairie
Avenue Bookshop (1974–2009), both founded by Wilbert and Marilyn
Hasbrouck. Photos: Hedrich Blessing © Chicago Historical Society
HB-10299-G, ArcaidImages.com 70894-20-1; photograph of Garrick
demolition protest in 1961 by Arthur Siegel, Chicago History Museum,
ICHi-37002.

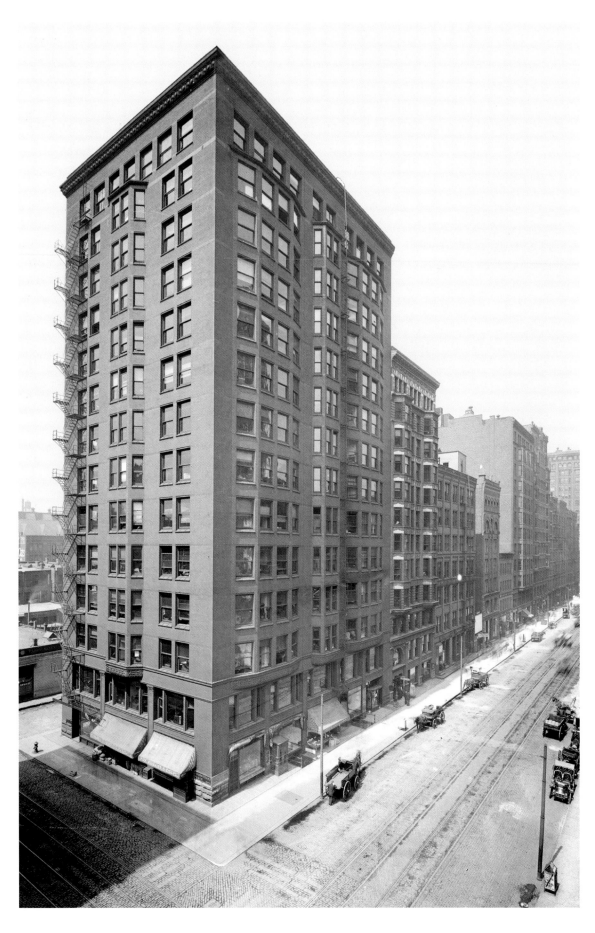

Left:
Holabird & Roche, Pontiac Building, 542 South Dearborn Street, 1891; restored, 1985, Booth Hansen. Photo: Barnes-Crosby Company, Chicago History Museum, ICHi-19195.

Right:
Henry Ives Cobb, Chicago Historical Society (later, Excalibur and various nightclubs), 632 North Dearborn Street, 1892. Photo: Charles R. Clark, Chicago History Museum, ICHi-70200.

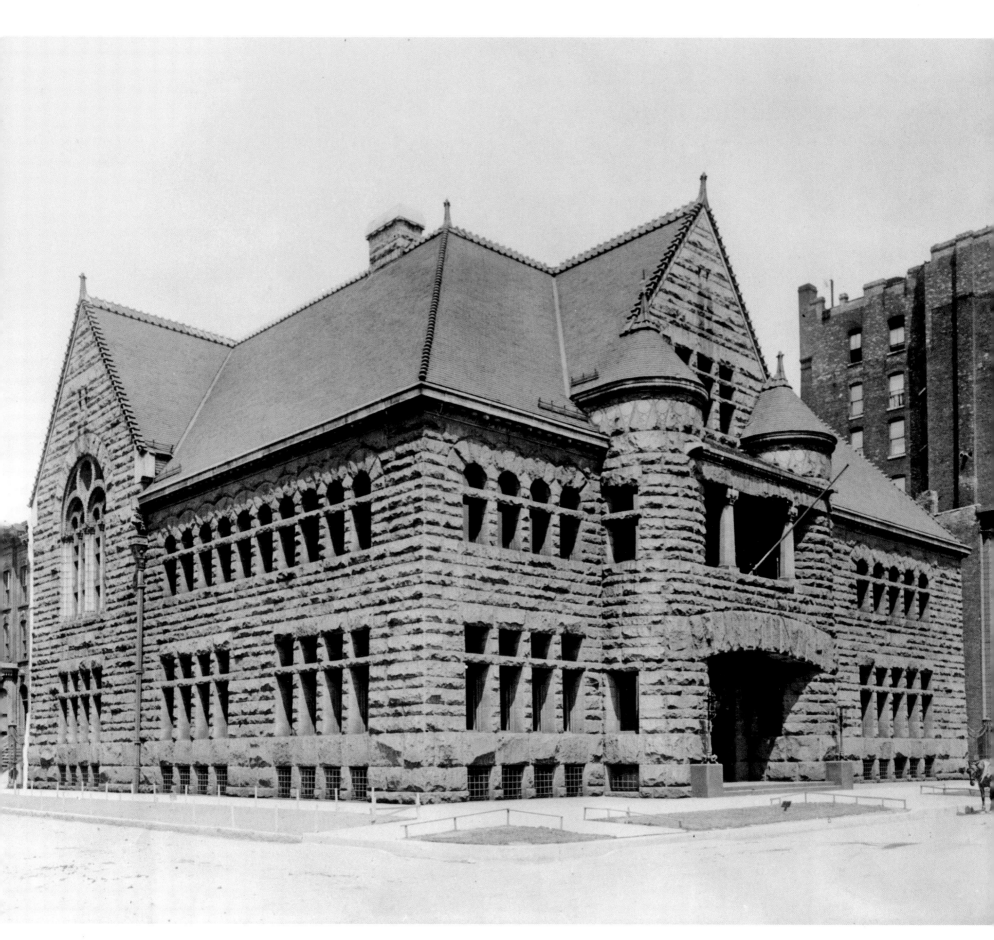

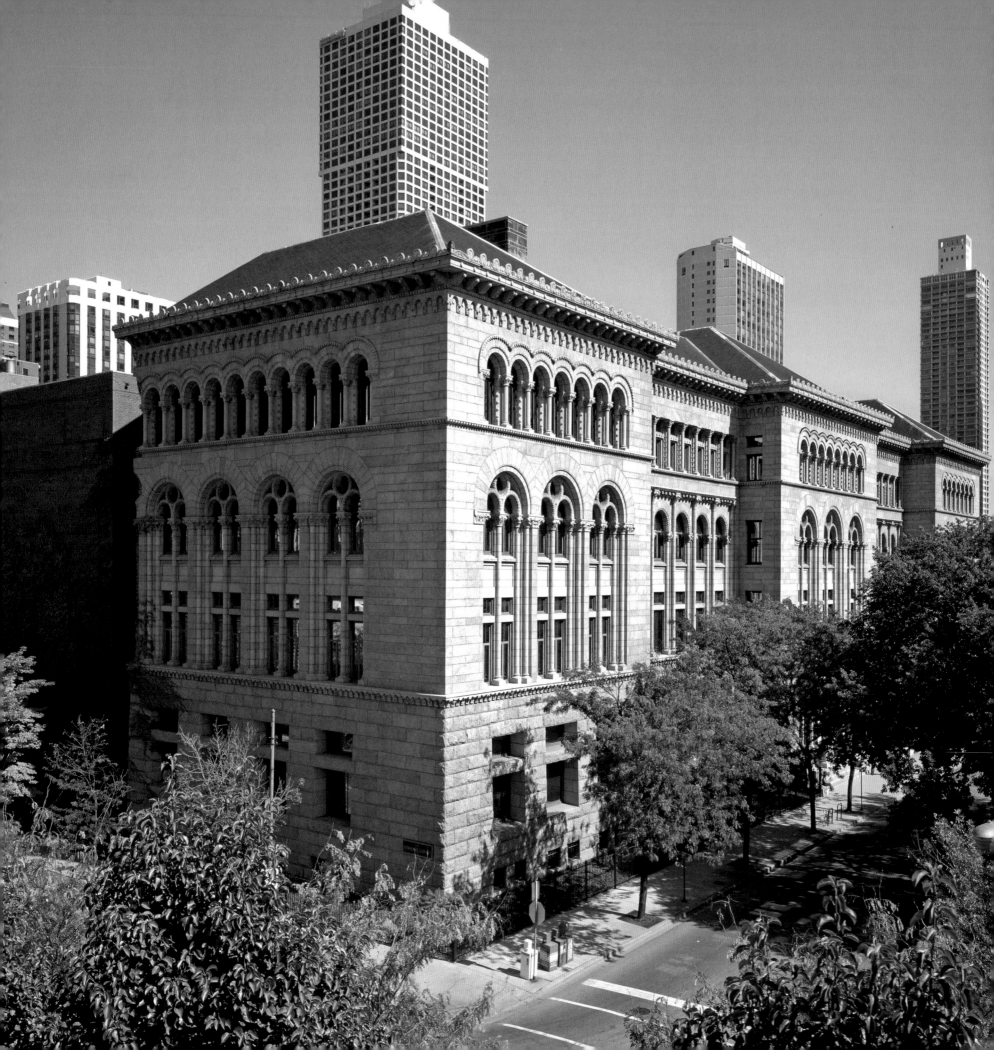

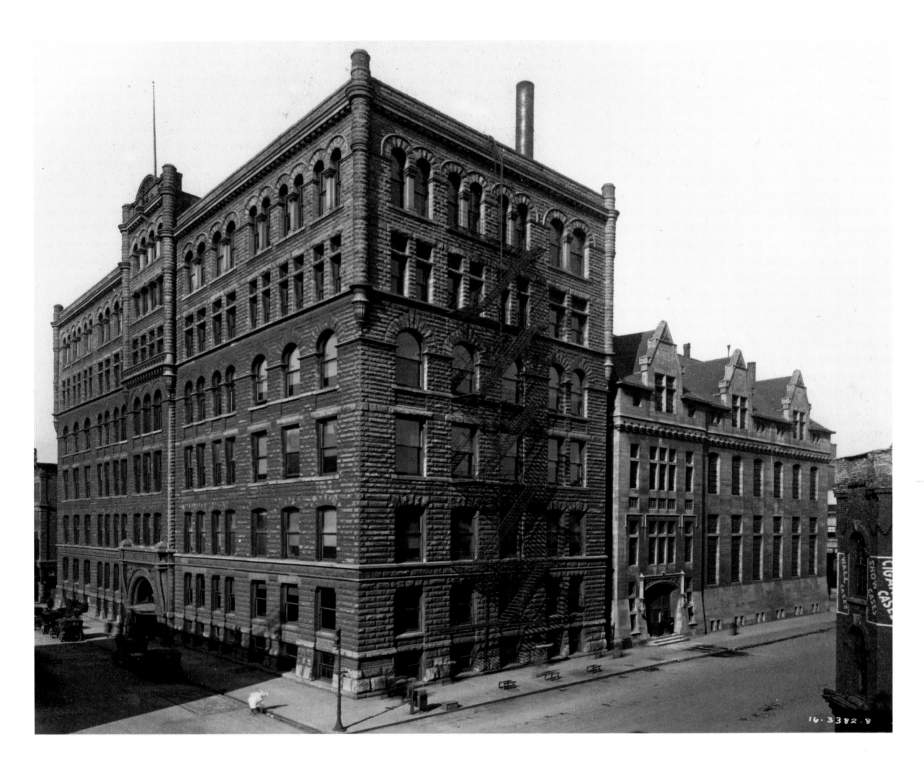

Above:
Otto H. Matz, Cook County Criminal Courts Building (now Courthouse Place), 54 West Hubbard Street, 1892–93, shown here c. 1916; renovated 1986, Solomon Cordwell Buenz. The building was the site of the Leopold and Loeb murder trial (1924) as well as the Chicago Black Sox scandal trial (1921), which involved White Sox team members in a conspiracy to throw the outcome of the 1919 World Series. Photo: Chicago History Museum, ICHi-00463.

Left:
Henry Ives Cobb, Newberry Library, 60 West Walton Street, 1893; addition to the left by Harry Weese 1981. Photo: Chris Barrett
© Hedrich Blessing, ArcaidImages.com 70298-20-1.

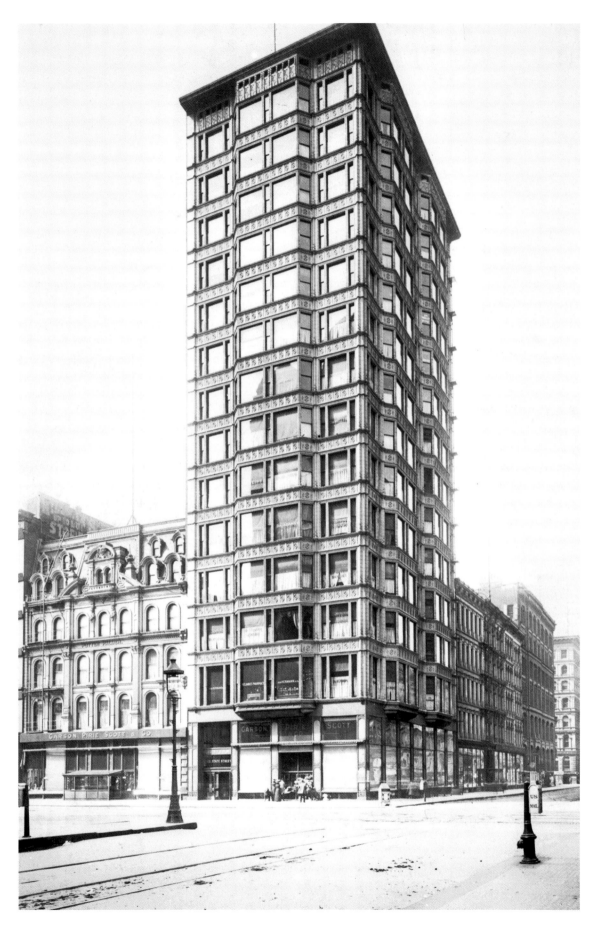

82

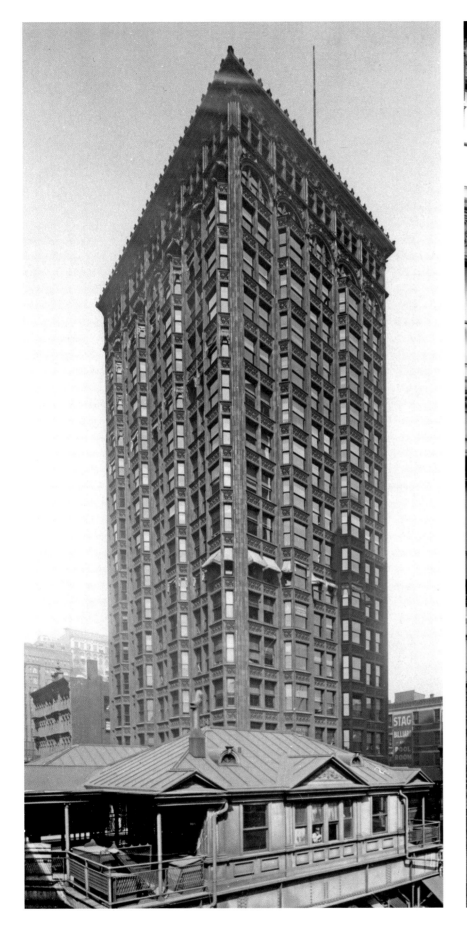

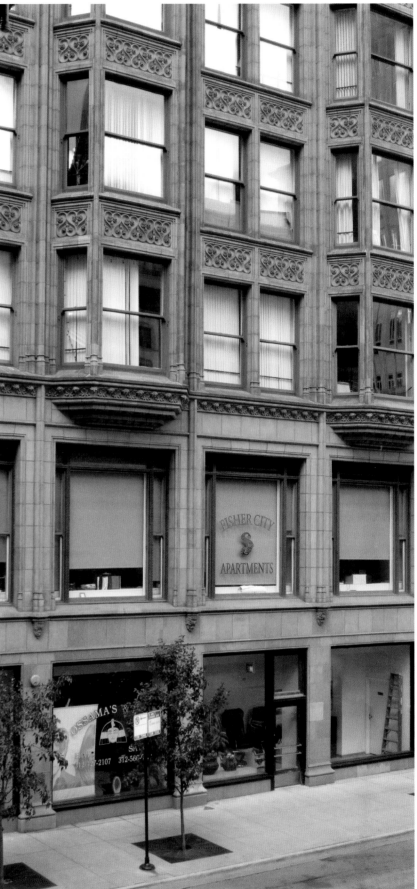

84

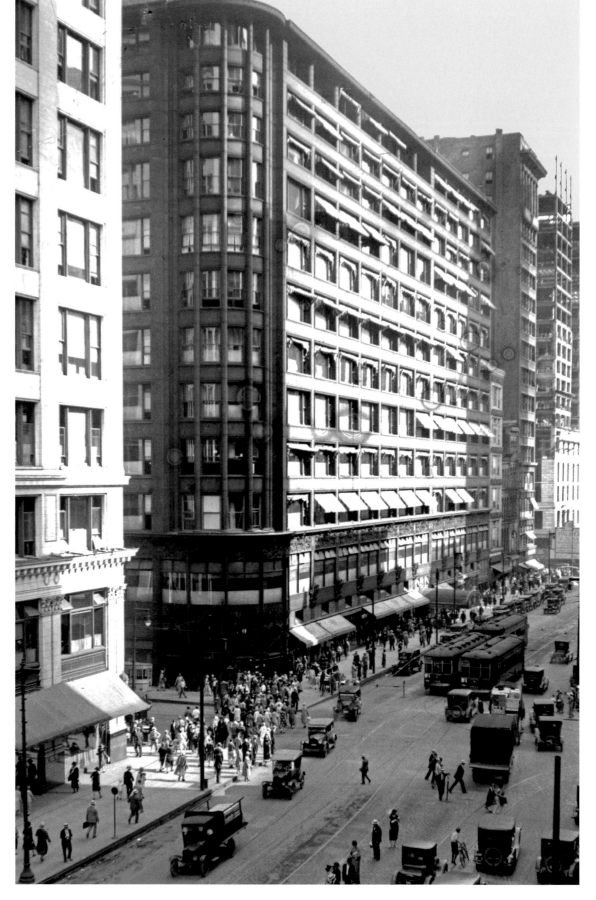

Louis H. Sullivan, Schlesinger and Mayer Department Store (later Carson, Pirie, Scott and Company Store and now Sullivan Center), 1 South State Street, 1899–1904 and later additions. This important building was restored by John Vinci in 1980, and again in 2006–11 by Gunny Harboe. Its location at what was the busiest corner in the world made it the center of a string of department stores along State Street. Photos: 1926 view (right) in *Chicago Daily News* negative collection, Chicago History Museum, DN–0081447; color view (far right) c. 1960 by Hedrich Blessing © Chicago Historical Society HB 19321-E2, ArcaidImages.com 70894-70-1; exterior detail today (above) by John Zukowsky.

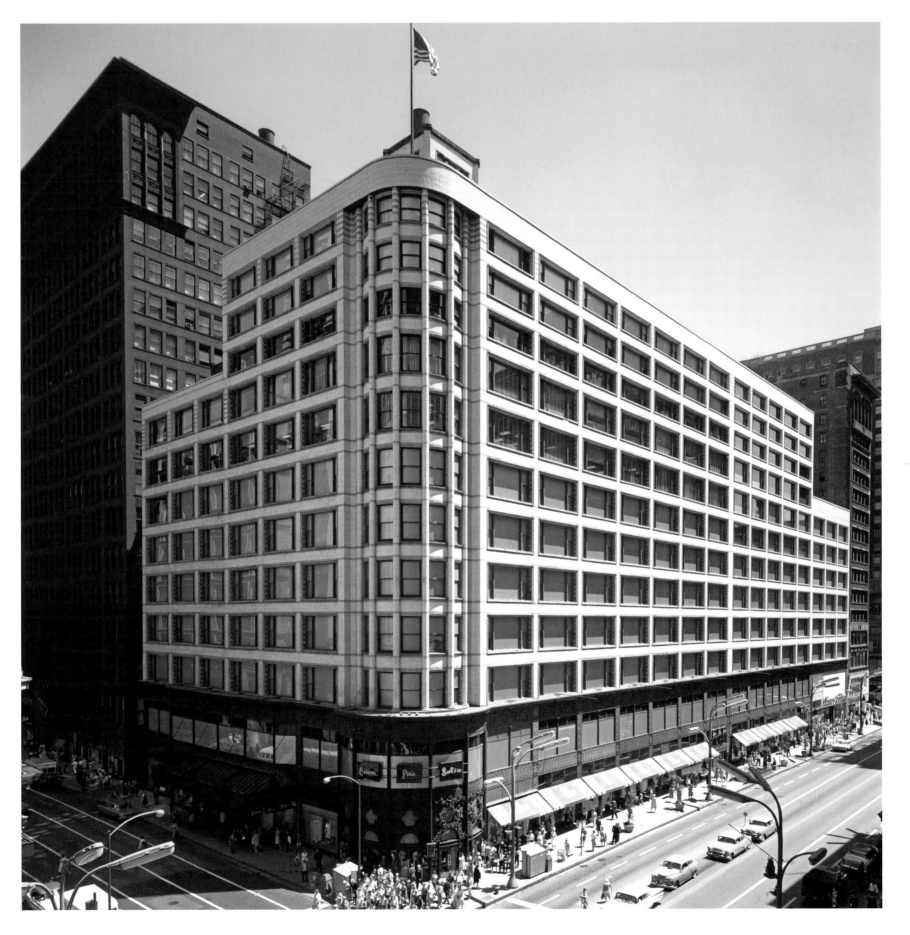

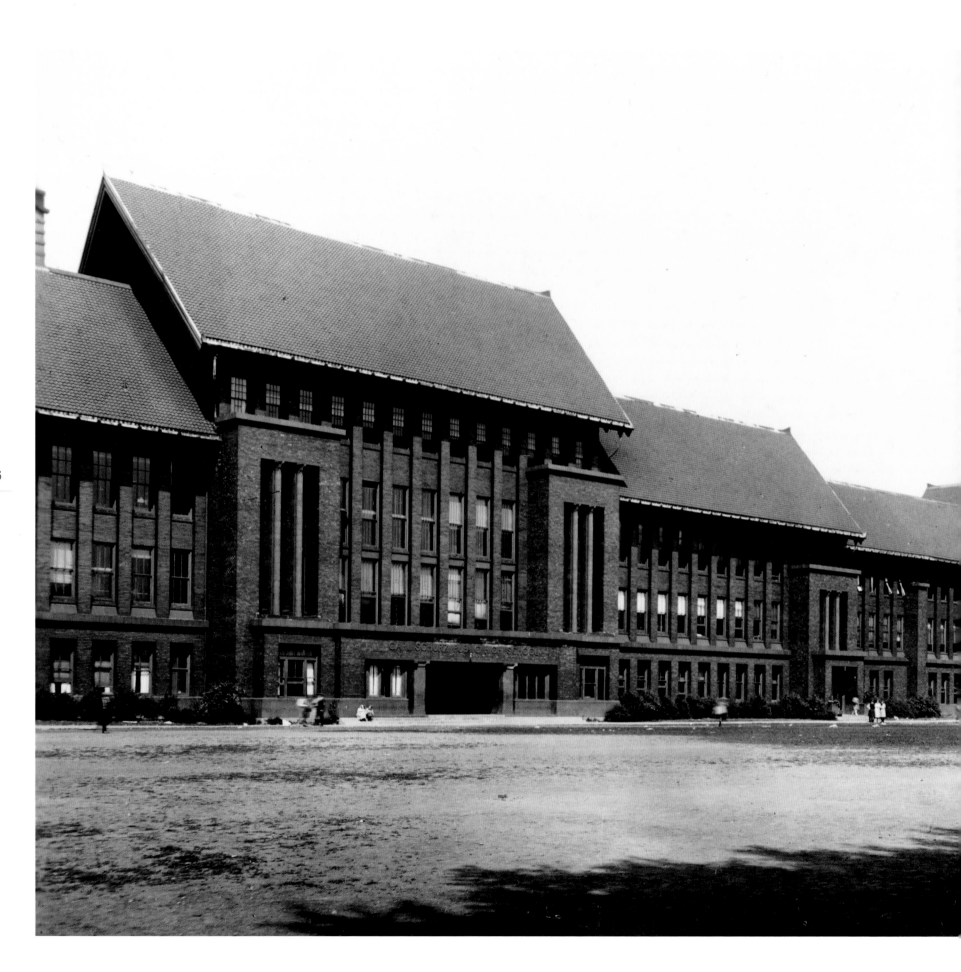

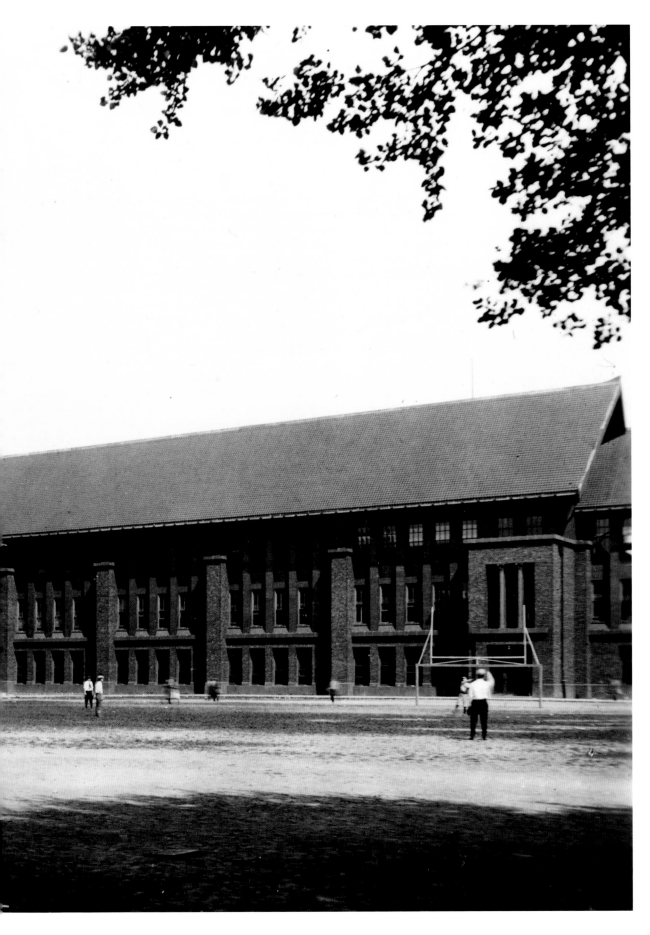

Dwight H. Perkins, Carl Schurz High School, 3601 North Milwaukee Avenue, 1908–10; later additions, 1915 and 1924; renovations, 2000, Ross, Barney and Jankowski. Photo: 1928 view by Kaufmann & Fabry Co., Chicago History Museum, ICHi-39472.

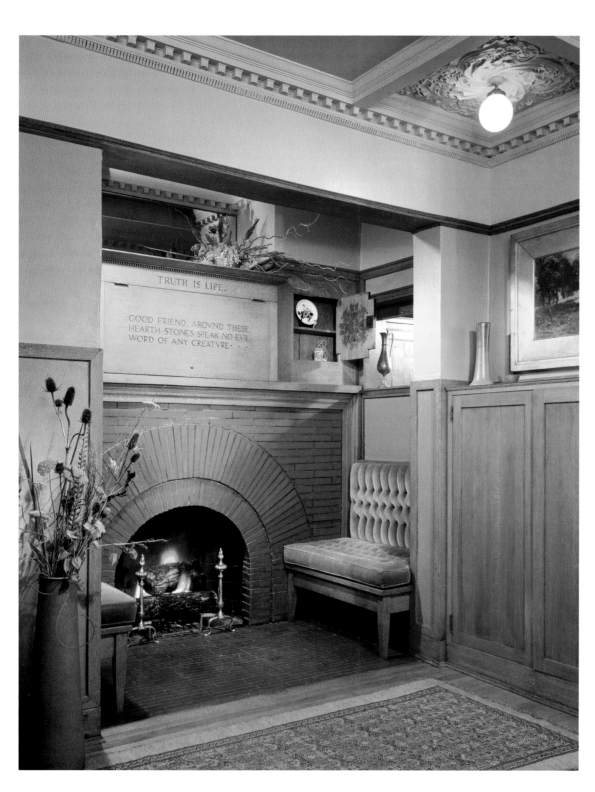

88

Frank Lloyd Wright, Home and Studio, 951 Chicago Avenue, Oak Park, 1889–1911; restored, 1986. Wright lived and practiced here until he left his first wife and traveled to Europe in 1909 with a client's wife, Mamah Borthwick Cheney. He returned to the United States in 1910 where he and she moved to Spring Green, Wisconsin, and built a new home called Taliesin (1911). While in Oak Park, Wright designed and built some twenty-five houses there, and even more throughout Chicago and its suburbs. Photos: Jon Miller © Hedrich Blessing.

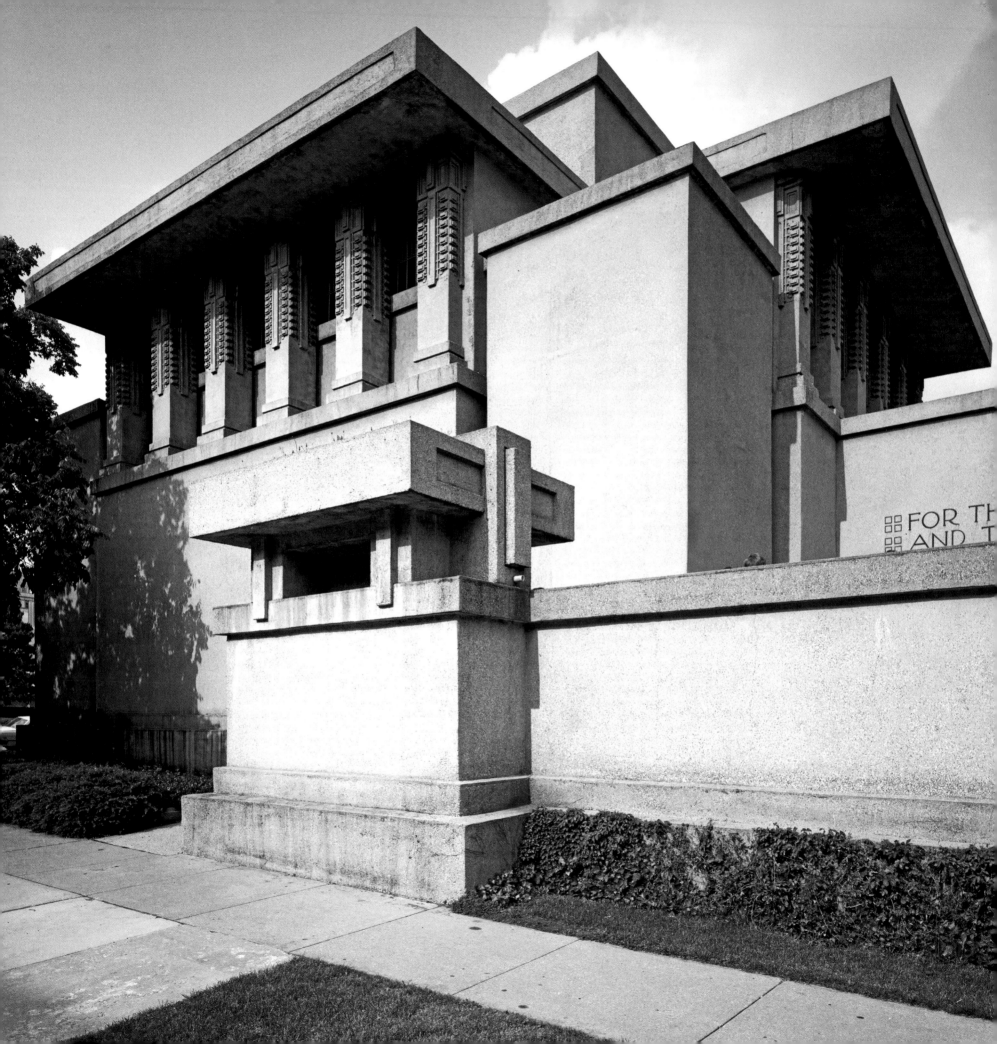

Left:
Frank Lloyd Wright, Unity Temple, 875 Lake Street, Oak Park,
1908. The structure was built of reinforced concrete to save the
congregation's funds; this photograph shows the exterior of the larger
worship space, the smaller services building being next door. Photo:
Hedrich Blessing Collection, Chicago History Museum, HB-19311-O.

Overleaf:
Frank Lloyd Wright, Frederick C. Robie House, 5757 South
Woodlawn Avenue, 1909; various restorations since 1997. Photos:
Jon Miller
© Hedrich Blessing (left) and Hedrich Blessing (right).

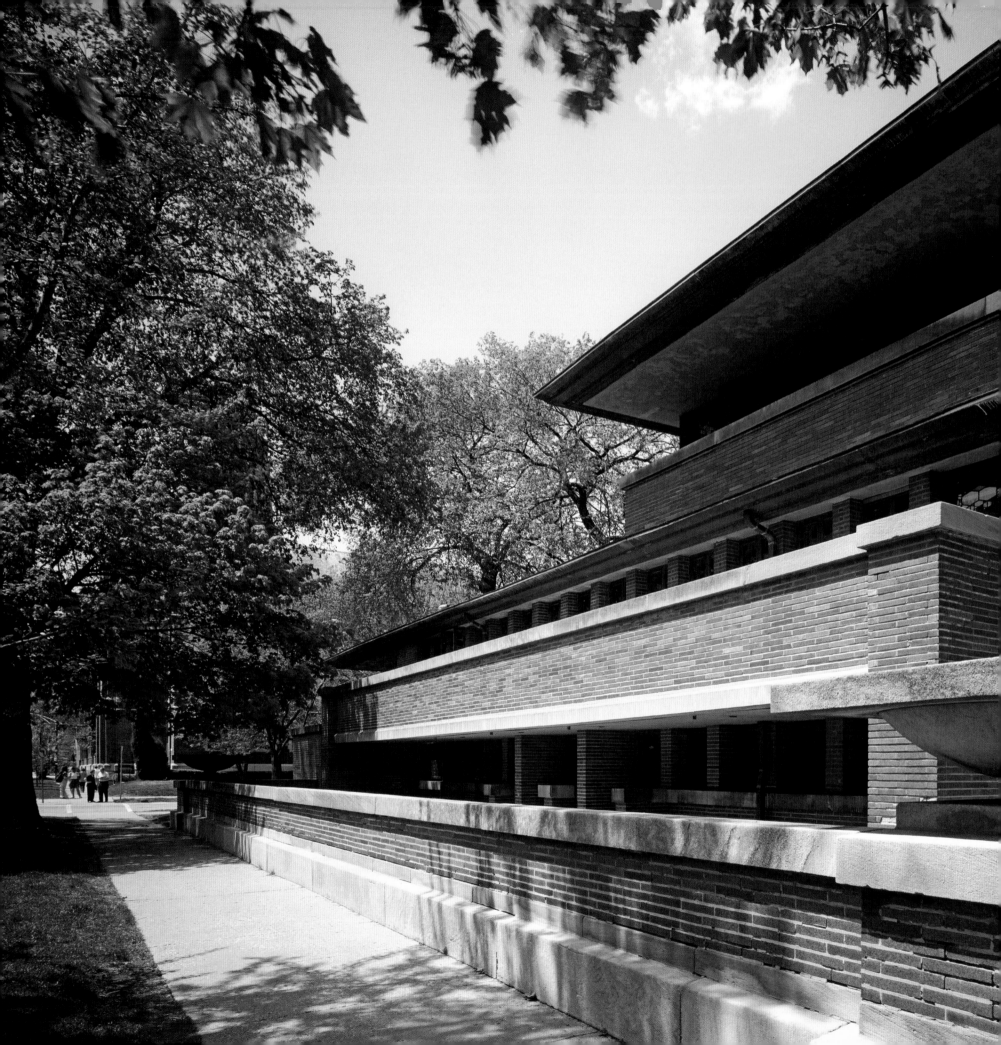

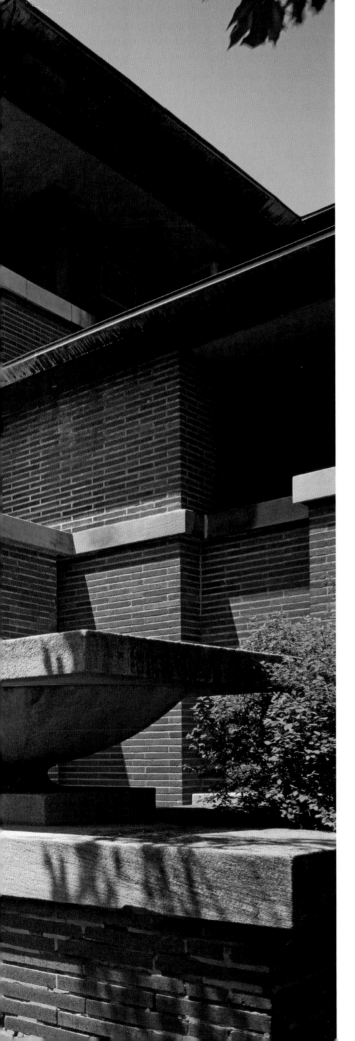

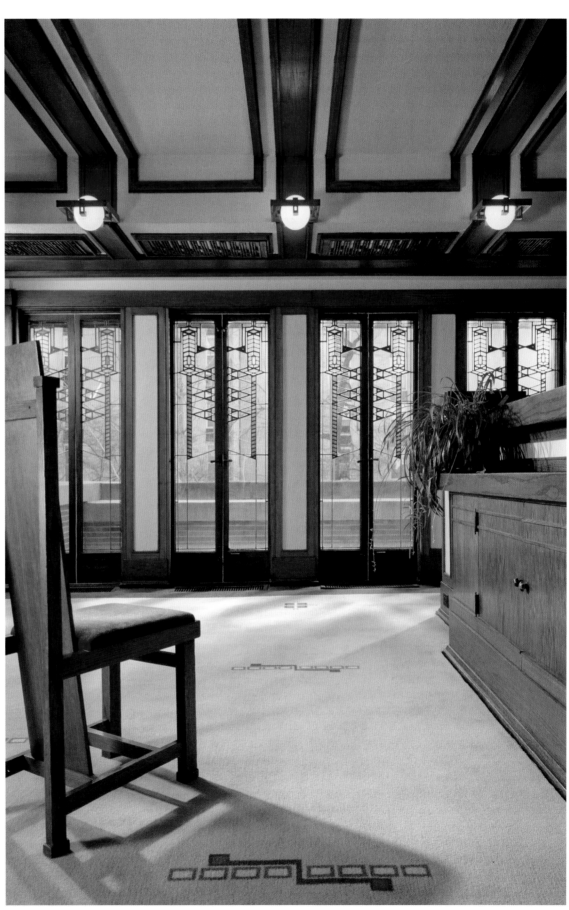

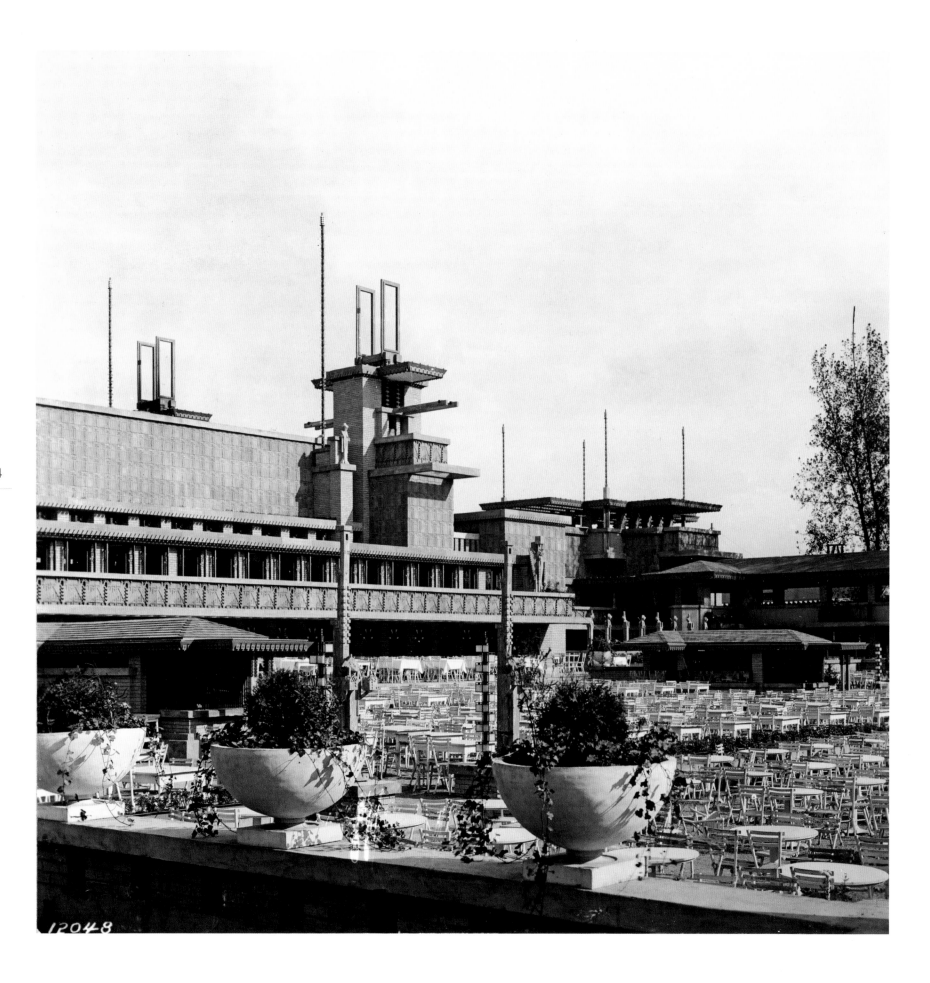

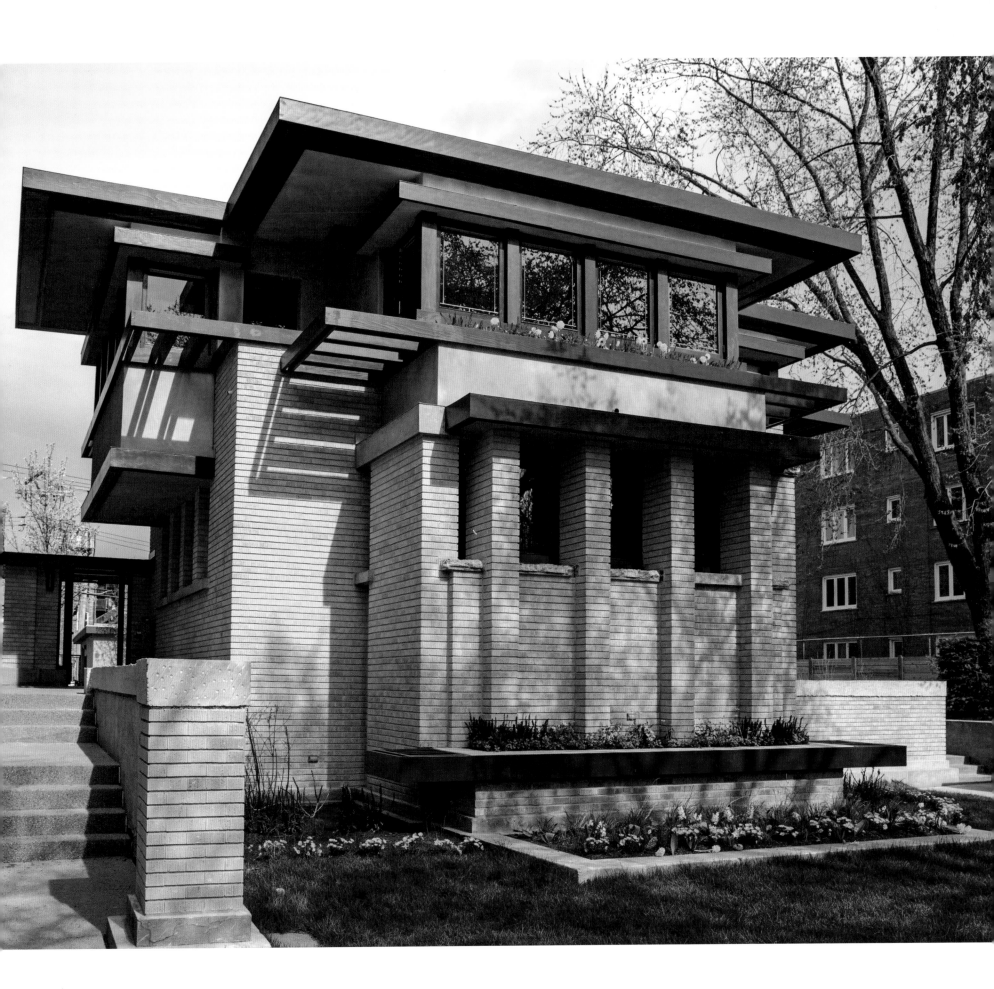

Overleaf, left:
Frank Lloyd Wright with Alfonso Iannelli, Midway Gardens, East 60th
Street and Cottage Grove Avenue, 1914 (demolished). Originally
designed as a beer garden and open during Prohibition as a dance
hall, the concrete and brick structure's owners always had financial
problems and finally closed it in 1929. Demolished soon after, various
statues done with Alfonso Iannelli, called Sprites, have been valued
by collectors and museums in recent years. Photo: Henry Fuermann,
Historic Architecture and Landscape Image Collection, Ryerson and
Burnham Archives, The Art Institute of Chicago. Digital File # 17856.

Overleaf, right:
Frank Lloyd Wright, Emil Bach House, 7415 North Sheridan Road,
1915. The Bach House is one of a few Wright-designed homes
within the city of Chicago. It was restored by Tawani Enterprises as
a vacation house and special-event venue. Photo: courtesy Tawani
Enterprises.

Right:
Louis H. Sullivan, with William C. Presto, facade detail of the Krause
Music Store (now Studio V Design), 4611 North Lincoln Avenue,
1922; restored, 2007, McGuire Igleski & Assocs. and Wheeler Kearns
Architects. Photo: Steve Hall © Hedrich Blessing, ArcaidImages.com
70124-20-1.

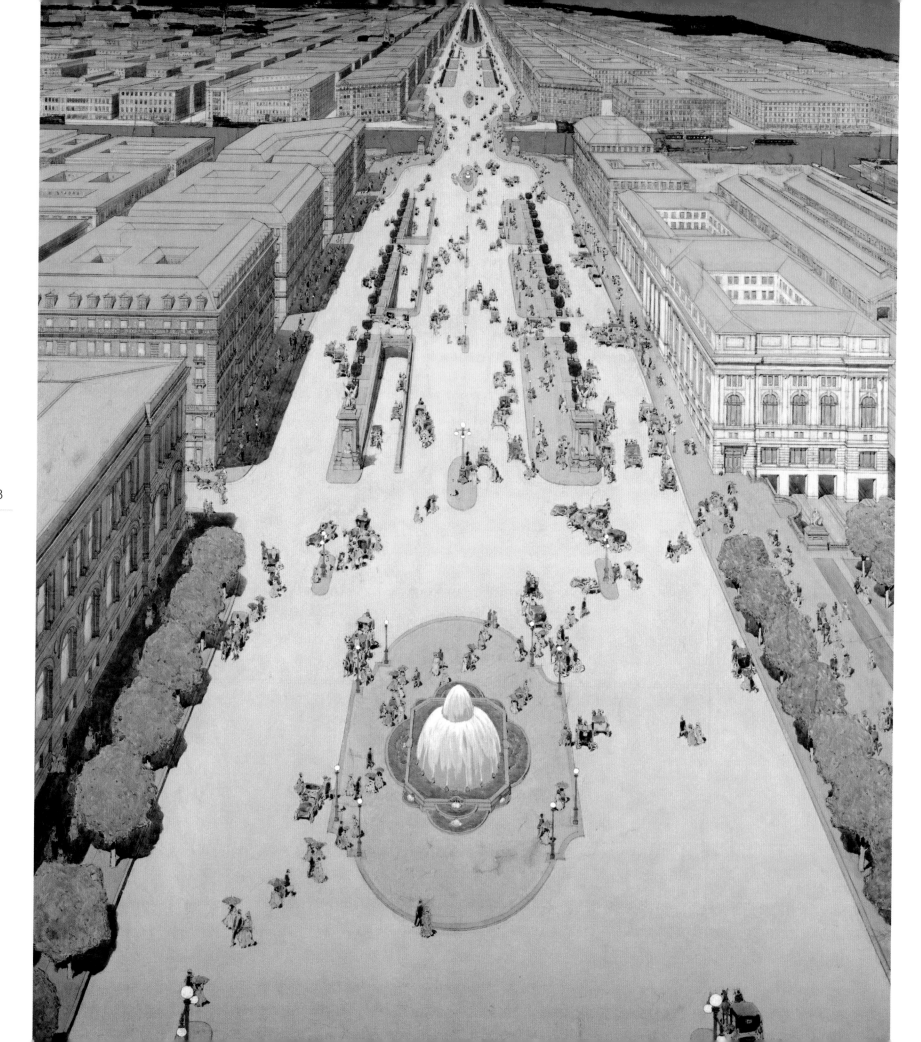

THE WORLD'S COLUMBIAN EXPOSITION AND THE CITY BEAUTIFUL MOVEMENT – THE TRIUMPH OF CLASSICISM

With the unexpected death of John Wellborn Root in 1891, Daniel H. Burnham lost his right-hand man in terms of architectural design. Root's preferences tended toward his own version of Romanesque as seen in the landmark Rookery (1887–88). But this tragic event likely led Burnham closer to his classicist peers who were assisting him in planning the World's Columbian Exposition of 1893. They were mostly New York and Boston architects such as Richard Morris Hunt (1827–1895), Charles F. McKim (1847–1909), Frederick Law Olmsted (1822–1903), Charles S. Peabody (1880–1935), George B. Post (1837–1913), and Henry Van Brunt (1832–1903). Chicagoans Louis H. Sullivan and William Le Baron Jenney were in the minority.

Those East Coast architects, already disposed to classicism, expressed that taste fully within structures for the world's fair. The visual impact of this coordinated ensemble of large classical buildings—all planned around an Olmsted-inspired waterscape—was undeniable. It inspired young architects such as Benjamin H. Marshall (1874–1944), who designed classical theaters, hotels, clubs, and apartment buildings throughout his career. Even city fathers from smaller cities, after visiting the fair, created their own versions of the classical exhibition shed; for example, Columbus, Ohio, built a large, glass greenhouse, now called the Palm House (1895), for its Franklin Park Conservatory.

For Burnham, this experience of coordinating the construction of the ChicagoWorld's Fair impacted on his own preference for classical buildings, cemented further by his friendship with McKim. It also led to Burnham's being one of the leading proponents of the City Beautiful movement in America. This is especially true as regards his expertise in city planning, first with the McMillan Commission in Washington, D.C. (1902), and later with comprehensive plans for cities such as Manila and San Francisco (both 1905) and then Chicago (1909). This impact continued well into the 1920s and 1930s as his protégé Edward H. Bennett continued Burnham's legacy in City Beautiful planning. Bennett and other local architects implemented parts of the *Plan of Chicago* in the 1910s and '20s, in Bennett's case notably the Michigan Avenue Bridge (1920) and Buckingham Fountain (1927). The latter, with sculptures by French artist Marcel Loyau (1895–1936), was based, in part, on Versailles's Latona Fountain (1667–89). And Burnham's architectural successors the firm Graham, Anderson, Probst & White continued his legacy of classical public and commercial buildings in Chicago, North America, and even abroad over the first decades of the twentieth century. Their great Chicago examples range from the Field Museum (1919) and adjacent Shedd Aquarium (1929) to Union Station (1925).

Chicago and the United States became immediately enraptured with classicism after the World's Columbian Exposition. These include massive temples of culture such as the Art Institute of Chicago (1893), originally built as one of the auxiliary conference and meeting buildings in conjunction with the World's Columbian Exposition, to the smaller elevated railroad stations of the 1890s with their classical pilasters surrounding the ticket offices visible from the street intersections below.

The late 1890s and early 1900s witnessed the great era of classical civic buildings here and elsewhere, from museums and libraries to hospitals and even stadia—great civic structures that populated the metropolis. The prevalence of classical buildings and ensembles over the next decades prompted Louis H. Sullivan to rant, in *The Autobiography of an Idea* (1924), that the World's Columbian Exposition set

Daniel H. Burnham, Plan of Chicago, 1909. Jules Guérin's rendering of Proposed Boulevard (now Michigan Avenue) to connect the north and south sides of the Chicago River, original drawing for plate 112 in Daniel H. Burnham and Edward H. Bennett, *The Plan of Chicago*, 1909. Photo: Chicago History Museum, ICHi-59758.

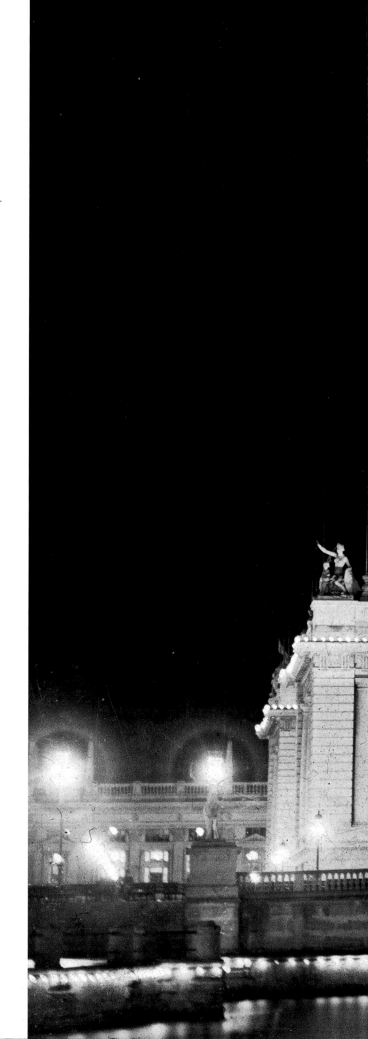

back the progress of a true American architecture by several decades, something more easily said in hindsight two decades after the fair:

"[T]he virus of the World's Fair, after a period of incubation . . . began to show unmistakable signs of the nature of the contagion. There came a violent outbreak of the Classic and the Renaissance in the East, which slowly spread Westward, contaminating all that it touched. . . . Thus Architecture died in the land of the free and the home of the brave. . . . The damage wrought by the World's Fair will last for half a century from its date, if not longer. It has penetrated deep into the constitution of the American mind, effecting there lesions significant of dementia."

As Sullivan's own popularity waned, and with the Spanish flu pandemic of 1918 likely on his mind when he wrote *The Autobiography of an Idea*, Sullivan witnessed the widespread adoption of classical styles in all building types, even in examples of the Chicago School commercial blocks themselves. These include the blocky Renaissance palazzo of the Marquette Building (1895) by Holabird & Roche through Burnham's own high-rise structures such as the Railway Exchange (1904) and Marshall Field & Company's main store, which is now Macy's on State Street. Both Burnham buildings retain Chicago windows and a fairly stark appearance highlighted by classical details on the terracotta of the former and a grand columned entrance for the latter on State Street. Marshall Field's also has iconic highly decorative clocks at the corners on State Street, which have served as meeting places for Chicagoans decades past. Even more, both have spacious courts within, likely derived from Parisian department stores of the nineteenth century and also seen within the earlier Rookery building (1887–88) by Burnham and Root. One of those Marshall Field's courts has spectacular Tiffany mosaic vaults comparable, in glistening impact, to the Tiffany dome and adjacent mosaic-decorated spaces within Preston Bradley Hall at the Chicago Cultural Center, the former Chicago Public Library (1897).

Classical style in the decades that followed the World's Columbian Exposition also represents the United States' place in the world through the 1900s, with spheres of influence in the Caribbean and Pacific. Everywhere, classicism became an imperial style for an imperial age as European nations also vied for influence in Asia and Africa before World War I. Moreover, American classical styles such as Colonial Revival—as well as Queen Anne, Dutch Colonial, Georgian, and Adam or Federal Style—rivaled and even superseded the Chicago School and Prairie Style as *American* styles. The training that many American architects had in Paris at the École nationale supérieure des Beaux-Arts (or simply École des Beaux-Arts), or in American architecture schools with similar curricula, likely validated French and Italian Renaissance classicism for American buildings of the era. Burnham's planning protégé Bennett studied there, as did one of his sons, Hubert Burnham (1882–1968), along with other Chicago architects such as John A. Holabird (1886–1945), Andrew N. Rebori

Daniel H. Burnham with various architects, World's Columbian Exposition, Jackson Park, 1893 (demolished). Richard Morris Hunt, Administration Building at night. Photo: Chicago History Museum, ICHi-17519.

(1886–1966), John Wellborn Root Jr. (1887–1963), and surprisingly even Louis Sullivan, at least for a very short informal period in 1874–75. What the École des Beaux-Arts taught architectural students was a rational discipline in space planning and presentation. One might posit that Sullivan's ideas about skyscrapers being analogous to columns in design, or that a rational geometry underpins the wildest of his naturalistic ornament, may well come from his learning that discipline during his informal stint at the École des Beaux-Arts.

Classical Chicago from the World's Columbian Exposition of 1893 through the first decades of the twentieth century is in some ways a fulfillment of Burnham's dream to make the city a "Paris by the lake." The city was dramatically transformed by compatibly styled buildings by his firm as well as others, such as Henry Ives Cobb, Frost and Granger, Alfred Hedley, Holabird & Roche, Marshall and Fox, Shepley, Rutan and Coolidge, and so many more.

Left and overleaf:
Shepley, Rutan and Coolidge, Chicago Public Library (now Chicago Cultural Center), 78 East Washington Street, 1897; restored, 1977–78, Holabird & Root. Photos: Exterior, John Zukowsky; interiors courtesy Holabird & Root.

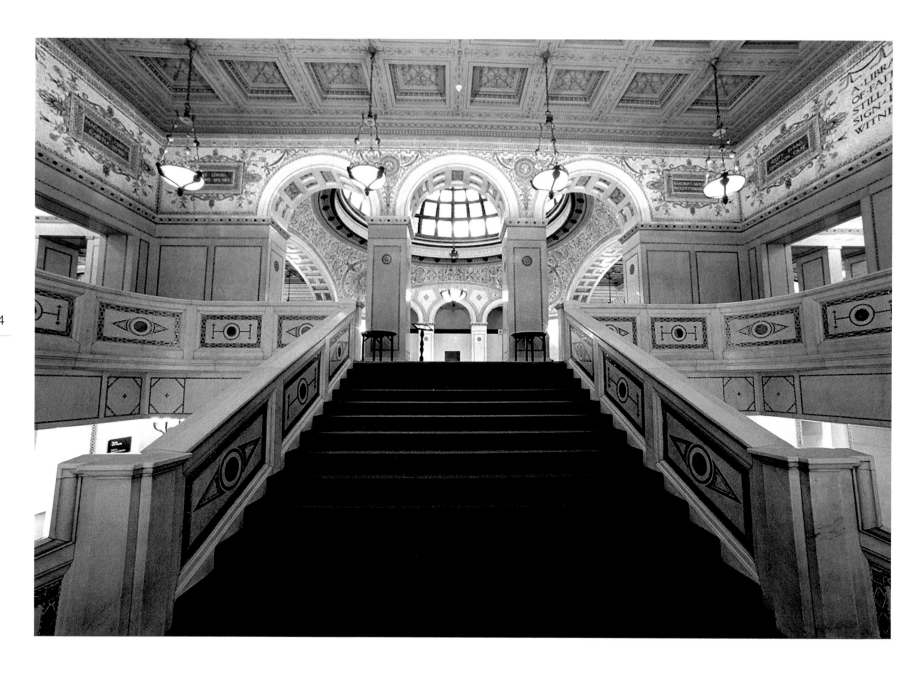

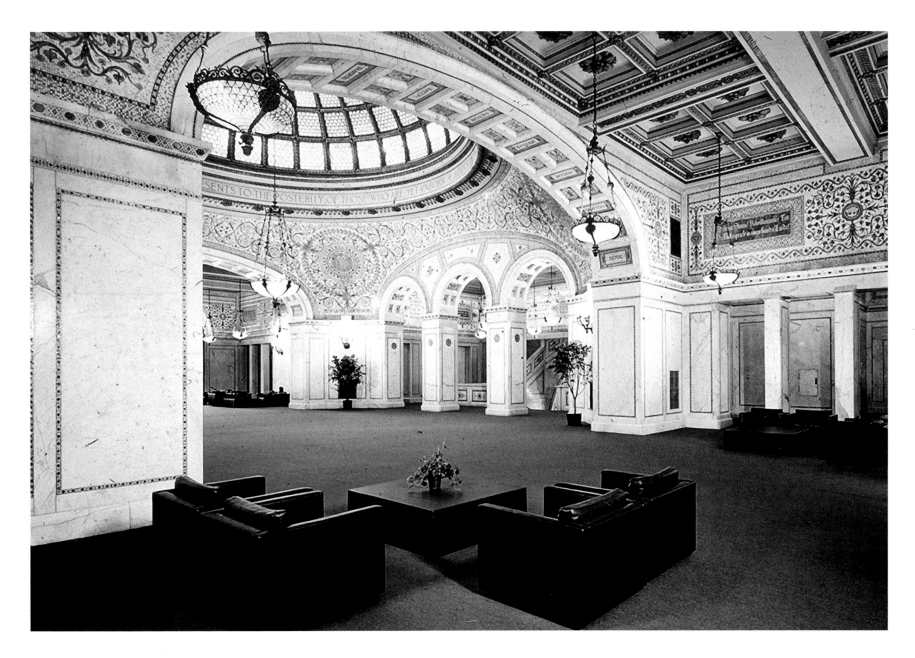

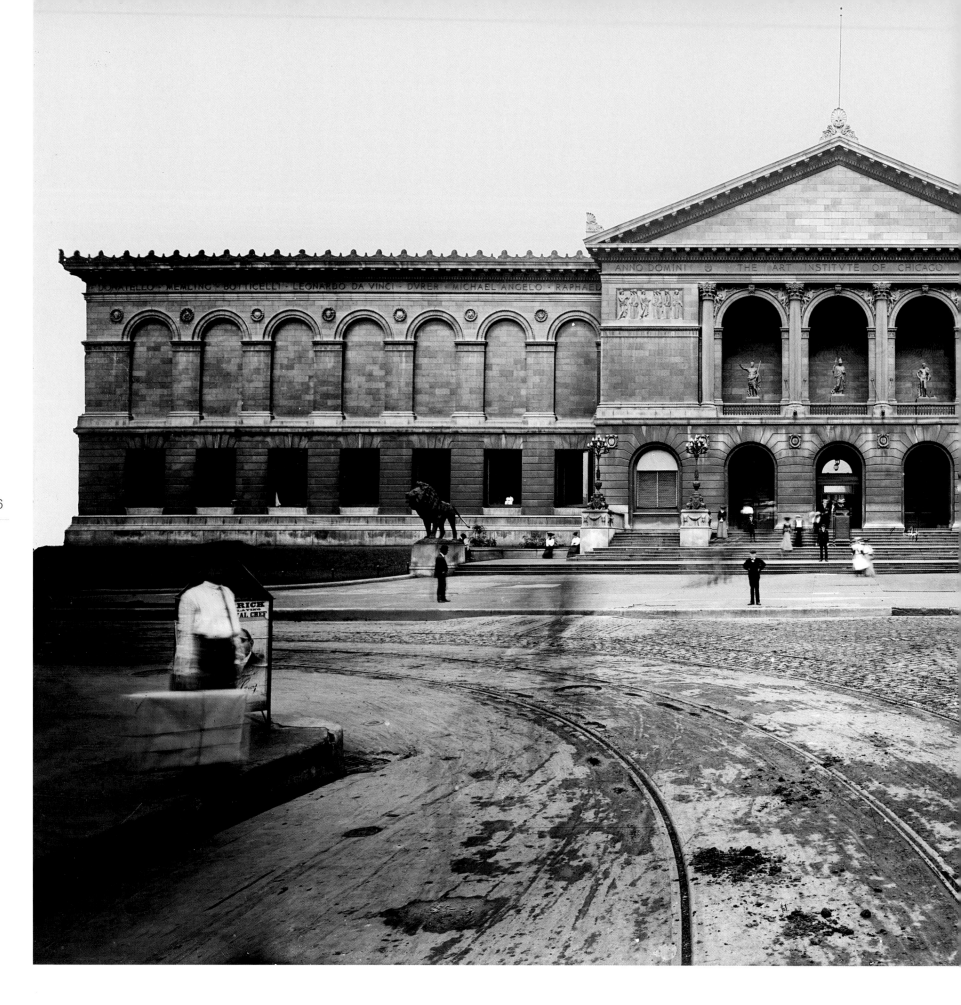

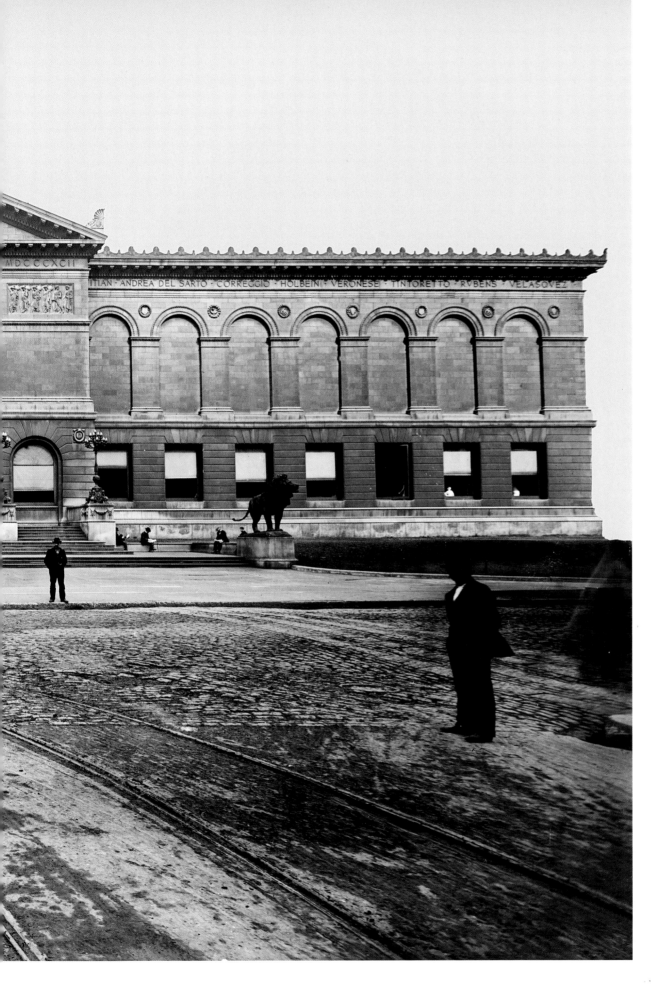

Shepley, Rutan and Coolidge, The Art Institute of Chicago, 111 South Michigan Avenue, 1893, various additions. The Allerton Building, shown here in an image from about 1893, was restored by John Vinci and SOM in 1985. The building was constructed as a meeting hall for the various World's Congresses of the World's Columbian Exposition and was turned over to the trustees of the Art Institute after the fair. Photo: Barnes-Crosby Company, Chicago History Museum, ICHi-19219.

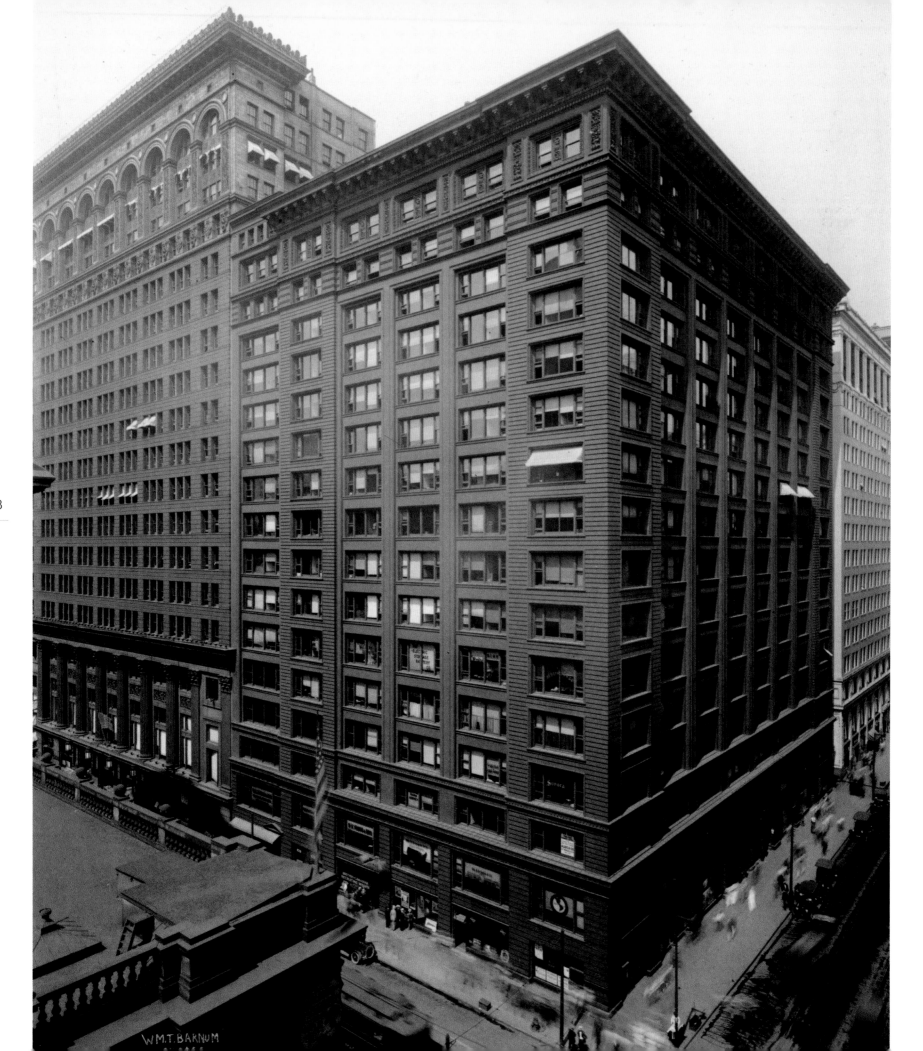

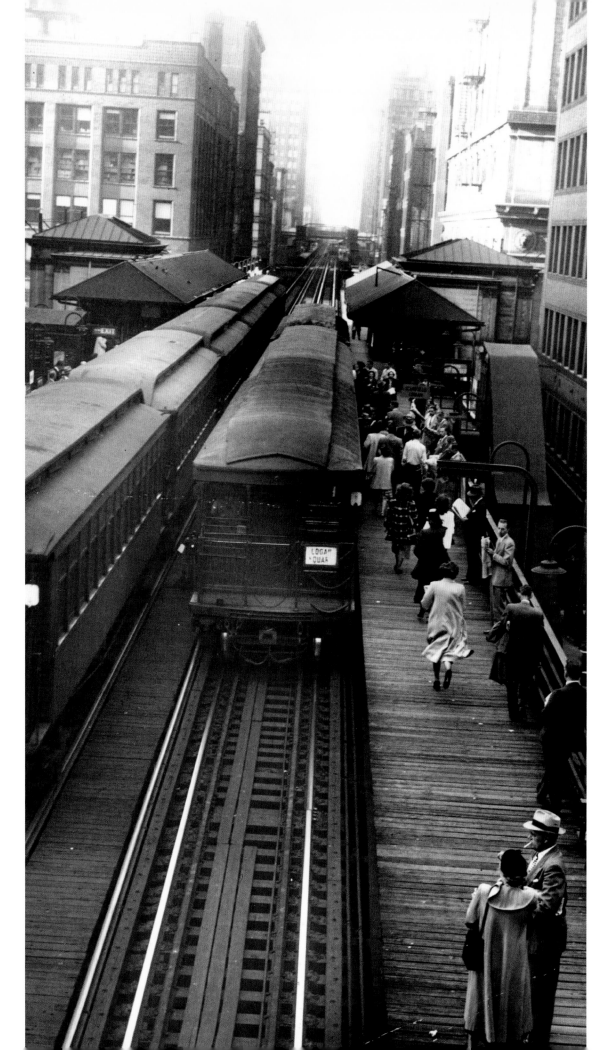

109

Left:
Holabird & Roche, Marquette Building, 140 South Dearborn Street, 1894; restored, 1981, Holabird & Root; further restoration, 2003, McClier Corporation. Photo: William T. Barnum, Chicago History Museum, ICHi-39479.

Right:
Alfred M. Hedley, Quincy Station of Chicago Transit Authority Elevated Railroad, West Quincy and South Wells Streets, 1897; restored, 1988. The station is seen here in a 1949 image. Photo: Phillips, Chicago History Museum, ICHi-39591.

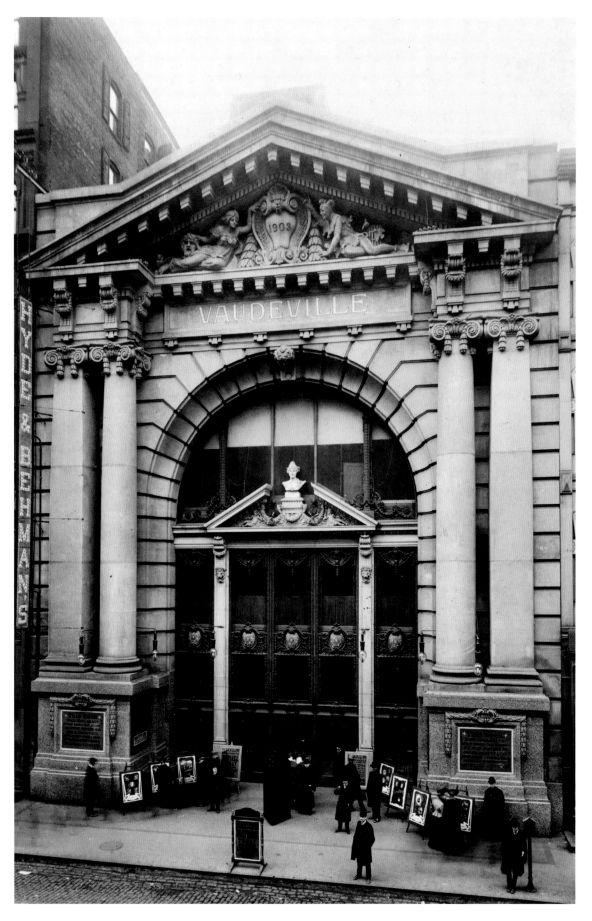

Left:
Benjamin H. Marshall, Iroquois Theatre, 24–28 West Randolph Street, 1903 (damaged); rebuilt soon after in 1904 as Hyde and Behmann's Music Hall and then the Colonial Theatre (demolished). The Iroquois witnessed a calamitous fire soon after it opened, on December 30, 1903, when more than 600 people perished. The fire catalyzed the creation of new safety measures, including panic hardware on outward-opening doors and highly visible exit signs. Photo: Kaufmann and Fabry Co., Chicago History Museum, ICHi-52238.

Right:
D. H. Burnham & Co., Orchestra Hall (Symphony Center), 220 South Michigan Avenue, 1904, top floor added c. 1908 by Burnham's firm, with interiors designed by Howard Van Doren Shaw for the Cliff Dwellers club; later renovations through the 1990s by architects including Harry Weese and SOM. The image here shows it under final construction c. 1904. Photo: *Chicago Daily News* negatives collection, Chicago History Museum, DN-0001100.

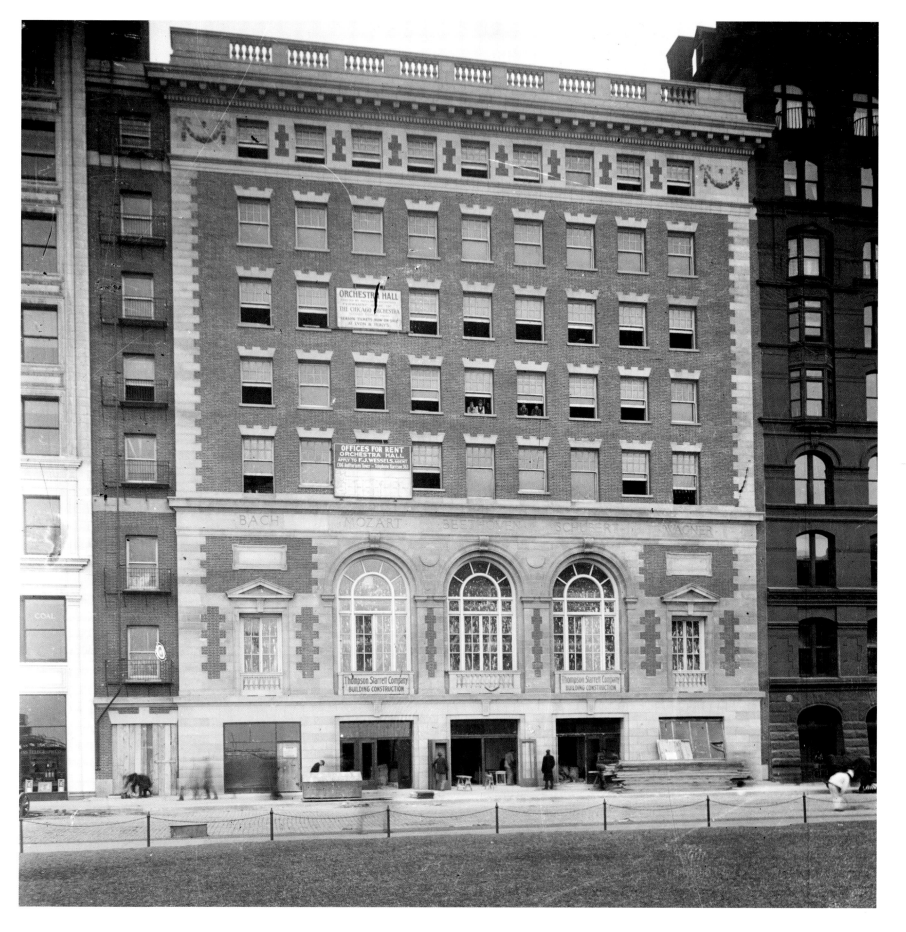

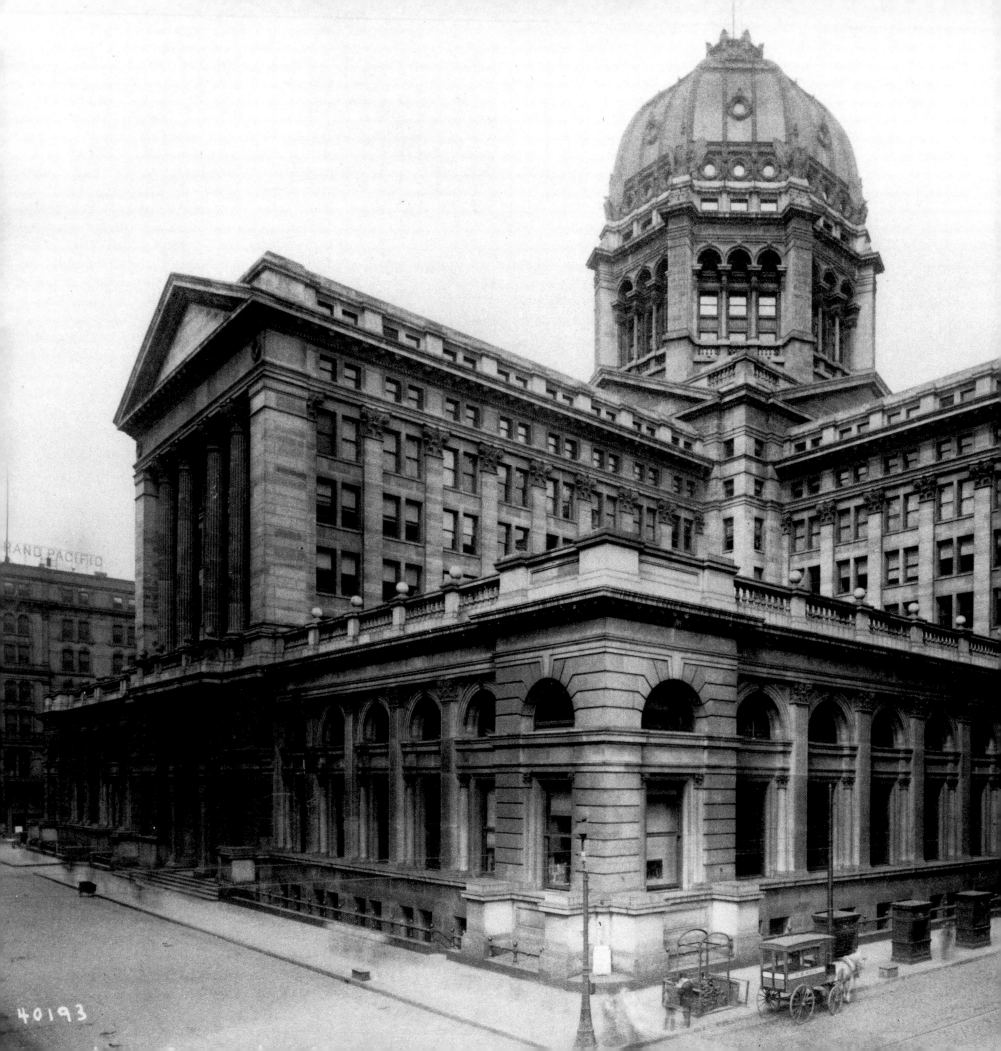

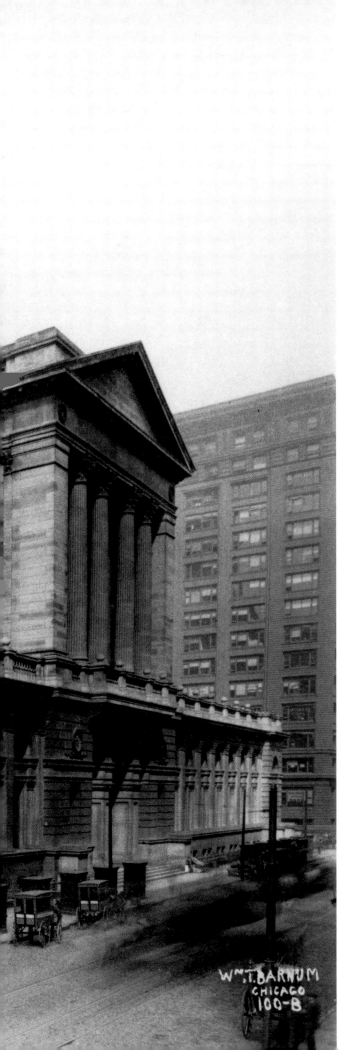

Henry Ives Cobb, Chicago Federal Building, Jackson Boulevard, Clark, Dearborn and Adams streets, 1905 (demolished) in a c. 1906 view. Photo: William T. Barnum, Chicago History Museum, ICHi-18264.

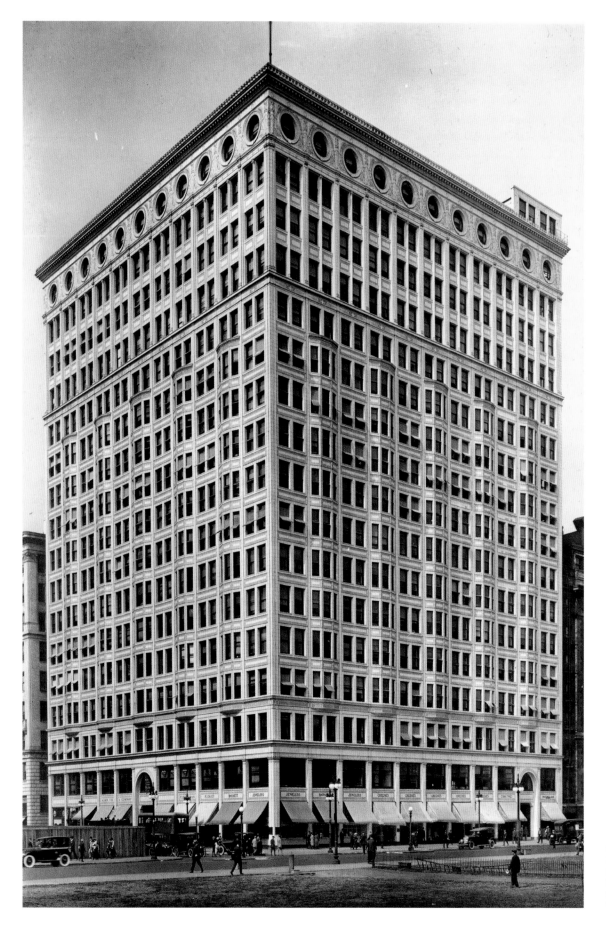

D. H. Burnham and Co., Railway Exchange Building (now Santa Fe Center), 80 East Jackson Boulevard at Michigan Avenue, 1904; restored and renovated, 1985, Metz Train & Youngren and Frye Gillan Molinaro. Photos: Exterior in 1922 by Kaufmann & Fabry Co., Chicago History Museum, ICHi-39459; original interior Barnes-Crosby Co., Chicago History Museum, ICHi-19245.

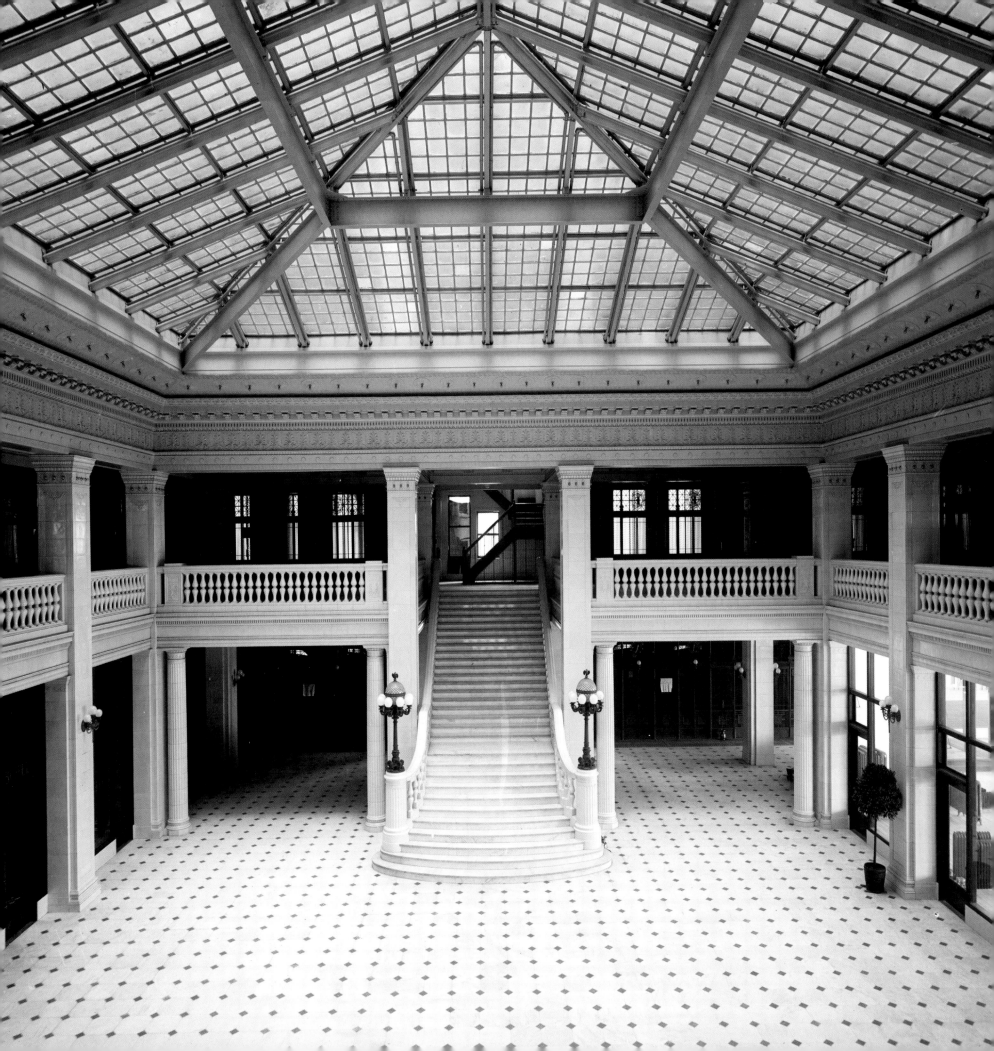

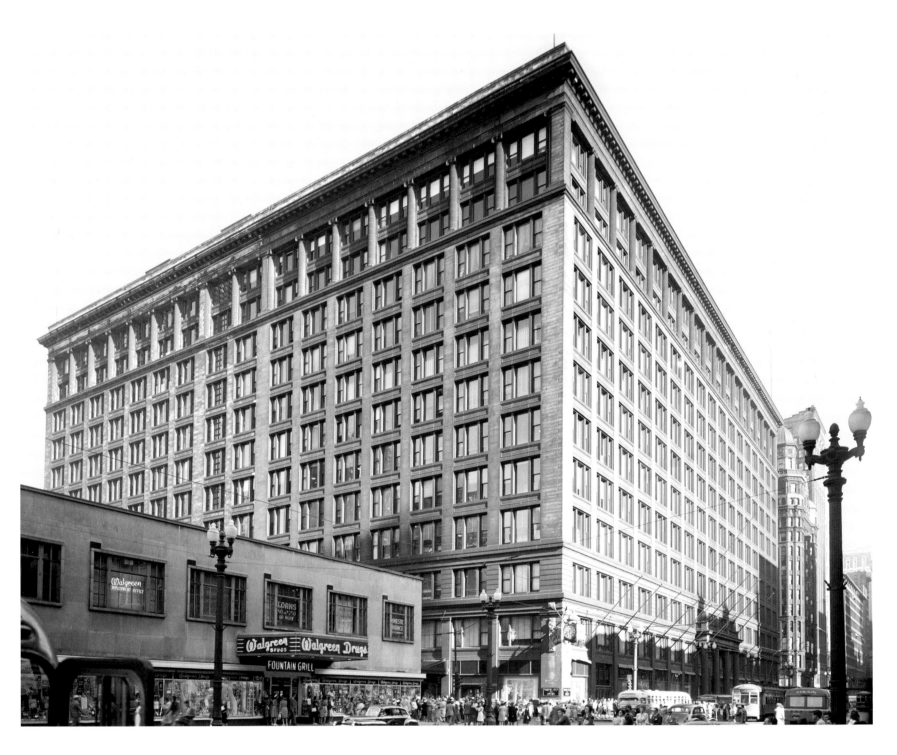

This spread and overleaf:
D. H. Burnham and Co., Marshall Field & Company (now Macy's on State Street), 111 North State Street, 1902–10. The exterior's mass is relieved only by decorative columns and corner clocks, though the interiors burst into highly decorated spaces including one with a spectacular Tiffany mosaic vault. The exterior view from the 1940s (above) shows, in the left foreground, the two-story retail building that replaced the Burnham and Root Masonic Temple (1892), itself now demolished and replaced by a high rise. Photos: Exterior view in the 1940s, Hedrich Blessing, © Chicago Historical Society HB-10378-A, ArcaidImages.com 70894-30-1; main entry (right), Christmas 1907, *Chicago Daily News* negatives collection, Chicago History Museum, DN-0052023; clock (overleaf, left), September 20, 1947, *Chicago Daily News*, Chicago History Museum, ICHi-25669; (overleaf, right) color Tiffany Dome, Caroline Nye Stevens.

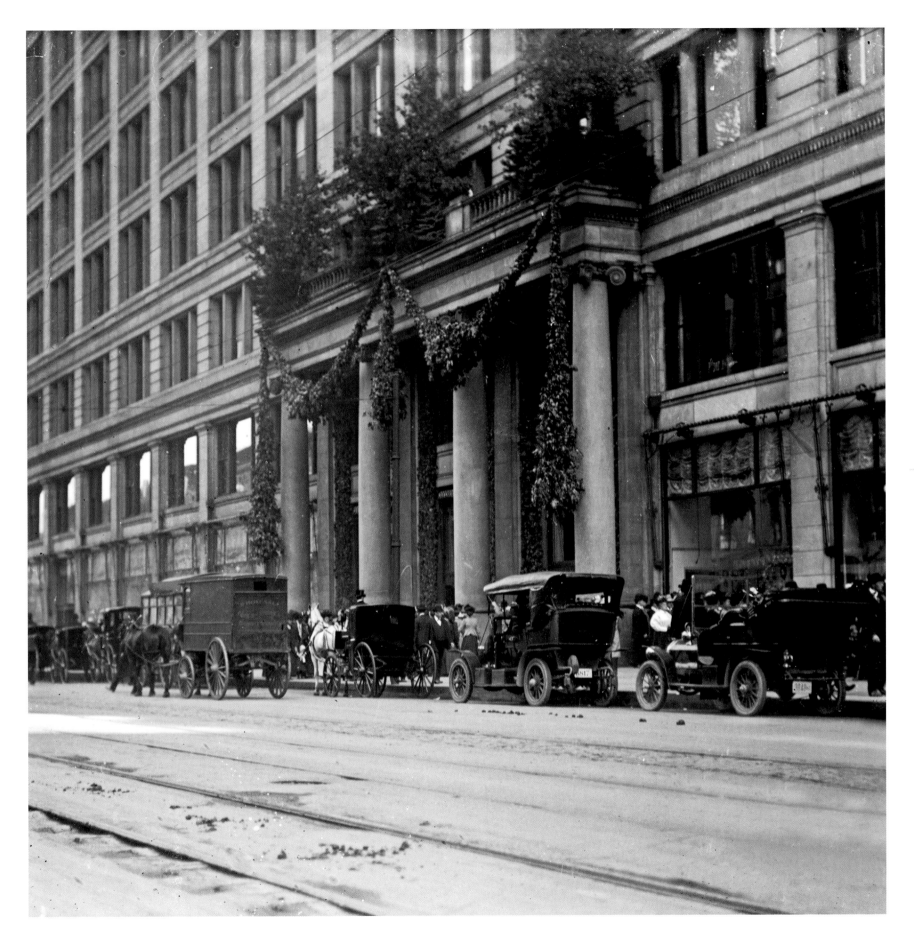

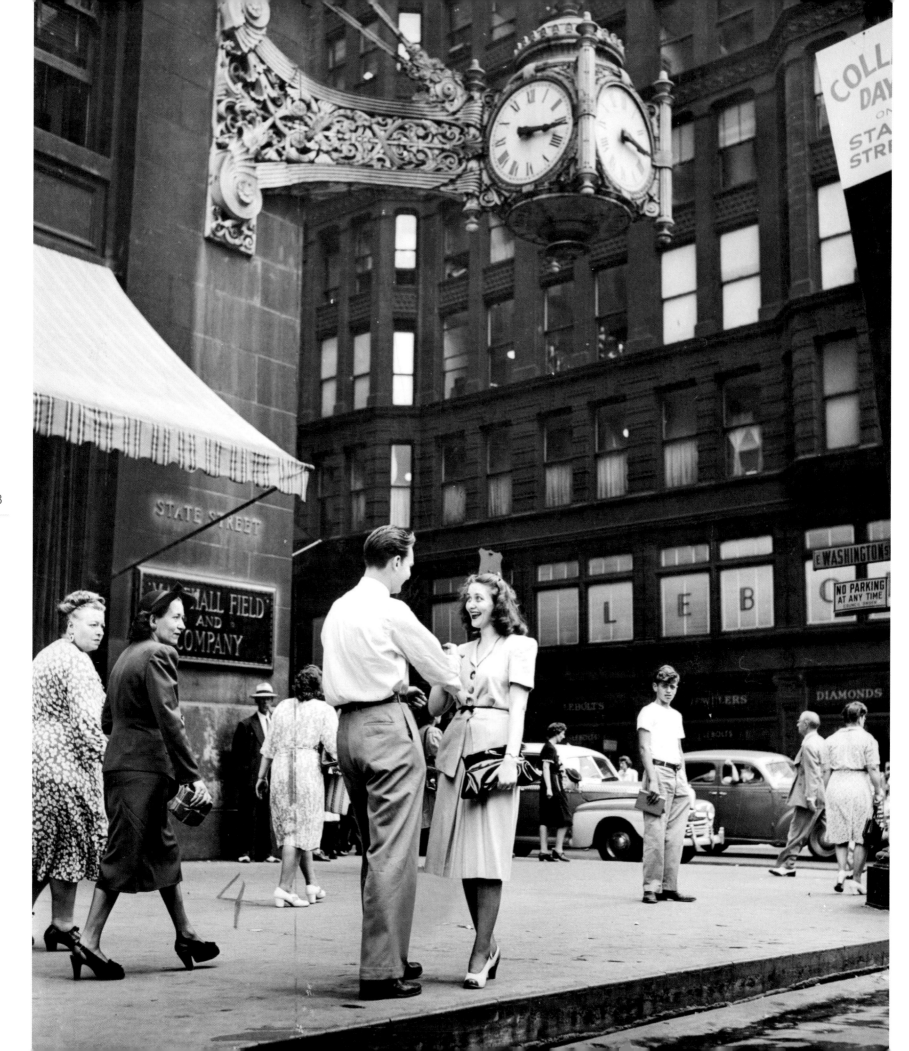

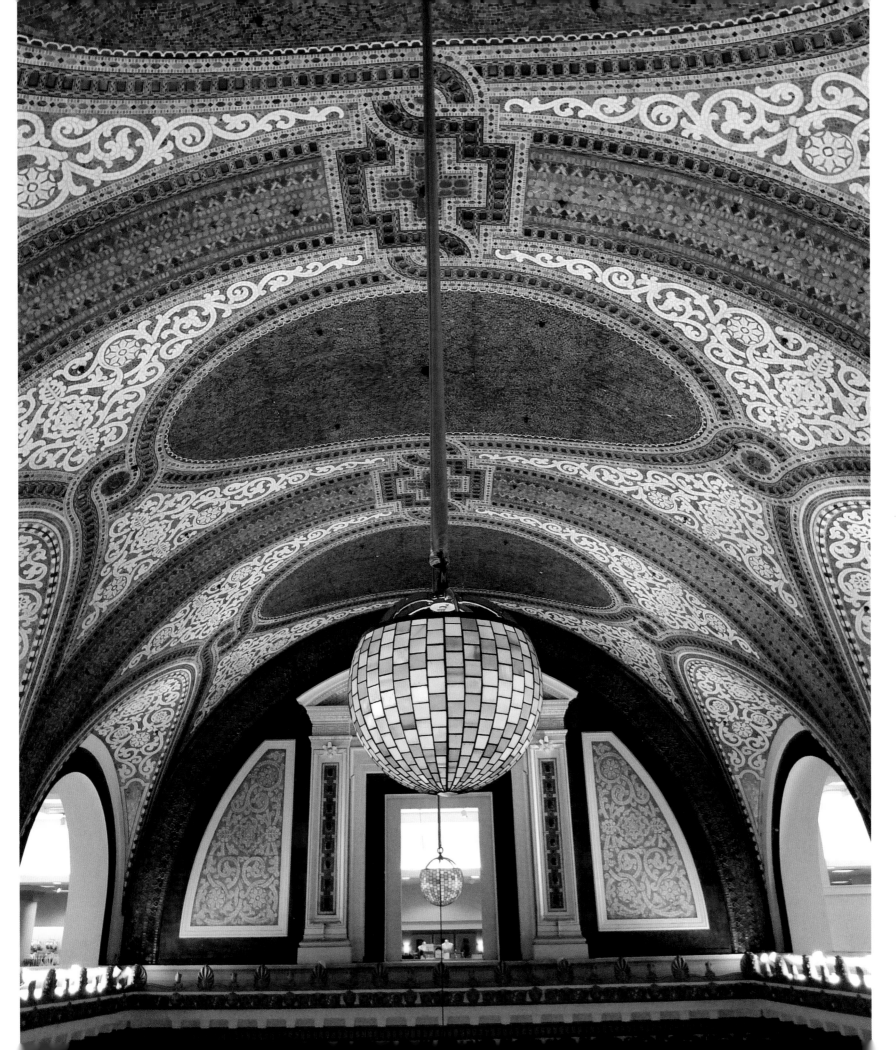

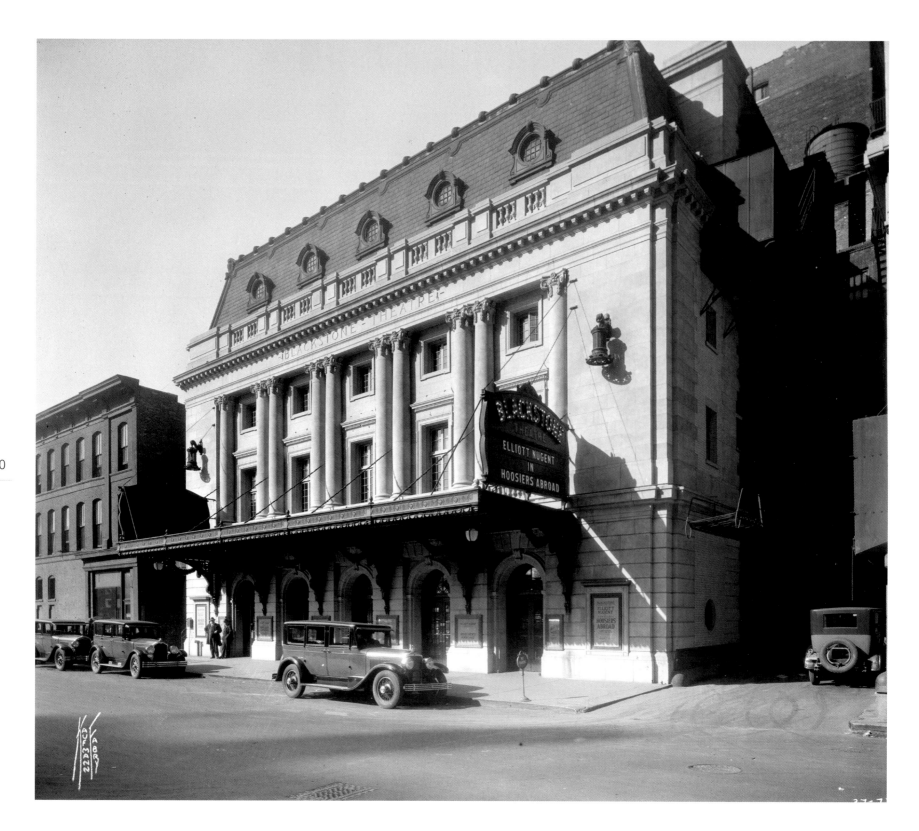

Marshall and Fox, Blackstone Hotel and Theatre, 636 South Michigan Avenue (hotel) and 60 East Balbo Street (theater), 1910. Hotel renovated 2008 by Lucien Lagrange Architects and Wiss, Janney, Elstner Associates. The theater today is the Merle Reskin Theatre of De Paul University. Photos: Kaufmann & Fabry Co., theater in 1927 and hotel in 1925, Chicago History Museum, ICHi-51579 and ICHi-25934.

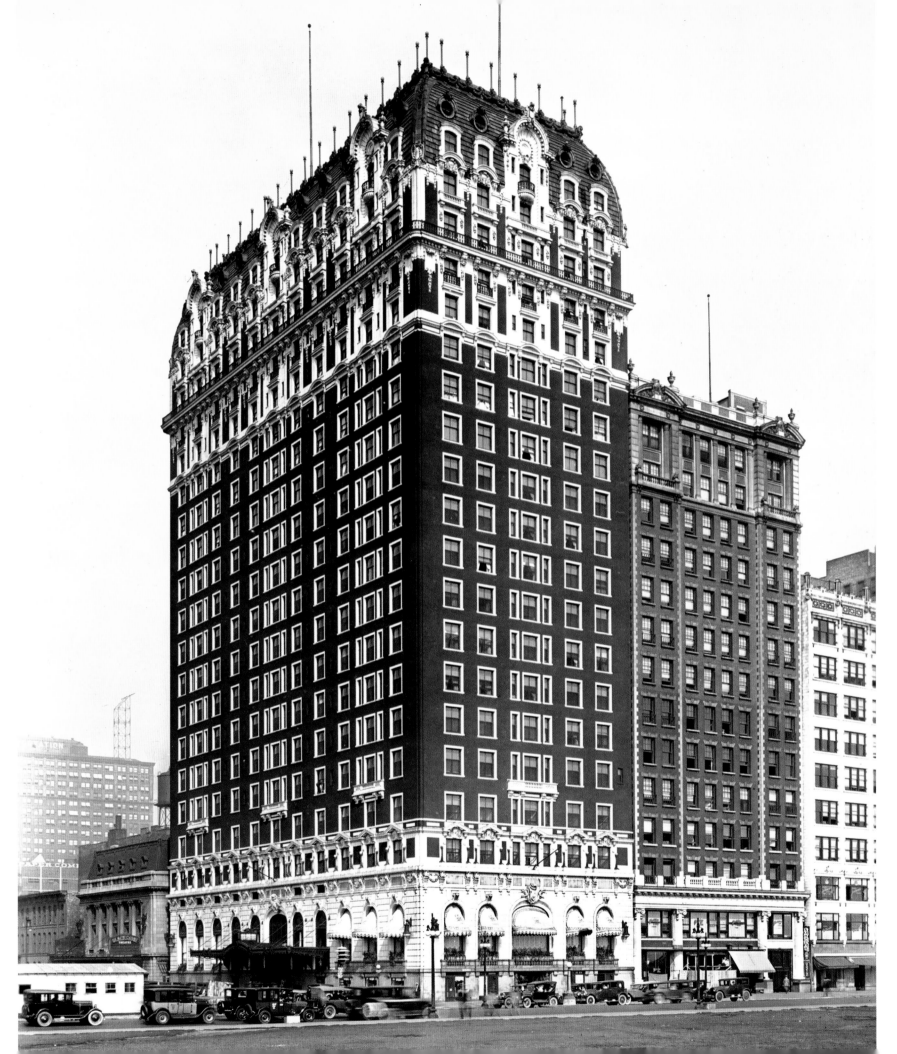

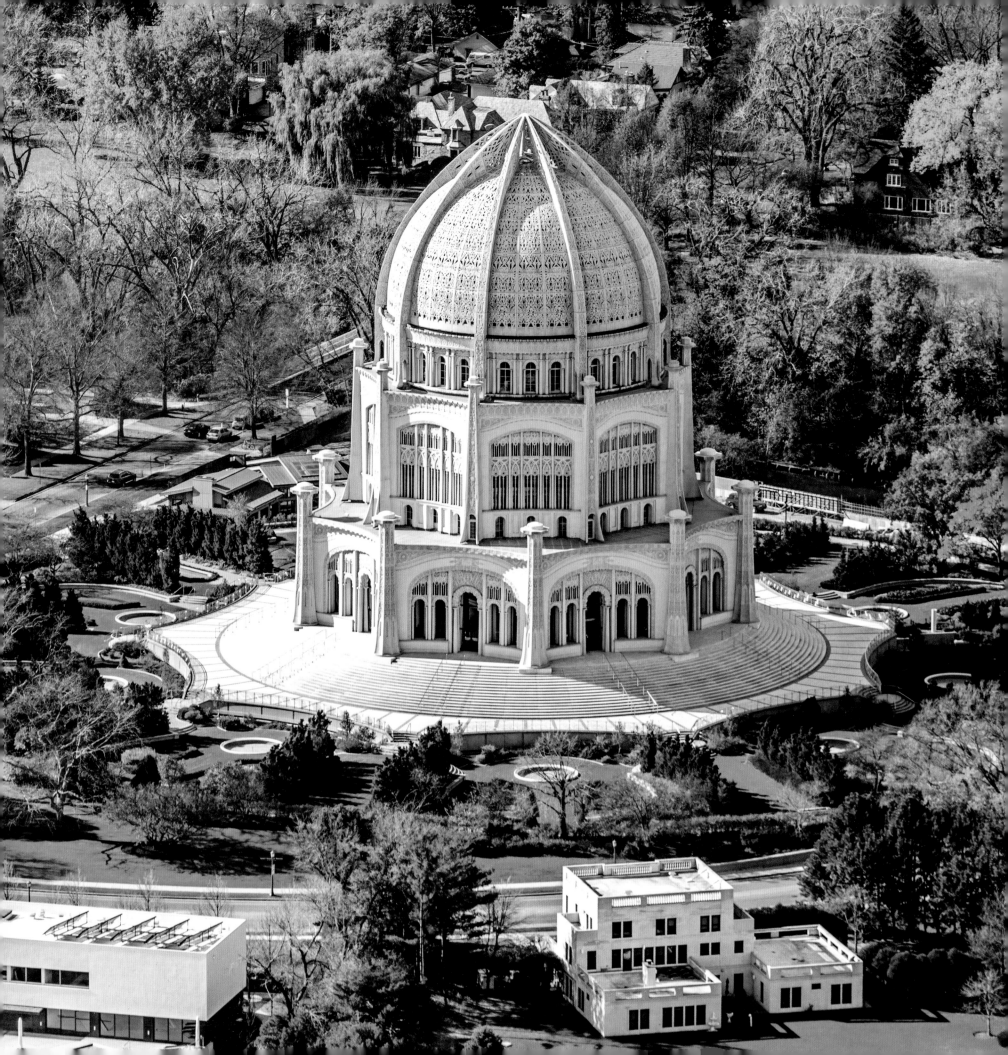

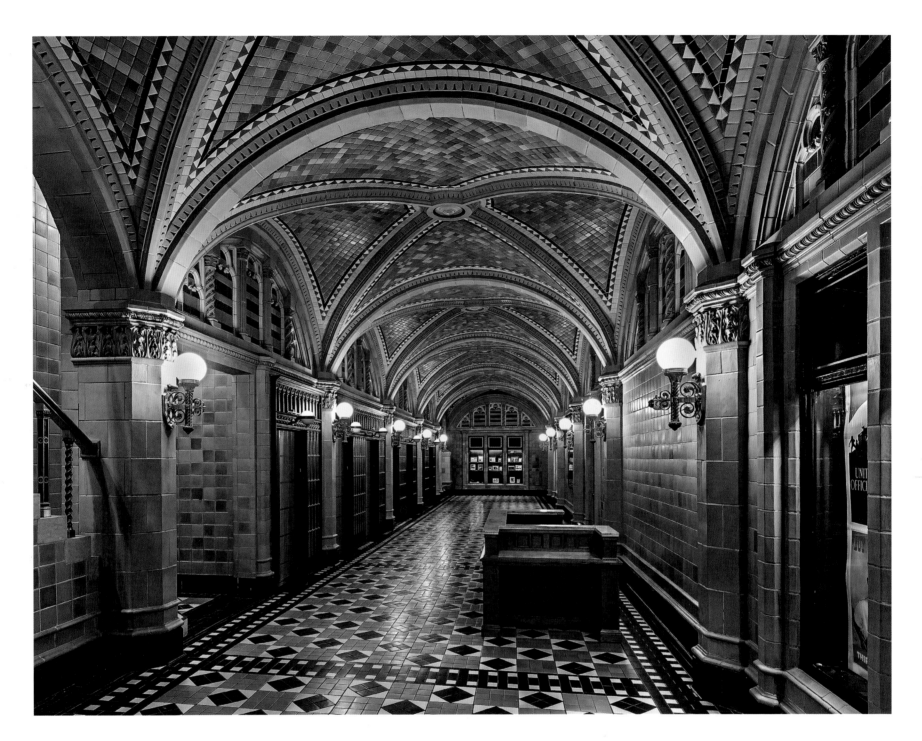

Left:
Jean-Baptiste Louis Bourgeois, Bahá'í Temple, 100 Linden Avenue, Wilmette, begun 1912, built c. 1921–53. Photo: November 7, 2014 © Tigerhill Studio Corp., John T. Hill, 5775-00083.

Above and overleaf:
Holabird & Roche, The University Club of Chicago (overleaf, left) and its dining room (overleaf, right), 1909, and Monroe Building (above), 1912, corner of Michigan Avenue and Monroe Street. The Monroe Building lobby shown here was restored in 2012 by Holabird & Root. The University Club's Cathedral Hall dining room was modeled after London's Crosby Hall from the fifteenth century. Photos: Monroe Building Lobby © Mark Ballogg; University Club exterior overall, Bill Hedrich, and Cathedral Hall Dining Room, Jon Miller, both © Hedrich Blessing.

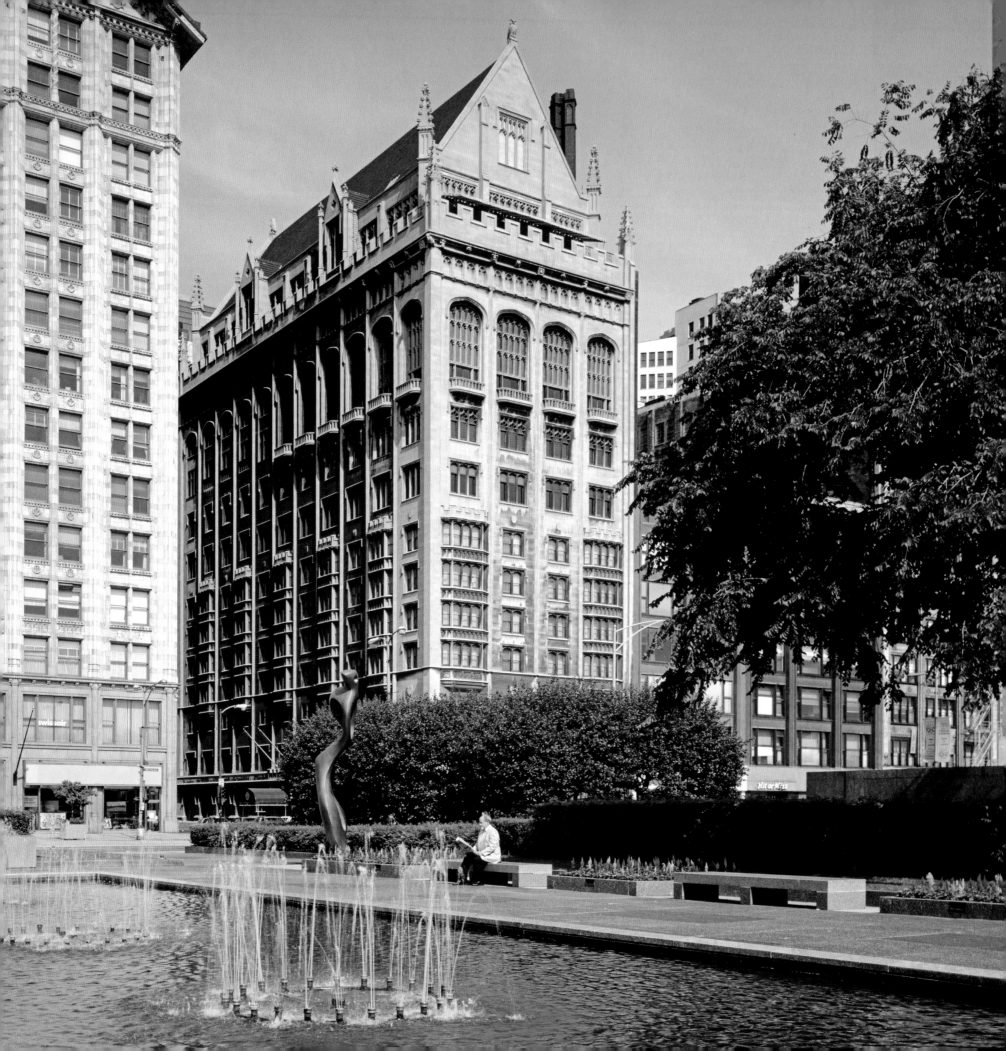

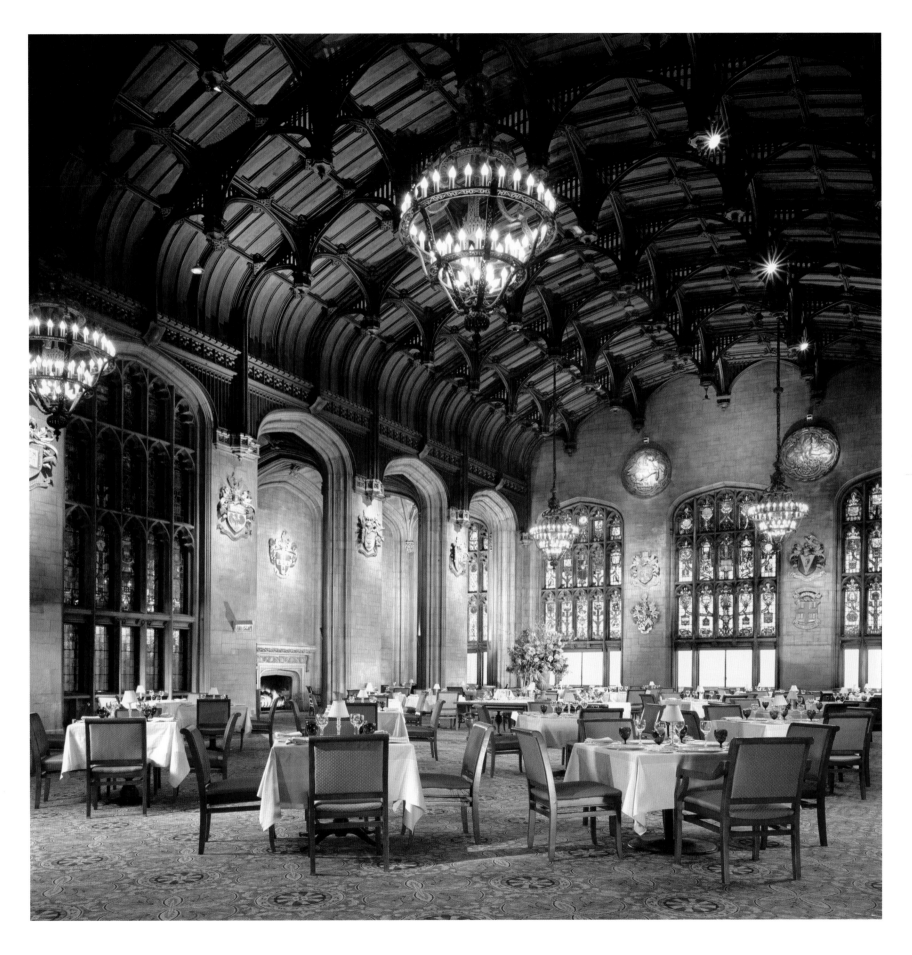

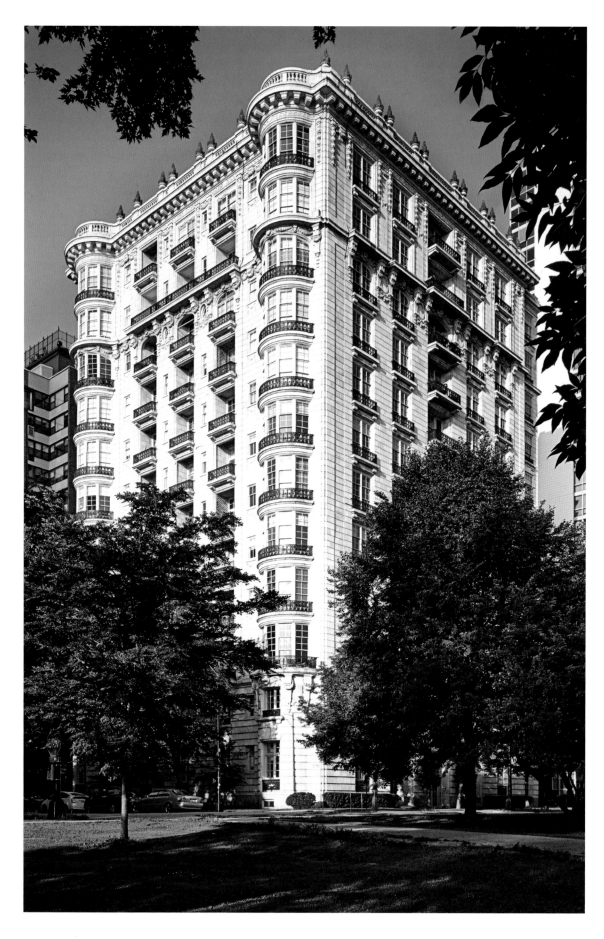

Marshall and Fox, 1550 North State Parkway, 1913. This probably remains the epitome of Marshall's apartment towers in the French Renaissance style. Originally a rental building that Marshall both designed and owned, he is said to have sold it in order to invest the proceeds in expanding his Edgewater Beach resort complex. Photos: Tom Harris, © Hedrich Blessing.

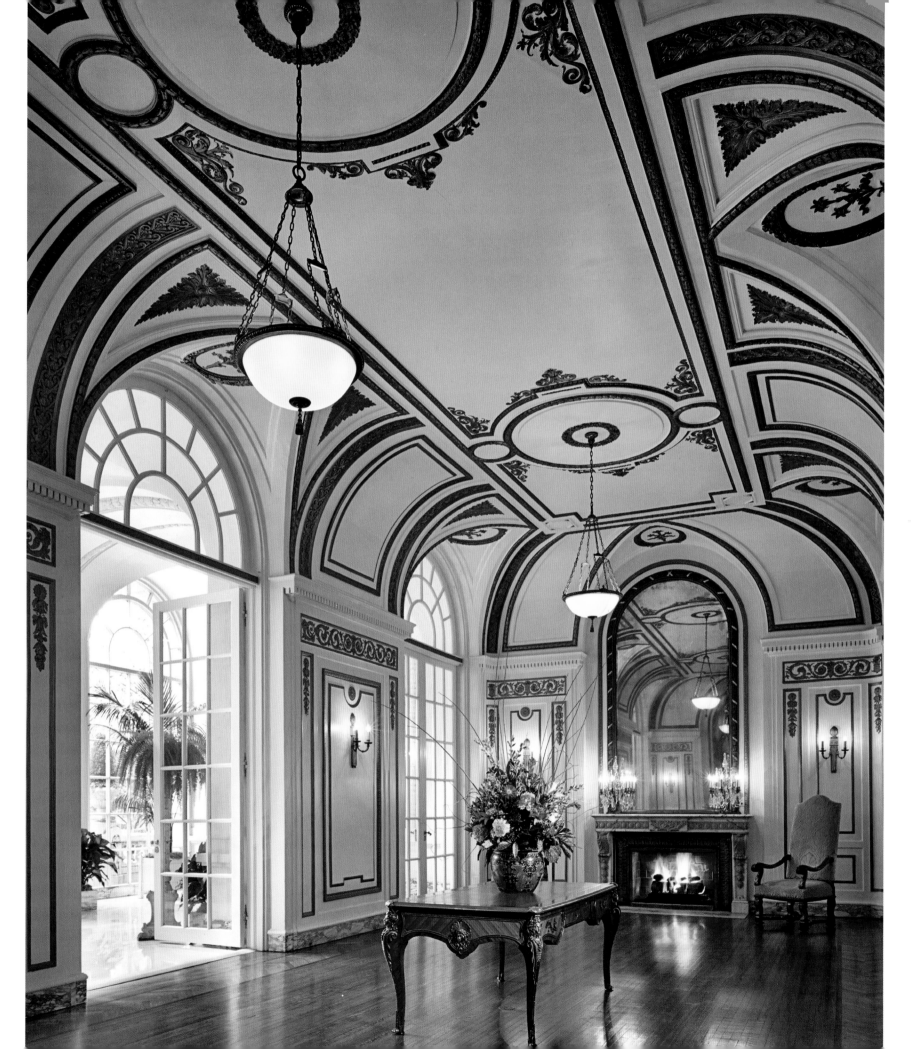

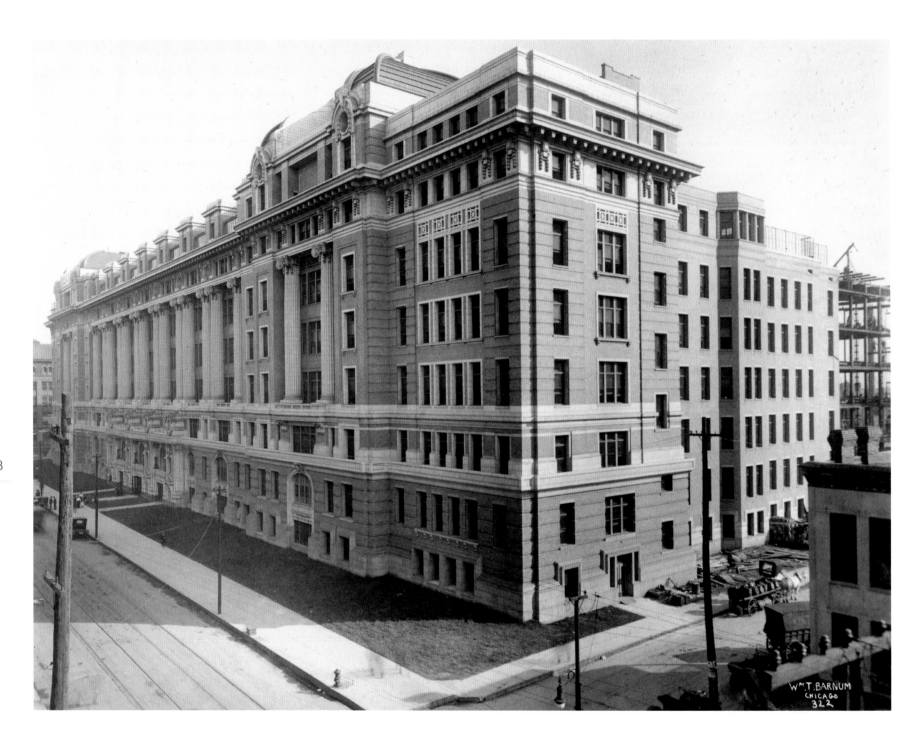

Above:
Paul Gerhardt in association with Schmidt, Garden and Erickson, Cook County Hospital, 1835 West Harrison Street, 1914, with later additions. The old hospital shown here was replaced by the John H. Stroger, Jr. Hospital of Cook County in 2002, and the vintage landmark building is awaiting adaptive reuse. Photo: William T. Barnum, Chicago History Museum, ICHi-31784.

Right:
Marshall and Fox, South Shore Country Club (now South Shore Cultural Center), 7059 South Shore Drive, 1916. This club replaced a smaller one that Marshall and Fox had designed in 1906. Its Mediterranean-style stucco exterior disguises elaborate Adam Style interiors replete with decorative plaster ornament. The once-exclusive club, with links designed by noted golf-course architect Tom Bendelow (1868–1936), has been owned by the Chicago Park District since 1974. Photo: Tom Harris, © Hedrich Blessing.

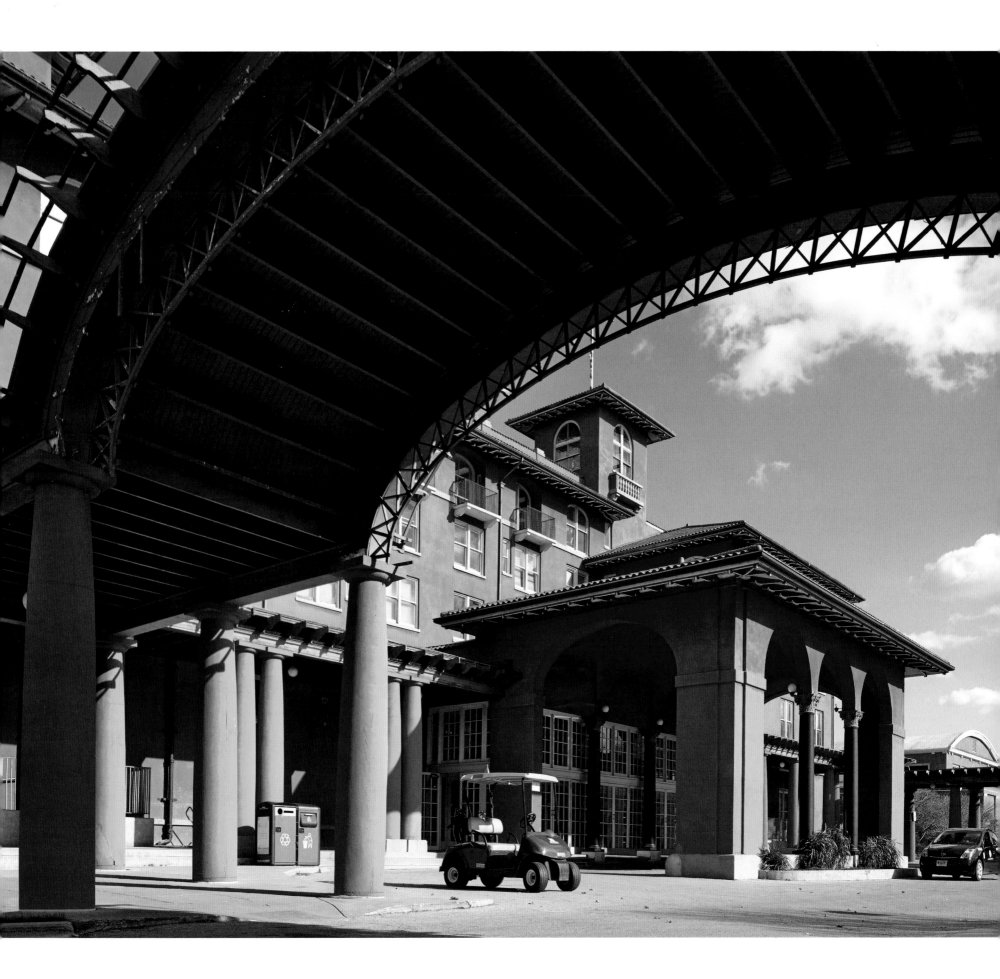

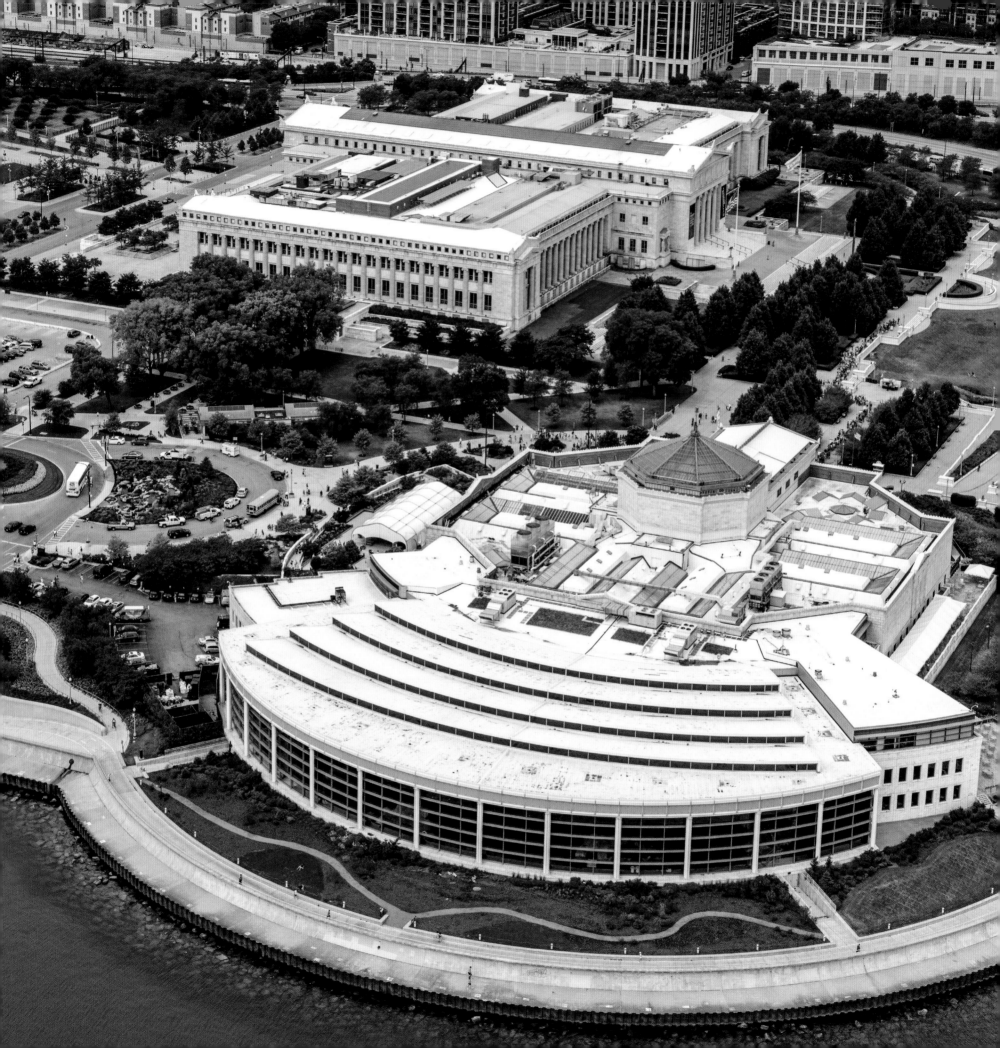

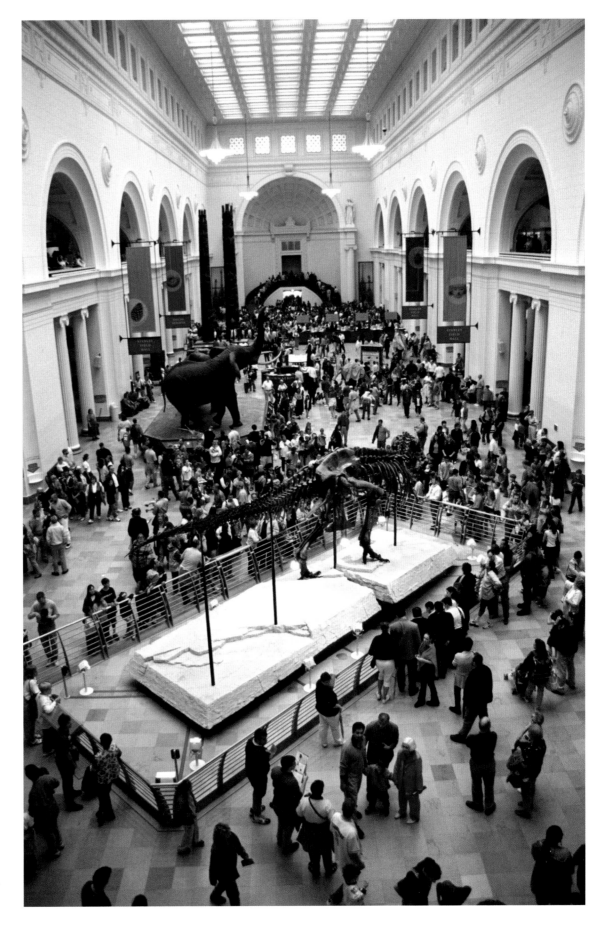

Graham, Anderson, Probst & White, Field Museum, 1400 South
Lake Shore Drive, 1913–21, and their nearby Shedd Aquarium
(foreground), 1929, with 1991 Oceanarium addition by Lohan
Associates. Interior lobby of the Field Museum. Photos: June 21, 2012
© Tigerhill Studio Corp., John T. Hill, 5537-00064; Field Museum
Lobby © Field Museum, GN89752.

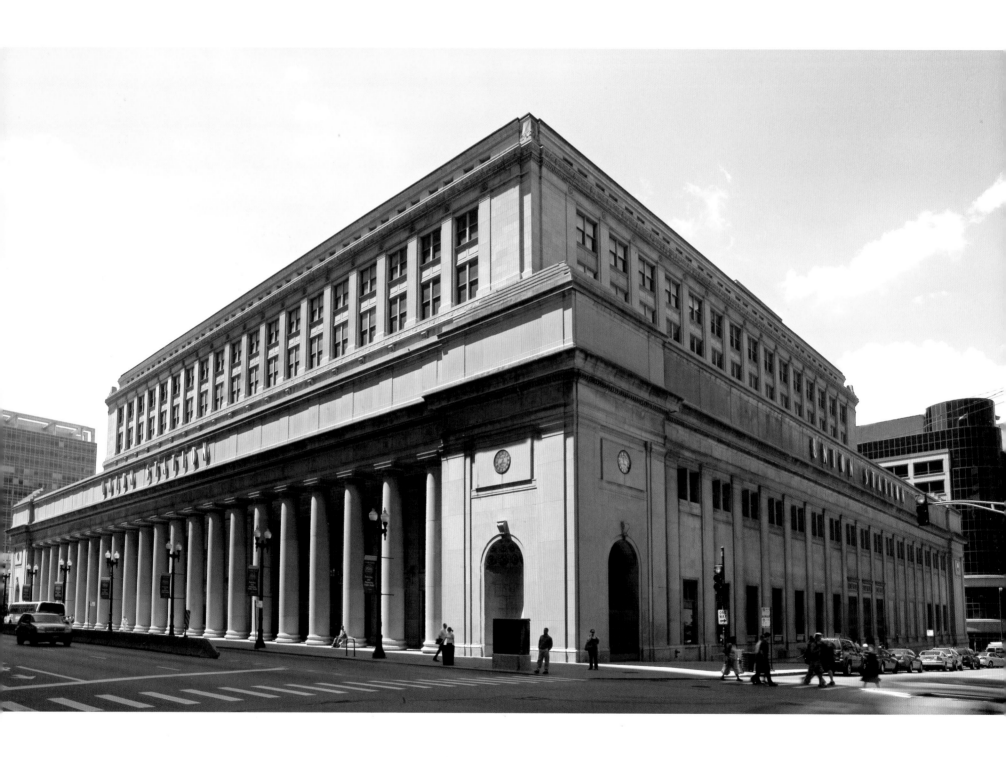

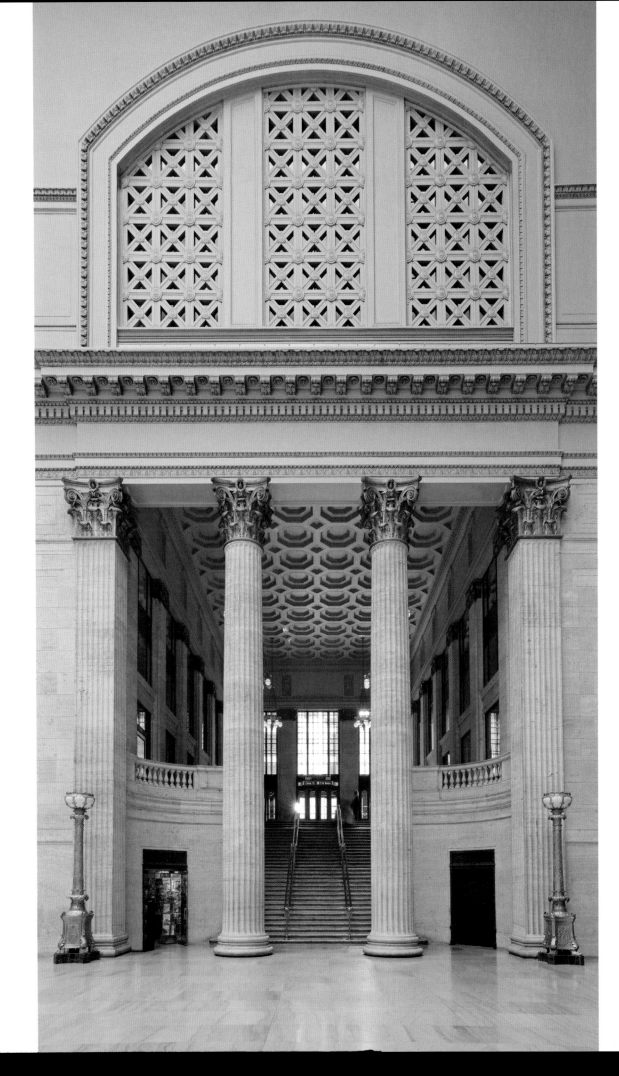

133

Graham, Anderson, Probst & White. Union Station, 210 South
Canal Street, 1913–25; renovated, 1992, Lucien Lagrange.
Photos: © William Zbaren.

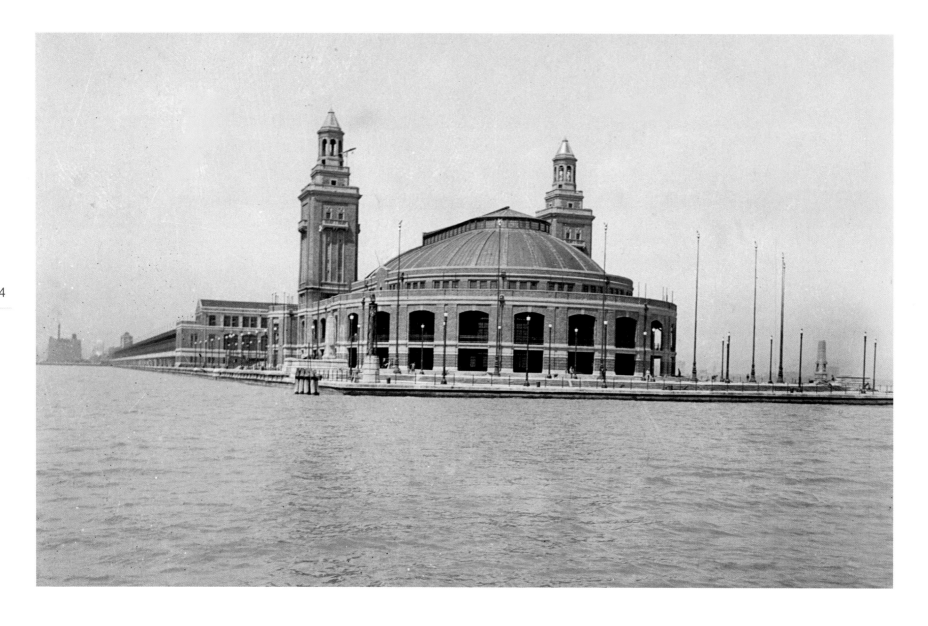

Charles S. Frost, Chicago Municipal Pier, later Navy Pier, 1916; renovated, 1995, VOA and Benjamin Thompson Associates, with 2016 and later renovations and additions by James Corner Field Operations, in progress. Navy Pier today is one of Chicago's major tourist attractions with more than 9 million visitors annually. Photos: Exterior of the headhouse on May 6, 1916, from the southeast in Lake Michigan, *Chicago Daily News* negatives collection, DN-0066201, with aerial October 11, 2012 © Tigerhill Studio Corp., John T. Hill, 5767-00092.3FR.

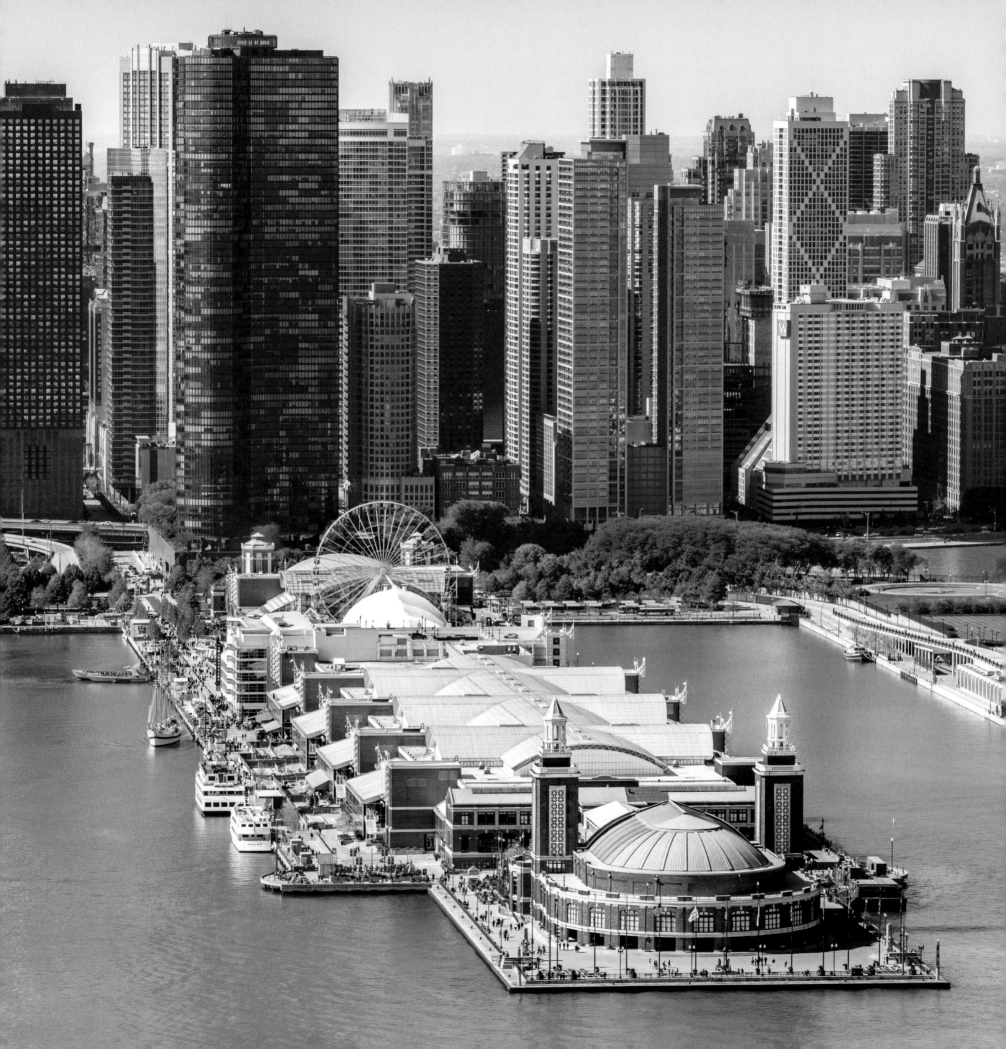

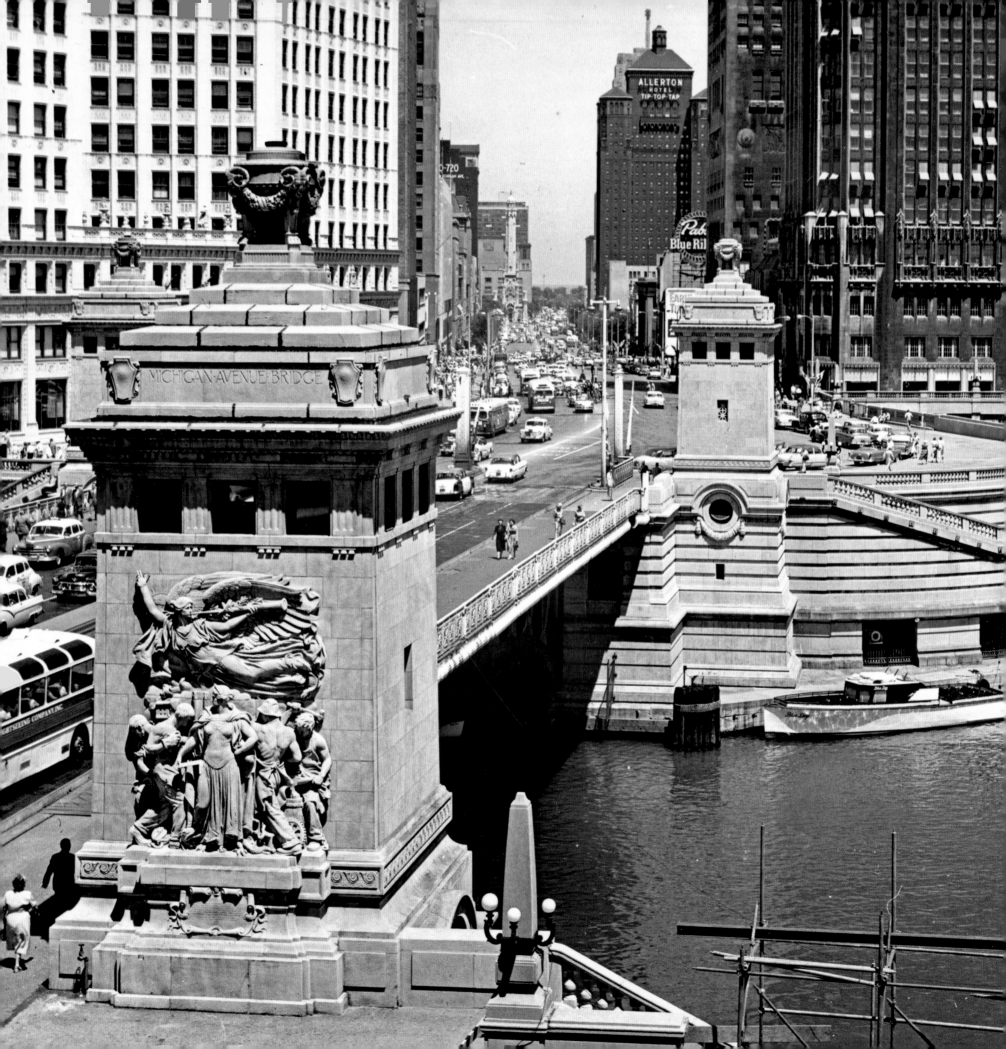

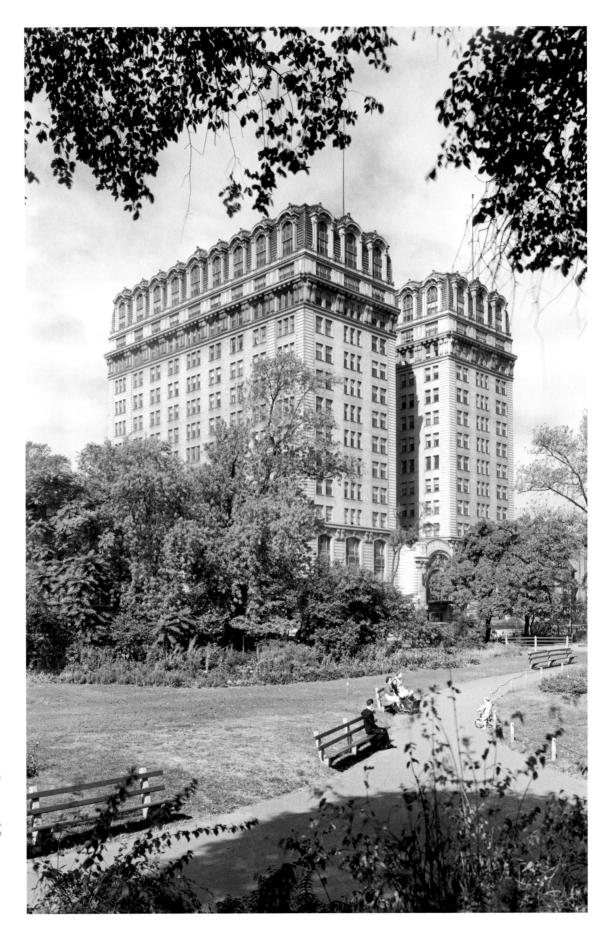

Left:
Edward H. Bennett, Michigan Avenue Bridge, 1918–20, shown in a
1955 photograph. In 2010, the bridge was renamed DuSable Bridge
after Jean Baptiste Point du Sable, Chicago's first resident. The bridge
sculptures were executed in 1928 by a number of artists. They depict
heroic scenes from Chicago's early history. The sculpture shown
here by Henry Hering (1874–1949), titled *Regeneration*, depicts
reconstruction after the Great Fire of 1871. The view on July 12, 1955,
is from the third floor of 333 North Michigan Avenue. Photo: J. Sherwin
Murphy, Chicago History Museum, ICHi-39471.

Right:
Fridstein & Co., Belden Stratford Apartment Hotel, 2300 Lincoln
Park West, 1922–23, shown on October 4, 1939, from Lincoln Park.
Photo: Hedrich Blessing Collection, Chicago History Museum,
HB-05472-B.

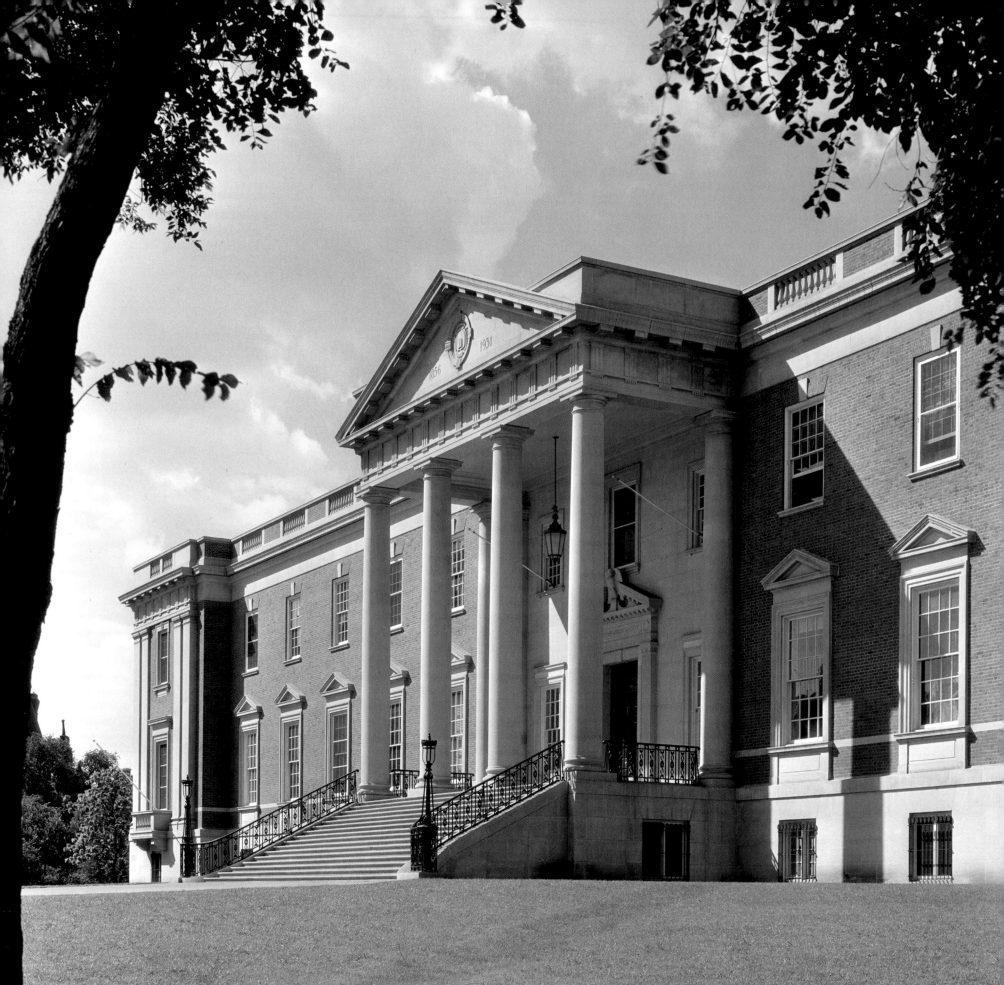

Overleaf:
David Adler, Mrs. Kersey Coates Reed House, Lake Forest, 1931–32.
David Adler (1882–1949) was one of America's great country-house
architects, with examples of his work built in Chicago's northern
suburbs as well as elsewhere in the United States. This massive
Georgian Revival villa, with its 224-foot-long facade, had interiors
decorated by Adler and his interior-designer sister, Frances Elkins
(1888–1953). Photo: October 14, 2010 © Tigerhill Studio Corp.,
John T. Hill, 5307-00083.3FR.

Left:
Graham, Anderson, Probst & White, Chicago Historical Society (now
Chicago History Museum), North Avenue and Clark Street, Lincoln
Park, 1932. The historical society moved here from its smaller urban
location into this grand Georgian Revival building. Additions were
made on the Clark Street side, but this previous entry space remains
on the east or park side; the building has restored rooms by Hammond,
Beeby and Babka, 2005. Photograph of the east facade, August 22,
1932. Photo: Hedrich Blessing Collection, Chicago History Museum,
HB-00888-D2.

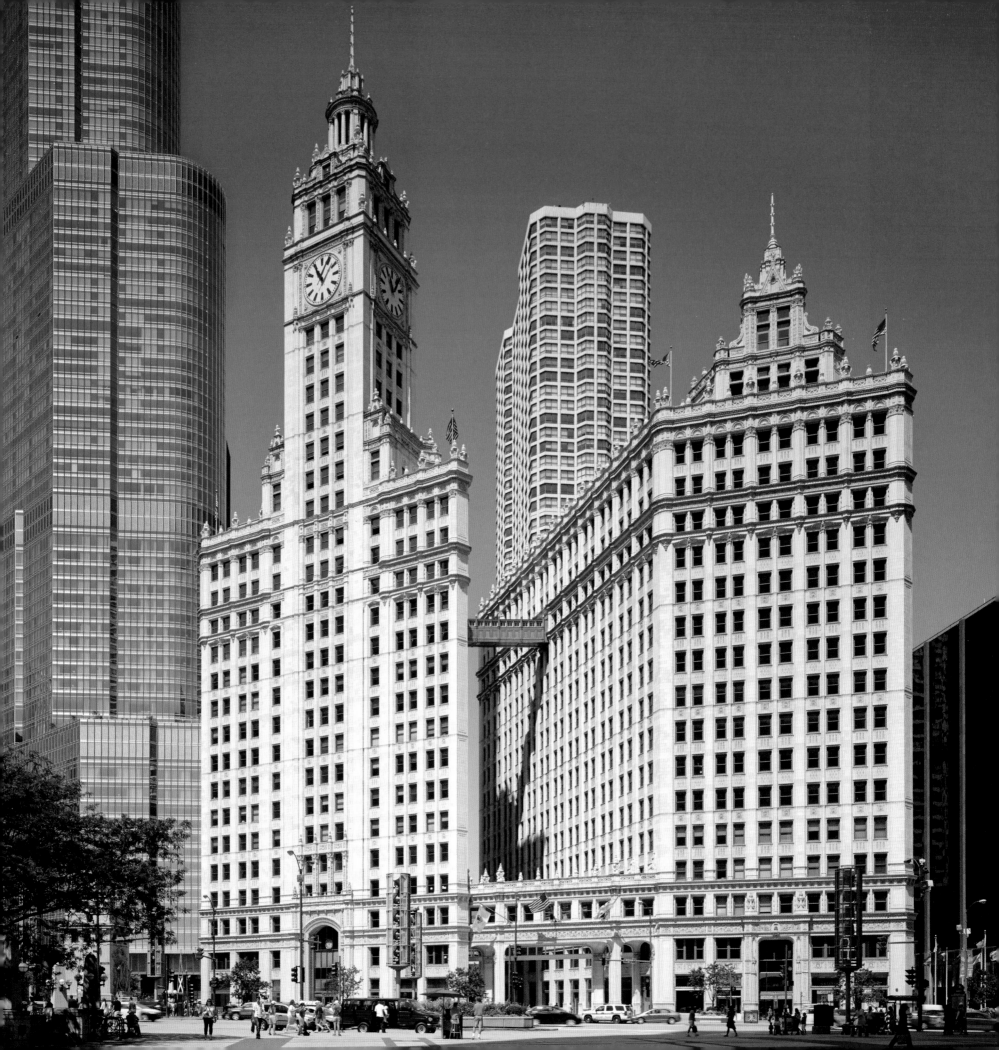

GANGSTERS, FLAPPERS AND JAZZ AGE DESIGN IN CHICAGO

The Roaring Twenties of the interwar years, especially those years in Chicago, have usually been associated with gangsters like Al Capone and bootlegged liquor during national Prohibition of 1920–33. The era after World War I witnessed the contradictions that existed between the image of a more formal, conservative, prewar society and a society trying to adapt to new, more democratic ideas and lifestyles. We observe this in period novels such as F. Scott Fitzgerald's *The Great Gatsby* (1925) and current television series such as *Downton Abbey* (2010–2016), *Boardwalk Empire* (2010–14), and *Mr. Selfridge* (2013 through today). Technologically, the age was also grappling with the change from buggies and horseless carriages to fast automobiles, from balloons to airplanes, and also of new entertainment choices with the introduction of motion pictures and radio programming.

With regard to architecture, technology proceeded apace with ever taller urban buildings, though the early 1920s in Chicago saw them governed by a 260-foot-high limit for a building's mass. Towers were often excluded from this restriction—hence the design of the graduated-tone, white terra-cotta Wrigley Building (1922) by Graham, Anderson, Probst & White. Its white got whiter up through a spiky tower atop the decorated mass below, to a total of 438 feet. The minaret La Giralda (1198), now part of Seville Cathedral in Spain, was the source of inspiration for Wrigley's tower. It is one of the many so-called copies of this highly decorated Spanish tower, others including that at Stanford White's Madison Square Garden (1890; demolished) in New York and the famed Ferry Building tower (1898) in San Francisco by Arthur Page Brown. Wrigley's gleaming white terra-cotta projected the image of cleanliness and purity regarding Wrigley products, their chewing gum. It also marked the beginning of the newly widened Pine Street into the Michigan Avenue boulevard or "Boul Mich" just north of the newly completed Michigan Avenue Bridge (1920).

Wrigley's massive two-story-high clock helped reinforce the tower's landmark function in this neighborhood. Immediately above it, on the twenty-sixth floor, visitors could ascend to an observatory to witness the new Chicago being built around them and also sample Wrigley's gum, a stick of which was included with the five-cent admission price. The whiteness of buildings such as the Wrigley with its 250,000 terra-cotta tiles, the light tones of the limestone London Guarantee (1923) across the river, and even the new Chicago Tribune Tower (1925) all projected the image that this was the boulevard of today and tomorrow. They were consciously compared with the older grimy, sooty, and thus dark buildings of a generation or two before that lined the smaller grid pattern of Chicago's former commercial center south of the river, the Loop.

The new Michigan Avenue north of the Chicago River continued to grow with other high and mid-rises such as Philip B. Maher's (1894–1981) Woman's Athletic Club (1928), as well as the Allerton House (1924) by Murgatroyd and Ogden, with Fugard & Knapp, and the exotic Medinah Athletic Club (1929) by Walter W. Ahlschlager (1887–1965). The Medinah Athletic Club, now the InterContinental Chicago Magnificent Mile Hotel but originally built as an affiliate of the Shriners, has Babylonian and Arabic detailing inside and out. It was intended to include 440 hotel rooms and suites, but during the Great Depression the club went into bankruptcy, and the building was converted into a commercial hotel. Writer Tennessee Williams remarked on the spacious two-story suites within. It is amazing that

143

Left and Overleaf:
Graham, Anderson, Probst & White, Wrigley Building, 400–410 North Michigan Avenue, 1922; lobby and arcade restoration, 2014, Goettsch Architects. Photos: Jon Miller, © Hedrich Blessing, courtesy Goettsch Architects.

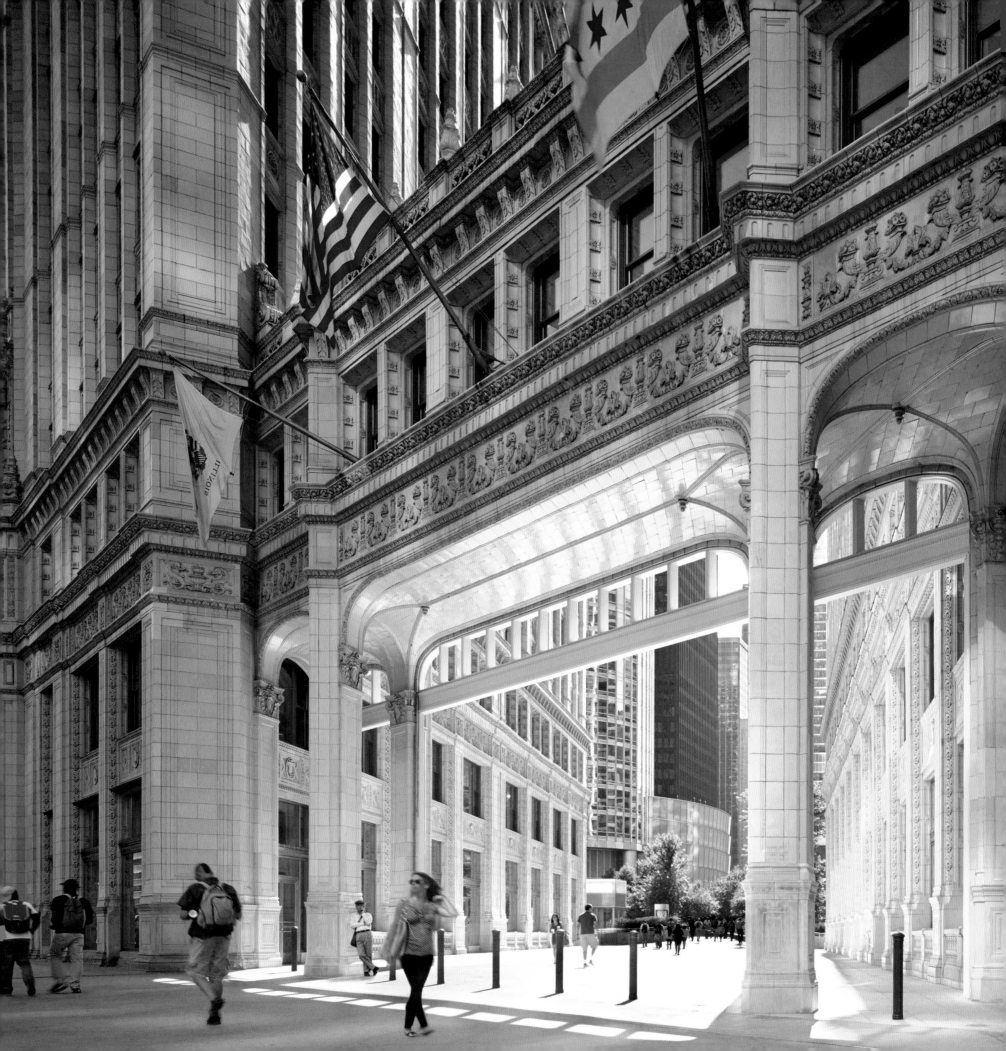

the elaborate public spaces, including a spectacular swimming pool, and double-story suites survived and were restored in 1989 by architect Harry Weese.

The area south of the river, in and near the Loop commercial district, also witnessed the construction of massive classicist hotels by Holabird & Roche, in the Stevens Hotel, now Hilton Chicago, and the Palmer House (both 1927). When built the two hotels combined had some 5,000 rooms, the Stevens having elaborate French Renaissance public spaces, whereas the Palmer House featured a history of French architecture in its public interiors, culminating in the so-called Napoleonic Empire Room. Equally large in scale to those classical giants is the 40-story Jewelers Building (1926), later Pure Oil Building, by Thielbar & Fugard with Giaver and Dinkelberg. Its distinctively domed pavilion first housed an observation deck and dining room, with an open-air terrace and roof promenade immediately below. Originally designed for jewelers, the security-conscious building had a completely mechanized garage lift that took diamond merchants in their cars up through twenty-two floors of showrooms with parking spaces adjacent. The cupola and decorative scheme for the cream-colored terra-cotta building were inspired by the architecture of the fifteenth-century Italian monastery Certosa di Pavia.

The Loop also has snazzy, snappy Art Deco buildings, such as the Carbide and Carbon Building (1929) by the Burnham Brothers—Daniel H. Burnham's sons—as well as One North LaSalle Street (1930) by Vitzthum & Burns, and the Holabird and Roche–designed Chicago Board of Trade (1929). The term Art Deco derives from the 1925 Paris world's fair, L'Exposition internationale des arts décoratifs et industriels modernes. The style often connotes concentric, flashy, angular and metallic shapes and forms within its decorative schemes, perhaps best exemplified in New York skyscrapers such as the Chrysler and Chanin Buildings (both 1930). Those Chicago buildings cited above are comparable in design to New York examples. The Carbide and Carbon has been likened to the black-and-gold American Radiator Building in New York (1924) done by Raymond Hood, whereas the One North LaSalle Street tower has lobby details worthy of any Art Deco high-rise of the era. Though more prevalent perhaps in New York, this kind of zigzag angular detailing can be seen in other period works, such as Chicago's Powhatan Apartments (1928), the Merchandise Mart (1923–30) hallway and lobby interiors, and even some of the setback relief decorations of the ornamental medallions atop facades within the soberly designed brick housing complex of the Marshall Field Garden Apartments (1929–30). Middle-class housing blocks such as that prefigured the larger subsidized local and federal government housing projects within the next few years of the Great Depression and after World War II.

The Chicago Board of Trade Building by Holabird & Roche,later Holabird & Root, with its relatively severe setback high rise and 605-foot high—the tallest in Chicago until the 1955 Prudential Building—houses an exuberant three-story lobby that shares multicolored dynamic design detailing with the architectural firm's famed Diana Court atrium on Michigan Avenue (1930; demolished). As some have observed, the Chicago Board of Trade lobby visually prefigures the dynamic streamlined locomotives of the 1930s, such as the Henry Dreyfuss–designed New York Central trains that operated from the nearby LaSalle Street Station in the later 1930s. The building is topped with a spectacular aluminum statue of Ceres, Roman goddess of agriculture, by sculptor John Henry Bradley Storrs (1885–1956).

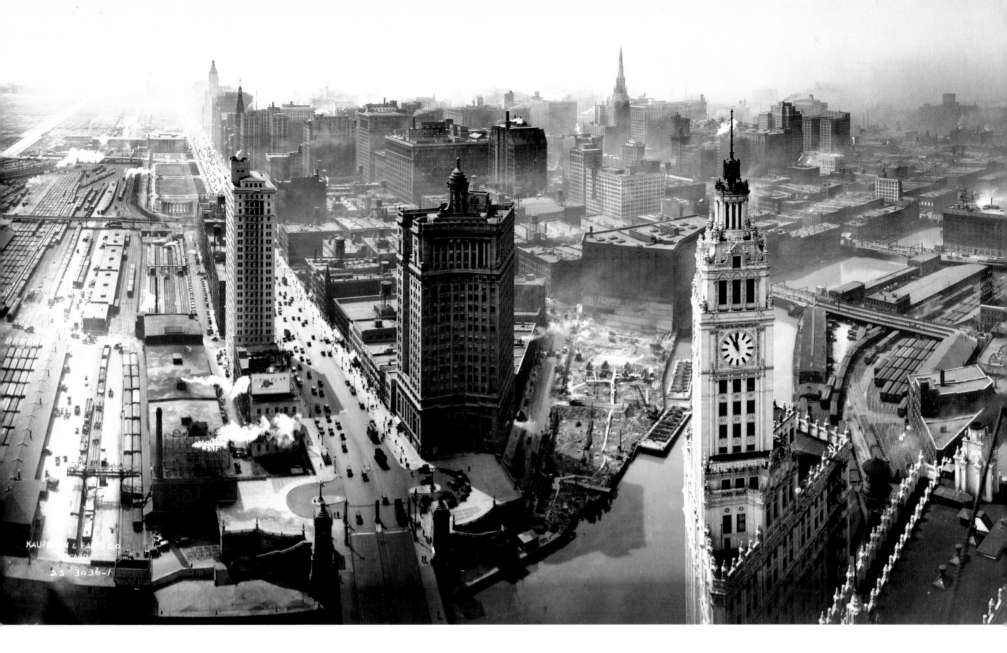

The Jazz Age also saw the expansion of the city to the far north along the lakefront, into essentially what was an entertainment district of Uptown and Edgewater beyond the Loop's theaters. Two architectural anchors of this type in those neighborhoods were the Aragon Ballroom (1926) by Huszagh & Hill, its interiors akin to the fantasy spaces of atmospheric theaters of the era, and the legendary Edgewater Beach Hotel and Apartments (1916–27) by Benjamin H. Marshall of Marshall and Fox, an amazing resort at the edge of the city.

Marshall himself was the bon vivant of Chicago architects in this era, driving custom Packards of his own design as well as entertaining celebrities and showgirls in his suburban Wilmette retreat (1924; demolished). This also served as his studio, complete with ancient Asian artifacts and a swimming pool where rumors circulated about disappearing bathing suits worn by his showgirl and starlet guests. His Edgewater Beach Hotel and Apartments with more than 1,200 rooms total, featured Polynesian and yacht club–styled restaurants, a private beach, custom-designed courtesy buses, a golf course, a radio station, and even seaplane rides for guests! All that remains today is the apartment tower (1927), but its lobby detailing and indoor swimming pool recall luxurious lifestyles of the Gatsby-like Jazz Age in Chicago.

Alfred Alschuler, London Guarantee Building, 360 North Michigan Avenue, 1923; being renovated into hotel space, 2015, Goettsch Partners. The image taken c. 1925 shows the Wrigley Building tower in the foreground right and London Guarantee Building in the center. Photo: Kaufmann & Fabry Co., Chicago History Museum, ICHi-38229.

Left:
Howells and Hood, Chicago Tribune Tower, 435 North Michigan
Avenue, 1922–25. The image shows the Wrigley Building to the left
and, in the center behind the Tribune Tower, the Medinah Athletic
Club, now the InterContinental Chicago on the Magnificent Mile Hotel.
Photo: © Hedrich Blessing, ArcaidImages.com 70005-80-1.

Right and overleaf:
Walter Ahlschlager, Medinah Athletic Club (now InterContinental
Chicago on the Magnificent Mile Hotel), 505 North Michigan Avenue,
1929. Photos: Exterior, John Zukowsky; interiors of second-floor lobby
Hall of Lions and apartment suite, Raymond W. Trowbridge, Chicago
History Museum, ICHi-73630 and ICHi-73631.

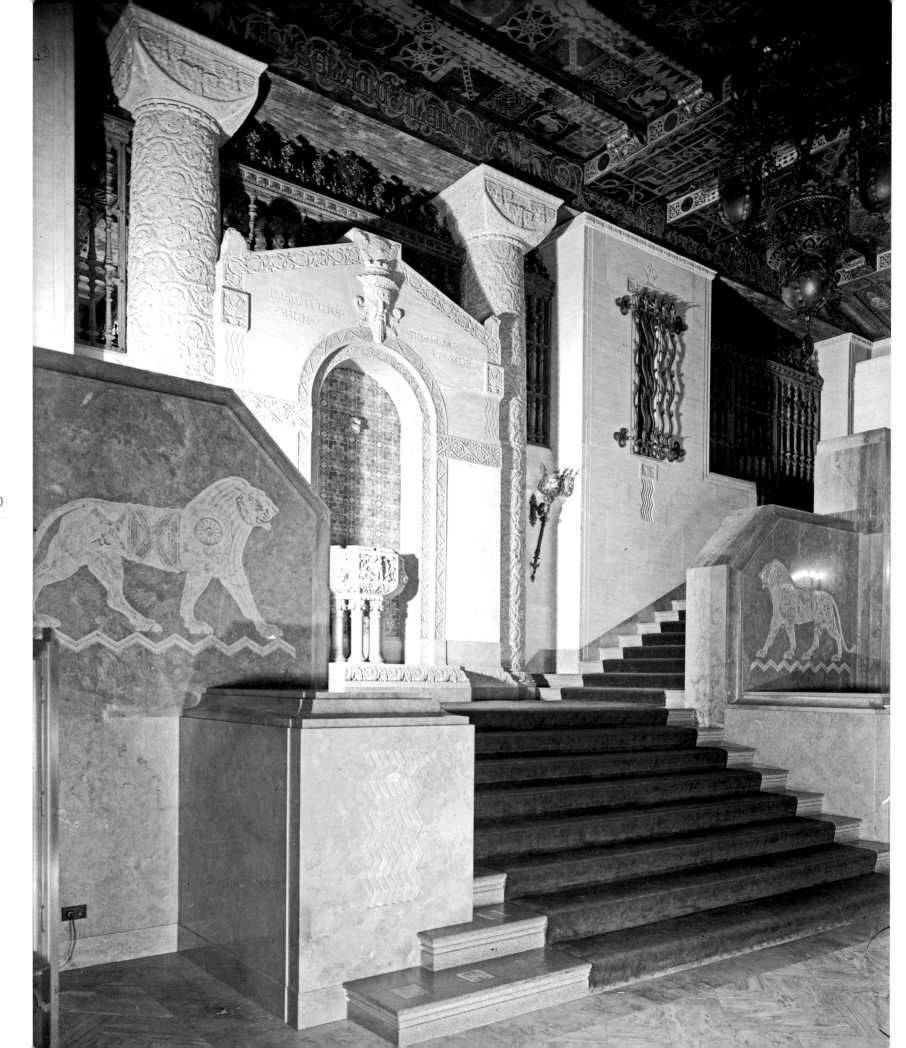

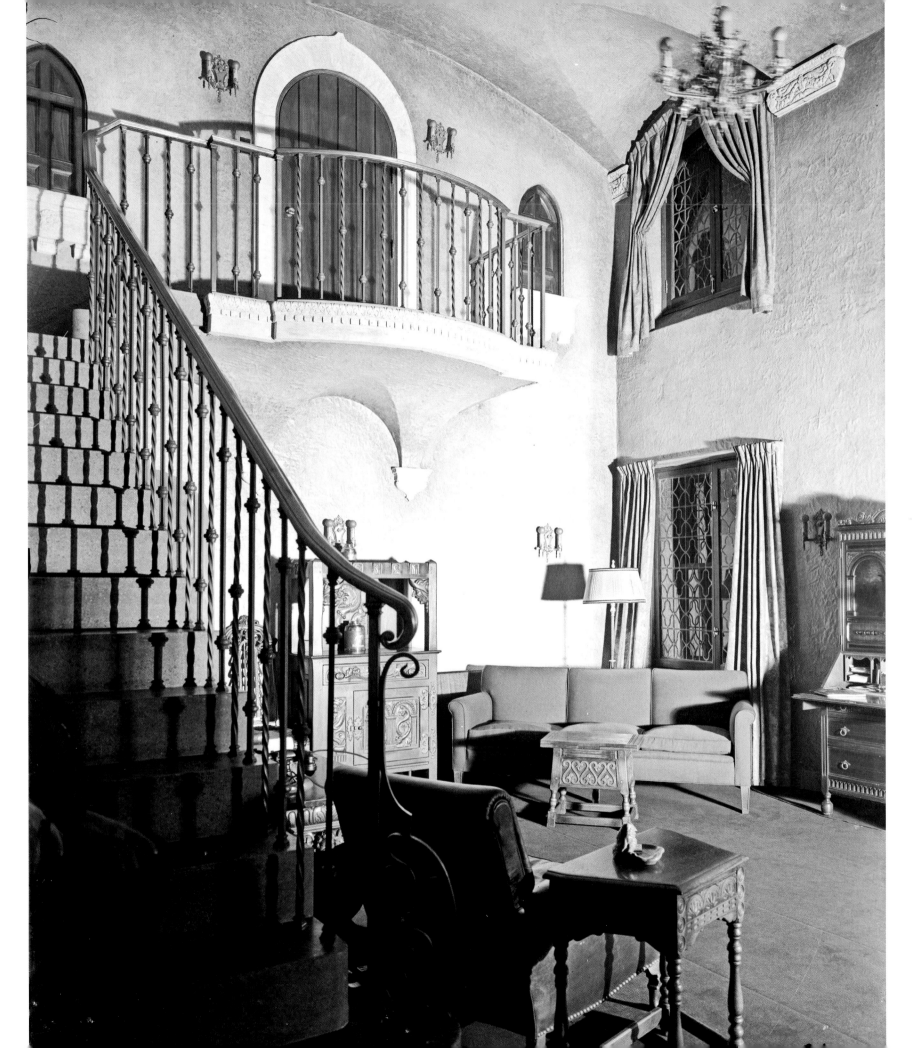

Above:
Rapp and Rapp, Chicago Theatre, 175 North State Street, 1921;
renovated, 1986, Daniel P. Coffey. This December 10, 1952, view
shows State Street pedestrian traffic as well as the two-story building
now replaced by the Joffrey Tower of 2008 designed by Booth Hansen.
Photo: J. Sherwin Murphy, Chicago History Museum, ICHi-19349.

Right:
Holabird & Roche, Palmer House Hotel, 17 East Monroe Street, 1927.
Interiors of the lobby stairs to the Empire Room on November 15,
1937. Photo: Hedrich Blessing Collection, Chicago History Museum,
HB-04399-B.

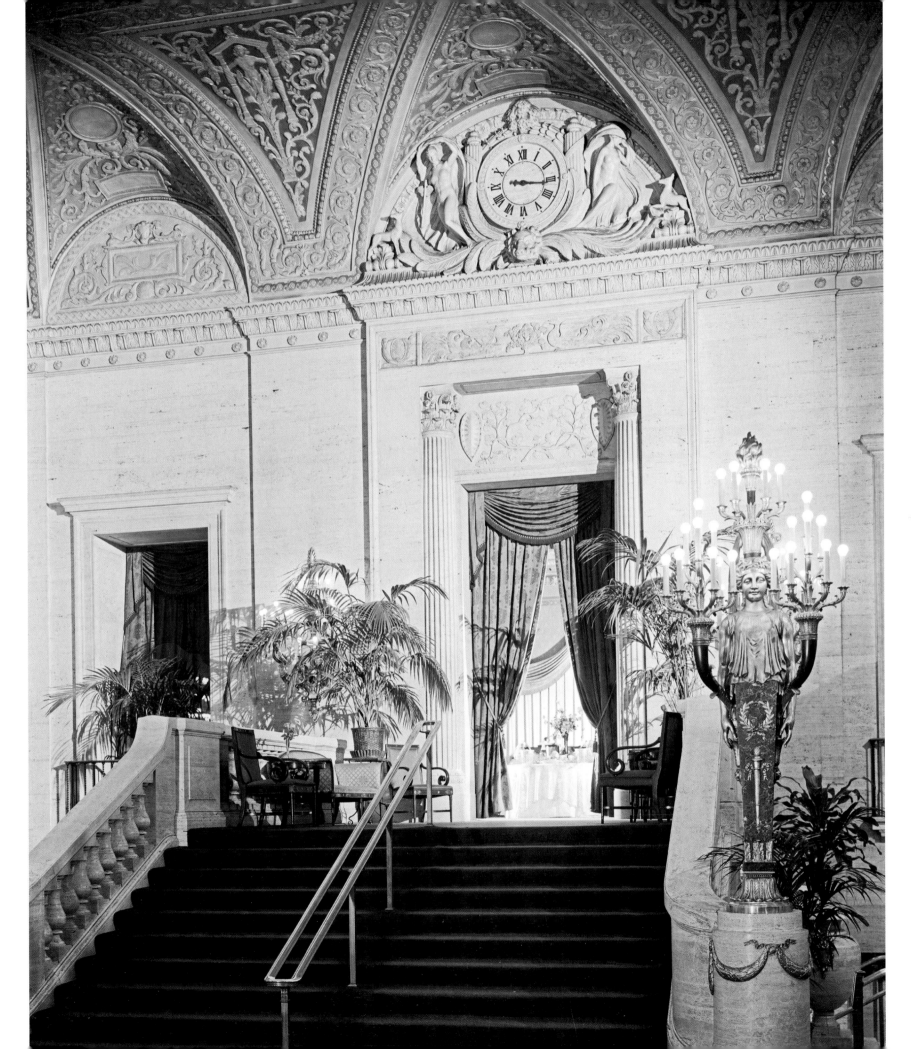

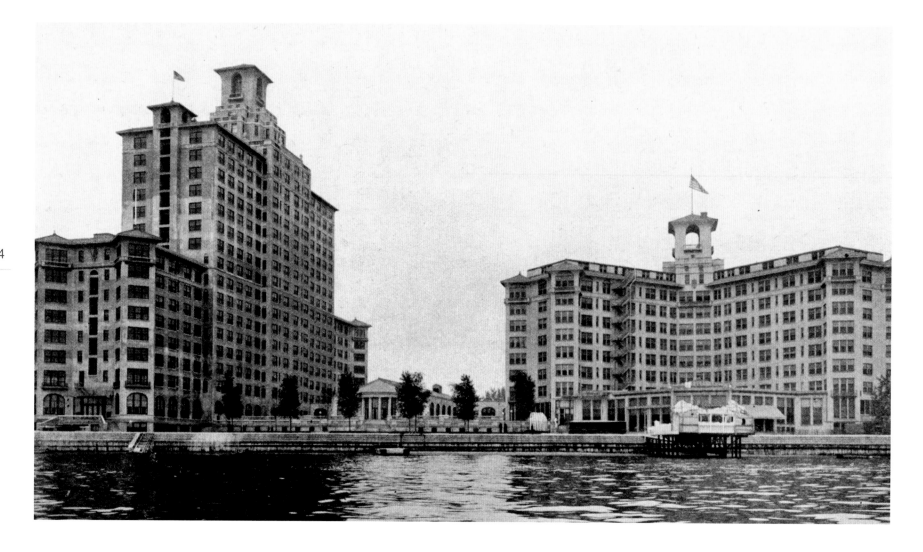

Benjamin H. Marshall, Edgewater Beach Hotel Apartments, 5555
North Sheridan Road, 1927 (right); the earlier 1916 and 1923 hotel
blocks (at right; now demolished) constituted the Edgewater Beach
Hotels, 5349 North Sheridan Road, by Marshall and Fox. The resort
complex at the northern edge of the city had more than 1,000 rooms.
When Lincoln Park was extended along with Lake Shore Drive c.
1954, parkland on landfill replaced the private beach at the hotel's
backyard. The number of visitors declined, and the two hotel blocks
were closed in 1967 and subsequently demolished in 1971. Nothing
remains of the hotel buildings themselves except a sign in the Chicago
History Museum galleries, though Chicago is fortunate to have the
apartment tower intact, complete with some vintage interiors, including
a swimming pool. Photos: Chicago History Museum, ICHi-21458 (left)
and Tom Harris © Hedrich Blessing (right).

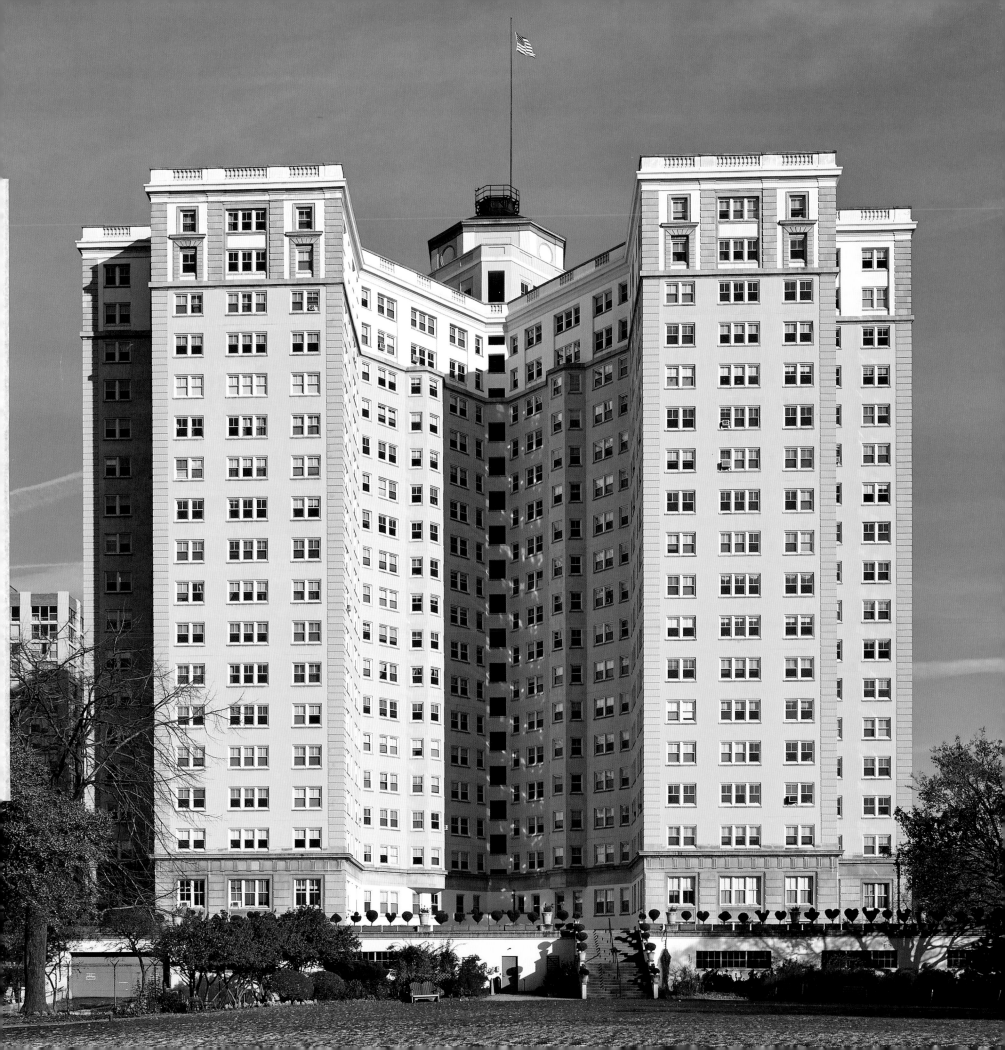

156

Huszagh & Hill, Aragon Ballroom, 1106 West Lawrence Avenue,
1926. Photos: Raymond W. Trowbridge, Chicago History Museum,
ICHi-20347 (exterior) and ICHi-38966 (interior), with exterior detail ©
John Gronkowski.

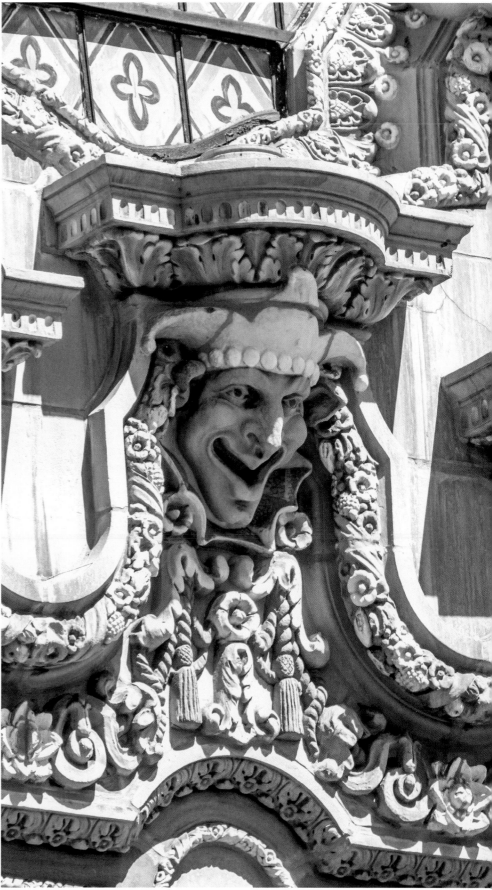

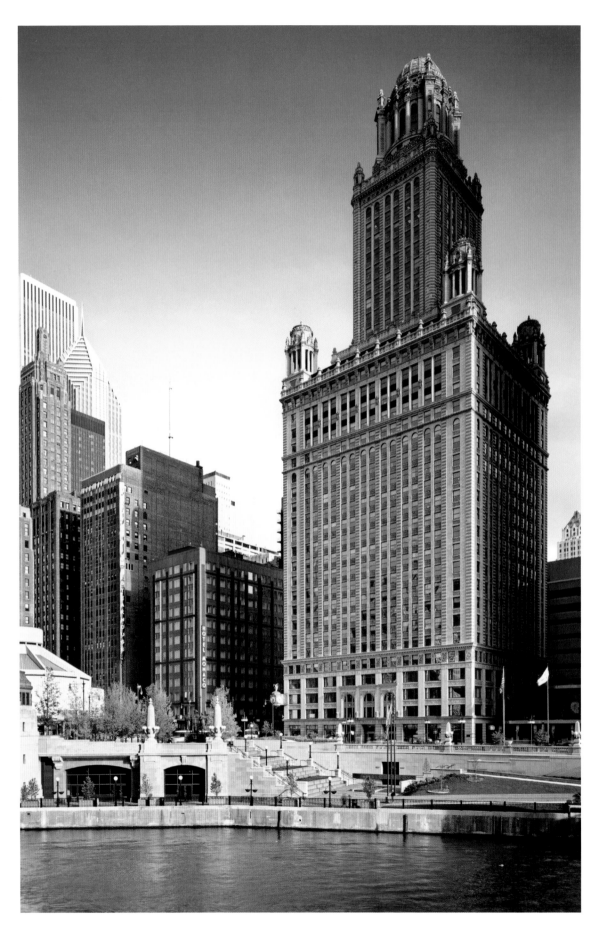

158

Thielbar & Fugard with Giaver and Dinkelberg, Jewelers Building, 35 East Wacker Drive, 1926; renovated, 2005, Goettsch Architects. Photos: Jon Miller © Hedrich Blessing, ArcaidImages.com 70075-40-1 (exterior)and 70075-20-1 (lobby).

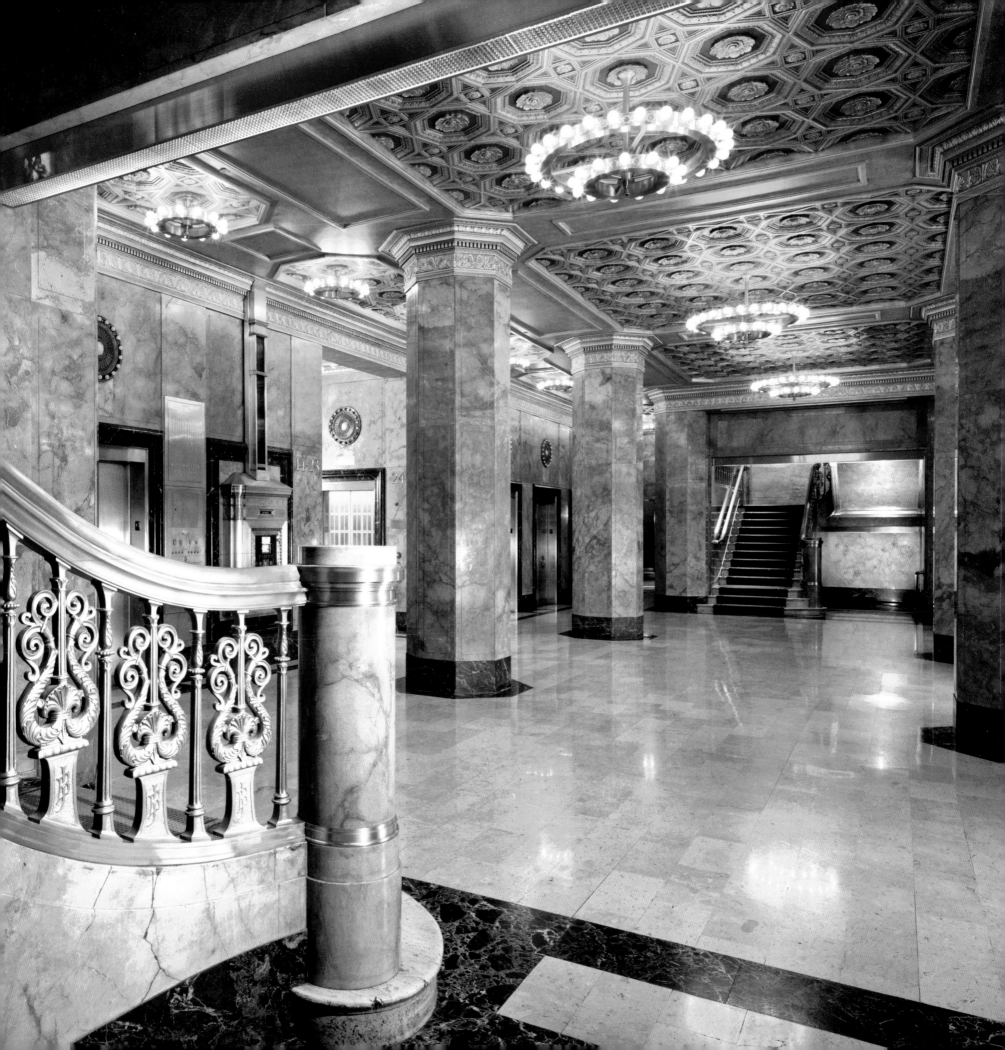

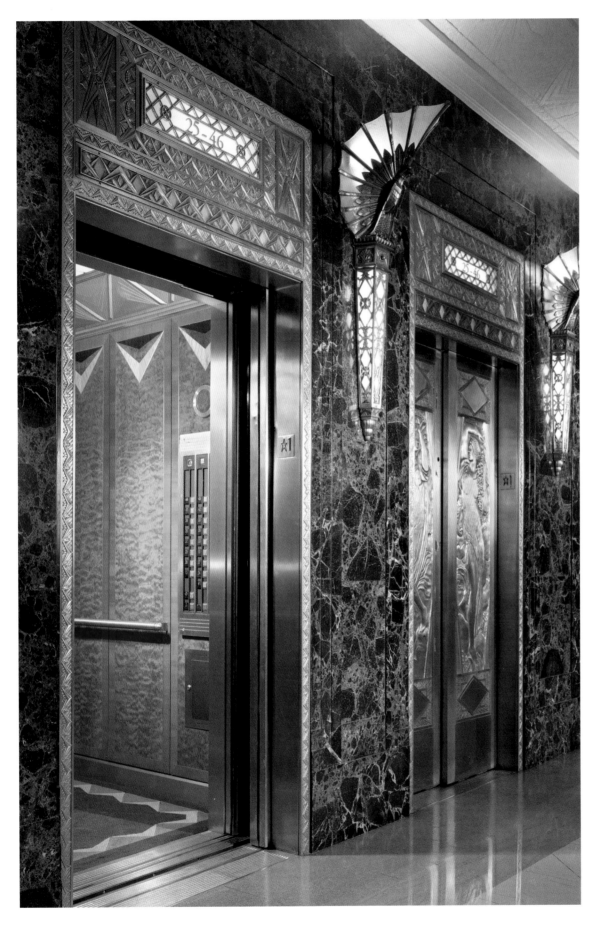

160

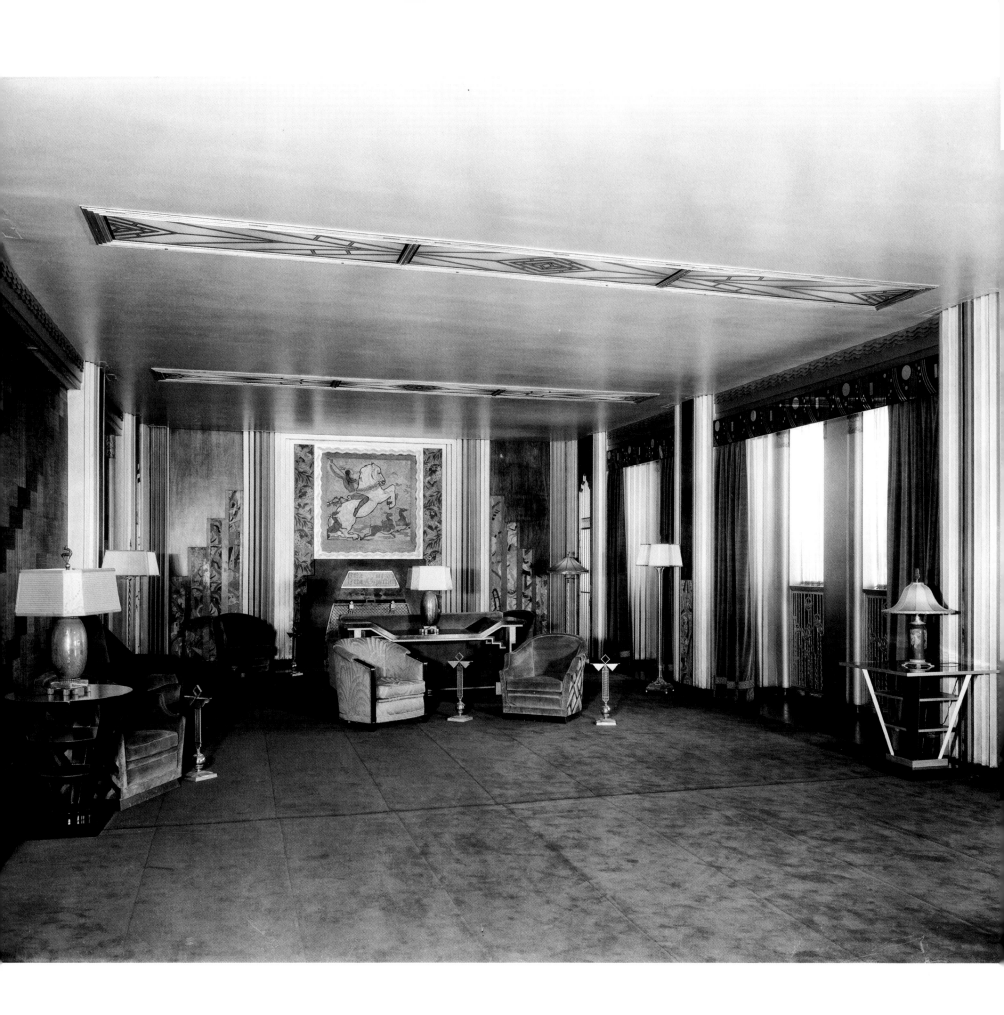

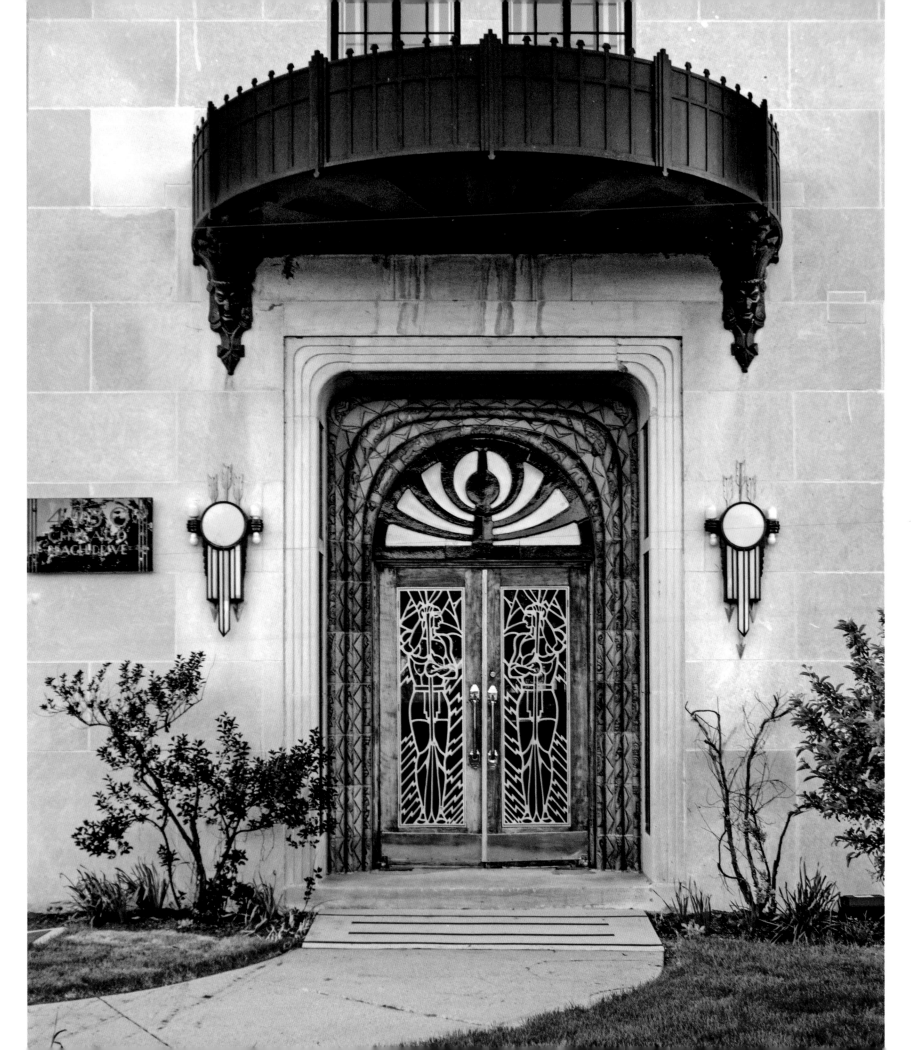

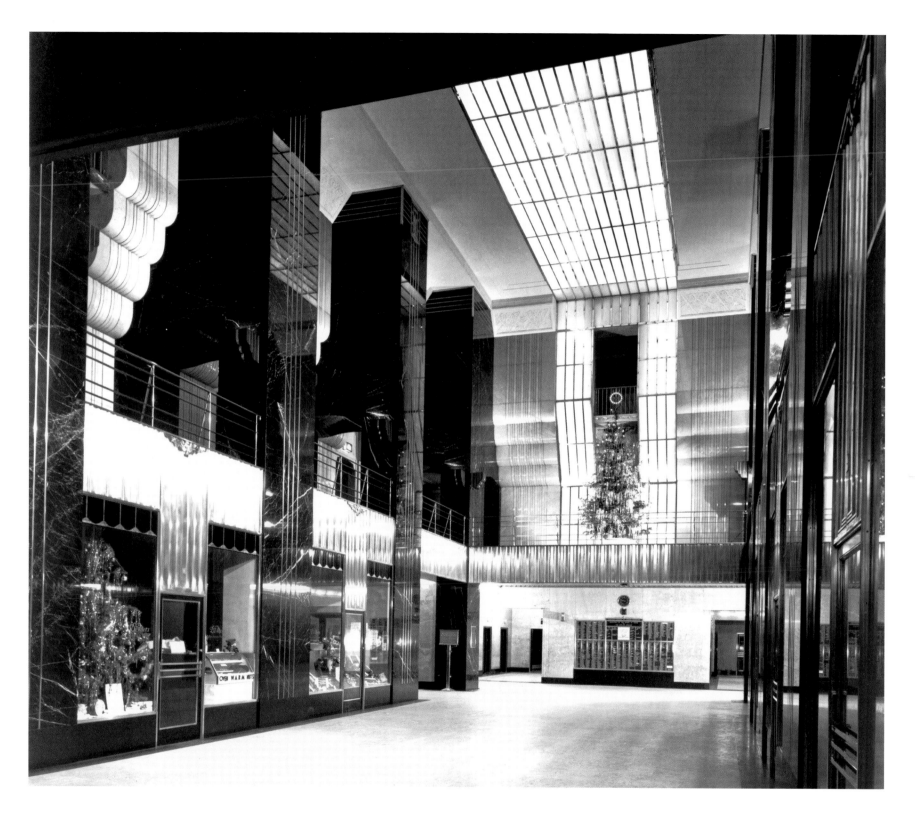

Holabird & Roche,later Holabird & Root, Chicago Board of Trade, 141
West Jackson Boulevard at LaSalle Street, 1929. Photos: Hedrich
Blessing, © Chicago Historical Society, exterior HB-00893-A,
ArcaidImages.com 70568-10-1 and lobby HB-06228,
ArcaidImages.com 70718-10-1.

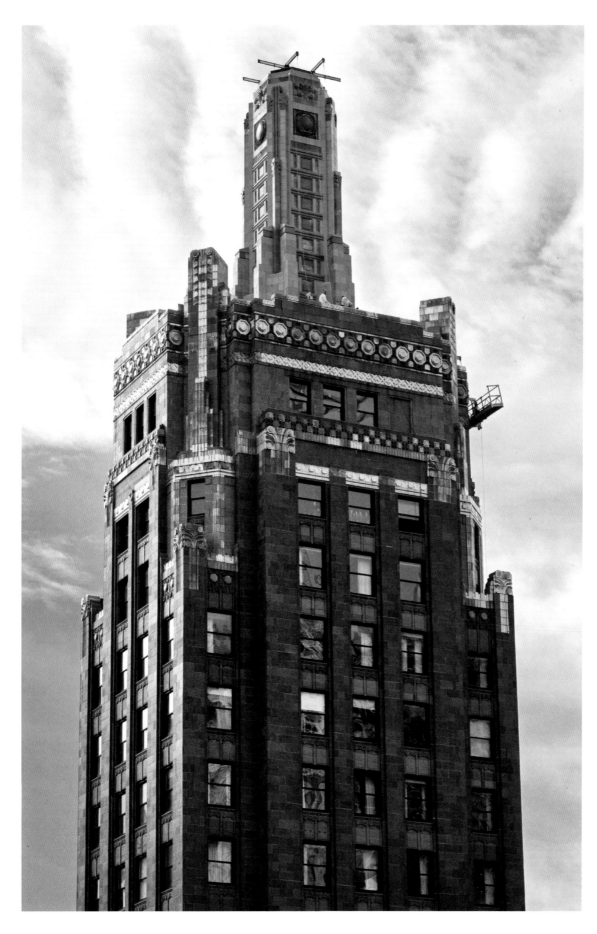

Left:
D. H. Burnham (Burnham Brothers), Carbide and Carbon Building
(now Hard Rock Hotel), 230 North Michigan Avenue, 1929; restored,
2004, Lucien Lagrange, with Yabu Pushelberg–designed hotel lobby.
Photo © William Zbaren, courtesy Lucien Lagrange.

Right:
Philip B. Maher, Woman's Athletic Club, 626 North Michigan Avenue,
1928. View on May 10, 1930. Photo: Hedrich Blessing Collection,
Chicago History Museum, HB-00242.

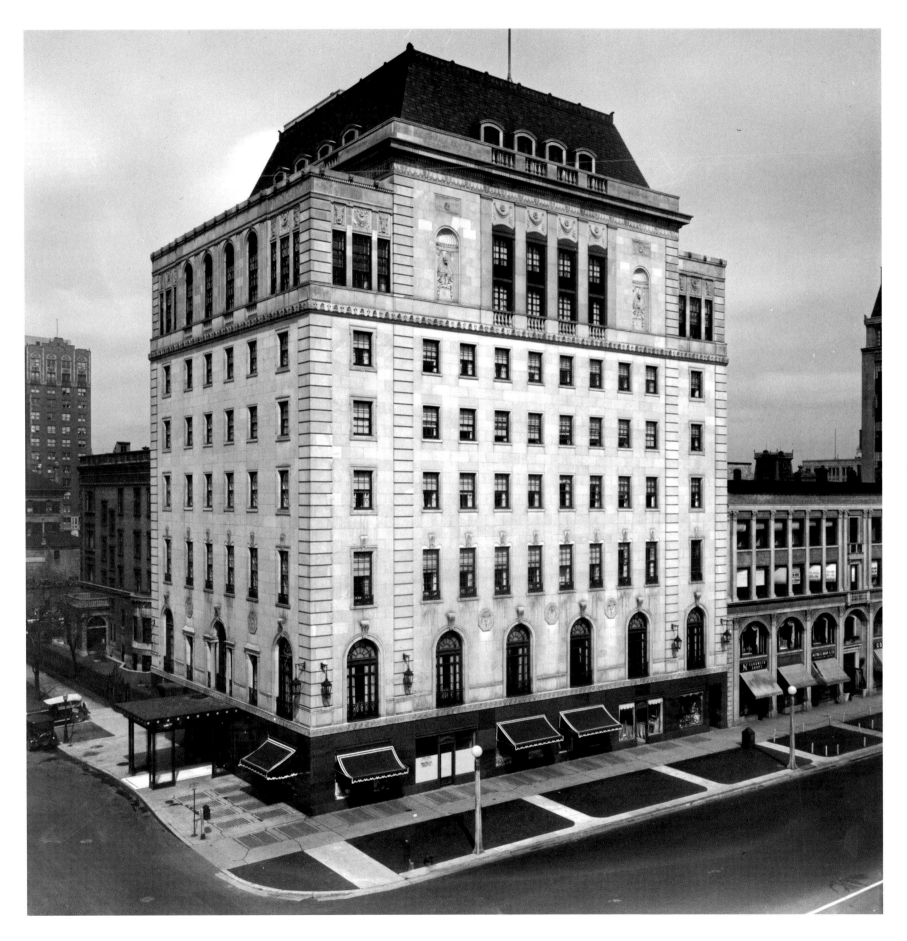

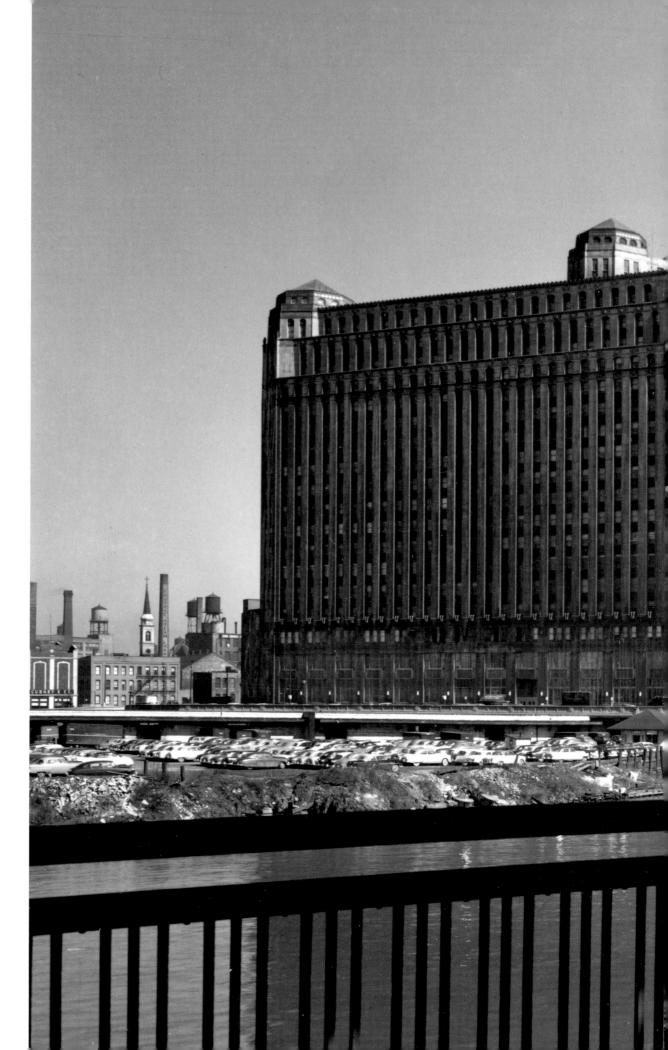

168

Graham, Anderson, Probst & White/GAPW, Merchandise Mart, north bank of the Chicago River between Wells and Orleans Streets, 1923–30; renovated, 1991, GAPW and Beyer Blinder Belle. When completed, it was the largest building in the world in terms of square footage, at 4 million square feet. Photo: Hedrich Blessing Collection, Chicago History Museum, HBSN-00911-C.

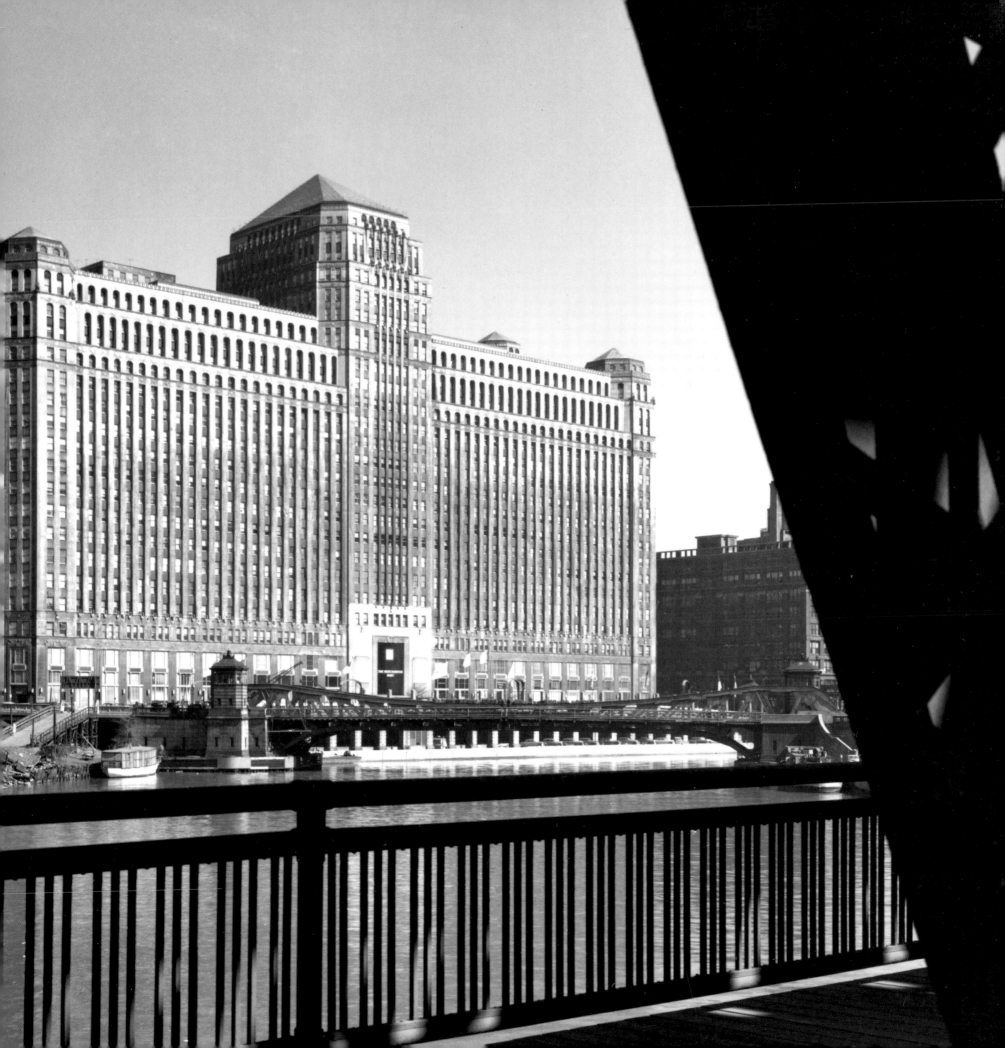

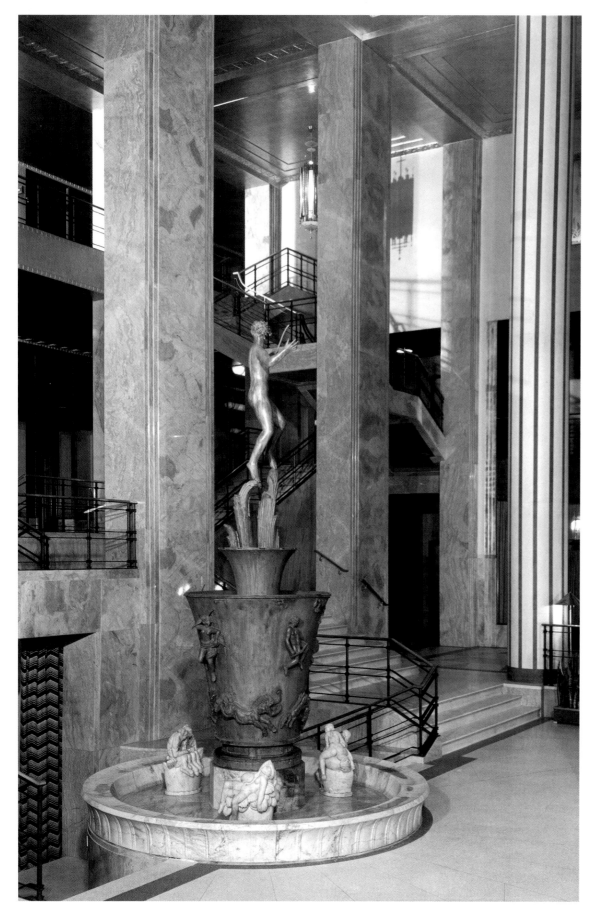

Left:
Holabird & Root, Michigan Square Building–Diana Court, 540 North Michigan Avenue, 1930 (demolished). Photo: Hedrich Blessing © Chicago Historical Society, HB-00648-F, ArcaidImages.com 70557-50-1.

Right:
Andrew Thomas with Graham, Anderson, Probst & White, Associate Architects, Marshall Field Garden Apartments, 1448 North Sedgwick Street, 1929–30. Photo: Hedrich Blessing © Chicago Historical Society, HB-02284-E, ArcaidImages.com 70629-40-1.

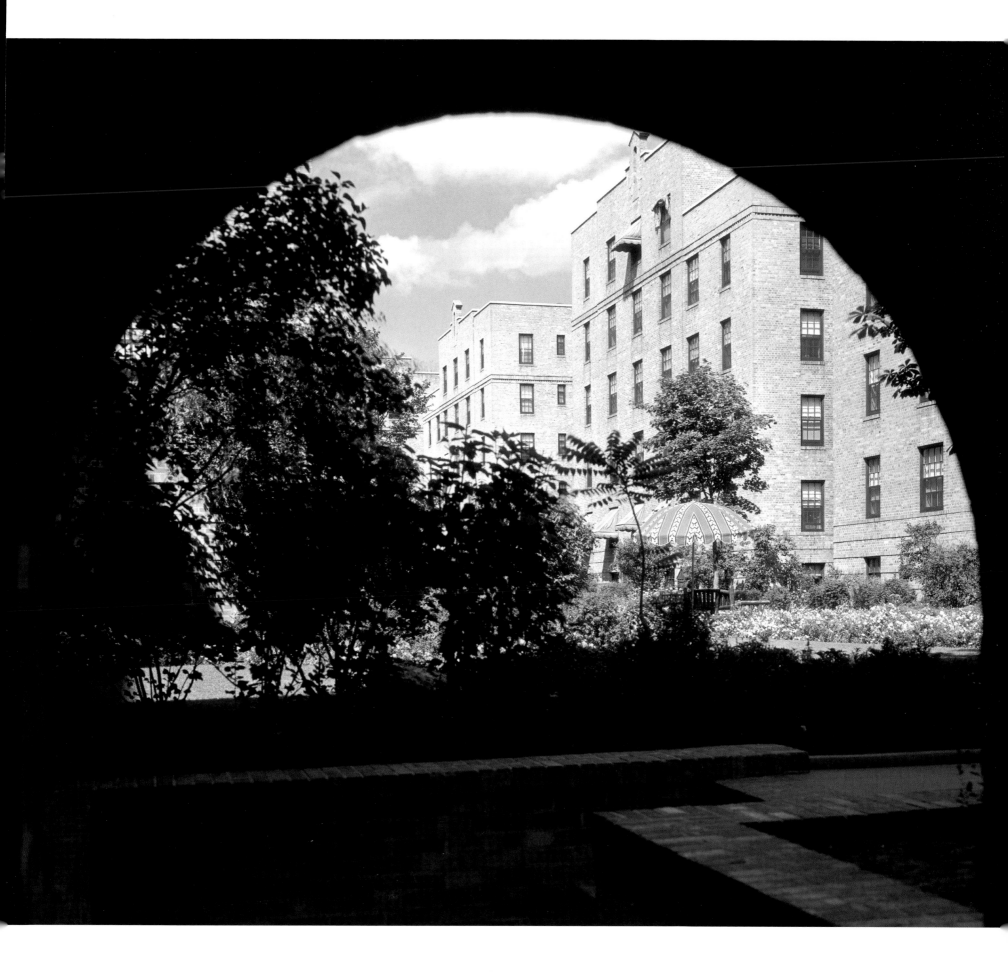

MODERNIST CHICAGO: THE GREAT DEPRESSION AND WORLD WAR II

The almost two-decade-long period of the Great Depression and World War II impacted greatly, both positively and negatively, on Chicago architecture. Buildings created then and throughout the United States are often characterized by a sleekly sober modernist expression. They are often simply massed, rectilinear constructions of masonry-covered steel, with only some decorative details that are also subdued seen beside their flashy, Jazz Age, Art Deco, and even classical counterparts. Many call this Conservative Modernism or American Modernism, and observations about this substantial Modernism compared with more transparent, dynamic European Modernism are generally valid ones. Good examples include the Empire State Building (1931), by Shreve, Lamb and Harmon and the RCA Building (1933), now Comcast Building and home of NBC, in Rockefeller Center by Raymond Hood, both in New York.

In Chicago, a great example of this masonry modern design can be seen in the limestone Palmolive Building (1929), later Playboy headquarters, by Holabird & Root. Its eye-catching Lindbergh Beacon of 2 billion candlepower, erected in an aluminum tower more than 600 feet above street level, could be easily seen by aviators as far away as Milwaukee. Intended to aid aerial navigation for Chicago Municipal (later Midway) Airport, the blazing light was deactivated in the late 1960s when larger residential and hotel buildings were constructed nearby. The actual beacon was de-installed and donated to the Experimental Aircraft Association Museum in Oshkosh, Wisconsin. A 2001 attempt at lakeside-only reactivation with the building's restoration and conversion into luxury condominiums drew criticism from residents in other high rises, so the subsequent replacement was toned down in its intensity.

Beyond that uncontestable masterwork, there are a number of great buildings in this modern masonry style throughout Chicago, from the 41-story limestone and granite LaSalle Wacker Building (1929) by Holabird & Root with Andrew Rebori, to the 42-story limestone, granite, and white bronze Field Building (1933–34) by Graham, Anderson, Probst & White. The LaSalle Wacker's windy rooftop was used by Rebori and his committee to audition Sally Rand, the famed burlesque fan dancer, for the Streets of Paris concession within the Century of Progress International Exposition (1933). That world's fair was important because it presented a survey of modern architecture and technology for the general public, as well as popular sideshow amusements and foreign villages that were concessions within the fair plan. The Field, built on the site of Jenney's Home Insurance Building, was one of the streamlined modern buildings that, along with New York's Empire State Building and San Francisco's Golden Gate Bridge (1937), were new structures tasked to be seen by Konstanty Gutschow when he was commissioned to investigate a new skyscraper and suspension bridge for Hamburg, Germany, in 1937.

Chicago also saw other masonry modern buildings throughout the 1930s and even after World War II, buildings that ranged from the massive Post Office (1931–32) by Graham, Anderson, Probst & White, still in search of an adaptive reuse since 2009, through city architect Paul Gerhardt Jr.'s terminal building at Chicago's Municipal Airport (1947; demolished). It was officially renamed Midway Airport in 1949, named so after the 1942 naval aviation battle that many consider one of the turning points of World War II.

Beyond those Chicago examples of American or conservative Modernism that are the hallmarks of Depression-era modern architecture in the United States, the decade of that worldwide financial

Holabird & Root with Andrew Rebori, LaSalle Wacker Building, 221 North La Salle Street, 1929. The photograph shows the LaSalle Wacker Building at left foreground with all the 1920s skyscrapers that were lit at night, the center showing the Wrigley Building with the Chicago Tribune tower. Photo: Chicago Architectural Photographing Company, Chicago History Museum, ICHi–36540.

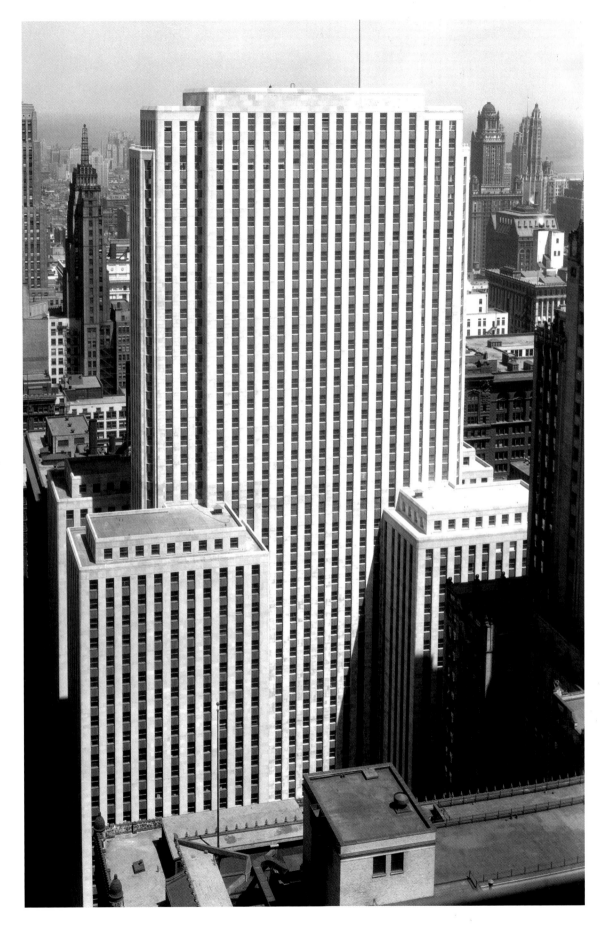

Alfred Shaw of Graham, Anderson, Probst & White, The Field
Building, 135 South LaSalle Street, finished 1932–34. Photo: Hedrich
Blessing © Chicago Historical Society, exterior (at left) HB-01325-J,
ArcaidImages.com 70582-20-1; entry (at right) HB-01325-B,
ArcaidImages.com 70001-30-1.

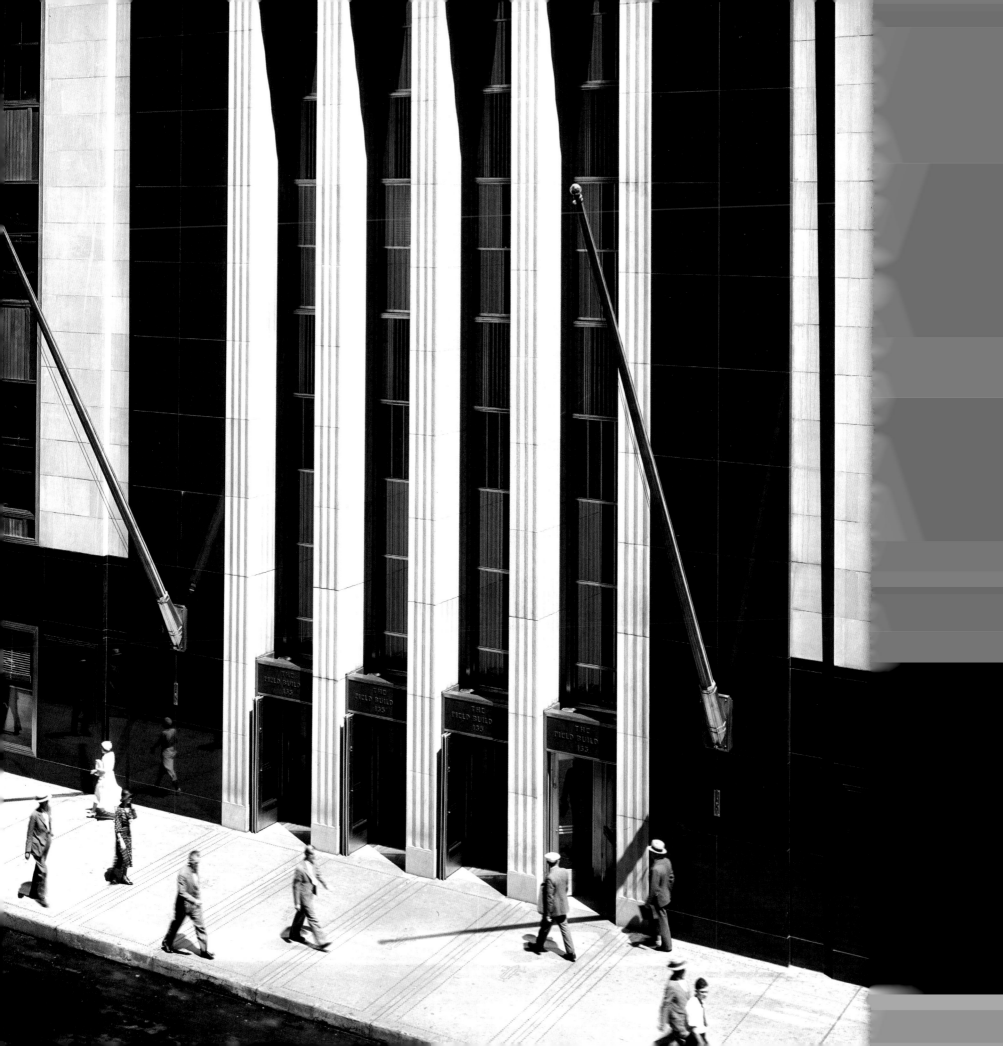

depression witnessed government programs for infrastructure support and expansion at federal, state, and municipal levels. Two such federal projects in Chicago are the Outer Drive Bridge (1937), at Lake Shore Drive and the Chicago River, and the construction of the first stages of the Chicago subway system. The initial subway Loop and near north stops for the Red Line were opened in 1943. The construction of the Blue Line, and additional Red Line stops, were halted during the remainder of the war. With federal government orders for war materials, Chicago factories shifted into high gear, with some even being constructed from scratch. The latter was the case with the Douglas Aircraft Co. factory at Orchard Field, built mostly of nonstrategic materials such as timber framing, asbestos siding, and plastic plumbing in 1942–43 to construct their C-54 (later DC-4) large transports. After the war, the factory was demolished, and the field expanded with new terminals to become Chicago O'Hare International Airport, named after World War II naval ace Edward "Butch" O'Hare in 1949. Airline baggage labels today still bear the abbreviation ORD, referencing O'Hare's start as Orchard Field.

The war saw the expedited development of a number of materials that revolutionized construction afterward in the postwar era, from gypsum board and drywall to Plexiglas and PVC pipe. The first years after war's end in 1945 witnessed a struggle between those who wanted to return to prewar social conditions versus those who wished to expand upon wartime social progress. Architecturally, this was also the case where Cape Cod suburban homes were the norm compared with the more open, modern Usonian homes developed by Frank Lloyd Wright and his followers. This dichotomy can be seen in the entries to the *Chicagoland Prize Homes* competition (1945) organized by the *Chicago Tribune*. Several of the prizewinning entries were built on the northwest side of Chicago, and those model homes were toured by 212,000 people over a one-month period.

It took some years through the end of the decade and beyond into the 1950s, but Modernism prevailed all over the world, including Chicago. The 1940s witnessed a variety of modern expressions for schools, private residences, apartments, department stores, and corporate interiors that heralded what was to come in the fifties. These all planted the seeds for the diversity of modern architectural expressions that could be found in the 1950s and 1960s. These postwar works include starkly open concrete-and-glass homes by Ralph Rapson and Bertrand Goldberg to the new Bond department store (1950) on State Street by Friedman, Alschuler, and Sincere in conjunction with Morris Lapidus. That last is an important work of the era that was recycled recently for the federal government but sadly not restored to its flashy fifties look. The immediate postwar era also witnessed works by Skidmore, Owings & Merrill/SOM in another important corporate modernist space that was subsequently demolished, the ticket offices for Trans World Airlines/TWA (1946–47) within the 1903 Sharp Building on Wabash Avenue and Monroe Street. This prefigured their sophisticated corporate designs, which they developed further in the 1950s and 1960s within buildings such as Inland Steel (1958).

This pluralism within the Modern Movement in America at the time is best expressed within the Museum of Modern Art's 1944 exhibition and catalogue, organized by Elizabeth Mock, titled *Built in USA 1932–1944*. Although the only Chicago example was the North Avenue Bridge over Lake Shore Drive (1944), the book in a way shows a wide range of Modernist expressions throughout the nation. The museum's successor exhibition (1953)—and catalogue, *Built in USA: Post-War Architecture* (1952), edited by Henry-Russell

178

Graham, Anderson, Probst & White, Chicago Post Office, 433 West Van Buren Street, also straddling Congress Street, completed 1931–32. Photo: Hedrich Blessing © Chicago Historical Society, HB-02202-D, ArcaidImages.com 70624-10-1.

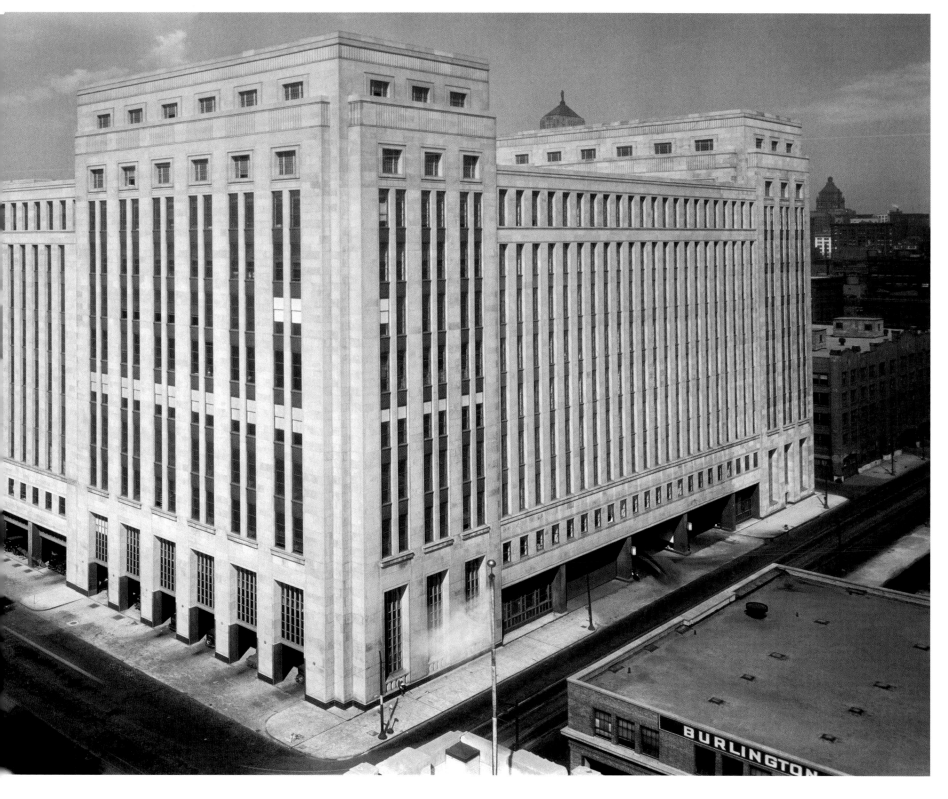

Hitchcock and Arthur Drexler—showcased Chicago as having several new buildings by Ludwig Mies van der Rohe. It was Mies's hand that helped shape Chicago in this era. He trained the next generations of architects at Illinois Institute of Technology/IIT after his move from Berlin to the United States in 1937 and Chicago in 1938. In addition, he designed structures on that campus, buildings that laid the foundation for international recognition of his impact on Chicago's architectural scene in the next two decades.

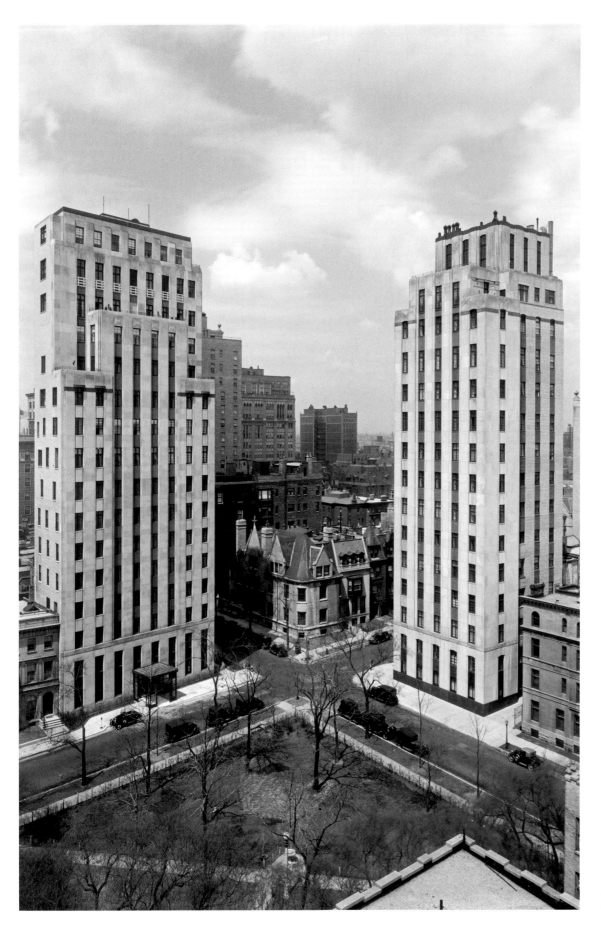

180

Philip B. Maher, 1260 North Astor Street, 1930–31 (left) and 1301 North Astor Street, 1928–29 (right). The two buildings were photographed together on May 9, 1932. Maher, the son of Prairie School architect George Maher, lived within the 1301 building; the interior of his apartment is shown here in 1930. Photos: Hedrich Blessing Collection, Chicago History Museum, HB-01265-B (left) view of both and interior photographed by Kenneth A. Hedrich, HB-00604-C (right).

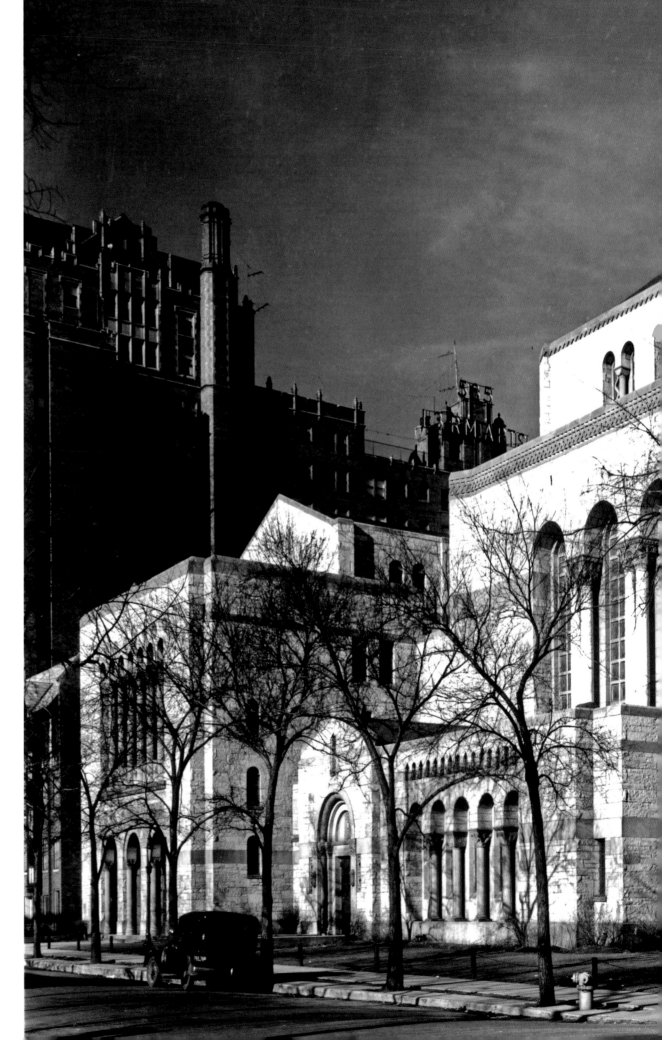

Loebl, Schlossman and DeMuth with Coolidge and Hodgdon, Temple Sholom, 3480 North Lake Shore Drive, 1930. View on February 19, 1938. Photo: Hedrich Blessing Collection, Chicago History Museum, HB-04518-A.

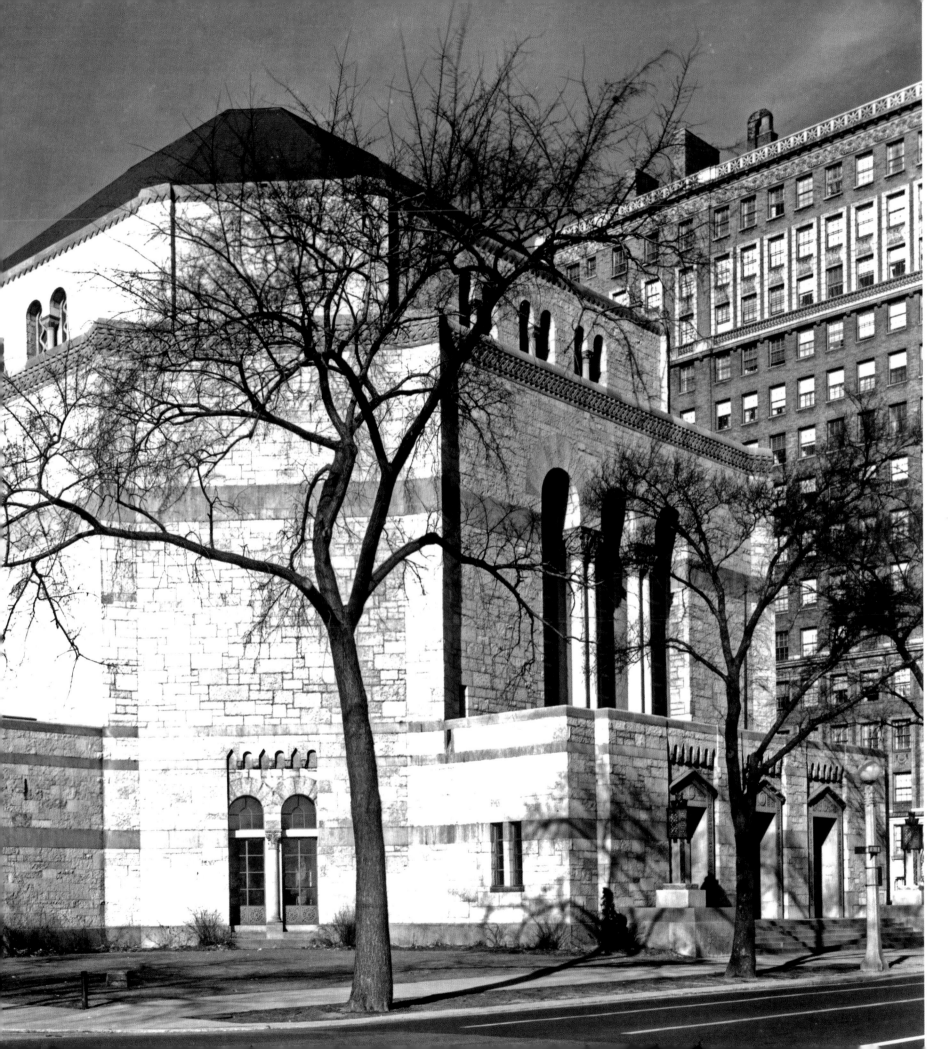

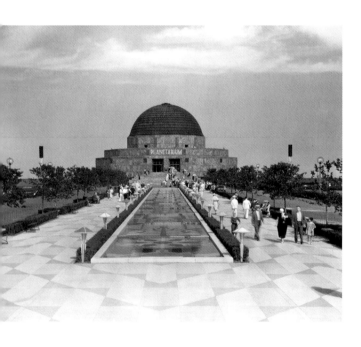

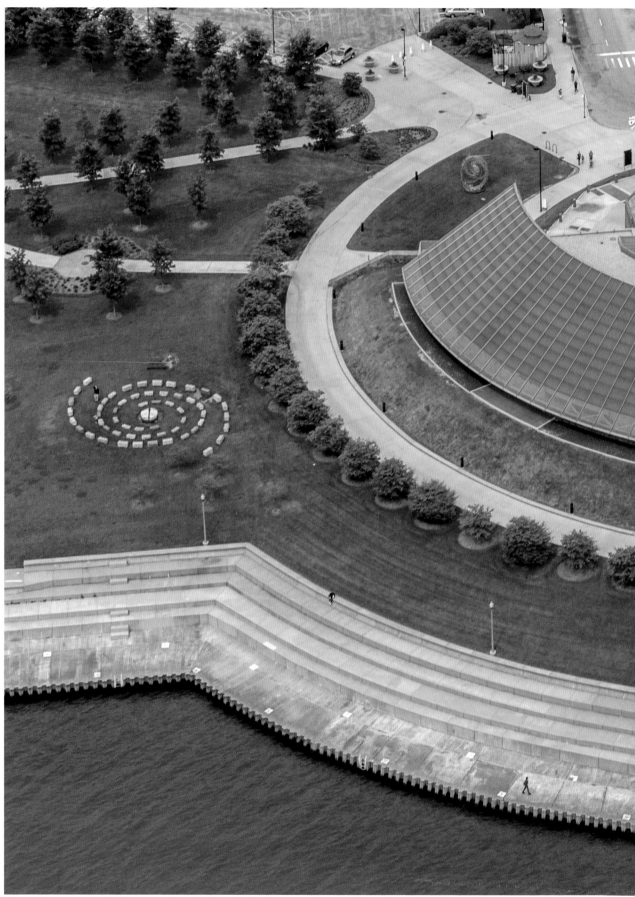

Ernest A. Grunsfeld Jr., Adler Planetarium and Astronomy Museum, 1300 South Lake Shore Drive, 1930, with concentric 1998–99 Sky Pavilion by Lohan Associates. Photos: Shown at the 1933 World's Fair (left), Hedrich Blessing Collection, Chicago History Museum, HB-01727-F; May 15, 2010 (right), © Tigerhill Studio Corp., John T. Hill, Tigerhill Aerial 5254-00021.

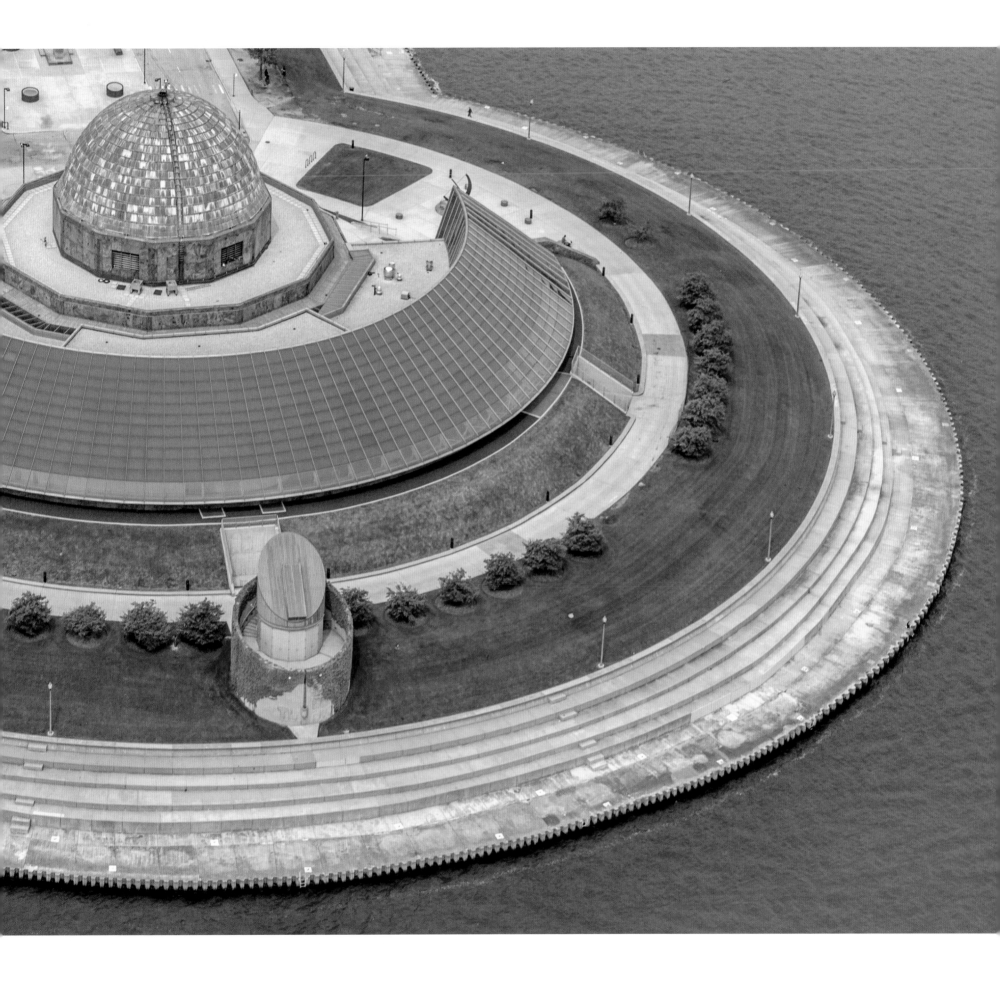

Century of Progress International Exposition, 1933 (demolished). Clockwise from left: The Chrysler Building, at night, by Holabird & Root; the cable-stayed roof of the Travel and Transport Building by Bennett, Parsons and Frost; and the Streets of Paris concession by Andrew Rebori. The Streets of Paris featured an entry that alluded to the ocean liner *S.S. Normandie* and streetscapes that included, according to the publicity statement, "Picturesque cigarette girls, artists, and the curious folk that throng the streets. . . ." Photos: Hedrich Blessing © Chicago Historical Society, Chrysler HB-01718-X, ArcaidImages.com 70001-50-1 and Travel and Transport HB-00770-B2, ArcaidImages.com 70565-10-1.

"Meet Me in Paris" *Normandie* ocean liner–themed photo: Kaufmann & Fabry Co., Chicago History Museum, ICHi-19911. (Right) "Picturesque cigarette girls . . . ," June 1, 1933. Photo: Chicago History Museum, ICHi-74024.

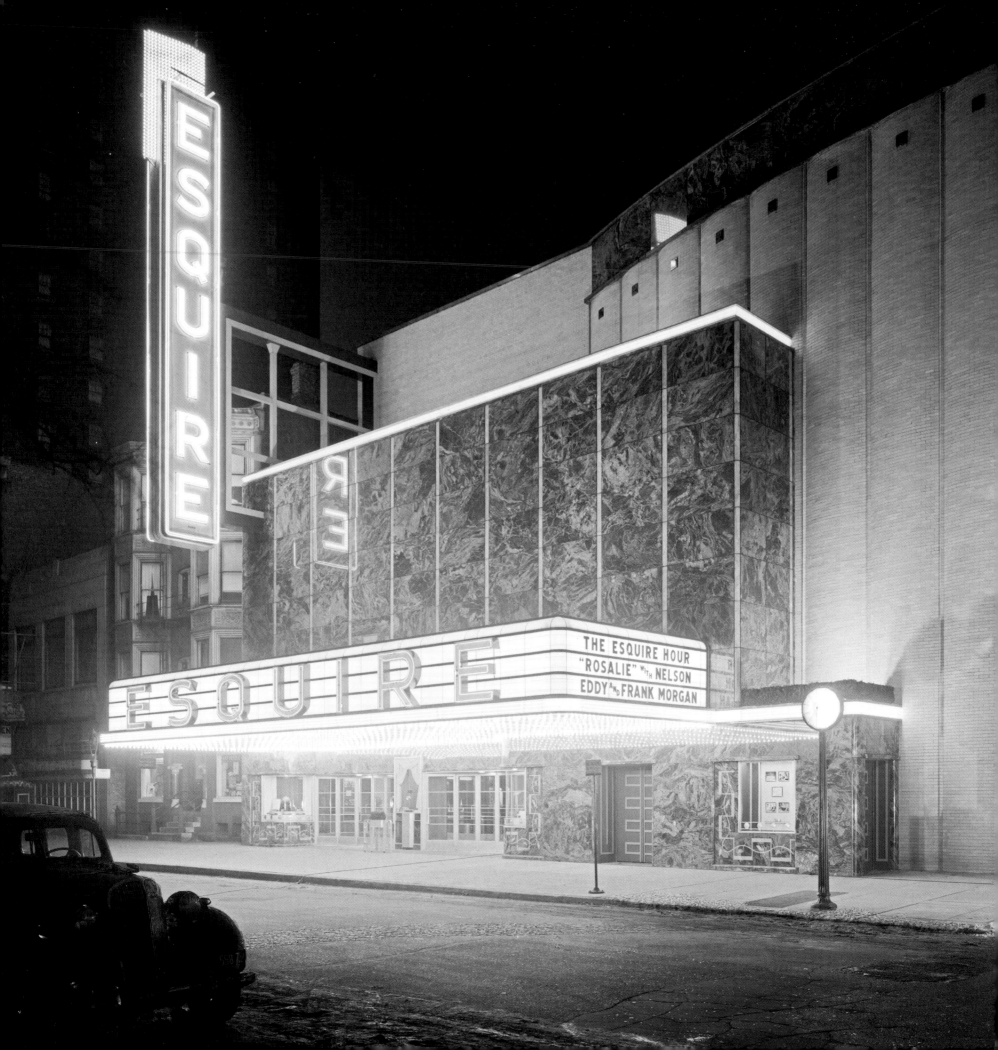

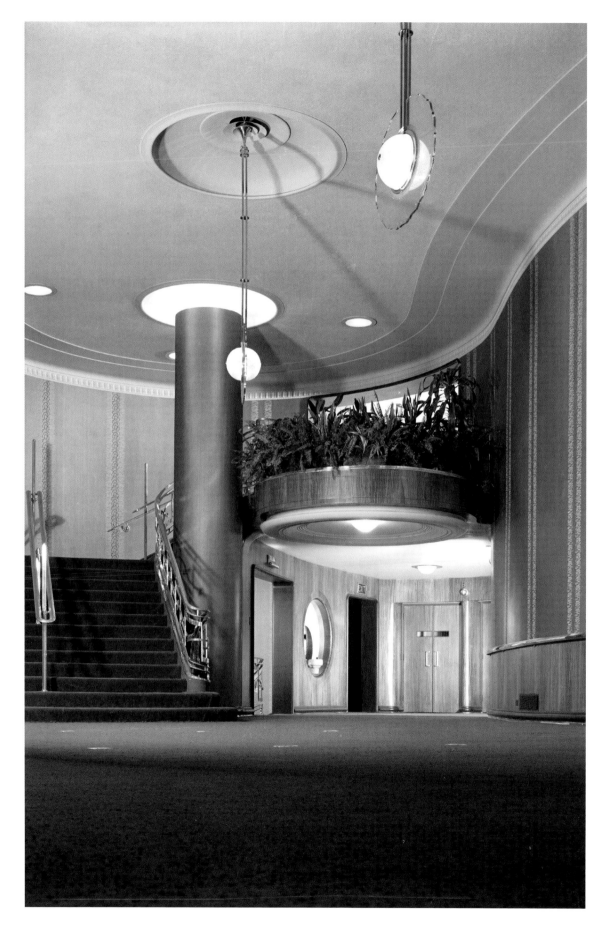

189

William and Hal Pereira, Esquire Theater, 58 East Oak Street, 1938, (now greatly altered). William Pereira (1909–1985) spent most of his career afterward in Los Angeles, including being part of the team that designed the Theme Building at Los Angeles International Airport (1961) and the Transamerica Tower (1972) in San Francisco. Photos: March 5, 1938, Hedrich Blessing Collection, Chicago History Museum, HB-04606-C and HB-04606-B.

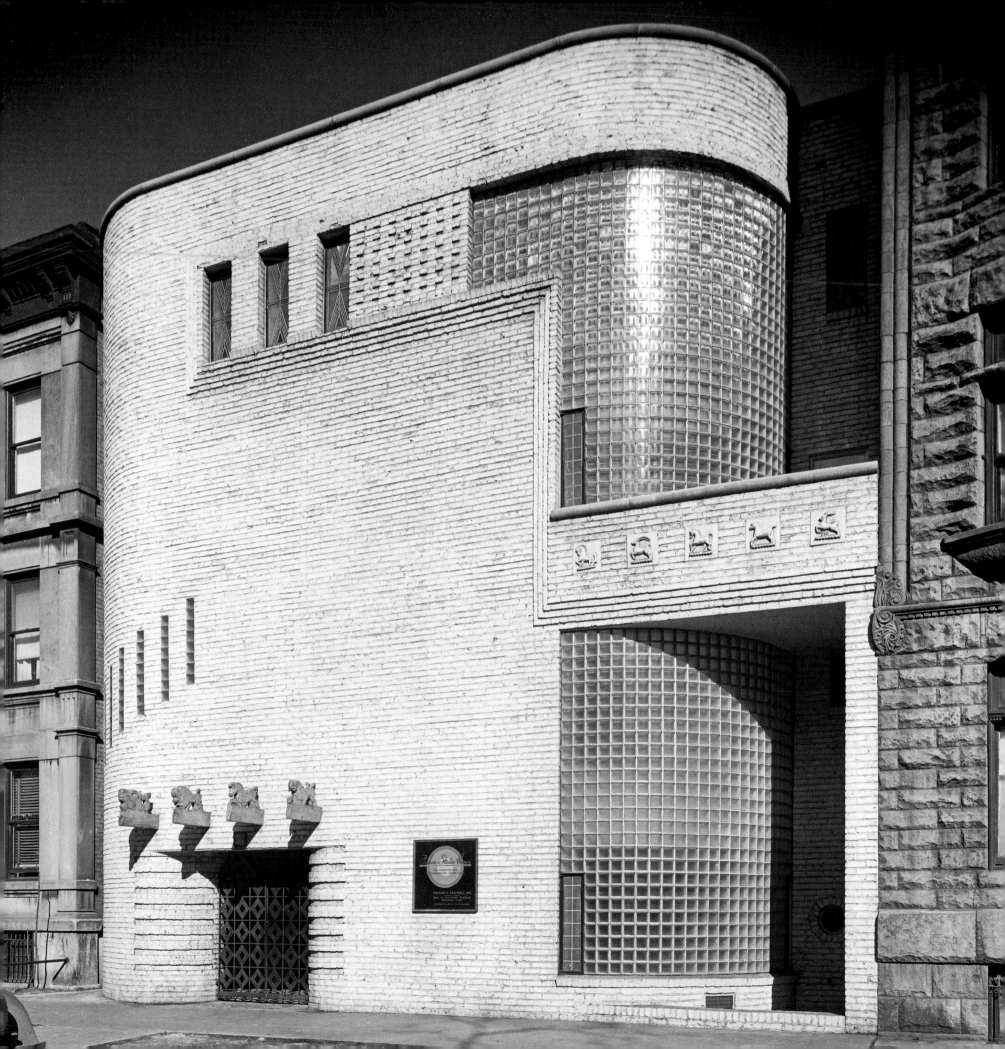

Andrew Rebori and Edgar Miller, Fisher Studio Houses, 1209 North State Parkway, 1937. Photo: William Hedrich, Hedrich Blessing Collection, Chicago History Museum, HB-03929-A.

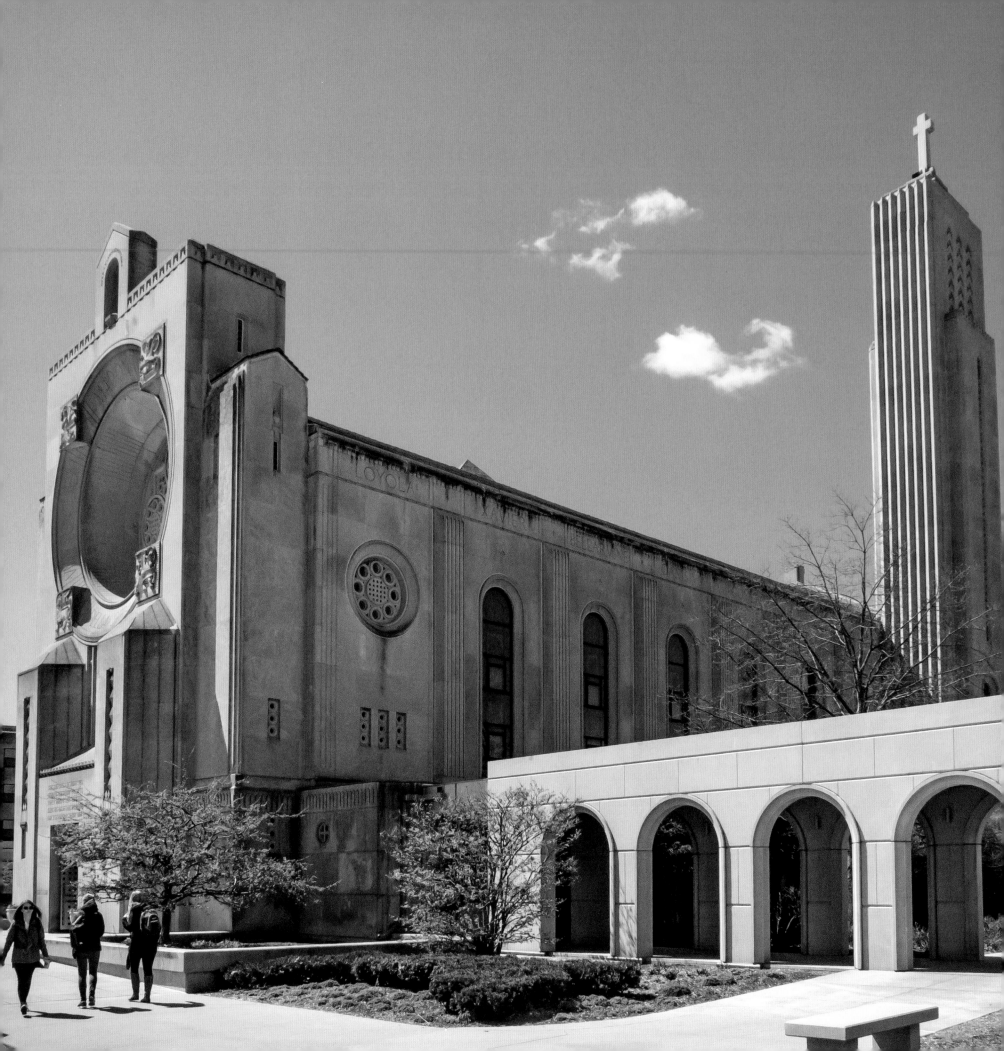

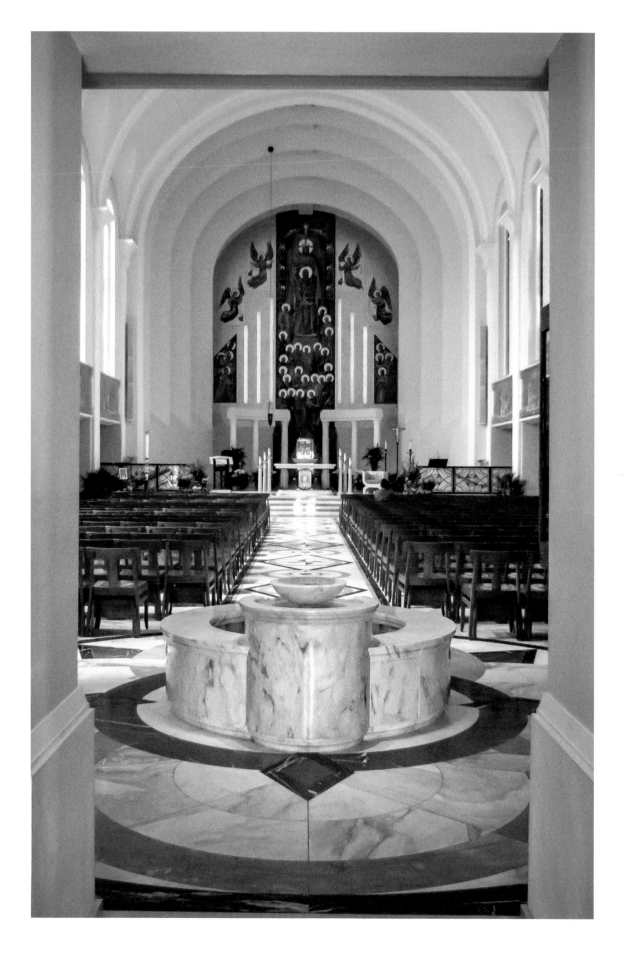

193

Andrew Rebori, Madonna della Strada Chapel at Loyola University, northeast of North Kenmore Avenue off Sheridan Road on the university campus, 1939. Photos: © John Gronkowski.

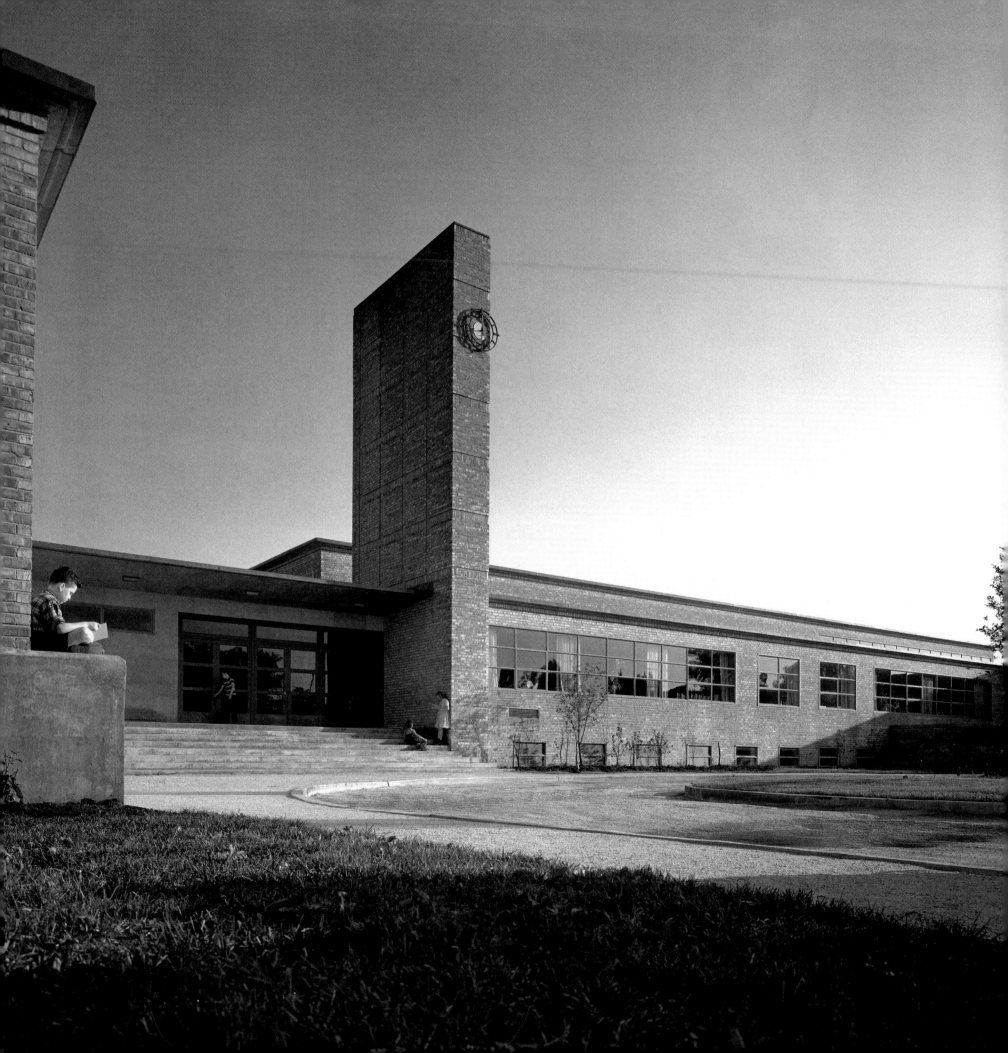

Left:
Eliel and Eero Saarinen with Perkins, Wheeler & Will, Crow Island
School, 1112 Willow Road, Winnetka, 1940. This primary school
was important for instituting progressive ideals in planning, with large
windows, low ceilings as in residential architecture, brightly colored
decorations, and movable furniture, all impacting on future schools.
It also set the stage for Perkins, Wheeler & Will, later Perkins & Will,
to be leaders in postwar school design. Photo: Kenneth A. Hedrich,
taken November 25, 1940, Hedrich Blessing Collection, Chicago
History Museum, HB-06184-Y.

Above:
The Austin Company, Douglas Factory at Orchard Field (now Chicago
O'Hare International Airport), 1943 (demolished). Constructed of
nonstrategic materials, the factory built large four-engine C-54 (DC-4)
transports, though it was dramatically photographed from underneath a
Douglas C-47 (essentially DC-3) twin-engine transport. Photo: United
States Air Force, Chicago History Museum, ICHi-26532.

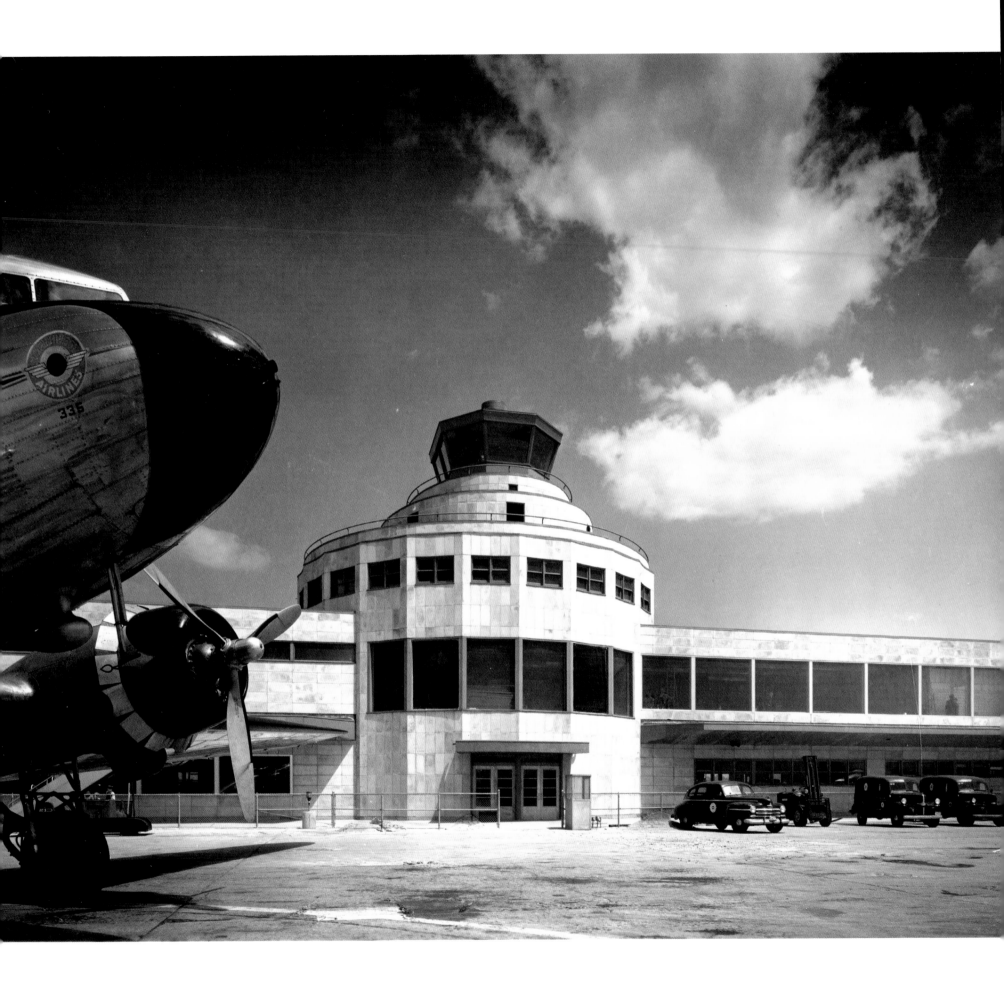

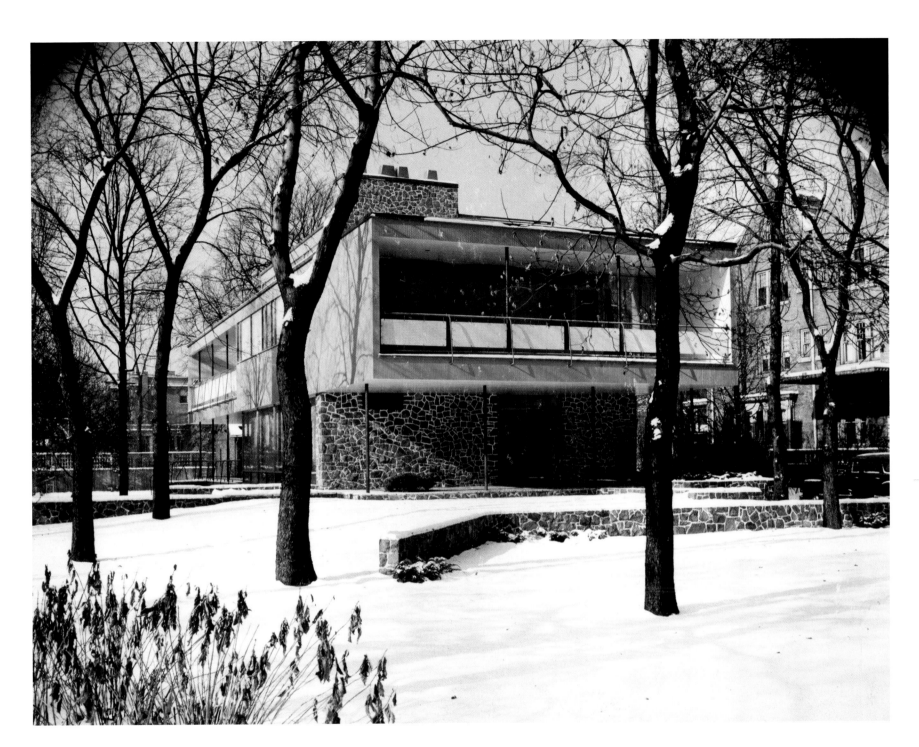

Left:
Paul Gerhardt Jr., Midway Airport Terminal, Cicero Avenue, 1947
(demolished). Photo: July 16, 1947, Hedrich Blessing Collection,
Chicago History Museum, HB-10147-H.

Above:
Ralph Rapson and John van der Meulen, Willard Gidwitz House, 4912
South Woodlawn Avenue, 1946. Photo: John van der Meulen Papers,
Ryerson and Burnham Archives, The Art Institute of Chicago. Digital
File # 200403_141223-001.

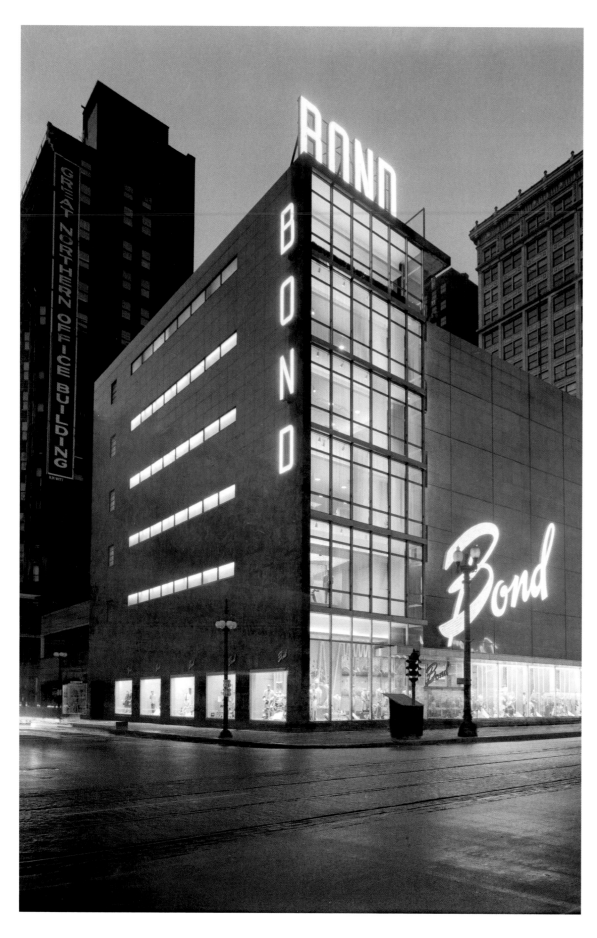

200

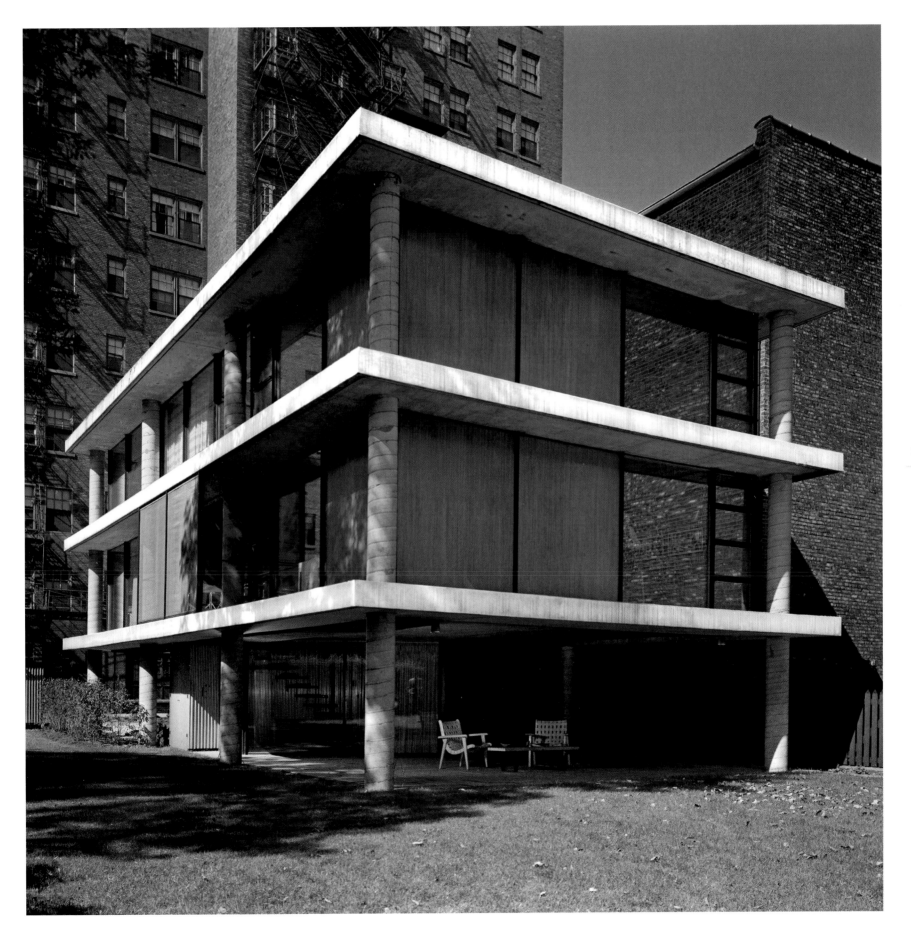

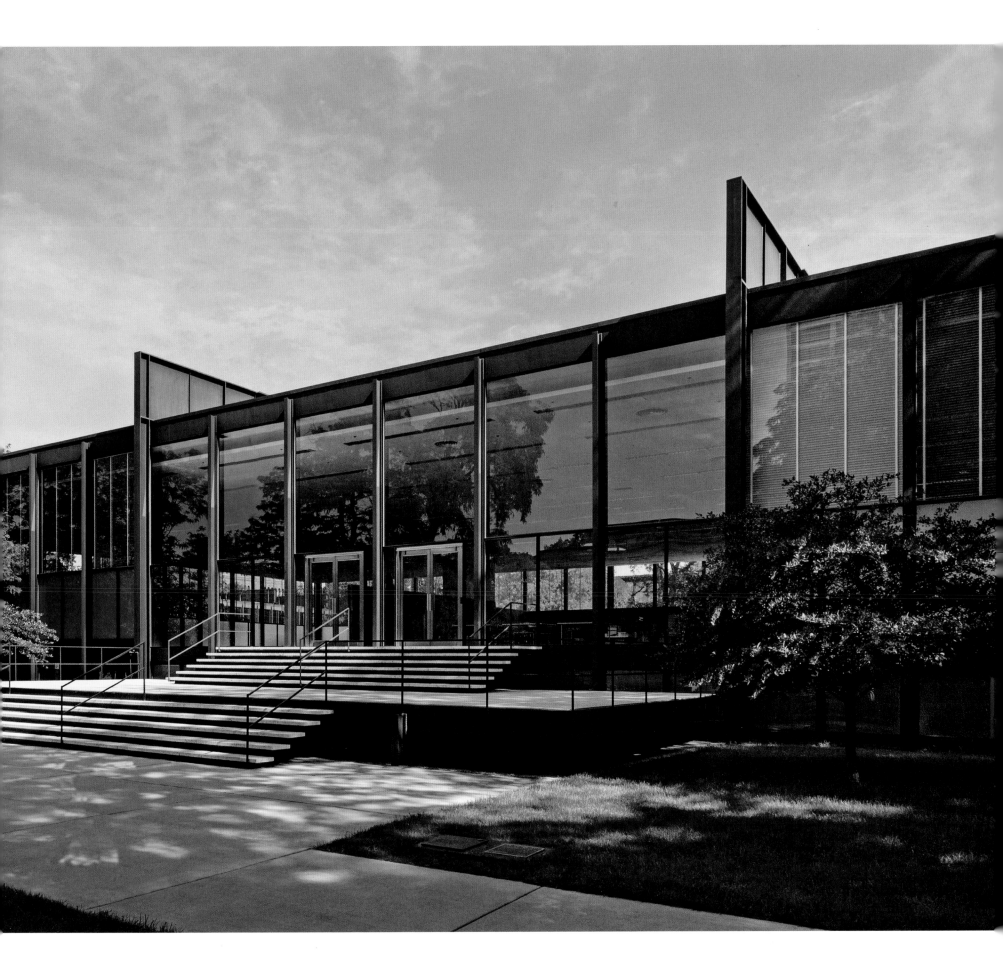

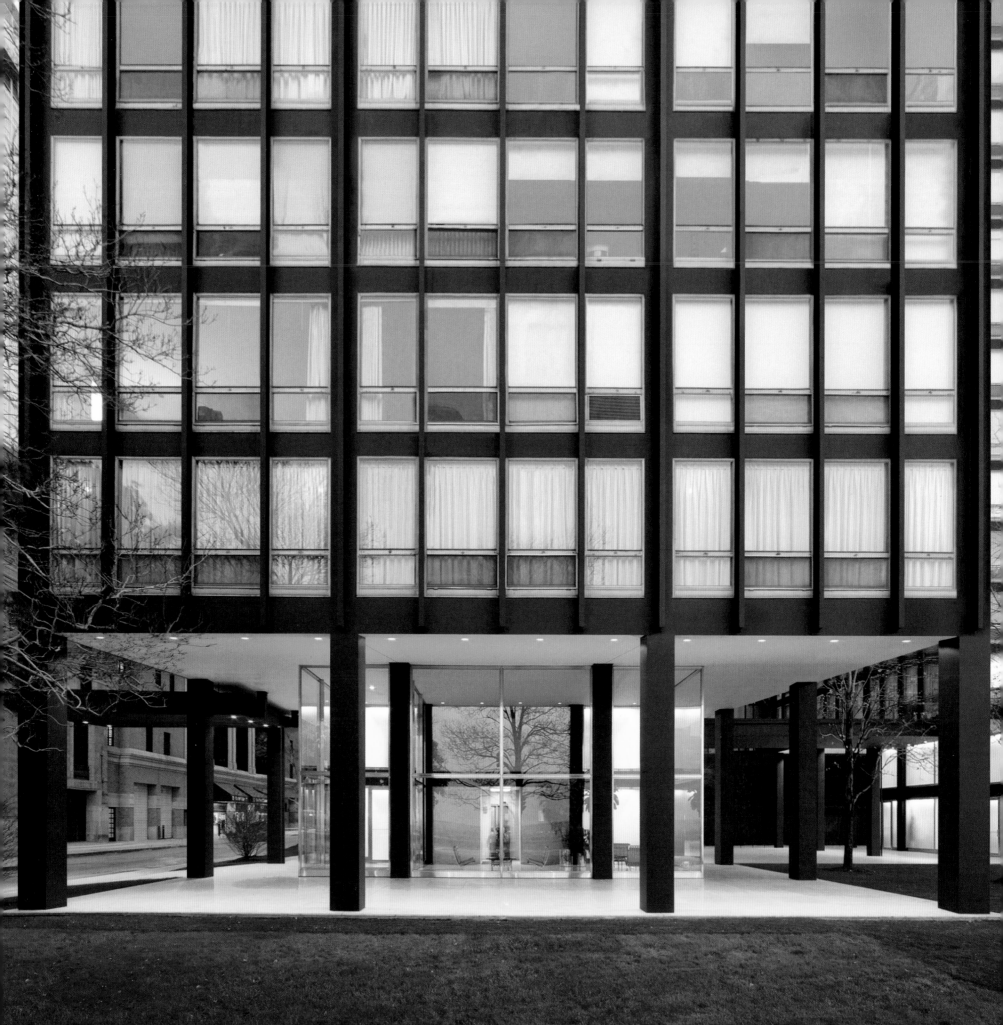

THE SECOND SCHOOL OF CHICAGO ARCHITECTURE AND POSTWAR AMERICAN MODERNISM

Ludwig Mies van der Rohe and his émigré colleagues such as Ludwig Karl Hilberseimer (1885–1967) and Walter Peterhans (1897–1960) infused Bauhaus design and teaching principles into the curriculum at Armour Institute of Technology in 1938, renamed two years later as the Illinois Institute of Technology/IIT. Their seeds soon took root with younger architectural students who became important practitioners of Miesian minimalism, such as Daniel Brenner (1917–1977), Jacques Brownson (1923–2012), George Danforth (1916–2007), Joseph Y. Fujikawa (1922–2003), Myron Goldsmith (1918–1996), David Haid (1928–1993), A. James Speyer (1913–1986), and Gene Rudolph Summers (1928–2011).

Beyond buildings at IIT, Mies also developed his own practice in skeletal high rises, first with the concrete Promontory Apartments (1949) and next, most importantly, in 860–880 Lake Shore Drive (1951). These latter steel-and-glass buildings heralded a new era for high rises in Chicago and, arguably, the world. Mies himself created variants with design improvements in the adjacent Esplanade Apartments at 900–910 Lake Shore Drive (1955) and other residential towers built for farsighted developer Herbert S. Greenwald. The cool, universal image of these buildings sited within a plaza made their way into Mies office building projects, from New York's Seagram Building (1958) and the Chicago Federal Center (1959 and later) to Toronto's Dominion Centre (1969) and Chicago's One IBM Plaza (1971). The formula also unfortunately found expression in countless other structures by lesser talents. Despite Frank Lloyd Wright's quip that Mies buildings such as 860–880 Lake Shore Drive were "flat-chested architecture," they influenced buildings around the world. They led historian Carl Condit to categorize them as the Second Chicago School of Architecture, linking their simple, but visually powerful, modernity to the pioneer functionalists of the late nineteenth century.

Postwar Modernism in Chicago, however, was more than simply that practiced by Mies and his disciples in the 1950s and 1960s. Most significant in this was the firm of Skidmore, Owings & Merrill/SOM. SOM was founded in Chicago in 1936 by Louis Skidmore (1897–1962) and Nathaniel Alexander Owings (1903–1984), the two partners being joined by John Ogden Merrill (1896–1975) in 1939. The giant created by those three warrants comparison with Mies's small boutique office.

Mies employed about six people in 1950, and twenty people some five or six years later. He often partnered with other firms who were architects of record or associate architects, as with 860–880 Lake Shore Drive. That job was done in conjunction with Pace Associates and Holsman, Holsman, Klekamp and Taylor. By contrast, SOM became its own architectural and engineering giant, having more than 900 architects and support staff in the early to mid-1950s and buildings across the nation and abroad.

SOM's megaprojects were government ones, from work for the United States Atomic Energy Commission in planning and building Oak Ridge, Tennessee (1942–49 and later) to the Air Force Academy in Colorado Springs (1954–55 and later). Well-connected partners brought them more corporate and institutional work after they pioneered their own versions of postwar steel-and-glass Modernism in examples such as Lever House (1952) in New York, the Inland Steel Building (1957–58) in Chicago, and the Crown-Zellerbach Building (1959) at One Bush Plaza in San Francisco. Each of those is its own subtle variation of steel-and-glass design, shaped, respectively, by different partners in different

Left and overleaf:
Ludwig Mies van der Rohe, 860–880 Lake Shore Drive, 1951; lower level and lobby restored, Krueck & Sexton. Overlooking Lake Michigan, the apartment buildings at 860–880 Lake Shore Drive are the first realization of Mies's dream for a glass-and-steel skyscraper. The restoration returned the buildings to their original elegance and extended the useful life of the public areas. Photos: Exterior © William Zbaren, courtesy Krueck + Sexton; with view of original lobby, Hedrich Blessing Collection, Chicago History Museum, HB-13809-L5.

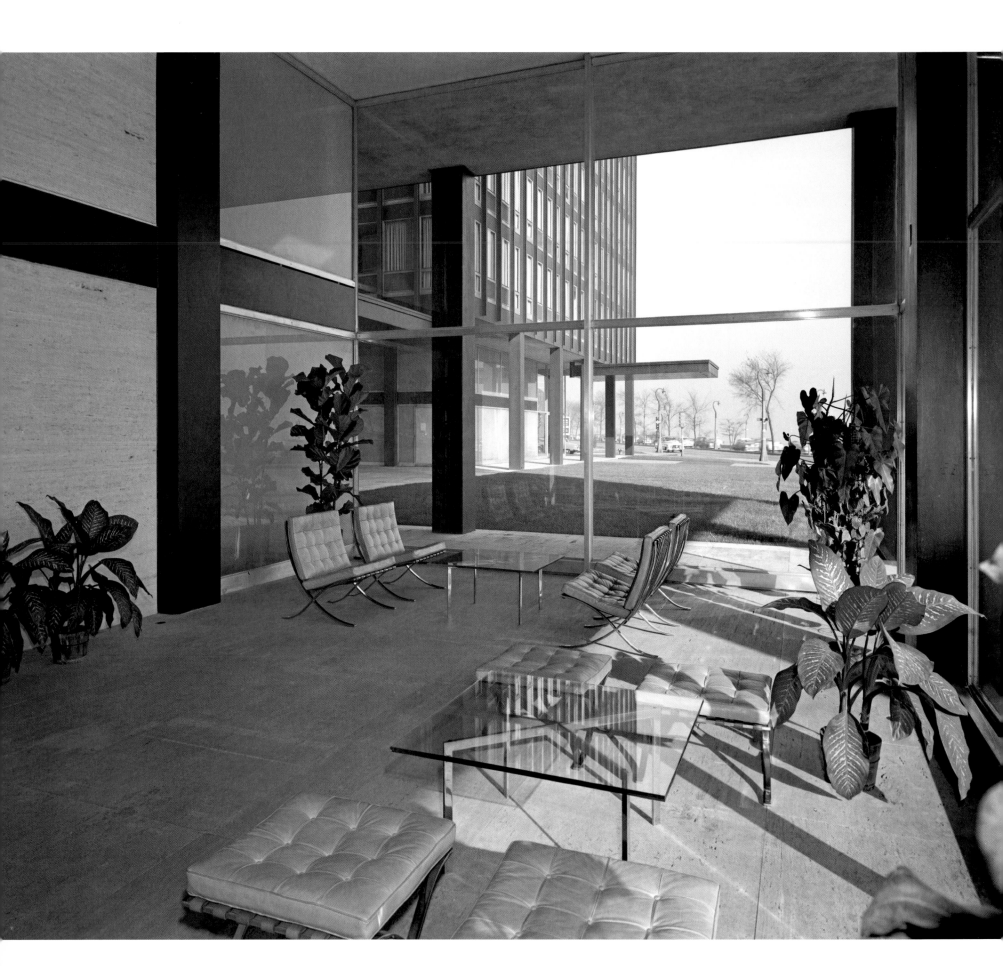

SOM offices—Nathaniel Owings in New York, Walter A. Netsch (1920–2008) and Bruce J. Graham in Chicago, and Edward C. Bassett (1921–1999) in San Francisco. If any American firm is the epitome of the corporate Modern look popularized in the television series *Mad Men* (2007–15) it was SOM.

With Mies's Second Chicago School style setting the international standard on one hand, and SOM's subtle pluralism on the other, there exists a range of interpretations that were "Modern" throughout Chicago. These include the more conservative 41-story expression of aluminum, glass, and limestone in Naess and Murphy's Prudential Building (1955), complete with a massive lobby with stainless-steel columns and pink Canadian granite, as well as the long-forgotten Stouffer's Restaurant and bar atop by Raymond Loewy (1893–1986); the importation of California-highway style in franchised McDonald's restaurants first built in suburban Des Plaines (1955; reconstructed on an adjacent site, 1985); and any number of rectilinear and curvilinear combinations of design forms, along with various combinations of building materials, seen in 1950s and 1960s structures by local firms such as Belli and Belli, Loebl, Schlossman and Bennett, and Perkins & Will, along with others who built in the Chicago region, such as Detroit-based Minoru Yamasaki (1912–1986).

While Modernism was happily percolating and procreating in its various design forms, two locally based, but highly influential, architects took their own distinct paths to design in the sixties and seventies—Bertrand Goldberg (1913–1997) and Harry M. Weese (1915–1998). Harvard- and Bauhaus-trained under Mies, Goldberg made his mark with creating centrally planned, curved concrete buildings, industrializing the poured-concrete process with fiberglass instead of wood formwork. His most famous structures are the twin towers of Marina City. They stand 65 stories or 587 feet high—the tallest reinforced-concrete buildings in the world when first constructed. The upper apartment floors feature units that radiate from the central core, culminating in overly generous curved balconies that spring off trapezoidal rooms. When opened, the building featured the latest in all-electric kitchen appliances. The lower floors of the towers have 450 automobile parking spots, and the base and adjacent buildings originally contained a theater, office building, shops, restaurants and even a boat marina on the river. Marina City's distinctive appearance has earned it the nickname Chicago's "Corn Cobs," though Goldberg's other buildings drew on a similar design vocabulary, from the Chicago Housing Authority's Hilliard Towers (1966) to River City (1986) and Prentice Women's Hospital (1975; demolished).

Goldberg's generally consistent style most likely developed from a very rational approach to problem solving, in a way comparable to Mies's design consistency. By contrast, Weese developed his own maverick signature style by creating a unique solution to every design problem. Weese's multifaceted training at the Massachusetts Institute of Technology, Yale University, and the Cranbrook Academy of Art under Eliel Saarinen may well have had something to do with that individualistic approach to design. Weese used a variety of materials and forms within his oeuvre. These range from the simple brick A-frame chapel appearance of the First Baptist Church in Columbus, Indiana (1965), through the circular concrete bunker of Chicago's Seventeenth Church of Christ, Scientist (1968), to the spectacularly coffered subway stations of the Washington, D.C., Metro (1976). His Chicago high rises defy Miesian minimalism and are unique solutions. These include the beautifully textured Cor-Ten steel-and-bronze glazed Time-Life Building (1968) and the triangular concrete Metropolitan

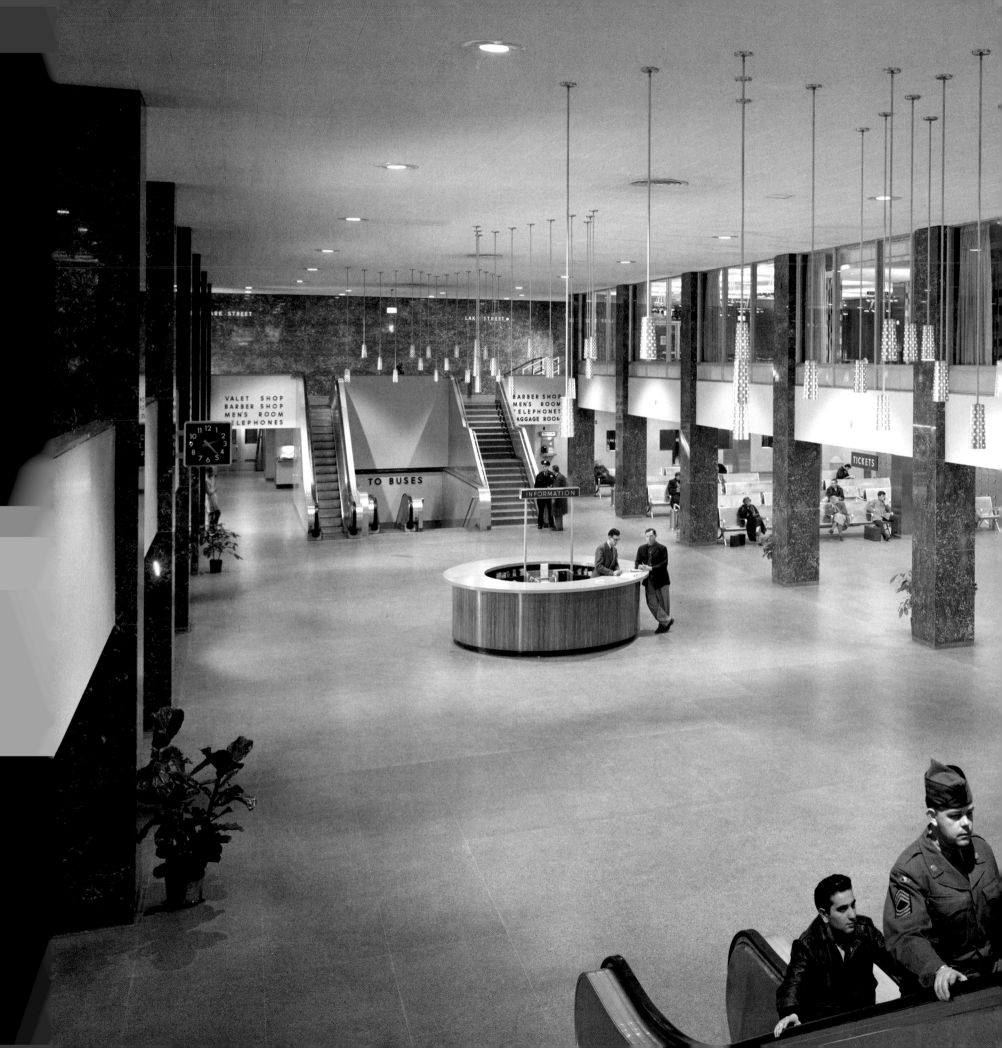

Skidmore, Owings & Merrill, Greyhound Bus Terminal, Clark and Randolph Streets, 1953 (demolished). Photo: June 26, 1953, Hedrich Blessing Collection, Chicago History Museum, HB-16086-B.

Correctional Center (1975), later officially the William J. Campbell United States Courthouse Annex, with its five-inch glazed slits for prison-cell windows and internal spaces that include double-story lounges more akin to dormitory design.

If architects such as Goldberg and Weese overtly went beyond the Miesian norm, then others built upon it to create new architectural forms. Perhaps the seed for this lies in buildings by Mies's followers, such as the sinuously curved Lake Point Tower (1968), by Schipporeit-Heinrich, or the work of Gene Summers and Helmut Jahn (born 1940) in the McCormick Place Convention Center (1969). These are two variants of what Mies himself planned but never built for a Glass Skyscraper (1922) and Convention Hall (1954), respectively. In a way, the last gasps of Modernism took place not long after Mies's death in 1969, with buildings such as those mentioned immediately above as well as Jahn's sleek Xerox Center (1980); Warren Platner's (1919–2006) dramatic glazed elevator shaft and interior of the Water Tower Place Mall (1976); and SOM's structural tour-de-force towers in the Hancock (1970) and Sears (1974; later re-named Willis). The latter two giants—record setters in their era—were the products of Bruce J. Graham and Fazlur Khan.

The real genius behind their construction lies with Kahn's experiments in tube design. There, outside walls are load-bearing ones, the four walls themselves creating a tube that reinforces itself as you ascend the tower. The angled, braced, or trussed tube of the Hancock was preceded by Khan using the framed tube in SOM's DeWitt Chestnut Apartments (1965). This and the Hancock were followed by the nine bundled tubes of varying height in the Sears Tower, each one supporting the other. Graham has stated that the design of the Hancock was intended to be the equivalent of an Eiffel Tower—a landmark for Chicago. With the design for the Sears Tower, said to have derived from an open pack of staggered cigarettes, Graham also talks about Sears in relation to the multiple towers of the Italian medieval hill town of San Gimignano for its landmark quality. The tube system developed by Khan impacted many skyscrapers afterward. It not only made the Sears Tower's world-record-holding height of 1,451 feet a reality from 1974 to 1996, it also informed the structural system used today in SOM's Burj Khalifa (2010) in Dubai at 2,717 feet high, currently the world's tallest.

Richard Bennett of Loebl, Schlossman and Bennett, Weiss Memorial Hospital, 4646 North Marine Drive, 1953. Photo: February 18, 1954, Hedrich Blessing Collection, Chicago History Museum, HB-16988-O.

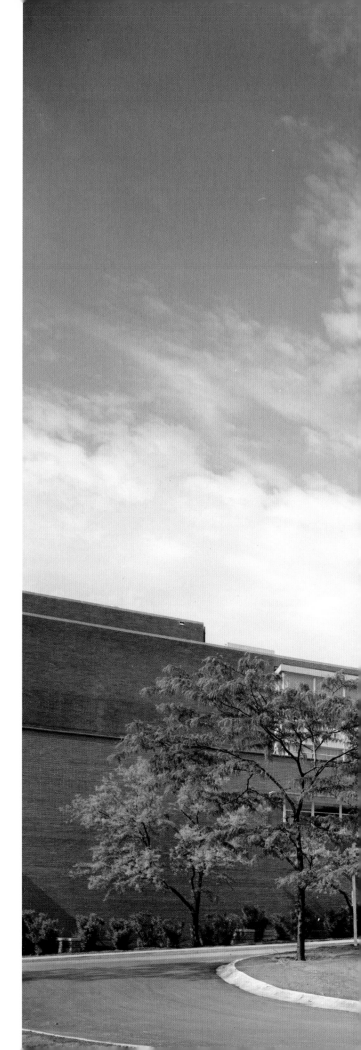

214

Naess and Murphy, Prudential Building, 130 East Randolph Street, 1955; with Raymond Loewy–designed Stouffer's Restaurant, 1956 (demolished). Photos: Exterior of the building, February 28, 1955, William Hedrich, Hedrich Blessing Collection, Chicago History Museum, HB-18500- G3, and lobby, HB-18500-J2; Stouffer's, October 15, 1956, Henry Hubert, Hedrich Blessing Collection, Chicago History Museum, HB-19824-J.

217

Left:
Stanley Meston, original designer, reconstruction of first McDonald's (now McDonald's #1 Store Museum), 400 Lee Street, Des Plaines (1985 reconstruction of the 1955 building shown here). These tiny standardized red and white-tiled buildings lit by neon metal arches, along with the slightly later parabolic neon sign with mascot "Speedee," were design elements that Ray Kroc used to successfully franchise these fast-food eateries across the nation. Photo: © John Gronkowski.

Right and overleaf:
Bruce J. Graham of Skidmore, Owings & Merrill, Inland Steel Building, 33 West Monroe Street, 1958. Photos: Hedrich Blessing © Chicago Historical Society, exterior HB-21235-B4, hallway HB-21235-H2A, and lobby HB-21235-I, all ArcaidImages.com, 70894-80-1, 70894-90-1, and 70894-100-1, respectively.

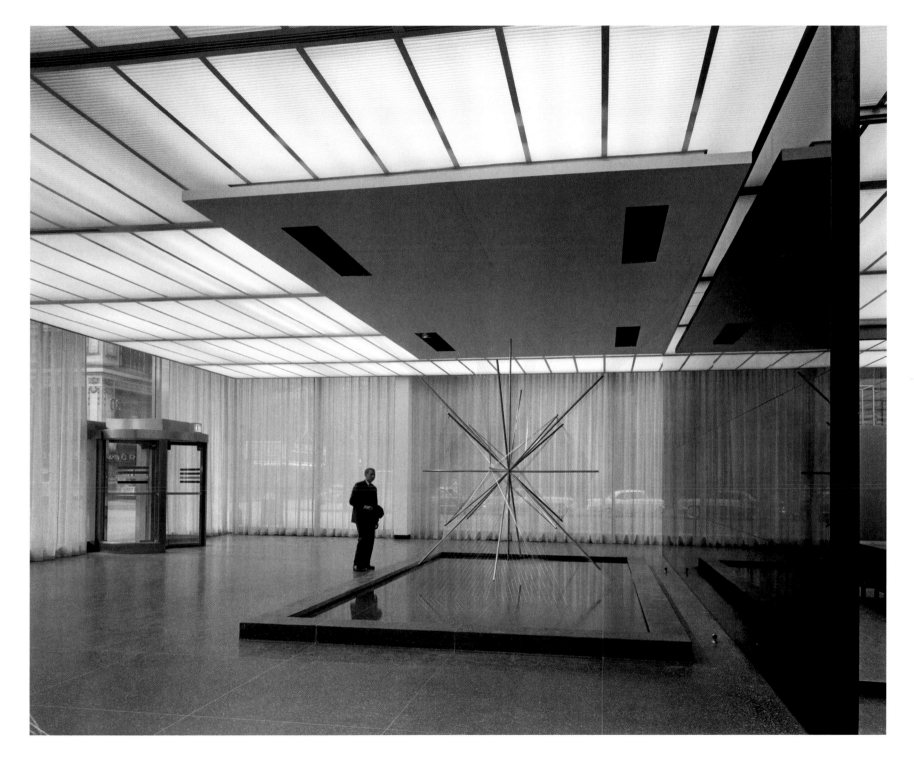

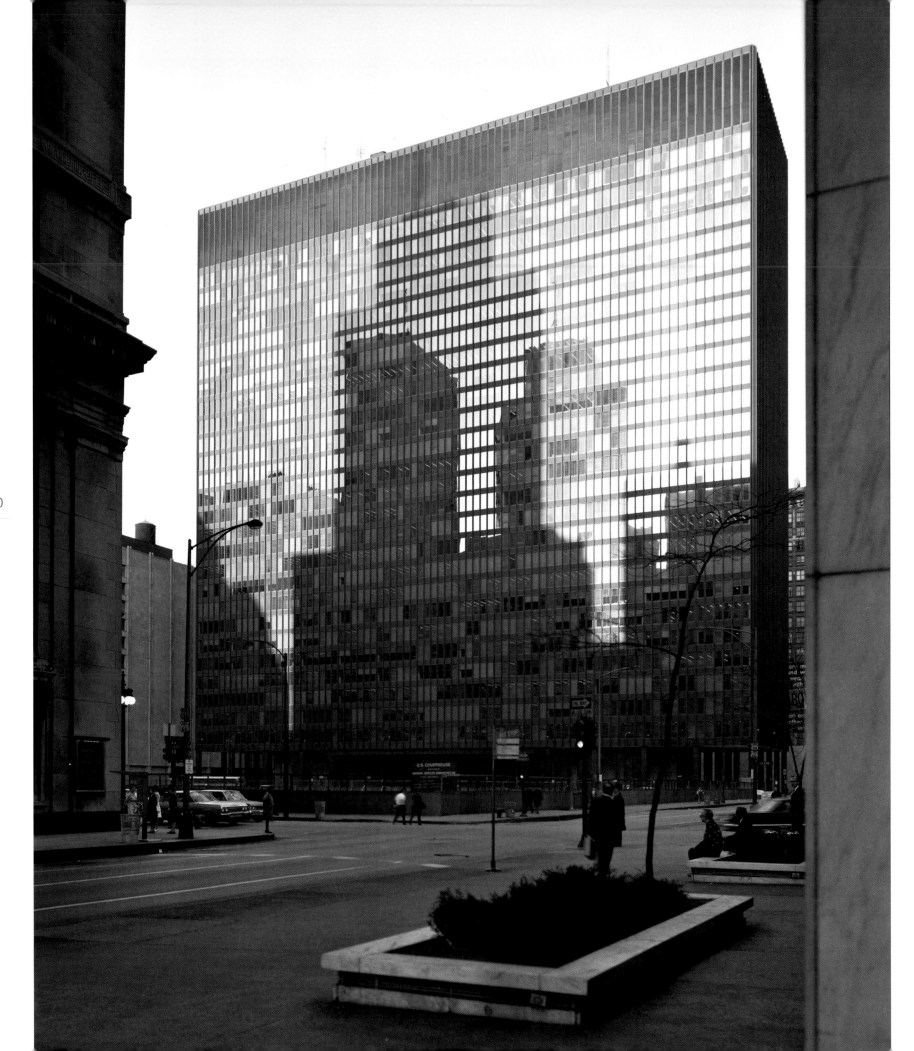

221

Left:
Ludwig Mies van der Rohe, with Schmidt, Garden and Erikson, C. F. Murphy Associates, and A. Epstein and Sons, Chicago Federal Center office building, courthouse, and post office, Adams, Jackson, Dearborn, and Clark streets, 1959 and later through 1975. The image shows the 30-story courthouse and office building, the Everett M. Dirksen Building, completed 1964. Photo: Hedrich Blessing © Chicago Historical Society HB-27043-R2, ArcaidImages.com 70894-140-1.

Right:
Jacques Brownson, C. F. Murphy Associates, Loebl, Schlossman and Bennett, and Skidmore, Owings & Merrill, Civic Center (Richard J. Daley Center), Washington, Randolph, Dearborn, and Clark Streets, 1965. The building is the result of a 1960 competition to accommodate 119 new city courtrooms. The generous plaza at its base has the famed Chicago Picasso (1967) sculpture, also fabricated of Cor-Ten steel, like the building. Photo: Hedrich Blessing © Chicago Historical Society, HB-25252-B8, ArcaidImages.com 70894-130-1.

Above:
C. F. Murphy and Associates, Chicago O'Hare International Airport,
1963; remodeled, 1999–2000, Murphy Jahn. Photo: Bill Engdahl,
Hedrich Blessing Collection, Chicago History Museum, HB-25500-B2.

Right:
Belli and Belli, St. Joseph's Hospital, 2900 Lake Shore Drive, 1961–
63. Photo: October 6, 1964, Robert Harr, Hedrich Blessing Collection,
Chicago History Museum, HB-27745-A.

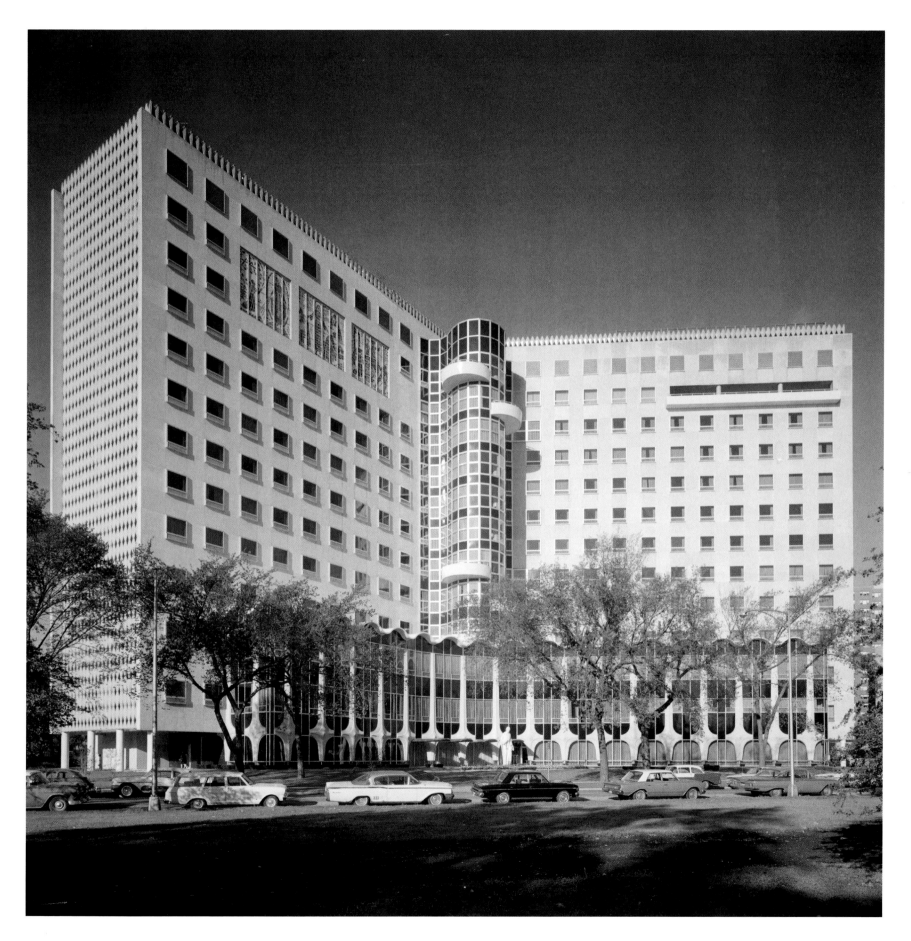

224

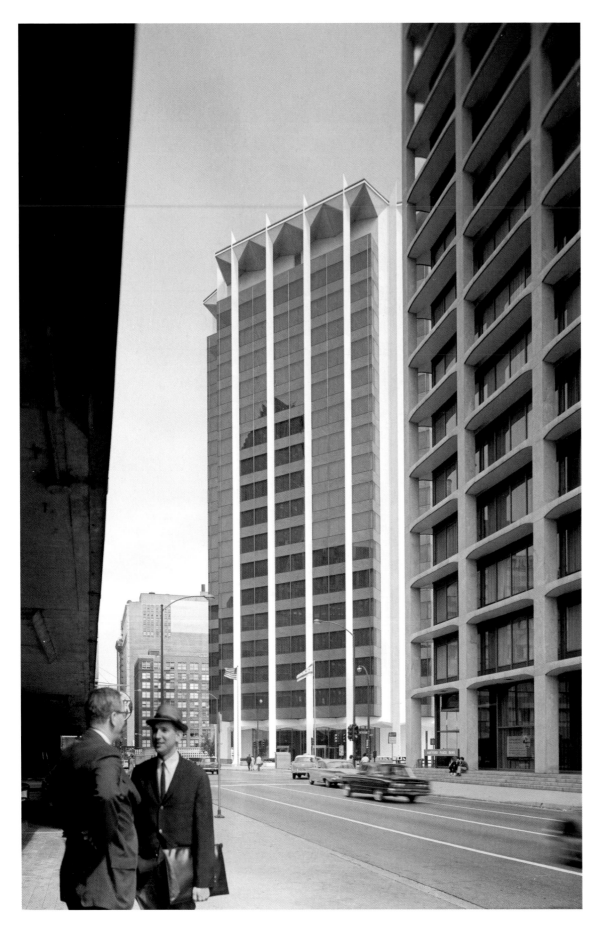

Left:
Perkins & Will, U.S. Gypsum Building, 101 South Wacker Drive, 1963 (demolished). Controversial from the start, the faceted marble-clad building sat within a 45-degree angle on the block. Architect Philip Will Jr. defended the design, in relation to blocklike steel-and-glass towers orthogonally sited in the grid, saying that his distinctive creation is more romantic, in the spirit of Frank Lloyd Wright. The image shows the U.S. Gypsum Building in the center background with the grid-like 100 South Wacker Drive building to the right, built in 1961 by Skidmore, Owings & Merrill. Photo: Hedrich Blessing Collection, Chicago History Museum, HB-26658-A2.

Right:
Minoru Yamasaki, North Shore Congregation Israel, 1185 Sheridan Road, Glencoe, 1964. Photo: June 1, 1964, Robert Harr, Hedrich Blessing Collection, Chicago History Museum, HB-26809-Q2.

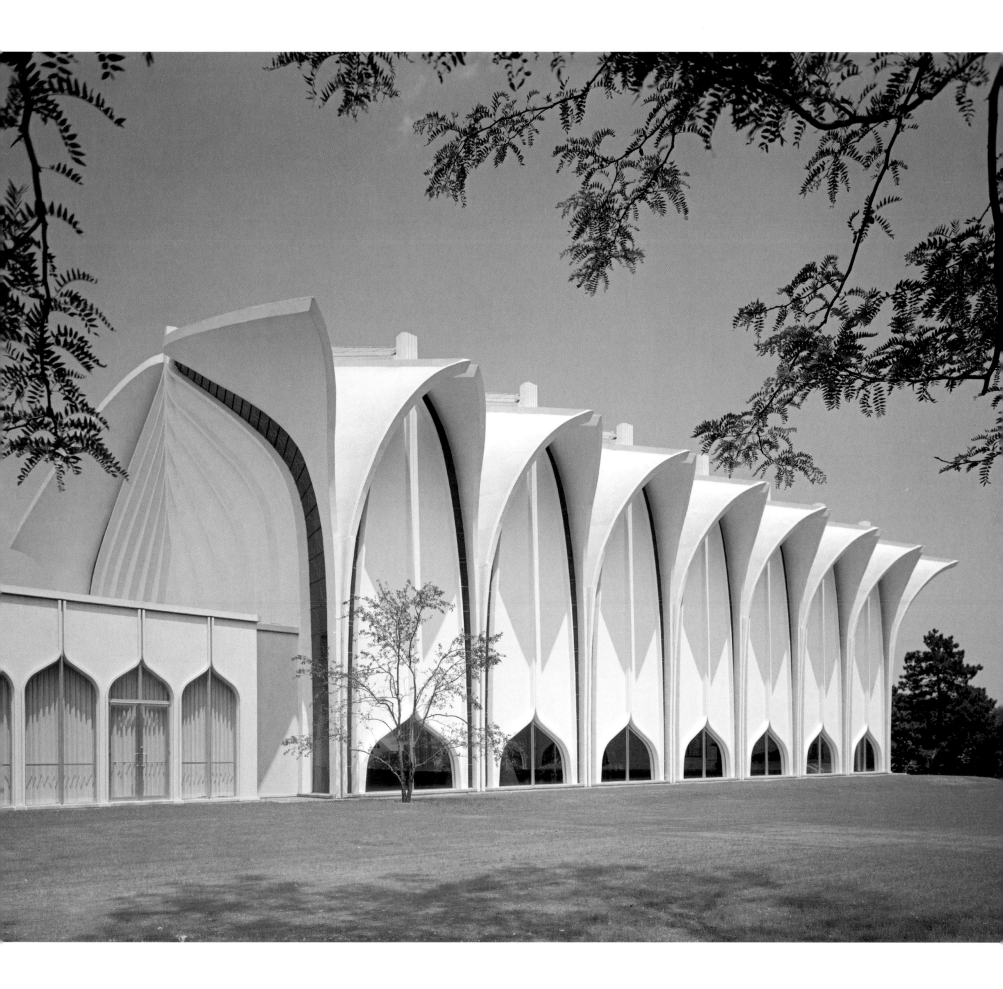

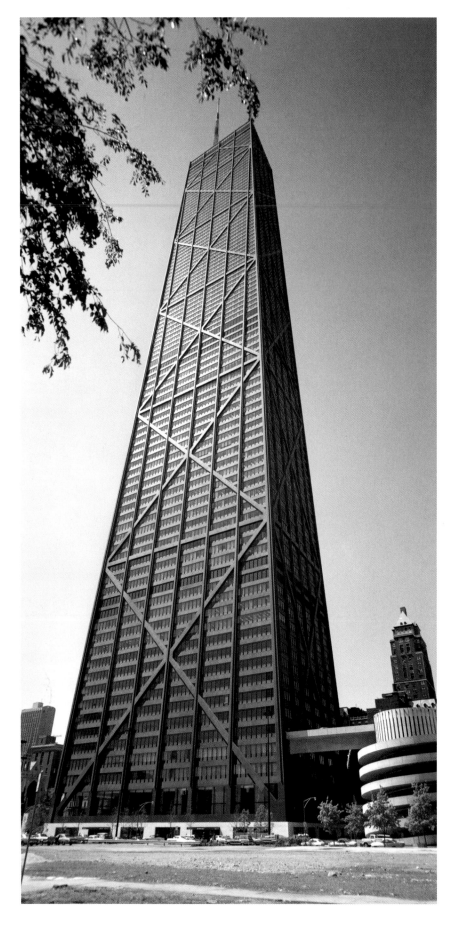

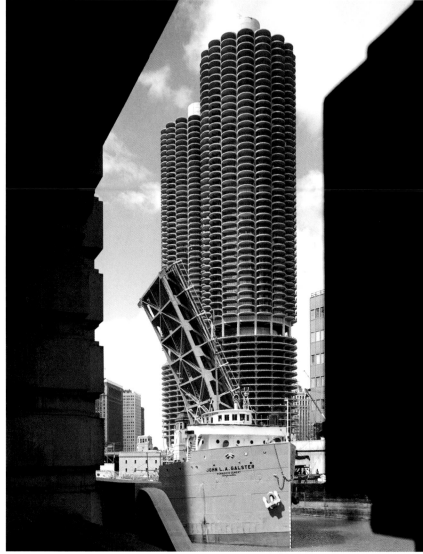

Left:
Bruce J. Graham with Fazlur Khan, Skidmore, Owings & Merrill,
John Hancock Center, 875 North Michigan Avenue, 1970. The
X-braces are said to derive from an Illinois Institute of Technology
thesis project by Mikio Sasaki (1964). This image shows the cylindrical
parking ramp that accesses six stories of garage above retail spaces.
The tower above has 27 floors of office space, a sky lobby with
services, apartments from the 45th to 92nd floors, with building
services and restaurant, bar, and observatory atop. Photo: July 31,
1972, Hedrich Blessing Collection, Chicago History Museum,
HB-31216-G3.

Above and Right:
Bertrand Goldberg, Marina City, 300 North State Street, 1967.
Marina City's twin towers, nicknamed "Corn Cobs," have helped put
Chicago's architecture on the international map. The towers were
featured on November 2, 2014, in Nik Wallenda's blindfolded skywalk,
broadcast around the world. Photos: Hedrich Blessing © Chicago
Historical Society, exterior HB-23215-X2, ArcaidImages.com 70000-
250-1; balcony HB-23215-E6, ArcaidImages.com 70894-110-1;
kitchen HB-23215-P3, ArcaidImages.com 70894-120-1.

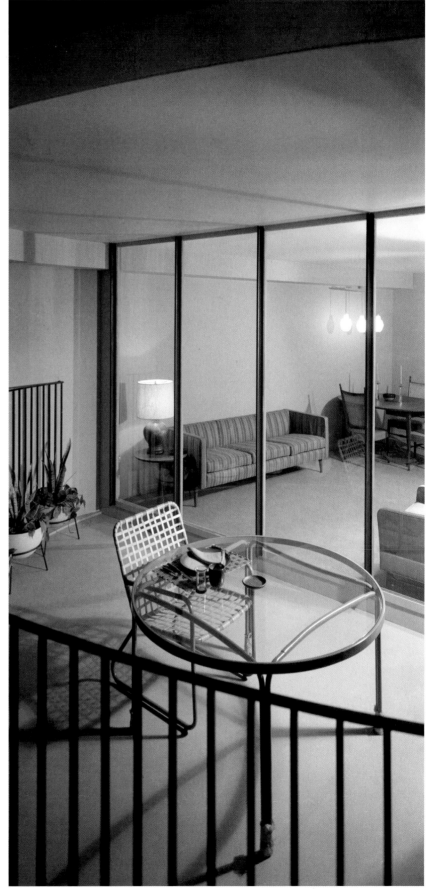

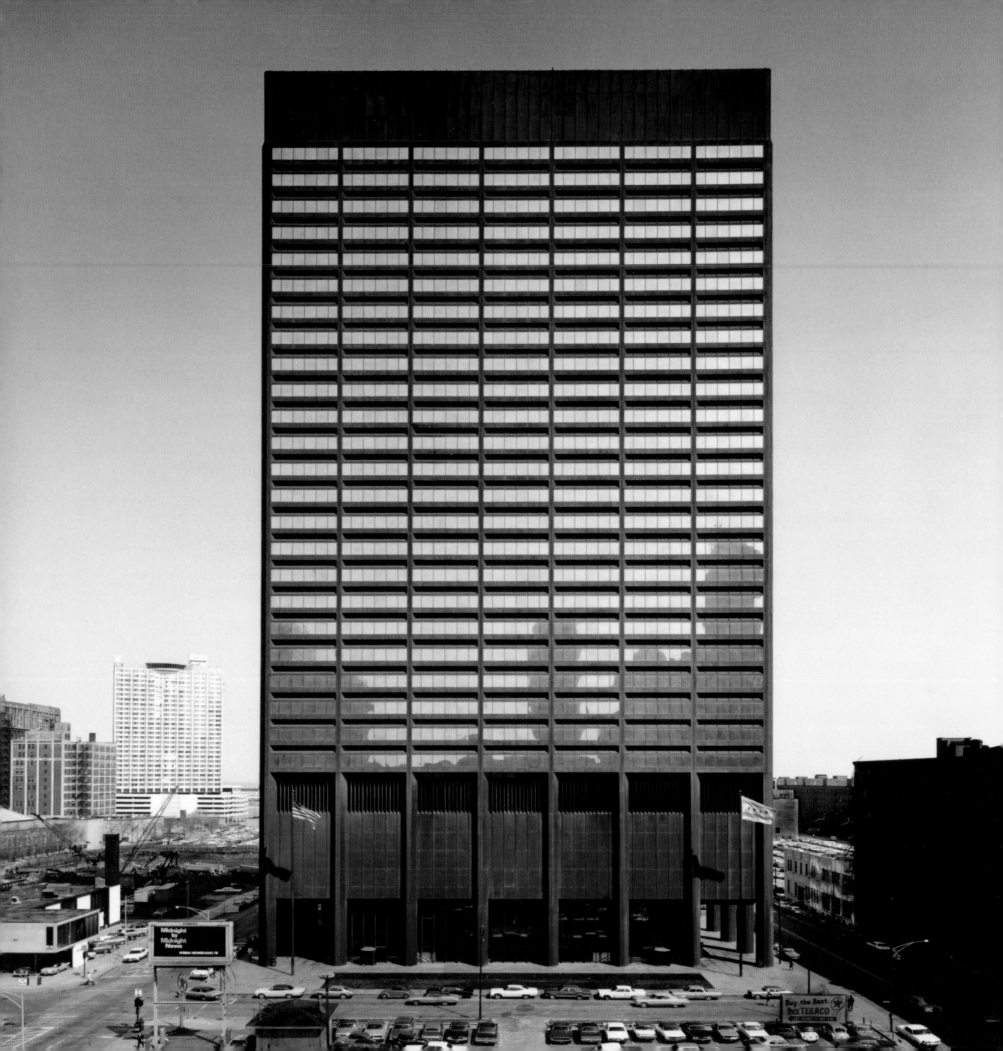

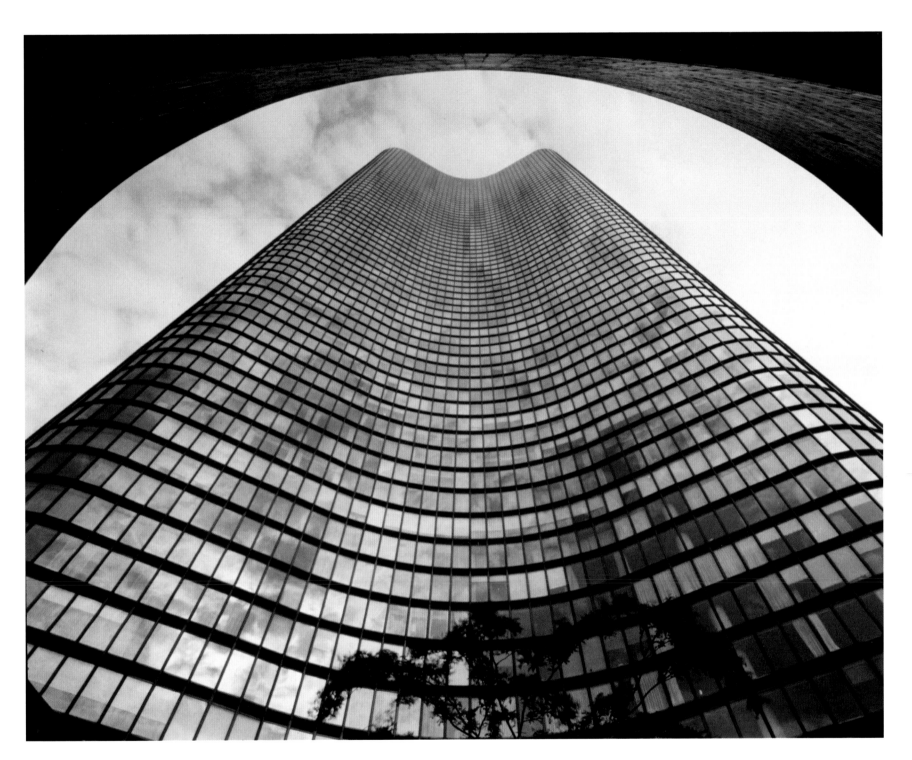

Left:
Harry Weese, Time-Life Building, 541 North Fairbanks Court, 1968.
Photo: Hedrich Blessing © Chicago Historical Society, HB-33664-A2,
ArcaidImages.com 70894-160-1.

Above:
Schipporeit-Heinrich with Graham, Anderson, Probst & White, Lake
Point Tower, 505 North Lake Shore Drive, 1968. Photo: Hedrich
Blessing © Chicago Historical Society, HB-28204-W2,
ArcaidImages.com 70001-160-1.

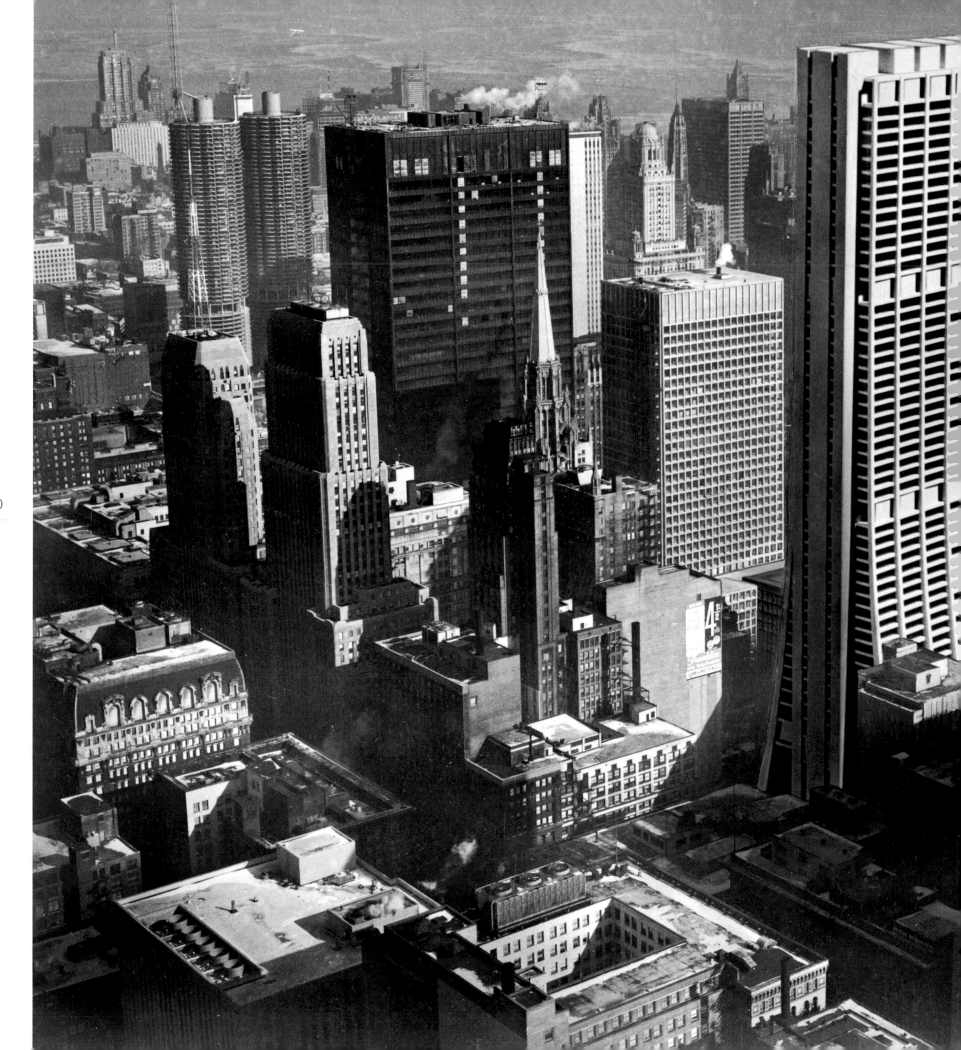

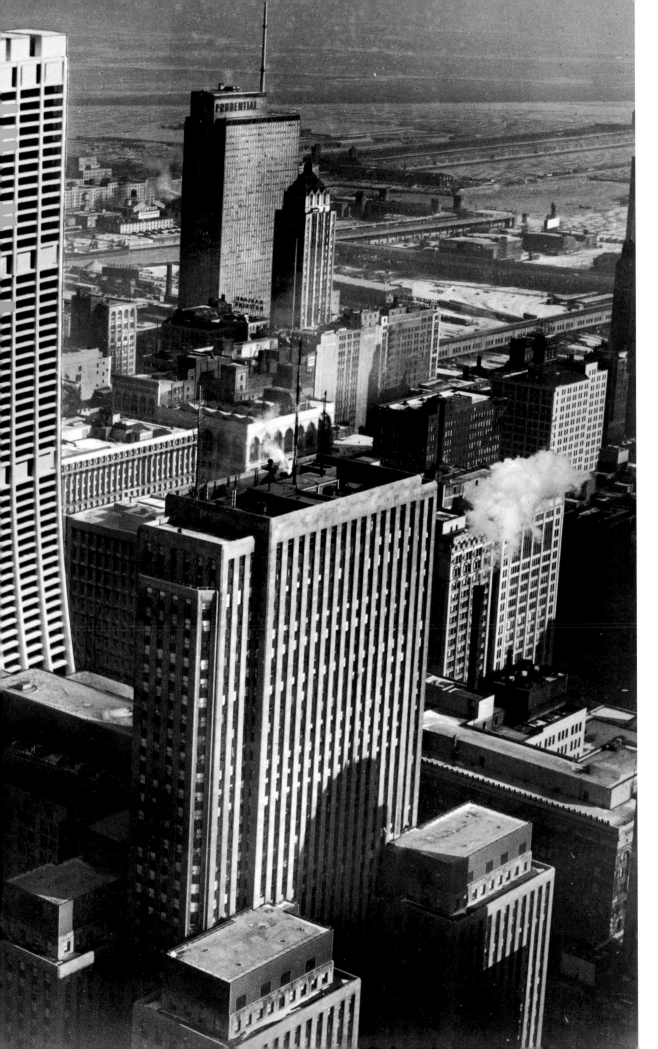

C. F. Murphy Associates with Perkins & Will, First National Bank Building (now Chase), Madison Street between Dearborn and Clark Streets, 1969. The curved facade accommodated public functions of the bank on the larger lower floors with offices above on the smaller ones. The adjacent site had the D. H. Burnham–designed First National Bank of Chicago (1896), which was demolished for a new plaza with Marc Chagall's *Four Seasons* mosaic-sculpture. The view shows the Prudential Building (1955) to the right of First Chicago and the Field Building (1933–34) in the lower right foreground, among other Loop skyscrapers. Photo: Hedrich Blessing Collection, Chicago History Museum, HB-28541-J2.

Above:
C. F. Murphy and Associates, McCormick Place, 2301 South Lake Shore Drive, 1969–71. The construction of this building with its open 300,000-square-foot exhibit hall helped make Chicago one of the convention capitals of the United States. Additional exhibition buildings on or near this campus by SOM (1986), Thompson, Ventulett, Stainback and Associates/TVS and A. Epstein and Sons (1996 and 2007) all reinforce that status. Photo: Hedrich Blessing Collection, Chicago History Museum, HB-34600-F3.

Right:
Bruce J. Graham with Fazlur Khan, Skidmore, Owings & Merrill, Sears (now Willis) Tower, 225 South Wacker Drive, 1973–74. Photo: November 2, 1973, Bob Harr, Hedrich Blessing Collection, Chicago History Museum, HB-37734-E.

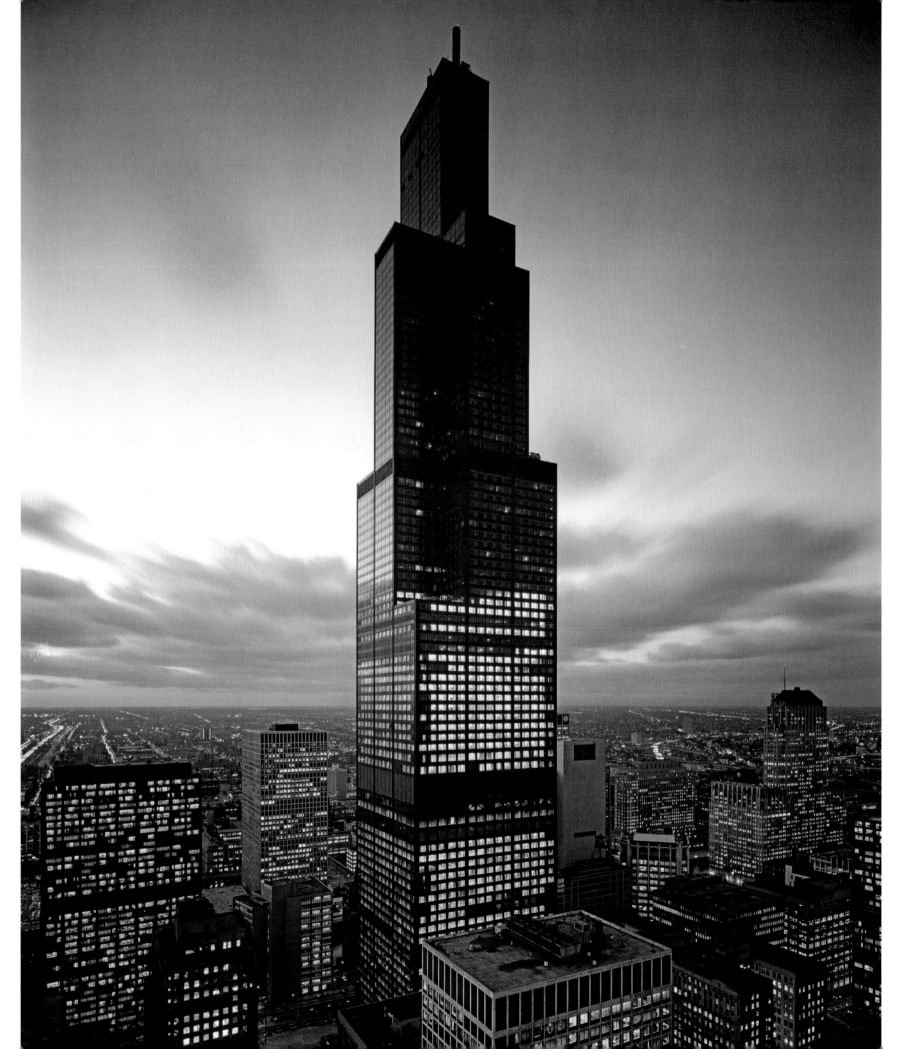

234

Harry Weese, Chicago Metropolitan Correctional Center (William J.
Campbell U.S. Courthouse Annex), 71 West Van Buren Street, 1975.
Photos: Hedrich Blessing © Chicago Historical Society, exterior HB-
39636-D and double-story lounge HB-39636-G, ArcaidImages.com,
70894-170-1 and 70894-180-1, respectively.

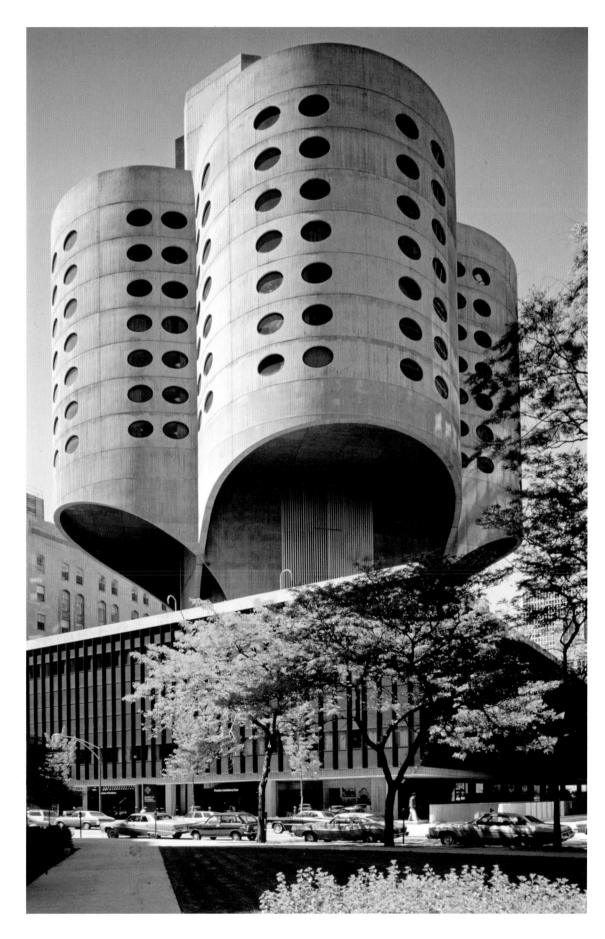

Bertrand Goldberg Associates, Prentice Women's Hospital, 333 East Superior Street, 1975 (demolished). Reminiscent of the preservation protests of the 1960s and 1970s that fought demolition of Sullivan buildings, preservationists recently argued to save this distinctive Goldberg design. They battled city hall and Northwestern University's Medical Center and even waged a social-media campaign with a Facebook page that had more than 3,400 likes. Despite their efforts, the building was demolished in 2014, and the site awaits further hospital development. Photo: Hedrich Blessing Collection, Chicago History Museum, HB-39160-I.

Left:
Loebl Schlossman Dart and Hackl with C. F. Murphy Associates and Warren Platner, Water Tower Place, with its atrium mall, 845 North Michigan Avenue, 1976; renovated, 2001, Wimberly, Tong and Goo. This multiuse complex of hotel, apartments, and seven-story shopping mall contains one of the first and most successful urban malls in the nation, having some 20 million visitors and shoppers annually. Photo: John Zukowsky.

Right:
Helmut Jahn of C. F. Murphy Associates/Murphy Jahn, Xerox Center, 55 West Monroe Street, 1980. The 40-story complex of enameled aluminum panels and glass, over a reinforced concrete structure, was originally designed as twin towers. They would have acted as a visual gateway, but only one was built. Photo: Rainer Viertlboeck, courtesy Jahn.

THE POWER OF THE PAST: POSTMODERN CHICAGO

1976 was a game-changing year in the United States. It was the year of the nation's bicentennial, which witnessed historically related projects across the country. Those events reminded all of us of our national and regional heritage. This greater appreciation of historical and local context was something that was going on throughout the world, and it found international expression in the 1970s and early 1980s works of Italians Aldo Rossi (1931–1997) and Carlo Scarpa (1906–1978), British architect James Stirling (1926–1992), and Japan's Arata Isozaki (born 1931). In the United States, architect-writer Robert Venturi (born 1925) prefigured this new appreciation of ornamental forms in his Guild House and Vanna Venturi House (both 1964). Even exhibits at the Museum of Modern Art celebrated ornament within elaborate architectural drawings, in *The Architecture of the Ecole des Beaux-Arts* exhibition (1975).

For Chicago, several exhibitions during the oil crisis and building recession of the 1970s commemorated the city's architectural past and looked toward its future. One was a 1973 exhibition organized in Munich but shown in Chicago's Museum of Contemporary Art (MCA) in 1976, titled *100 Years of Architecture in Chicago, Continuity of Structure and Form*. This focused on the work of Mies and the Second Chicago School of architecture. Another exhibit that year answered the MCA's one by showing the richness of Chicago's environment beyond functionalist and Miesian interpretations. Called *Chicago Architects*, it was organized by Benjamin H. Weese (born 1929), Laurence Booth (born 1936), Stuart Cohen (born 1942), and Stanley Tigerman (born 1930). It was a Salon des Refusés of a sort in that it published buildings and architects from the broader spectrum of historical Chicago. Those same architect-curators were featured in the 1977 groundbreaking exhibit at the Richard Gray Gallery titled *Seven Chicago Architects*. Beyond the initial four, the so-called Chicago Seven included Thomas H. Beeby (born 1941), James Ingo Freed (1930–2005), and James L. Nagle (born 1937), the group later joined by Gerald Horn (1935–2014), Helmut Jahn (born 1940), Kenneth A. Schroeder (born 1943), and Cynthia Weese (born 1940).

Their pluralistic efforts helped revitalize the Chicago Architectural Club (1979) and related journal, and they were featured in international exhibition catalogs such as *New Chicago Architecture* (1981). Publications were an important part of that widespread awareness about Chicago architecture—publications such as the *Chicago Architectural Journal*, the catalog for the "New Chicago Architecture" exhibition, and a number of architectural monographs were published by Rizzoli, whose bookstores were also an integral part of the distribution network about the latest in Postmodern architecture.

Beyond those temporary exhibitions, institutional collecting of historical archives and related exhibitions came to the forefront in the mid-1970s and early 1980s, for both the Chicago Historical Society (now Chicago History Museum) as well as the Art Institute of Chicago. The Chicago Historical Society made an agreement with the Chicago chapter of the American Institute of Architects in 1976 to establish an architectural archive. As chronicled in the museum's annual report of 1976–77, it was established to "recognize the important work of Chicago architects in the growth and development of the city's physical fabric by aggressively collecting drawings, photos, correspondence, models, and other records generated by Chicago firms." It was organized to

Left:
Kohn, Pedersen, Fox, 333 West Wacker Drive, 1983.
Photo: Marcel Malherbe, courtesy ArcaidImages.com 10150-40-1.

Overleaf:
Stanley Tigerman, Anti-Cruelty Society Building addition, 157 West Grand Avenue, 1981, exterior now altered.
Photo: HNK Architectural Photography, Howard Kaplan
© 1981, courtesy Tigerman McCurry Architects.

complement the collection of architectural materials in the Art Institute of Chicago, which focused more on the aesthetic aspects of architecture.

Soon collections came to the Chicago Historical Society that included the files of the Chicago Chapter of the AIA (1933–72) and papers (1922–1968) of Earl Howell Reed (1884–1968). The following year, the Society received the papers of Harry Weese and Associates, files of the Illinois Society of Architects, and a selection of AIA award-winning designs by local architects. In 1979 the Society acquired the extensive archives of Holabird & Roche/Holabird & Root, 1880–1940, and a number of materials from the Society's Architectural Archive were displayed in the newly opened Chicago History Galleries. Architectural records, papers, working drawings, sketches, and renderings from the practice of Chicago architect Barry Byrne were also collected in 1979. The society mounted its first major architectural exhibition—*Holabird & Roche/Holabird & Root: The First Two Generations*—in 1981 and formed the Architectural Collection as a distinct curatorial department with Frank Jewell as curator. In 1981, Ann Lorenz Van Zanten was named curator of the Architectural Collection.

Not to be outdone, the Art Institute of Chicago also jumped into the fray with collection development and changing exhibits during 1978–79 and with the establishment of an active exhibitions program and full curatorial department of architecture in 1982, with myself originally named as associate curator in charge and Pauline Saliga as assistant curator. Its collecting activities were often coordinated with the Chicago Historical Society, though there was a friendly rivalry between both institutions for some plum collections. The Art Institute's focus through the 1980s and 1990s led them to organize a host of traveling architectural exhibitions, some of which toured Europe. These were based on their own resources as well as those of the Chicago Historical Society and other public and private collections. Some of the accompanying publications can be found within this volume's list of selected sources. The two best known are *Chicago Architecture: 1872–1922* (1987) and *Chicago Architecture and Design: 1923–1993* (1993), both with essays by academic specialists on a host of related topics.

Perhaps the most powerful visual image of the widespread appreciation of historical context in the later 1970s and 1980s and the concurrent movement away from the works of Mies and minimal Modernism is Stanley Tigerman's clever 1978 photomontage *The Titanic* within the collection of the Art Institute of Chicago. It shows Mies's Crown Hall at IIT sinking into Lake Michigan. Regarding actual Chicago buildings from this era, Tigerman's Anti-Cruelty Society building's addition (1981) is among the earliest that incorporates contextual and historical references, in this case to aluminum-sided, two-story neighborhood buildings whose design suggested apartments above the stores. This accessible image to promote animal adoption contrasts with the stark, institutionalized appearance of the adjacent masonry main building of the 1930s. Tigerman's pedimented entry incorporates stylized references to a dog's ears, and the big display windows suggested the tune "How Much Is That Doggie in the Window?" Sadly, the building has been altered and resurfaced since then, but less altered works by Tigerman from this representational era of the 1980s still exist. They include a garage at 60 East Lake Street (1986) with a facade based on a classic car radiator and the Georgian facade of a Commonwealth Edison Substation (1989) at Dearborn and Ontario Streets.

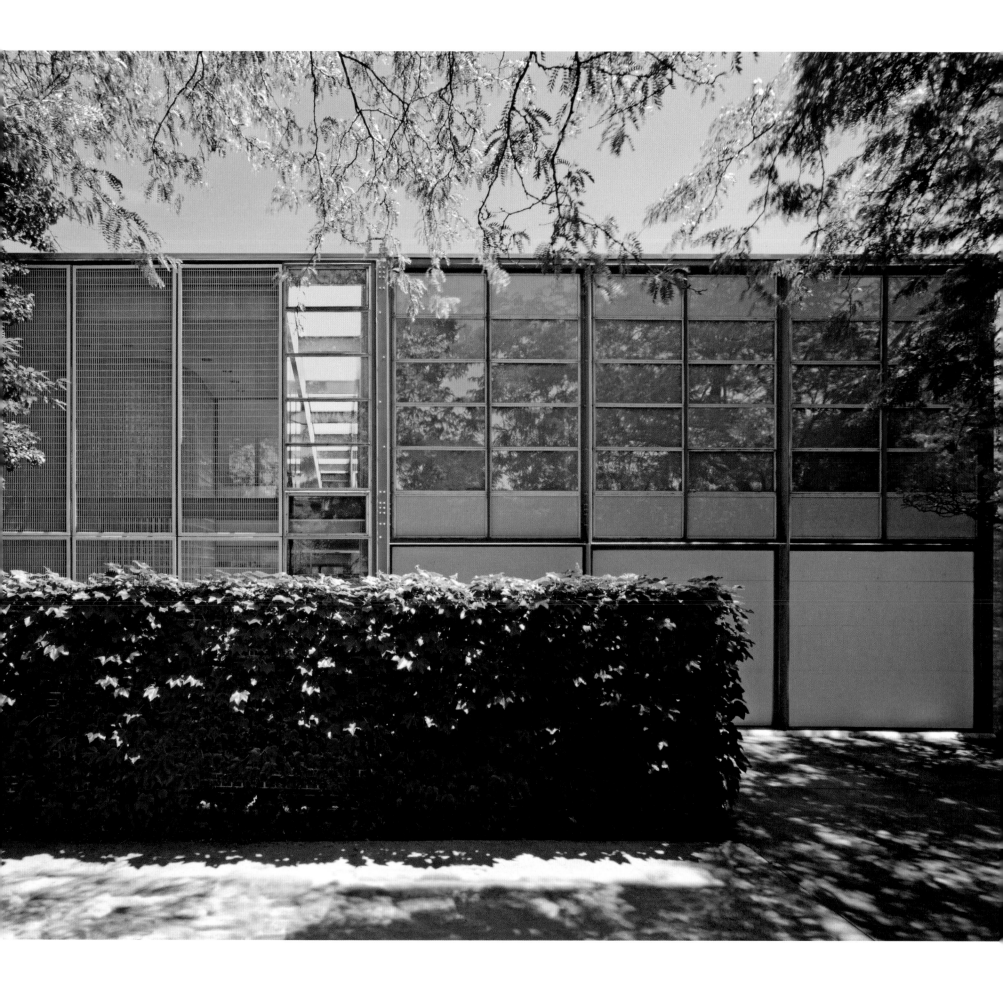

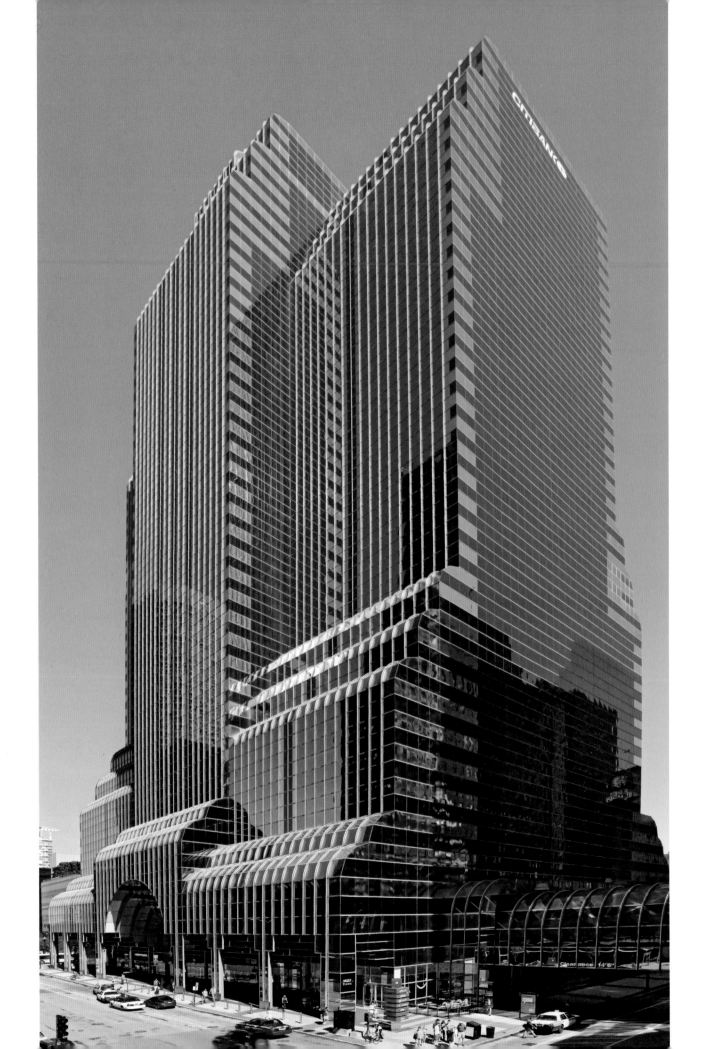

The 1980s and 1990s also witnessed the restoration of major historic buildings such as the Auditorium, Rookery, Monadnock, Railway Exchange, and Reliance, as well as restorations of the Chicago Public Library (Chicago Cultural Center) and the original Art Institute of Chicago. Restored commercial buildings at the time benefited from the federal tax credits passed by Congress during Ronald Reagan's administration (1981–89). And some buildings such as the North Avenue Beach House Reconstruction (1999) by Wheeler Architects and Laurence Booth's reconstruction of the Shoreacres Country Club (1984) in suburban Lake Bluff are literal re-creations, for the current age, of specific architectural forms and imagery from a particular building site's past.

Those decades also witnessed a number of overtly historicist buildings that pushed history and contextualism to the edge, if not over it. 190 South LaSalle Street (1989) by Johnson and Burgee has masonry exteriors that pay homage to Burnham and Root a century before and a classical lobby with a gold-leaf ceiling that rivals anything ostentatious you might imagine from decades past. The Rice Building of the Art Institute of Chicago (1988) by Hammond, Beeby and Babka, has a columned court that recalls the work of early-nineteenth-century Prussian architect Karl Friedrich Schinkel. The setback masonry NBC Tower (1989) by SOM draws its inspiration from Raymond Hood's RCA (now Comcast) Building in New York's Rockefeller Center, the national headquarters of NBC.

The last gasps of this overt historicism can be seen on mega and minor scales. The Hammond, Beeby and Babka–designed Harold Washington Library (1991) has supersized sculptural ornament and arcades, whereas Booth Hansen's skyscraper Residence Hall at the School of the Art Institute (2000) looks like a twentieth-century imitation of a Chicago School building like the Reliance down the block. Chicago's ubiquitous little bus shelters (1999–2002) created in the hundreds to the designs of Robert A.M. Stern (born 1939), are based, in ornamental design, on late-nineteenth-century Viennese kiosks by Otto Wagner. Lucien Lagrange's apartment buildings such as 65 East Goethe (2002) and others throughout the city's skyline, remind us of Benjamin H. Marshall's luxury apartments of French classical design in the first decades of the twentieth century.

Even more than new constructions that consciously replicated the power of the past, several architects practicing in the 1980s and 1990s created modern hybrids that use steel-and-glass vocabulary with planning and overall form influenced by historical precedents. In some ways, these are among the most interesting Postmodern buildings in Chicago. Arguably, Munich-born-and-trained Helmut Jahn was at the forefront of architects creating such masterworks. Among the most prominent is the State of Illinois Building (1985), later named after the Illinois governor who commissioned it, James R. Thompson. Controversial when first completed, its steel-and-multicolored glass, bulbous form and massive open atrium within all harkened back to centrally planned, domed state capitols as well as represented transparency of government today.

Perhaps a close second is Jahn's United Airlines Terminal (1988) at Chicago O'Hare International Airport, with its underground connections between air-side concourses and landside Jahn-designed subway station (1984). This exciting new terminal complex was based, in principle, on the grand transportation shed of nineteenth-century railroads. As executed here, it is a very dynamic expression

247

Helmut Jahn of Murphy Jahn, Northwestern Atrium Center and Station, 500 West Madison Street, 1987. Serving as a grand entry to Northwestern Station, the building's cascading forms and large entry arch recall streamlined trains and vintage railroad stations. A similarly skinned building, though with angular design expressions, is Jahn's earlier One South Wacker Drive (1982). Photo: Rainer Viertlboeck, courtesy Jahn.

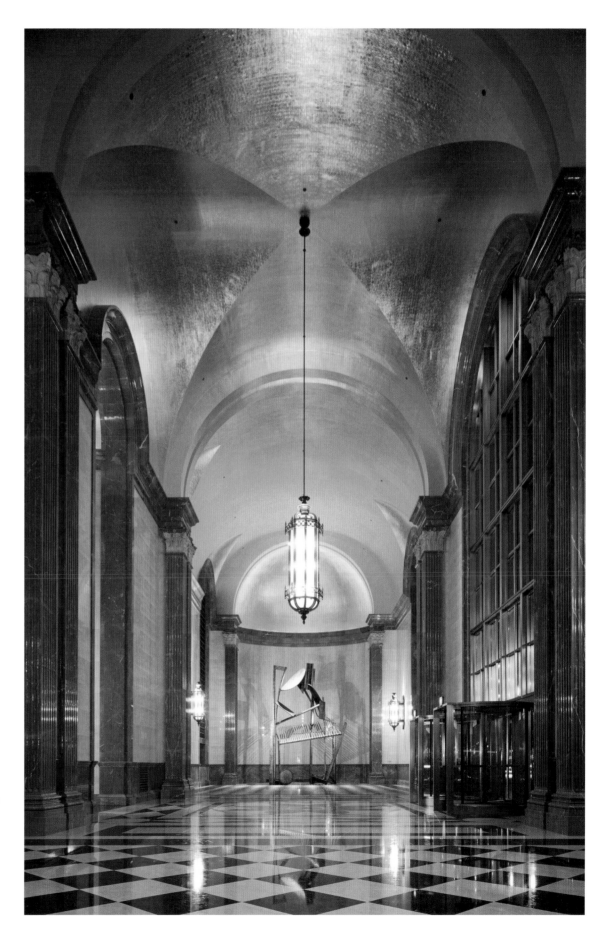

Philip Johnson of Johnson Burgee with Shaw and Associates, 190 South LaSalle Street, 1987. Design studies for this were in Dutch Renaissance and Art Deco before it was finally decided to choose a style that made reference to local Burnham and Root buildings such as the Rookery (1885–87) diagonally across the street and the Masonic Temple (1892; demolished). The 184-foot-long marble-and-gold-leaf lobby, however, is pure Johnson; he declared it to be "the most lengthy, high, and dignified lobby in the city." The sculpture at the apsidal end is by Anthony Caro. Photos: Interior, © Hedrich Blessing; exterior, Hedrich Blessing, © Chicago Historical Society, courtesy ArcaidImages.com 70001-140-1.

Overleaf:
Helmut Jahn of Murphy Jahn with A. Epstein and Sons, Terminal One–United Airlines Complex, Chicago O'Hare International Airport, 1988. Terminal One view along with Chicago Transit Authority subway station. Photos: Rainer Viertlboeck, courtesy Jahn.

comparable to larger versions of aluminum structural ribs within airships and airplanes. It helped reinforce O'Hare's long-term record as the world's busiest airport and prefigured the Perkins and Will–designed International Terminal (1993) and recent landside renovations by Jahn of the existing early Jet Age buildings done by his predecessor firm. Ralph Johnson of Perkins & Will, in addition to designing the new International Terminal, also created a steel-and-glass skyscraper for the Morton Salt Headquarters, now Boeing (1989), which referenced clock towers of twenties modernist buildings in central Europe.

Having great air terminals brought more direct international flights to Chicago and helped make it a more cosmopolitan city. This included hiring architects from the East Coast, as well as from Asia and Europe, to create spectacular Modern buildings for Chicago. These include works by Cesar Pelli (born 1926), Robert A.M. Stern, and Kohn Pedersen & Fox as well as German architect Josef Paul Kleihues (1933–2004) and Japanese architects Kenzo Tange (1913–2005) and Kisho Kurokawa (1934–2007).

Kurokawa's Sporting Club (1990), a steel-and-glass pavilion for a freestanding health club, is especially intriguing in this regard. Kurokawa drew his overall source of inspiration from Louis Sullivan's jewel-box bank buildings, particularly the four-towered People's Savings Bank (1910–11) in Cedar Rapids, Iowa. Pelli's 181 West Madison (1990) evoked Saarinen's Chicago Tribune Tower entry, and Stern's Banana Republic flagship store (1990; demolished) projected the image of tropical colonial architecture. Although some locals resented many of these architects as carpetbaggers, those designers from elsewhere brought new interpretations to Chicago's landscape. Beyond modern expressions with historic design roots, Chicago approached the end of the millennium with modernist concrete, steel, and glazed boutique stores on Michigan Avenue, such as the Crate & Barrel Flagship Store (1990), office towers such as the Blue Cross–Blue Shield Tower (1997), cleverly designed to accommodate vertical expansion, and a high-style, minimalist concrete private home in Lincoln Park (1998) designed by Japanese architect Tadao Ando (born 1941).

Hammond, Beeby and Babka, Rice Building, The Art Institute of Chicago, 1988. The image shows the installation of *Magritte: The Mystery of the Ordinary*, 1926–1938, June 24–October 13, 2014, Regenstein Hall. Photo: The Art Institute of Chicago, Image No. 0014999701.

Left:
Adrian Smith of Skidmore, Owings & Merrill, NBC Tower, 454 North Columbus Drive, 1989. The foreground smaller building on the Chicago River is the University of Chicago's Graduate School of Business by Lohan Associates, 1994. Photo: Emily Hagopian, ArcaidImages.com 12222-40-1.

Right:
Hammond, Beeby and Babka, Harold Washington Library, State and Congress Streets, 1988–91. Photo: Judith Bromley, courtesy HBRA.

Overleaf (left to right):
Ralph Johnson of Perkins & Will, Morton (now Boeing) Building, 100 North Riverside Plaza, 1990. Photo: Nick Merrick © Hedrich Blessing.

Kenzo Tange with Shaw and Associates, AMA Building, 515 North State Street, 1990. Photo: Mark Ballogg, ArcaidImages.com 12401-10-1.

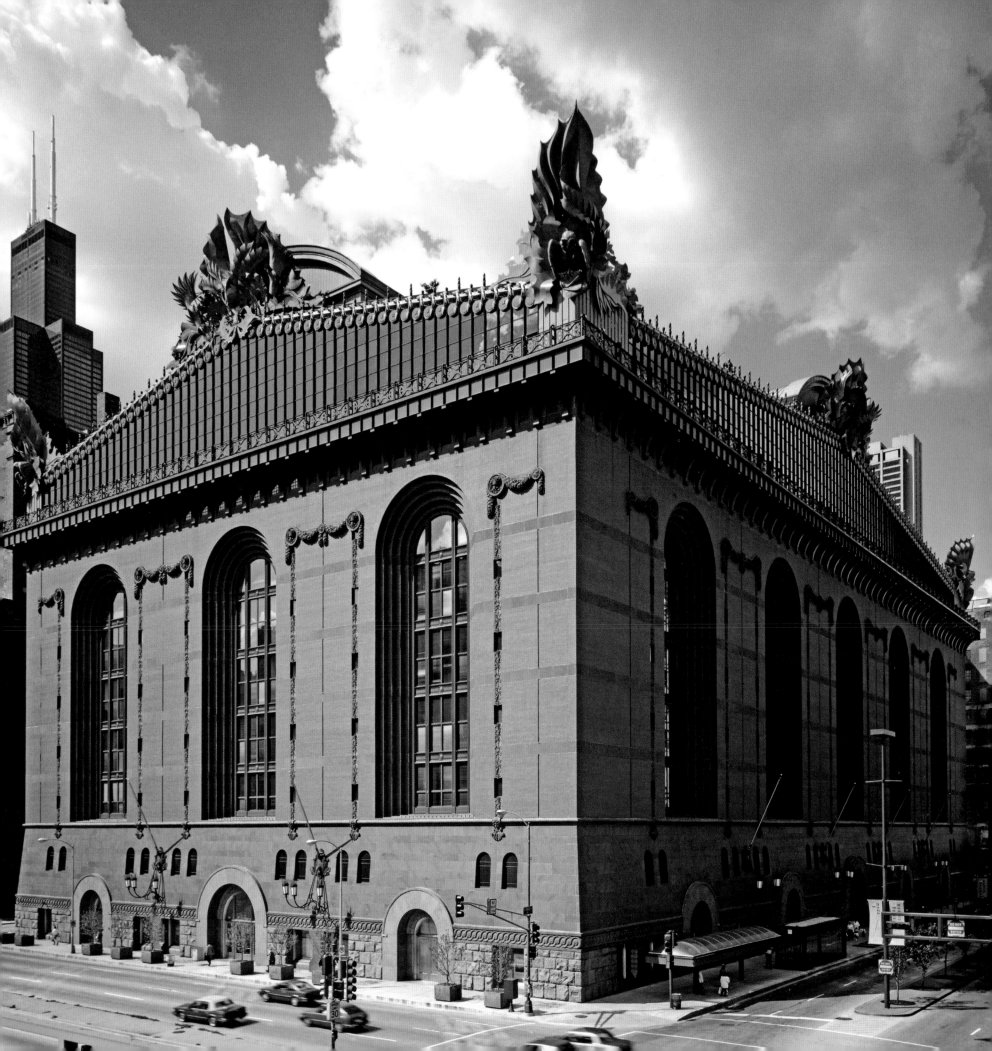

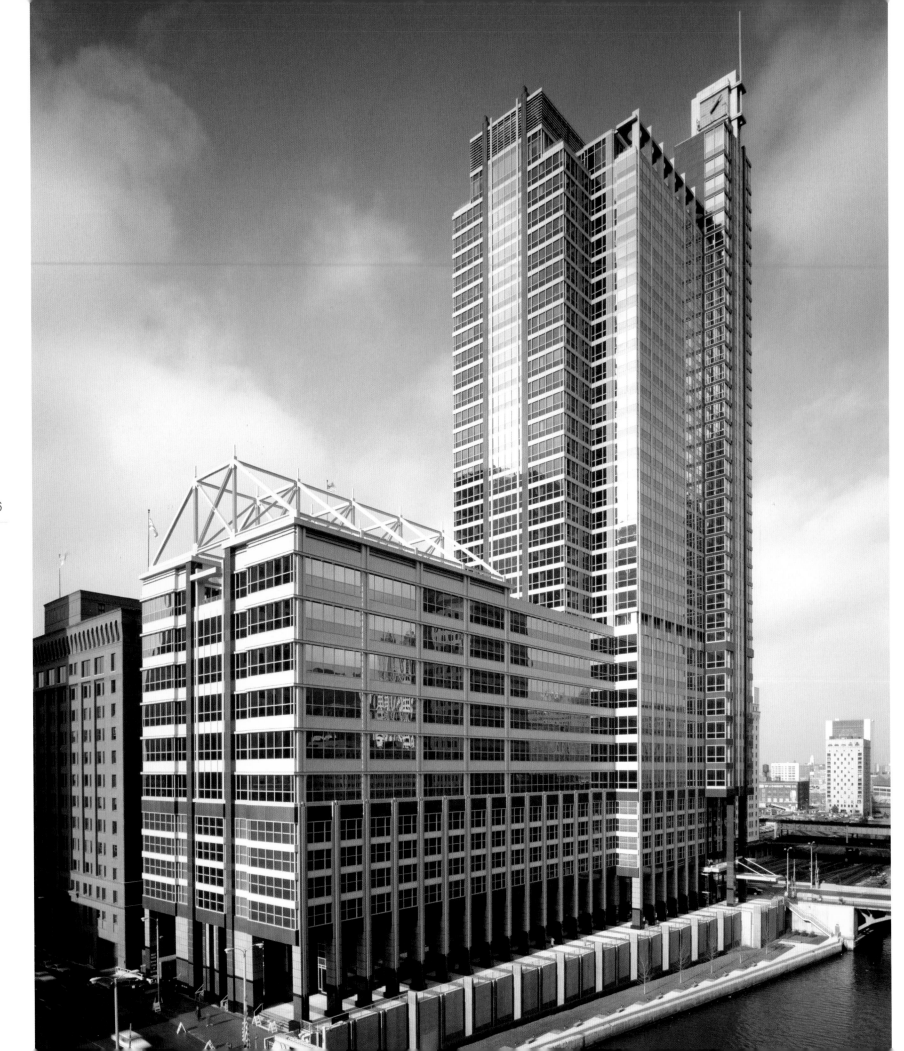

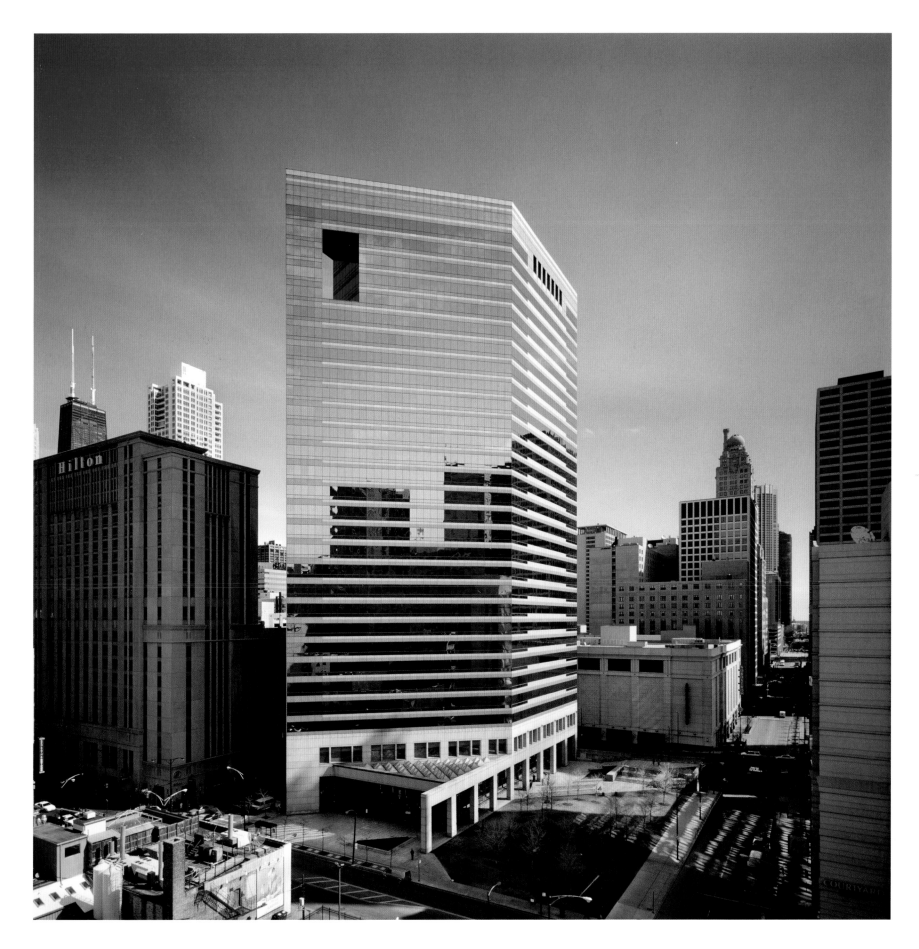

258

Kisho Kurokawa, The Sporting Club at Illinois Center (now Lakeshore
Sport & Fitness), 211 North Stetson Avenue, 1990. Photo: Courtesy
Kisho Kurokawa Architect & Associates.

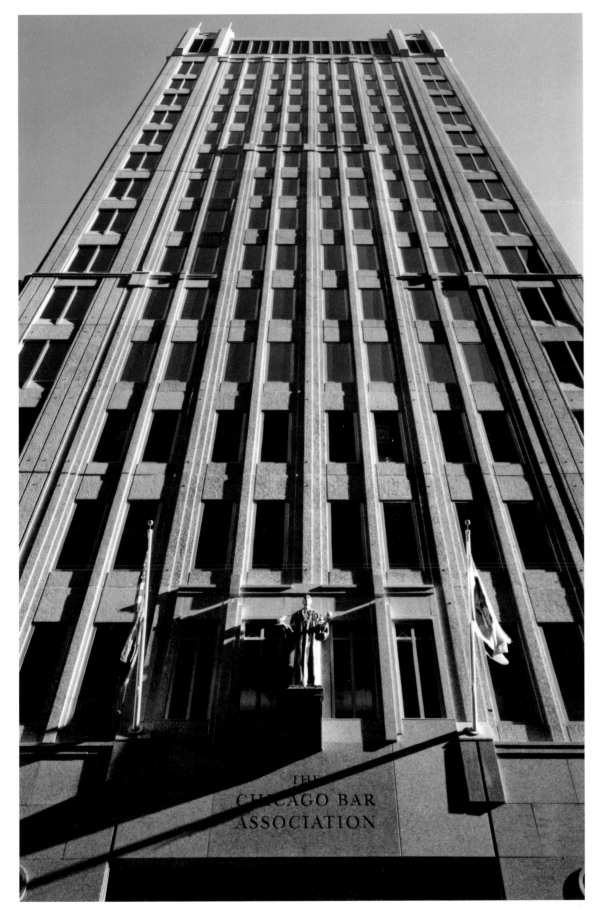

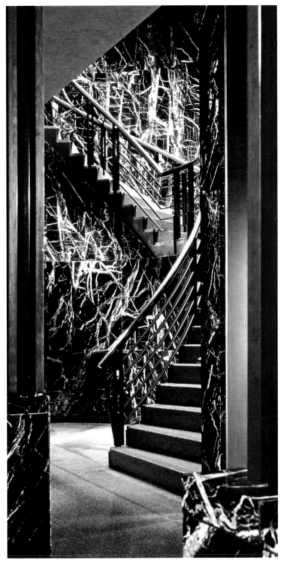

Stanley Tigerman and Margaret McCurry, Tigerman McCurry, Chicago Bar Association Building, 321 South Plymouth Court, 1990. The Chicago Automobile Club (1907) by Marshall and Fox stood on the site and was too deteriorated to be renovated for the Chicago Bar Association. Tigerman McCurry provided the association with a building that referenced commercial towers of the 1920s with interiors that recalled private club spaces of the past. Photos: Van Inwegen Photography, Bruce Van Inwegen © 1990, courtesy Tigerman McCurry Architects.

Left:
Solomon, Cordwell, Buenz, Crate & Barrel Flagship Store, 646 North Michigan Avenue, 1990. This was arguably the first such signature store on the so-called "Magnificent Mile," which is now dotted by other such showroom stores for Apple, Banana Republic, Disney, Garmin, Nike, and Ralph Lauren. Photo: © John Gronkowski.

Above:
Jordan Mozer, Cheesecake Factory, Hancock Tower, 875 North Michigan Avenue, 1995–97. Photo: David Clifton, courtesy Jordan Mozer and Associates.

Overleaf:
Josef Paul Kleihues, Museum of Contemporary Art, 220 East Chicago Avenue, 1996. Photo: Peter McCullough, © MCA Chicago.

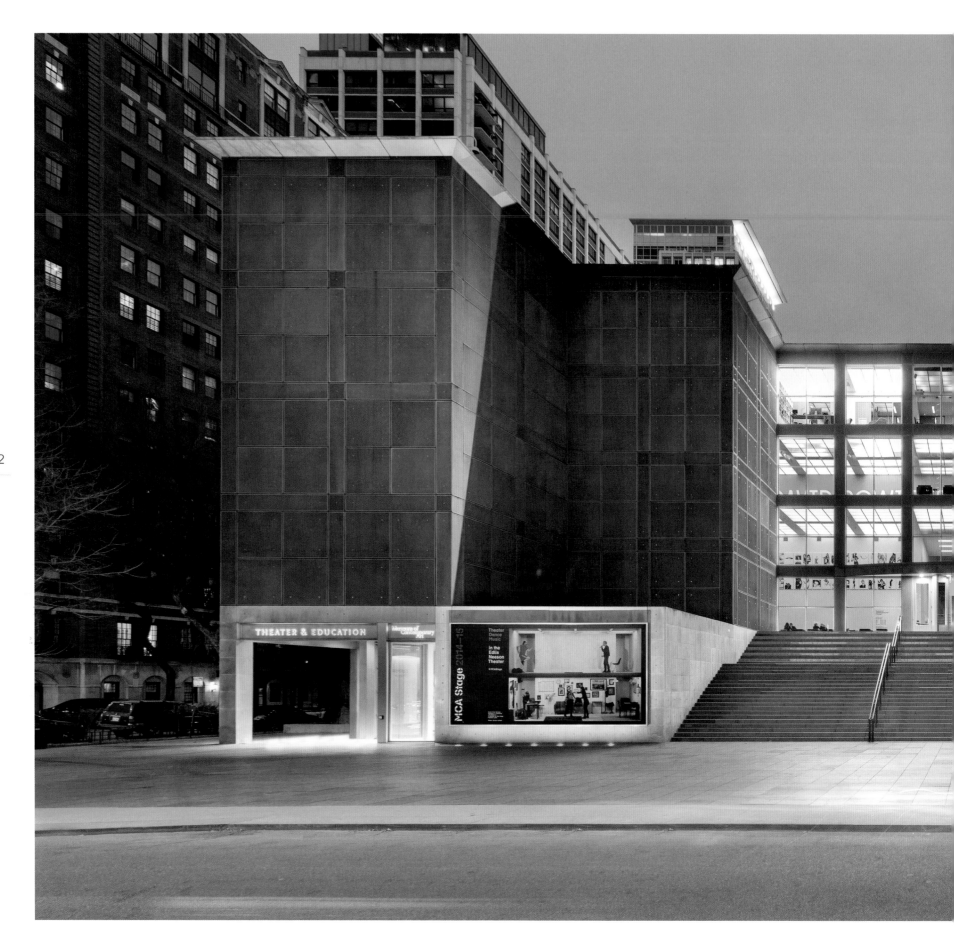

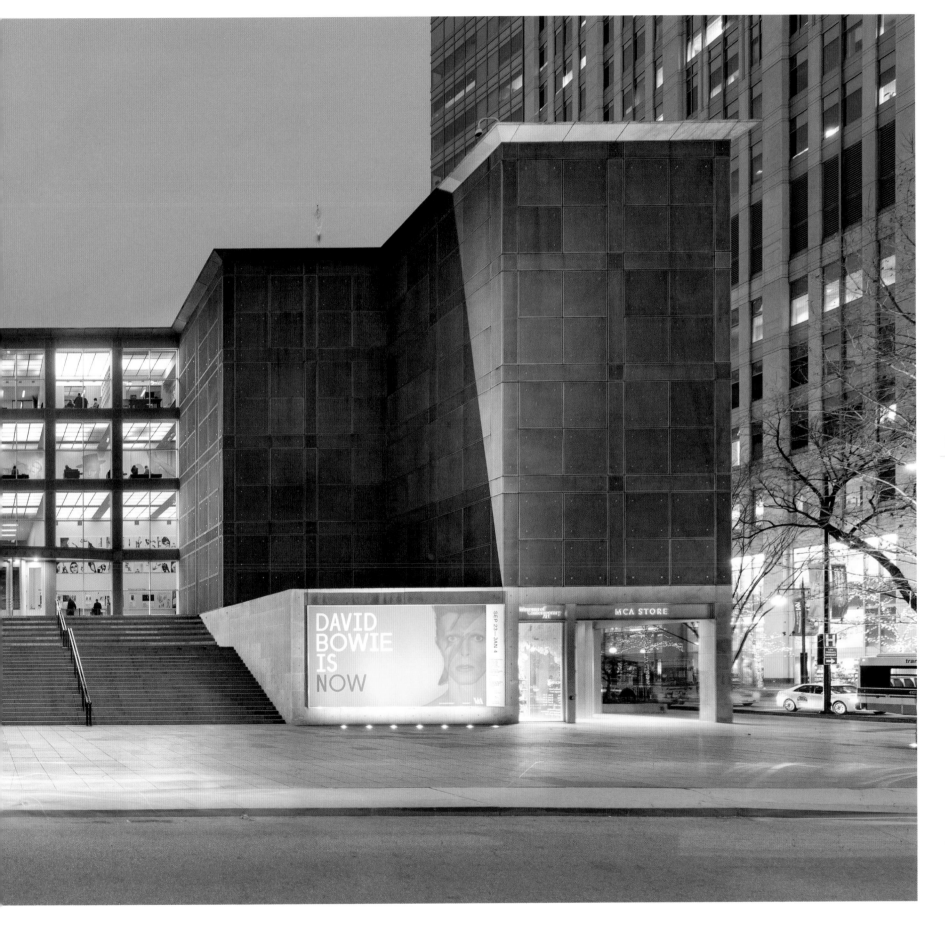

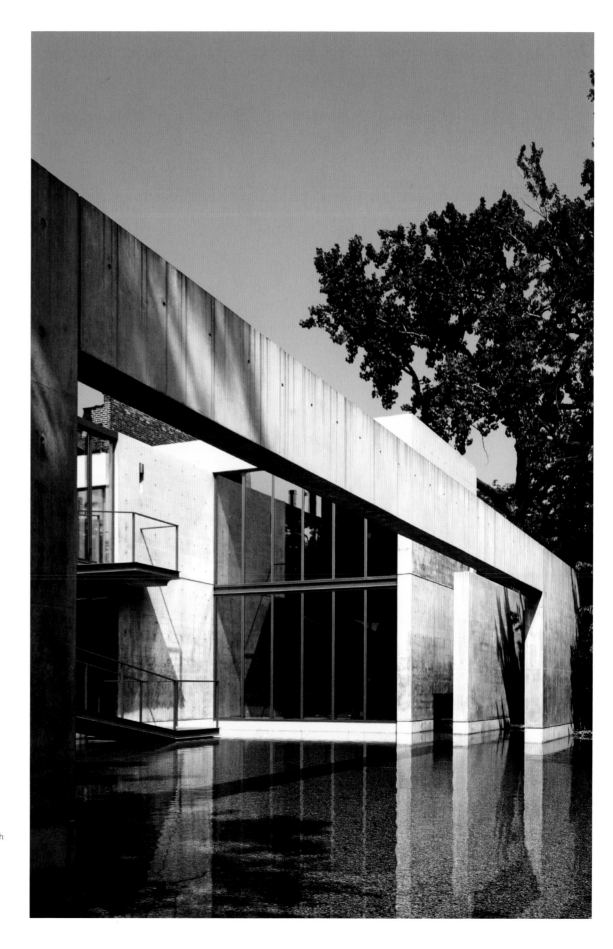

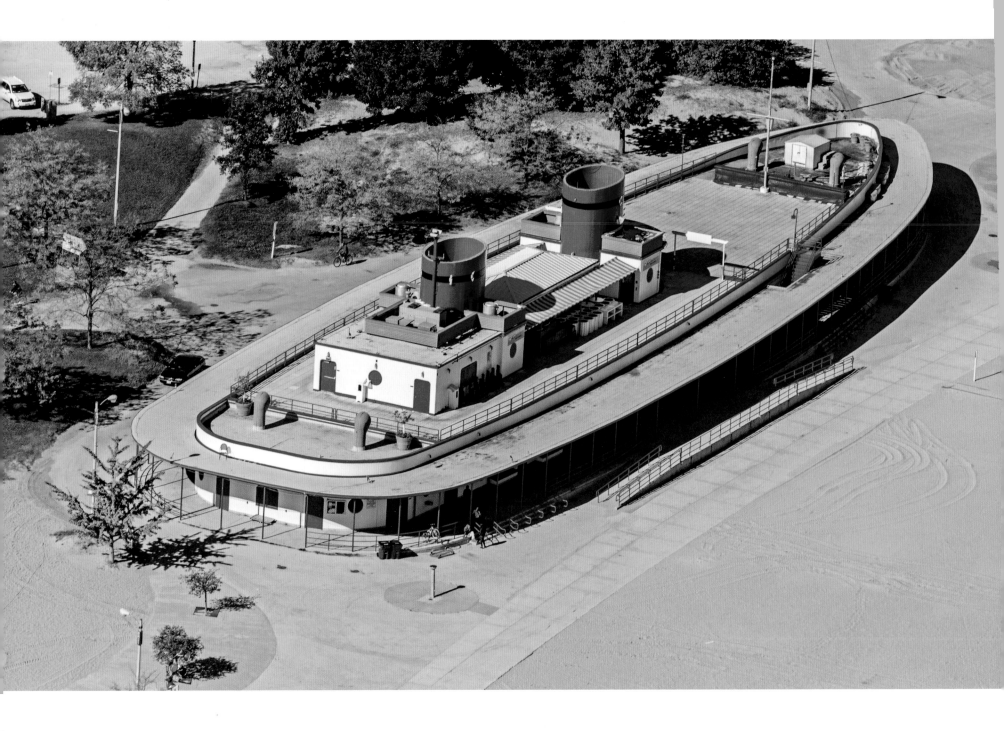

Wheeler Kearns Architects, North Avenue Beach House
Reconstruction, Lake Michigan Beach near North Avenue, 1999.
Photo: October 8, 2014 © Tigerhill Studio Corp., John T. Hill, 5764-
00376; view from North Michigan Avenue, Steven Hall © Hedrich
Blessing, courtesy Wheeler Kearns Architects.

Above:
Booth Hansen, School of The Art Institute of Chicago Residence Hall and Siskel Film Center, 164 North State Street, 2000. Photo: courtesy Booth Hansen.

Robert A.M. Stern, Standardized Bus-Shelters for J. C. Decaux, ca. 1999–2002. Photo: John Zukowsky.

Right:
Lucien Lagrange, Park Hyatt Hotel, 800 North Michigan Avenue at Chicago Avenue, 2000. Much of Lagrange's work draws upon the image of luxurious buildings of the early twentieth century. His apartment buildings recall the French Renaissance–style works of the early 1900s, though in modernized, simplified forms. This hotel, somewhat Art Deco in inspiration, references the famed Drake Tower (1928) by Benjamin H. Marshall on the exclusive East Lake Shore Drive. Photo: © William Zbaren, courtesy Lucien Lagrange.

Far Right:
Lucien Lagrange, 65 East Goethe Street, 2002.
Photo: © William Zbaren, courtesy Lucien Lagrange.

CHICAGO LANDMARKS FOR THE NEW MILLENNIUM?

When the clock struck 12:01 a.m. on January 1, 2000, everyone realized that the world would not come to an electronic end, and it was business as usual in terms of buildings for the new millennium. After the terrorist attacks on the World Trade Center on September 11, 2001, some feared that skyscrapers would never again be built, yet megascale buildings dotted the globe afterward, several dwarfing the once mighty Sears, now Willis, Tower. Today, Burj Khalifa (2010) is almost twice the height! And another is now under construction that will outsize Burj Khalifa—the former Kingdom Tower (now Mile High Tower) in Jeddah, Saudi Arabia. This is also designed by Adrian Smith, now of Gill Smith Architects, and is being constructed to a mind-boggling height of more than 3,281 feet!

Buildings such as these will be world landmarks. So, what about Chicago? What are the newer buildings that might be considered landmarks in decades to come? This is a hard call. All we might do is sort through a selection of works over the past decade to give you an idea of what architects have done. In almost all, Neomodernism is the stylistic tagline. This is a revival and refinement of Modernist concrete, metal, and glass facades, many often planar and without much depth between the metal members and the glazing. The buildings often express a geometric boldness and complexity made even more possible by increasingly sophisticated computer design programs. Buildings of all types designed over the past decade share a similar return to modernist vocabulary and even industrial materials.

Glazed skyscrapers continue to be built, ranging from commercial buildings such as the UBS Tower (2001) and 111 South Wacker Drive (2005), both by Goettsch + Partners, and the angular Chicago Sofitel Hotel (2002) by Jean-Paul Viguier, through the brash little Contemporaine (2004) condominium by Perkins & Will, and the enormous, super-sleek Trump International Hotel and Tower (2009) by Adrian Smith, then with SOM. That last soars to 1,389 feet high. It was the source of local controversy when a large 2,800-square-foot backlit TRUMP sign was installed 2014 on the Chicago River side of the building 200 feet above ground level.

Although Chicago's Trump Tower is a hotel that also has condominium units, other hotels and rental apartments were the high-rise types that continued to be actively constructed throughout Chicago and other American cities in the first and second decades of the twenty-first century, even after the financial crisis of 2008 to 2009. Chicago has good Neomodern examples by Brininstool and Lynch, Jackie Koo, Studio Gang, and Valerio Dewalt Train. Notable among those is the Aqua (2009–11) apartment, condominium, and hotel building created by Jeanne Gang (born 1964), a MacArthur Fellowship–awarded architect who was trained at the University of Illinois and Harvard. Aqua's computer-generated concrete balconies provide an animated texture to what is actually a rectilinear box, a visual technique that Gang has stated was inspired by the stacked limestone outcroppings that you can see around the Great Lakes. Hotel and restaurant renovations have also been implemented by high-profile interior architecture firms. These include the Thompson Chicago (2013), by London-based Tara Bernerd (born 1972), with its warm yet industrial, contemporary space that evokes a luxury lodge, and the sleek Sophie's restaurant (2015) atop Saks Fifth Avenue, designed by Andre Kikoski (born 1967). Named Sophie's after Sophie Gimbel, Saks' fashion designer noted for her sculptural forms, the sleek spaces and custom furnishings bring contemporary New York high-style department-store dining to the Windy City.

271

Lohan Caprile Goettsch/Goettsch Partners, UBS Tower, 1 North Wacker Drive, 2001. Photo: © David Seide, courtesy Goettsch Partners.

Public architecture as well as institutional architecture has flourished during the last fifteen years, as it usually does through various recessions. Perhaps the two largest examples of public architecture can be seen in the bold renovation of the historic Soldier Field (2003) and the truly audacious creation of Millennium Park (2004). The classical Doric arcades of the 1926 Soldier Field designed by Holabird & Roche were saved and opened to the public as part of a park promenade. Inserted within is a steel-and-glass construction for grandstands and skyboxes. These were created by the Boston-based firm of Wood and Zapata. Carlos Zapata (born 1961) designed it with the public park improvements created by the firm headed by Dirk Lohan (born 1938), Mies's grandson. Derided as "eyesore on lakeshore" and "acropolis meets apocalypse" the renovation has, nevertheless, creatively recycled a historic building for the twenty-first century.

Millennium Park was the brainchild of Mayor Richard M. Daley (in office 1989–2011) with the support of art-attuned business leaders. Critics cited cost overruns up to a total figure of $475 million and schedule delays. When it opened, however, the 24.5-acre site of former rail yards and then underground parking became a world-renowned sculpture park with art exhibits, summer concert band shell by Frank Gehry (born 1929), winter skating rink, and restaurant, all having an annual visitorship of 4.5 million people. It defined Michigan Avenue south of the Chicago River as the city's premier cultural district.

Those large public projects had an enormous impact on the city, but the same might be said for institutional buildings—universities, museums, nonprofits, schools, and community centers. Collectively, they filled out the cityscape with services in new constructions that contribute to Chicago's rich social and cultural life. University buildings are among the largest in this group, with substantial additions being made early in the first decade and a half of the new century to IIT, where Rem Koolhaas (born 1944) and Helmut Jahn created dynamic new additions (2003–4) to the mostly traditional modernist campus, with its landmarks designed by Mies. Likewise, the University of Chicago created, throughout the beginning of this decade and a half, new buildings within its mostly traditional Gothic Revival–style campus that rocked the proverbial boat—buildings such as the Max Palevsky (2002) dorms by Ricardo Legorreta (1931–2011), the Gerald Ratner Athletics Center (2003) by Cesar Pelli, the Charles M. Harper Center (2004) for the business school by Rafael Viñoly (born 1944), and, most recently, the Joe and Rika Mansueto Library (2011) by Helmut Jahn. The nearby Earl Shapiro Hall (2013) of the Lab School of the university, though not actually part of it, provides a contemporary boost to primary-school education in the neighborhood as much as those official university buildings.

Outside already established university campuses, the South Loop and Printers Row districts have seen tremendous growth in the college-level populations because of schools such as Columbia College, Harrington Institute of Interior Design, and Roosevelt University, the last housed in the historic Auditorium Building (1889) by Adler and Sullivan. VOA created a glazed skyscraper dormitory (2012) with student services and classrooms adjacent to that historic structure on Wabash Avenue. Along with the massive William Jones College Preparatory High School (2013) by Perkins & Will, an addition to their earlier school of 1968, these are two very large and modern buildings within the somewhat gritty urban landscape, complete with the urban theater of elevated trains that travel nearby.

Museums and cultural buildings also filled out local institutional works in this decade. They include: the 2005–6 remodeling of the Chicago History Museum, particularly the lobby and restored 1930s building, by Hammond, Beeby and Babka; glazed jewel boxes done for nonprofit organizations by Douglas Garofalo (1958–2011), Ron Krueck (born 1946), and John Ronan (born 1963); the massive Modern Wing (2009) at the Art Institute of Chicago by Renzo Piano (born 1937), its skeletal structure, large open central space, and gallery plan developed over almost a decade; and the insightfully designed, visually controversial, Illinois Holocaust Museum and Education Center (2009) by Stanley Tigerman, whose building moves from darkness to light and symbolizes, in a way, the evil of the Holocaust, relief through liberation, and rebirth after.

These all made Chicago a better place to be in the new millennium. Reinforcing those intellectual and cultural landmarks are spiritual and social ones that contributed to what Chicago is, and will be. Visibly notable among those are Stanley Tigerman's Pacific Garden Mission (2007) and Gensler's Gratz Center for the Fourth Presbyterian Church (2013). The Pacific Garden Mission constructed within an industrial area and using a comparable concrete-and-brick vocabulary, houses dormitories for the homeless, administrative and education space, a spartan gem of a chapel, and tomato greenhouses to encourage self-sufficiency. In the Gratz Center, you cannot miss the green weathered-copper cladding of the blocklike building that houses church offices, meeting rooms, and a multifunctional chapel around a labyrinth-patterned floor. The center is situated behind the historic Fourth Presbyterian Church (1912) on Michigan Avenue, the Gothic Revival jewel of Ralph Adams Cram (1863–1942).

Neomodernist buildings are the norm now, as are all things related to greenspace, energy savings, and recycling within our society. But, what will the near future hold for Chicago? Public buildings are still built, such as the Chinatown Branch of the Chicago Public Library (2015) by SOM. And, large private homes are still being constructed, such as the recent house near Lincoln Park (2011–15) designed by Margaret McCurry (born 1942). Its site included redesign challenges from the demolished Columbus Hospital and a former developer's plans for lower-level garages and town houses as part of the 2,550-condominium development. McCurry's tripartite design on eight 25-foot-wide lots incorporates I-beam detailing that recalls Modern architectural forms of the recent past, yet projects the serene image of a symmetrical, classical home. Projects for 2015–16 include: a Streeterville high-rise by Robert A.M. Stern; a new elevated train station at Madison-Wabash; an 88-story tower on the Chicago River designed by Jeanne Gang along with her designs for a new dormitory at the University of Chicago; a high-rise apartment tower on South Michigan Avenue by Helmut Jahn; a Lucas Museum of Narrative Art planned for the lakefront and designed by the Beijing/Los Angeles firm of MAD Architects; and the first Chicago Architecture Biennial, with some 120 top-notch design teams from around the world.

From October 2015 to January 2016, the Chicago Architecture Biennial included thought-provoking exhibitions by architects from across the globe, as well as the creation of lakefront kiosks. Four slated for 2016 construction include three designed by teams from local architecture schools: the Chilean firm of Pezo von Ellrichshausen with the Illinois Institute of Technology; Amsterdam-based Nigerian architect Kunlé Adeyemi and the School of The Art Institute of Chicago; and Denver-based Paul Andersen of Independent Architecture with Chicago's Paul Preissner of Paul Preissner Architects, collaborating with

the University of Illinois. A fourth kiosk titled *Chicago Horizon* was awarded via international competition to the design of Yasmin Vobis, Aaron Forrest, and Brett Schneider, all faculty from the Rhode Island School of Design. In a way, these kiosks are in the recent tradition of Chicago's earlier and popular Burnham Pavilions of 2009 by Zaha Hadid and Ben van Berkel, and they also evoke those sponsored by the Serpentine Gallery in London over the past 15 years. But the true importance of the Biennial, whose attendance topped more than a half million visitors, lies in the future, and how Chicago's architectural environment may have impacted on the architects and students who visited the city then.

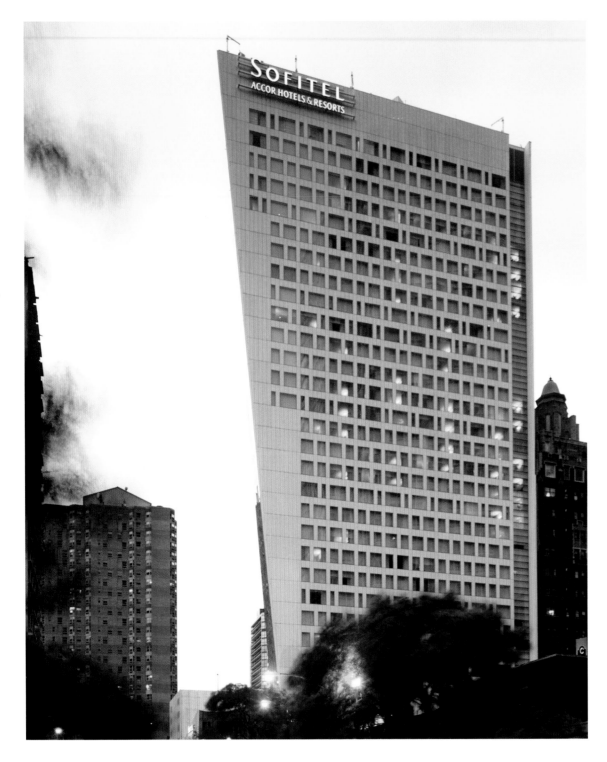

Left:
Jean-Paul Viguier, Chicago Sofitel, 20 East Chestnut Street, 2002.
Photo: Nicolas Borel, courtesy Jean-Paul Viguier et Associés.

Right:
Valerio Dewalt Train, Doblin House, 5017 North Ravenswood Avenue, 2002, expanded vertically at the corner, 2014. Photos: Steven Hall © Hedrich Blessing, courtesy Valerio Dewalt Train.

Overleaf:
Wood and Zapata with Lohan, Caprile and Goettsch (later Goettsch Partners), Renovations of Soldier Field, 2003; originally built 1926 by Holabird & Roche, 425 East McFetridge Drive. Photo: © David Seide, courtesy Goettsch Partners.

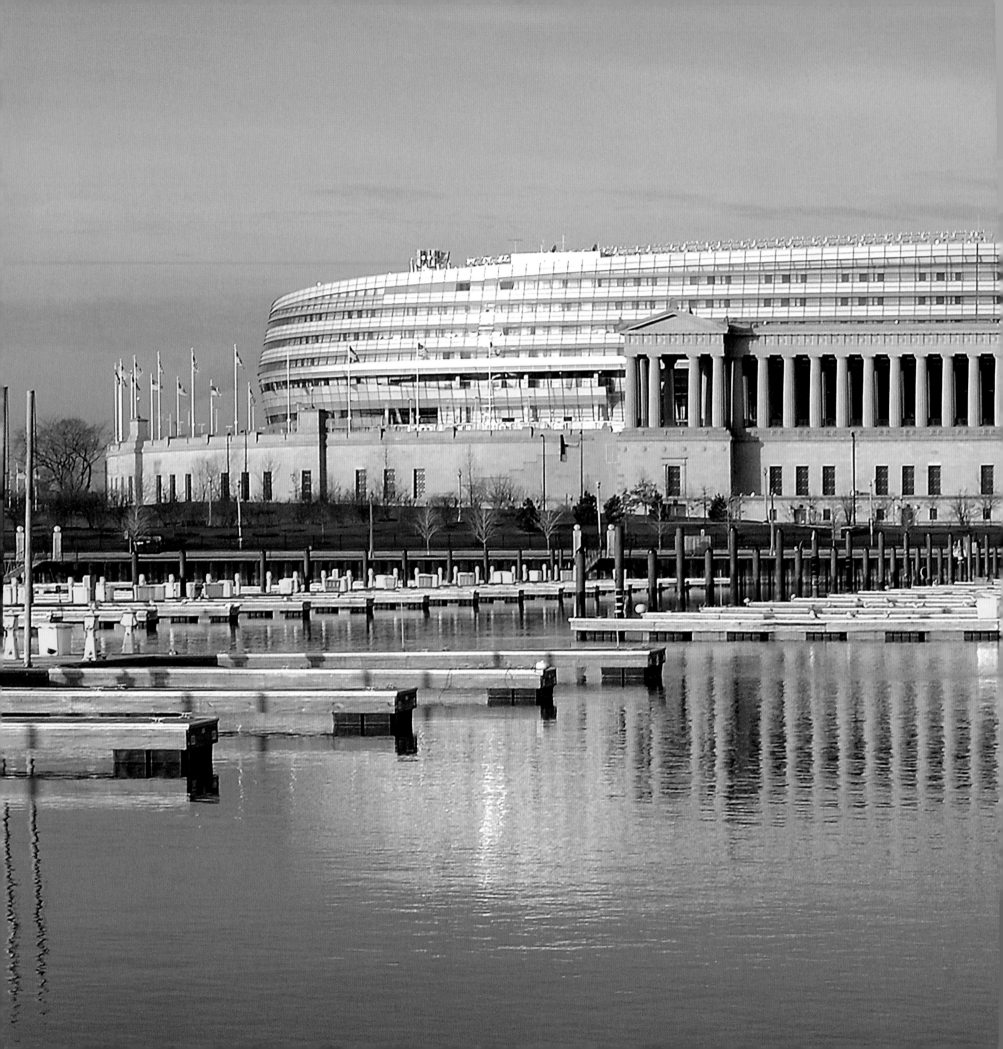

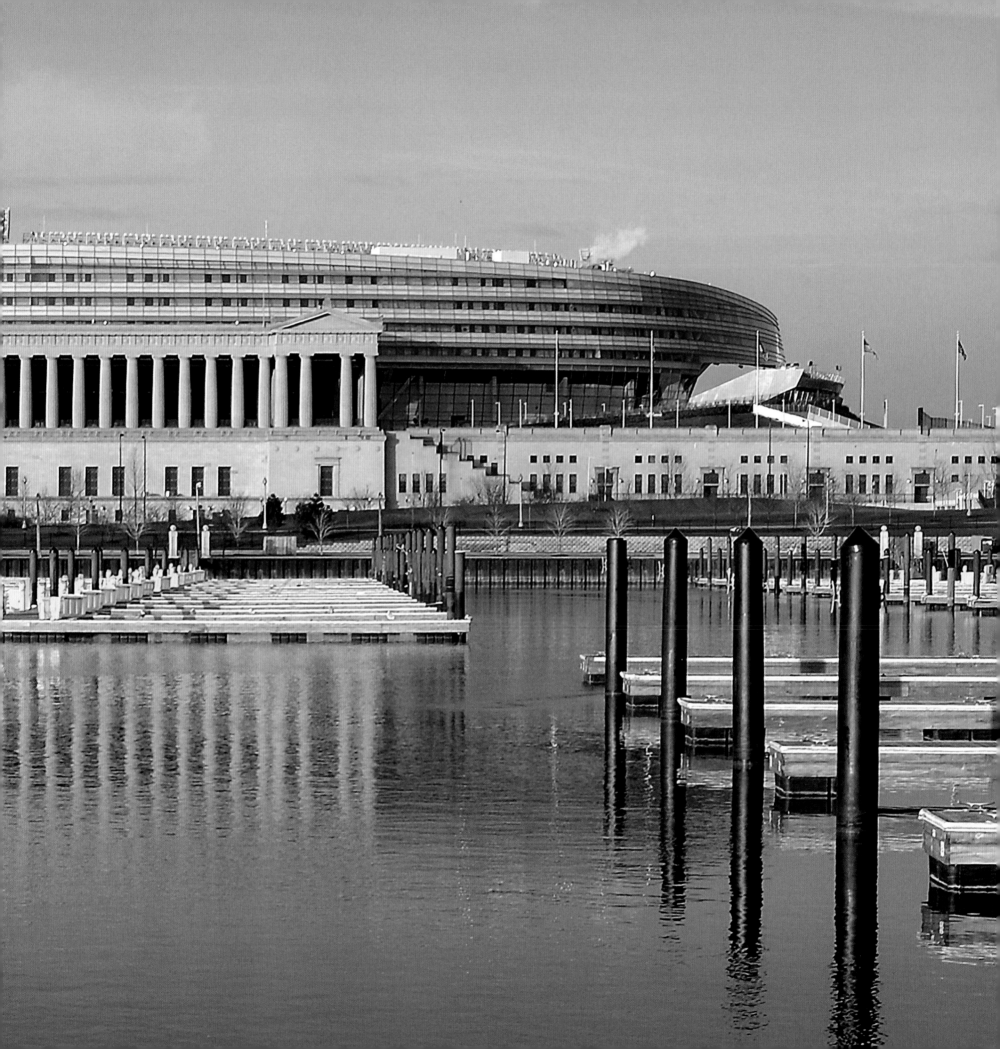

Finally, the success of the High Line in Manhattan as an urban park, created from a disused railroad line, has encouraged several Chicago nonprofits to work with the city's Department of Transportation to develop the similar 606 Bloomingdale Trail and Park (begun 2004, officially opened 2015). This is situated on 2.7 miles of disused freight-train tracks. The design was coordinated by ARUP North America. And one of the High Line's design firms, James Corner Field Operations, is currently working on a Navy Pier renovation initially designed 2012–13, with phase 1 scheduled to be completed 2016 for the pier's centennial. This will incorporate sustainable environments with local tree species, a new grand staircase that leads to the Ferris wheel, a Wave Wall visually attuned to the pier's lakefront location, and more.

Only time will tell which, if any, of all these constructions over the past decade or so, and even those planned for the near future, will be considered landmarks in the traditional sense. Nevertheless, in these recent works, we have seen that Chicago is still true to another one of the many maxims credited to the city's adopted son Mies: "Build, don't talk!"

279

Frank Gehry, Jay Pritzker Pavilion in Millennium Park, 2004, with Anish Kapoor and Jaume Plensa sculptures. The latter project was executed architecturally with Krueck and Sexton who state: "Crown Fountain reaffirms the power of architecture and art to improve and to inspire life. Because of the interactivity of the fountain, it transcends expectations and brings delight to all who experience it." Photos: Plensa detail photo, © Hedrich Blessing, courtesy Krueck + Sexton; overall view, © Mark Ballogg.

Left:
Perkins and Will, Contemporaine, 516 North Wells Street, 2004.
Photo © James Steinkamp, courtesy Perkins & Will.

Goettsch Partners, 111 South Wacker Drive, 2005. Founded by
James Goettsch, Goettsch Partners is a prolific Chicago firm with
contemporary high-rise work beyond Chicago, in the United Arab
Emirates, Saudi Arabia, and China Photograph © Steinkamp/Ballogg
Photography, courtesy Goettsch Partners.

Right:
Murphy Jahn, Illinois Institute of Technology Student Housing, 3303
South State Street, 2003. Photo: Rainer Viertlboeck, courtesy Jahn.

Brininstool and Lynch, 1620 South Michigan Avenue, 2006–7. The same firm executed a similarly large apartment block at nearby 1720 South Michigan Avenue (2006). Their two buildings are among the many similar multifamily housing blocks constructed in this area south of the Loop during the first decade of the twenty-first century, in part because of the site's proximity to the central business district. Photo: Darris Lee Harris, Padgett and Company, Inc., courtesy Brininstool and Lynch.

Douglas Garofalo, Hyde Park Art Center, 5020 South Cornell Avenue, 2006. This little institutional building represents Garofalo's only work in Chicago before his premature death in 2011. Photo: © John Gronkowski.

Left:
Hammond, Beeby and Babka, lobby renovation of the Chicago History Museum Addition of 1989 by Holabird and Root and interior of its 1932 building, Clark Street and North Avenue, 2005–6. Photo: © Hedrich Blessing, courtesy HBRA.

Right:
Krueck and Sexton, Spertus Institute of Jewish Studies, 610 South Michigan Avenue, 2007. Without directly mimicking the historic boulevard's bay windows and architectural forms from earlier eras, the angular Spertus facade "becomes both a luminous vessel gathering daylight from the outside and a window revealing to the city the building's multidisciplinary activities contained within," according to the architects. Photos: © William Zbaren, courtesy Krueck + Sexton.

Left and Center:
Valerio Dewalt Train, 1401 South State Street, 2008–9. The sleek glazed facade houses concrete loft interiors with painted walls and floors on the near south side that burgeoned with similar loft and apartment structures in the first decade of the twenty-first century. Photos: Steve Hall, © Hedrich Blessing, courtesy Valerio Dewalt Train.

Above:
Stanley Tigerman of Tigerman McCurry, Pacific Garden Mission, 1458 South Canal Street, 2007. Exterior court. Photo: Steve Hall © Hedrich Blessing, courtesy Tigerman McCurry Architects.

Overleaf:
Stanley Tigerman of Tigerman McCurry, Illinois Holocaust Museum and Education Center, 9603 Woods Drive, Skokie, Illinois. 2009. Photo: David Seide, Defined Space, courtesy Tigerman McCurry Architects.

Left:
Adrian Smith of Skidmore, Owings & Merrill, Trump International Hotel and Tower, 401 North Wabash Avenue, 2009. Photo: © Mark Ballogg.

Right:
Renzo Piano, The Art Institute of Chicago, The Modern Wing, Monroe Street between Columbus Drive and Michigan Avenue, 2009, exterior and interior Kenneth and Anne Griffin Court. Photos: © Paul Warchol, courtesy The Art Institute of Chicago, Images 00143859-01 and 00143837-01.

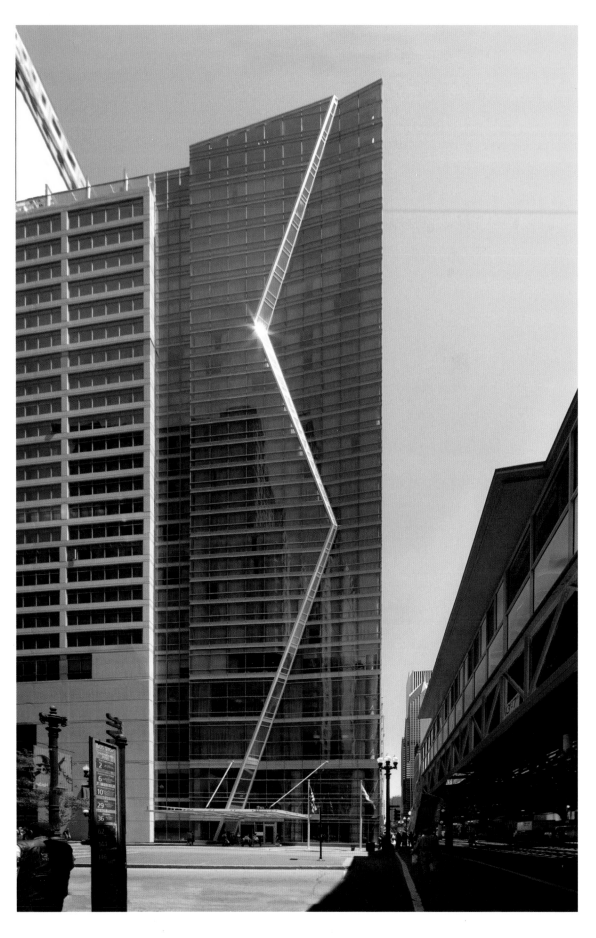

292

Left:
Jackie Koo of Koo and Associates, Ltd., The Wit, 201 North State
Street, 2009. The 27-story boutique hotel has two restaurants, 298
rooms, and related services. Its dramatic form relates to the industrial
forms of the El train nearby. Photo: © James Steinkamp Photography,
courtesy Koo and Associates, Ltd.

Right:
Jeanne Gang, Studio Gang, Aqua, 225 North Columbus Drive,
2009–11. Photo: Balcony detail, Steve Hall © Hedrich Blessing,
ArcaidImages.com 70012-830-1.

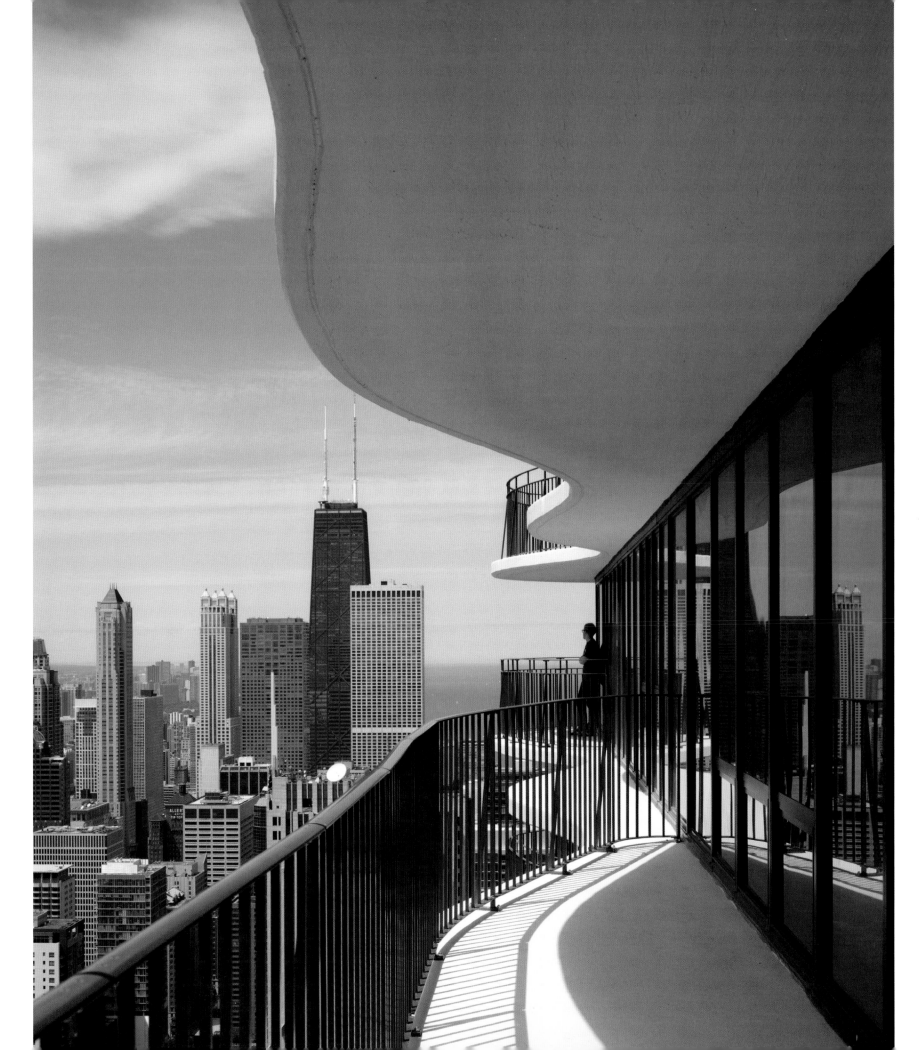

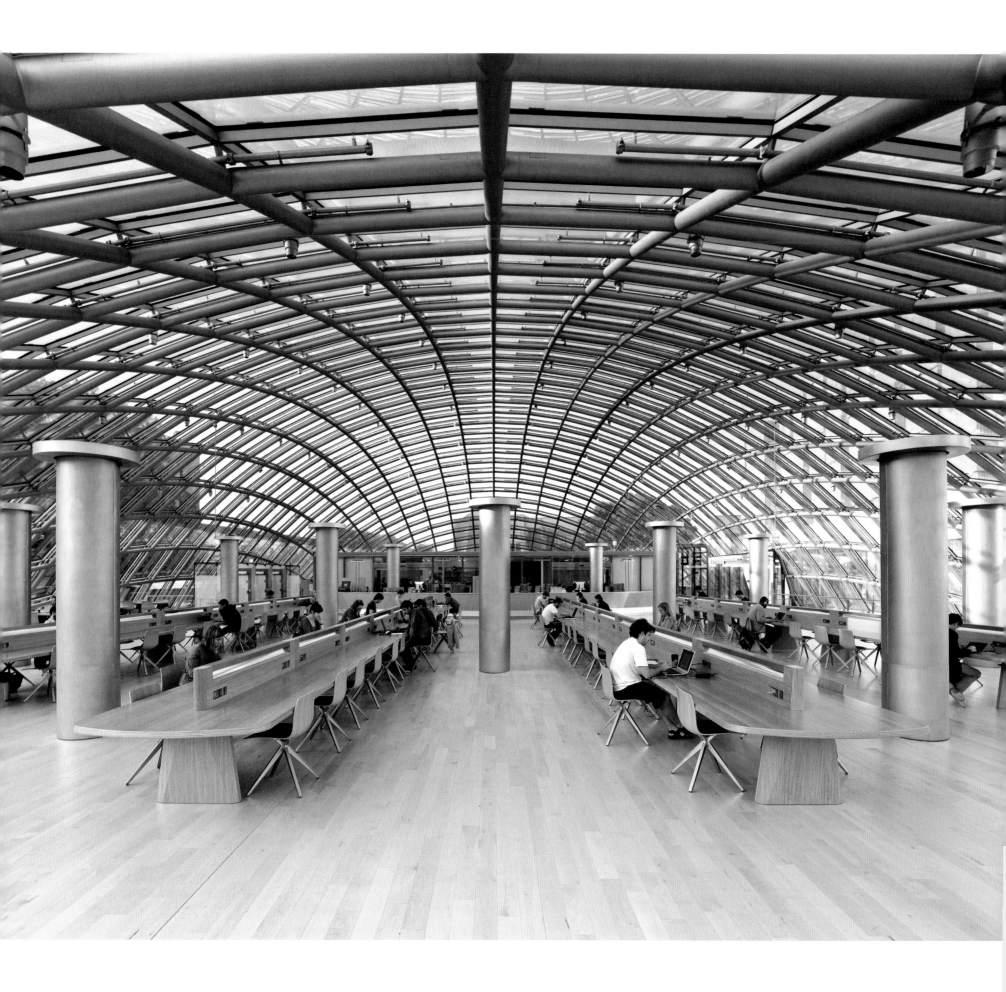

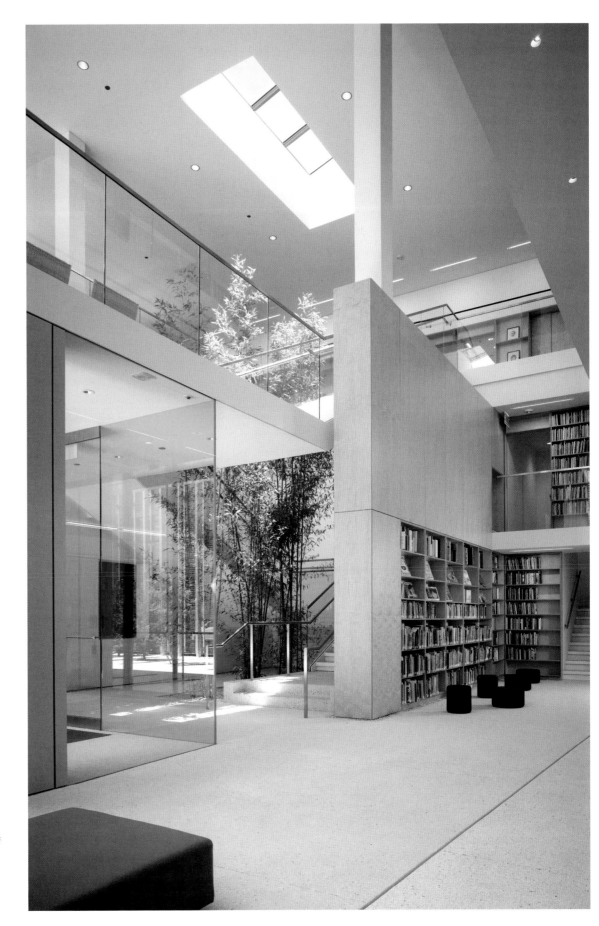

Left:
Murphy Jahn, Joe and Rika Mansueto Library, University of Chicago, 1100 East 57th Street, 2011. Photo: Rainer Viertlboeck, courtesy Jahn.

Right:
John Ronan, Poetry Foundation, 61 West Superior Street, 2011. Photo: Steve Hall, © Hedrich Blessing, courtesy John Ronan Architects.

Overleaf, left:
Perkins & Will, William Jones College Preparatory High School, 700 South State Street, 2013. Photo: © James Steinkamp, courtesy Perkins & Will.

Overleaf, top right:
Valerio Dewalt Train, Earl Shapiro Hall, Lab School of the University of Chicago, 1352 E. 59 Street, 2013. Photo: Barbara Karant, courtesy Valerio Dewalt Train.

Overleaf, bottom right:
Margaret McCurry of Tigerman McCurry, Lincoln Park House, 2015. Photo: Steve Hall, © Hedrich Blessing, courtesy Tigerman McCurry.

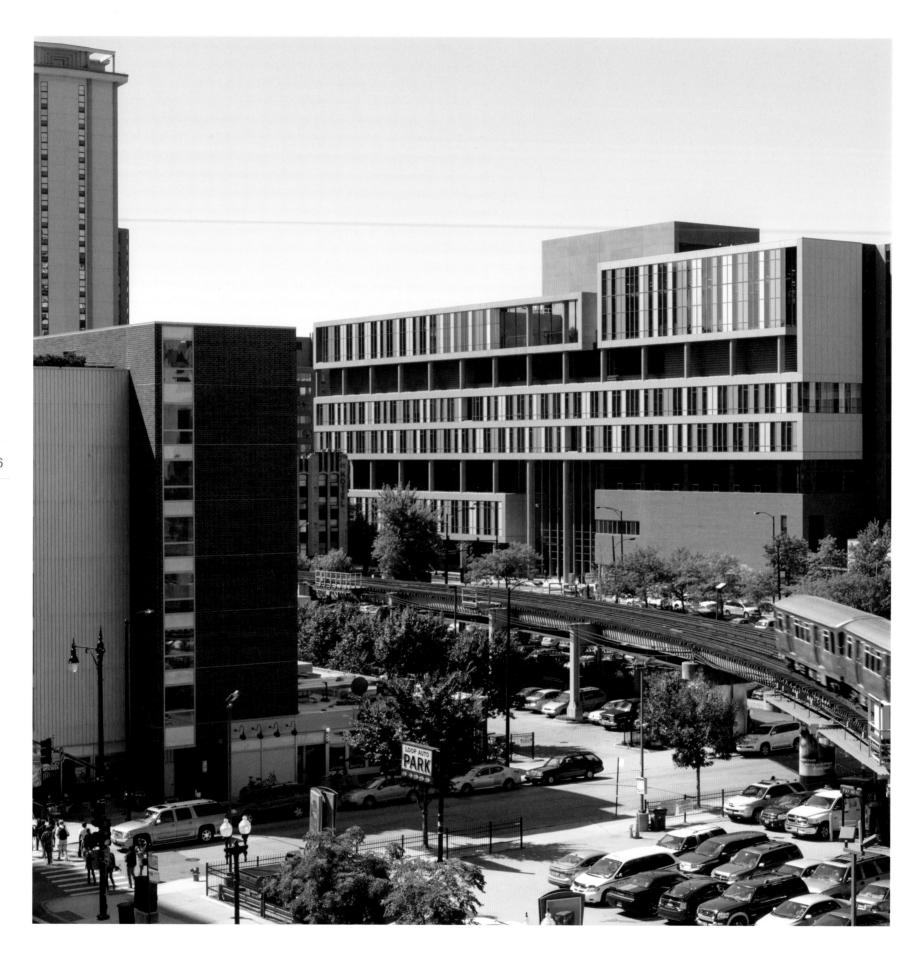

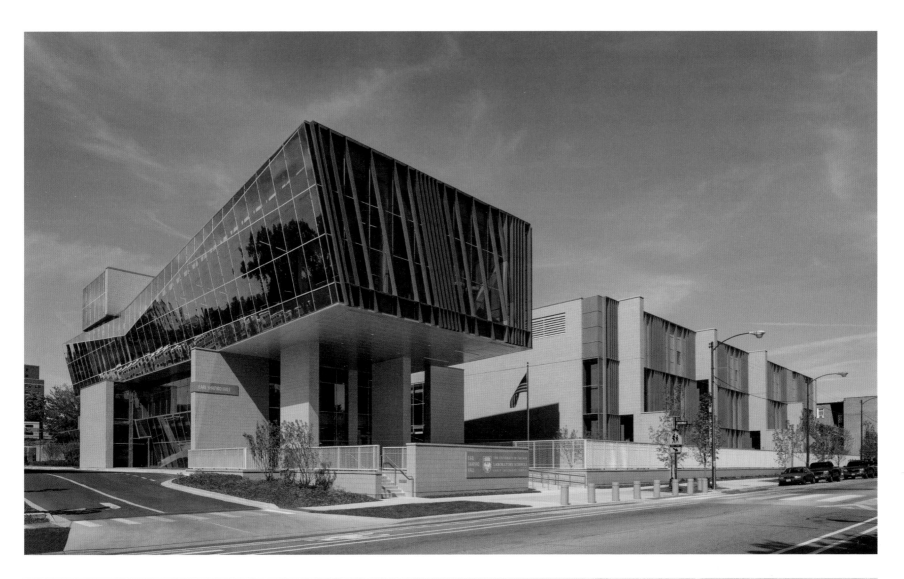

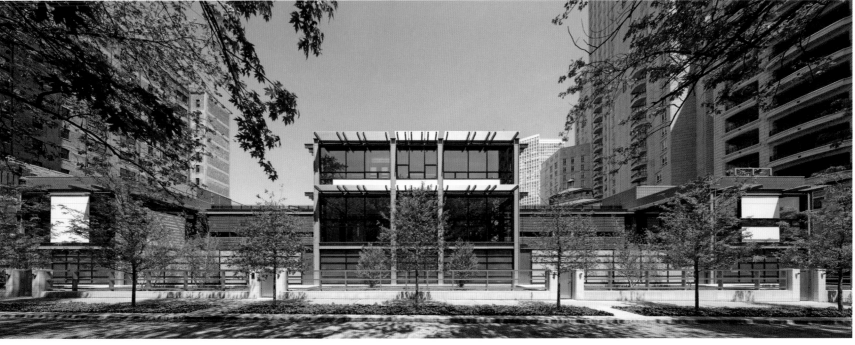

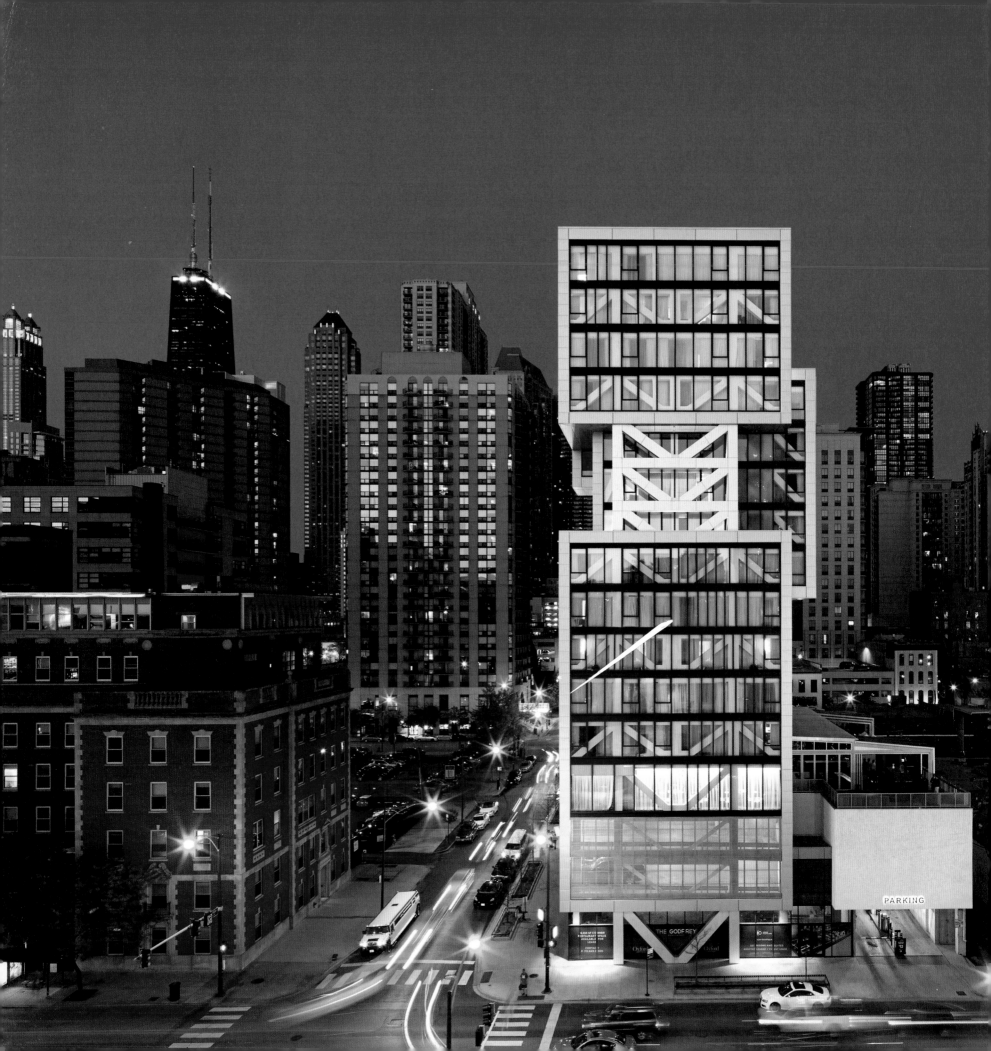

THE GODFREY

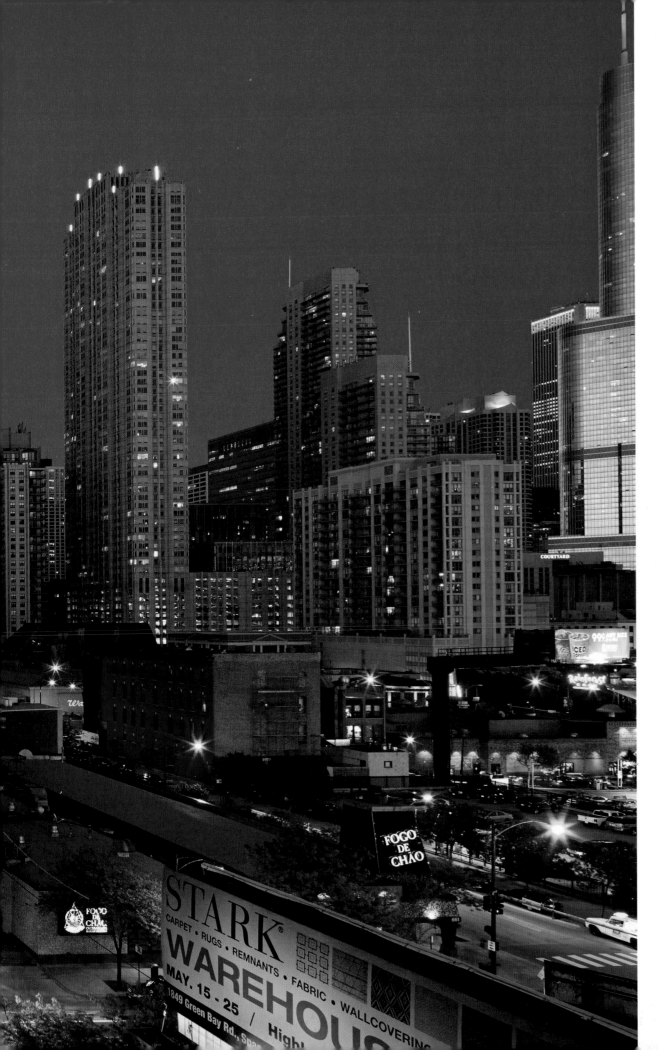

Valerio, Dewalt Train Godfrey Hotel, 127 West Huron Street, 2014.
Photo: Steve Hall, © Hedrich Blessing, courtesy Valerio Dewalt Train.

CHICAGO ARCHITECTURE: SELECTED SOURCES

Nowadays, just about anything you need to find is on the Internet, and the quality of information has improved on a number of websites. Searching sources such as the websites of contemporary architects as well as Wikipedia and *Encyclopedia Britannica* for historic architects can be fruitful, as are using the website of the Ryerson and Burnham Libraries of the Art Institute of Chicago, especially their catalog, the Chicago Architects Oral History Project, and digital resources pages. Likewise, the Research Center of the Chicago History Museum, particularly the ARCHIE search engine, and their Encyclopedia of Chicago are all useful resources. The websites of the Chicago Chapter of the American Institute of Architects and their *Chicago Architect* magazine can also be helpful, especially as regards new local building and recent awards programs and entrants. Other good sites include that on skyscrapers created by the Council on Tall Buildings and Urban Habitat and journals such as *The Architect's Newspaper*. Rather than listing any of those actual URLs that may change over time, searching keywords in the above sentences will bring up those sites for your use.

Publications have always been an essential part of any research on Chicago architecture. Journals such as the Chicago History Museum's *Chicago History* and architectural ones such as *Inland Architect* and the *Chicago Architectural Journal* are essential periodicals to be consulted. Searching online book sources will also find any number of monographs on a variety of Chicago architects, past and present. You can also find several guides and architectural surveys. Some are the following:

Rolf Achilles, *The Chicago School of Architecture*. Oxford, 2013.

H. Allen Brooks. *The Prairie School: Frank Lloyd Wright and His Midwest Contemporaries*. New York, 2006.

Carl W. Condit, *The Chicago School of Architecture*. Chicago, 1964, and new edition, 1998.

Neil Harris, *Chicago Apartments*. New York, 2004.

Tony Hiss, with an introduction by Tim Samuelson. *Building Images: Seventy Years of Photography at Hedrich Blessing*. Chicago, 2000.

Edward Keegan, *Chicago Architecture 1885 to Today*. New York, 2008.

Judith Paine McBrien, *Pocket Guide to Chicago Architecture*. New York, 2004.

Jay Pridmore and George Larson, *Chicago Architecture and Design*. New York, 2005.

Frank A. Randall, *History of the Development of Building Construction in Chicago,* second edition rev. John D. Randall. Urbana and Chicago, 1999.

Pauline A. Saliga, ed. *The Sky's the Limit: A Century of Chicago Skyscrapers*. New York, 1990, repr. 1992.

Alice Sinkevitch and Laurie McGovern Petersen, *AIA Guide to Chicago*, third edition, Urbana and Chicago, 2014.

John Zukowsky, ed. *Chicago Architecture: 1872–1922* and *Chicago Architecture and Design: 1923–1993*. Munich, 1987 and 1993.

John Zukowsky and Martha Thorne, *Masterpieces of Chicago Architecture*. New York, 2003.

ACKNOWLEDGMENTS

Every author knows that he or she can never write books without help, and, I might add, often substantial help. This book is no exception, and many people deserve my thanks for their assistance. Among these, Rizzoli International Publications staff members are at the forefront, particularly editors Douglas Curran and David Morton. I sincerely thank them for their advice during the research phase of the project as well as their assistance throughout, and even from the start, selecting me in 2014 to author this volume.

This current Chicago book focuses on the fantastic resources of the Chicago History Museum, and their staff deserve my gratitude for making this task an easy one to complete. Gary T. Johnson, their President, and Russell Lewis, Executive Vice President and Chief Historian, both endorsed the project from the very start. Luciana Crovato, Executive Assistant and Manager, initially helped orchestrate meetings there as well. Their collections and research staff warrants my special thanks for assisting with the visual research on this book and the delivery of that great imagery: M. Alison Eisendrath, Andrew W. Mellon Director of Collections; Angela Hoover, Licensing and Reproductions Manager; Sarah Yarrito, Licensing and Reproductions Coordinator; Stephen Jensen and Joseph Campbell, Photographers/Imaging Specialists; Ellen Keith, Director of Research and Access; and Lesley A. Martin, Research Specialist.

Many of the photos within the museum and published here come from the Hedrich Blessing Collection, and also through one of their digital-image suppliers, Arcaid Images. Others come directly from Hedrich Blessing or from architects who have hired them. I am grateful to Jon Miller, President, Hedrich Blessing Photographers with Jackie Furtado, Production Manager, and Jenling Norman, for their consistent cooperation, along with Lynne Bryant of Arcaid Images. Aerial photographer John Hill of Tigerhill Studio went above and beyond in his efforts to provide photographs of some of the more difficult sites, as did John Gronkowski.

Beyond my partners listed above for this project, I thank staff at my former workplace, The Art Institute of Chicago. They provided suggestions, advice, and assistance with research toward several important buildings and spaces, and their related images: Zoë Ryan, the John H. Bryan Chair and Curator of Architecture and Design, and Lori Boyer, Collections Manager, both from the Department of Architecture and Design; Mary K. Woolever, Art and Architectural Archivist, Nathaniel Parks and Amelia Zimet, both Assistant Archivists, Ryerson and Burnham Libraries; Aimee L. Marshall, Manager of Image Licensing; and Nina Litoff, Public Affairs Assistant.

This book is filled with amazing photographs that were graciously supplied through the generosity of others—building owners, their agents, architects, and photographers themselves. They all deserve my gratitude because without their diligent cooperation, this volume would have been woefully incomplete. They, and others who led me to spectacular shots, include Katherine Bajor, Krueck + Sexton Architects; Mark Ballogg and Kyle Wolff, Digital Production Artist, Ballogg Photography; J. Paul Beitler, President, and Eileen Koss of Beitler Real Estate Services; Lorraine Bezborodko, Chargée de communication, Jean-Paul Viguier et Associés; Laurence Booth and Michael Sandrzyk of Booth Hansen; Lucas R. Clawson, Reference Archivist, Manuscripts and Archives Department, Hagley Museum and Library; Rebekah

Cole, Marketing Coordinator, Holabird & Root; Mary Dwyer, Museum Curatorial Assistant, The Richard H. Driehaus Museum; Sheniqua Faulkner, Marketing and Communications Manager, Hyde Park Art Center; Theresa Gorman, Chris Groesbeck, and Kevin Krejca of VOA Associates Incorporated; Elena Grotto, Media Relations Manager, Museum of Contemporary Art Chicago; Karla Ikpi of Gensler; Michael Kaufman, Sayaka Nakamura of Kisho Kurokawa Architect & Associates; Nikki O'Donnell, and Mike Voss of Goettsch Partners; Howard N. Kaplan; Rachel Kaplan of Koo Associates; Andre Kikoski and Alex Polier in Andre's office; Lucien Lagrange; J. D. McKibben, Associate Principal, New Business Director, Perkins & Will; Jordan Mozer; Louisa Shields-Munie, Graphics/Promotions Designer, HBRA Architects; Isabella Palmer, Skirt Public Relations for Thompson Chicago; Stephanie Pelzer, Executive Graphics & Communications, Jahn; John Ronan and Sam Park of John Ronan Architects; Jennifer N. Pritzker, Colonel (IL), IL ARNG (Retired), President & CEO Tawani Enterprises with staff in that organization, especially Mary Parthe, Chief of Staff and Paul J. Rades, Property Manager, J & J Arnaco, LLC; Pauline Saliga, Executive Director, Society of Architectural Historians; Caroline Nye Stevens; Stanley Tigerman and Margaret McCurry, with Taber Wayne and Jessie La Free of Tigerman, McCurry Architects; William Tyre, Executive Director and Curator, Glessner House Museum; Joe Valerio, Adam Farooq, and Christine McGrath of Valerio Dewalt Train; Emily J. Waldren, Interim Public Relations Director, The Field Museum; Dan Wheeler and Beth Garneata of Wheeler Kearns Architects; and William Zbaren.

Finally, I apologize if I missed anyone who has supported my work in this effort to bring highlights of Chicago's great buildings over the past two centuries to the reader. And I am especially indebted and incredibly grateful to my wife, Milli, who has patiently supported me in this and so many publishing journeys over the past decades.

INDEX